John Stapler
5/11

TREASURES *of* LSU

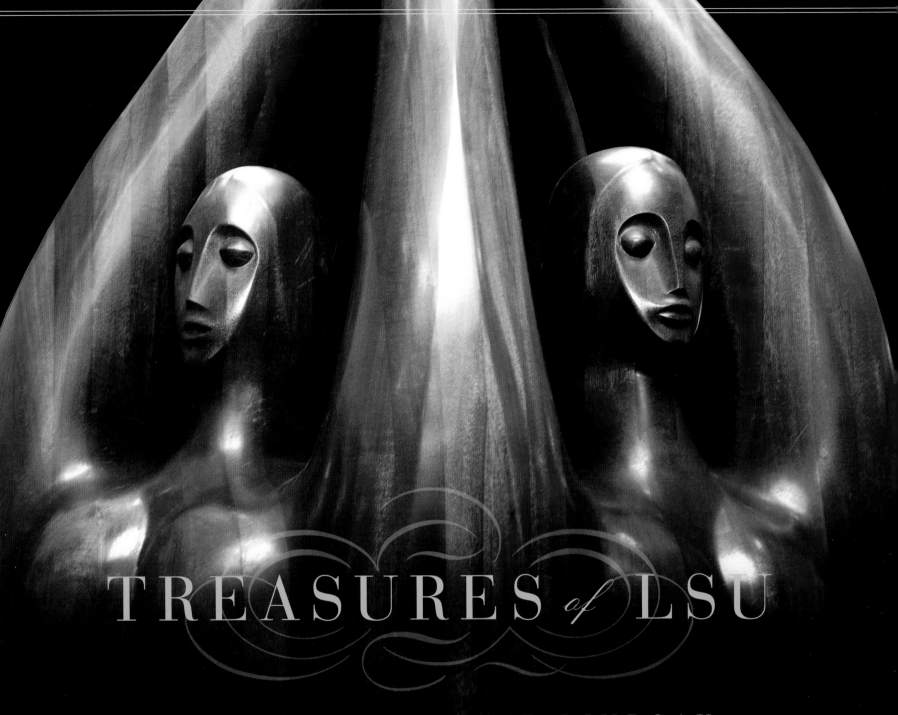

TREASURES of LSU

EDITED BY LAURA F. LINDSAY

WITH A FOREWORD BY PAUL W. MURRILL

Louisiana State University Press, Baton Rouge

Published by Louisiana State University Press
Manufactured in the United States of America
First printing

Designer: Faceout Studio, Jeff Miller
Typefaces: Adobe Garamond, Futura, and Trade Gothic
Typesetter: Faceout Studio, Jeff Miller
Printer and binder: Walsworth Publishing Company, Inc.

Library of Congress Cataloging-in-Publication Data
Treasures of LSU / Laura F. Lindsay, editor ; with a foreword by Paul W. Murrill.
 p. cm.
 Includes bibliographical references.
 ISBN 978-0-8071-3677-5 (cloth: alk. paper)—ISBN 978-0-8071-3678-2 (pbk. : alk.
paper) 1. Louisiana State University (Baton Rouge, La.). I. Lindsay, Laura F.
 LD3113.T74 2010
 378.763′18—dc22
 2009053712

The paper in this book meets the guidelines for permanence and durability
of the Committee on Production Guidelines for Book Longevity
of the Council on Library Resources. ∞

Contents

V. Fine Arts: "Native Flora" and Other Acquisitions

VI. Louisiana Legacy: Interior of a Steamboat and Other Glimpses into Southern Arts and Culture

VII. Libraries and Literature: Bonaparte's *l'Égypte* and Other Rare Items

VIII. Cultural Artifacts: Hand-Spun Quilt from Acadiana and Other Clues to the Past

IX. Research Collections: Birding, Excavating, and Other Faculty Endeavors

Foreword

Louisiana State University is currently celebrating the sesquicentennial of its founding in 1860. But what is LSU? Is it the 35,000-person community that lives and works on campus today, or is it the hundreds of thousands who have been a part of the campus over the decades? Is LSU a lone student reading a history lesson in a dorm room, or is it Tiger Stadium on a Saturday night during football season? Is LSU a constitutionally based institution of higher education, or is it a group of architecturally significant buildings and open spaces, state-of-the-art athletic facilities, science laboratories, and museums?

In reality, of course, it is all of these at once. But what is there about LSU that has caused so many people over 150 years to bond their lives in one manner or another to the university? Their bonds have been widely different—some intellectual, some athletic, some economic, some emotional, some physical, some programmatic, some artistic. Logic tells us that there must be core values that have provided a foundation for this extended community that has such fond memories of LSU.

Where do we turn to understand and appreciate and gain insight into these core values that bind together the images, artifacts, activities, and people of LSU? A wise teacher two thousand years ago said, "Where your treasure is, there will your heart be also." Does LSU have treasures? Have the energetic and intelligent people of LSU accumulated treasures over the years? Can we look to these treasures for insight concerning the core values of LSU?

The University Commission on the History of LSU considered these questions as part of its thinking about how best to celebrate the 150-year existence of LSU. As a result, the commission challenged the campus community to look for its "treasures," and this publication represents a selection of what was found.

Some of these treasures derive their status from rarity, others from competitive achievement, still others from scholarly or artistic merit. Some derive their value from their appearance and reveal truth in beauty, and some reveal the beauty of truthful detail (the Native Flora of Louisiana watercolors, for example). Some enhance the environments in which we work and study. All reflect expressions of superb quality.

All encourage, in one way or another, the human spirit to soar. All demonstrate a commitment to excellence in human endeavor.

These treasures reflect well the spirit of LSU. As our alma mater states, "And may thy spirit live in us, forever LSU."

—Paul W. Murrill
Chancellor Emeritus
Baton Rouge, 2010

ix

Acknowledgments

The faculty and staff who took on the challenge of nominating and writing essays about the treasures of LSU deserve our gratitude. This book would not have materialized except for their engagement and dedication. They participated in a complicated collaboration that involved fifty essayists to support the concept of a book that included campuswide perspectives. The university is indebted to their contributions both here and on the LSU campus.

As readers browse these pages, they will be amazed by the many LSU friends who have discovered and collected rare objects and generously donated them to LSU. The university continues to strengthen its research foundation because of their vision and understanding of the importance of providing access to these invaluable tools for learning. They deserve recognition and our gratitude for their extraordinary gifts.

The encouragement for moving forward with this book came from the University Commission on the History of LSU. Founded in 1989 to preserve the history of Louisiana State University and Agricultural and Mechanical College, the commission had the following specific objectives:

—to assist the LSU Libraries in identifying, collecting, organizing, and providing access to materials which document the history of LSU;

—to promote graduate study, instruction, and research in the history of LSU;

—to facilitate the preparation of works interpreting the history of LSU;

—to serve in an advisory capacity to the University Archives and Oral History programs;

—to encourage an appropriate historical perspective in the observation and celebration of significant landmarks in the development of LSU, its colleges and departments;

—and to coordinate the identification and solicitation of resources to support projects related to the history of the university.

In addition to these goals, the commission also took on the responsibility of keeping up with important events. As the sesquicentennial approached, commission members urged the campus administration to set a timetable and sequence of events that would culminate in 2010 and address both the past and future contributions of the university. Among the recommendations that the commission presented to the administration was the creation of a book that would capture the spirit and highlight the treasures of LSU.

The editorial committee, a hard-working group of current and retired faculty and staff, alumni, students, and community members, spent many hours over a period of two years reviewing submissions and selecting the treasures portrayed in this text. Among these dedicated folks were Katrice Albert, Vice Provost for Equity, Diversity, and Community Outreach; Jackie Bartkiewicz, Editor, *Alumni Magazine*; Jennifer Cargill, Dean, LSU Libraries; James M. Coleman, Boyd Professor Emeritus, Coastal Studies Institute; Yasmine Dabbous, Ph.D. candidate, Manship School of Mass Communication; J. Michael Desmond, Professor, School of Architecture; Gresdna Doty, Alumni Professor Emerita, LSU Department of Theatre; Paul Hoffman, Paul W. and Nancy W. Murrill Distinguished Professor, LSU Department of History, *ex officio*; Laura F. Lindsay, Professor Emerita, Manship School of Mass Communication; Tom Livesay, Executive Director, LSU Museum of Art; Margaret Hart Lovecraft, Editor, LSU Press; Marchita B. Mauck, Professor, LSU School of Art; Tamara Mizell, Editor, University Communications and Relations; Michael Robinson, Senior Director of Development, LSU Foundation; Cary Saurage, LSU Alumnus and Community Representative; and Judy Stahl, Coordinator, LSU Union Art Gallery.

Several individuals deserve special mention for the roles they played in shaping the direction of this book. Margaret Stones, whose work appears in it, sent a copy of the University of Melbourne's publication *Treasures: Highlights of the Cultural Collections of the University of Melbourne* to Alumni Professor Emerita Gresdna Doty. A compilation of essays and photographs, edited by Chris McAuliffe and Peter Yule, it was produced to coincide with the University of Melbourne's 150th anniversary. Professor Doty's dialogue with Cary Saurage, an

alumnus and friend of LSU, culminated in the original proposal for LSU to produce a book about its treasures inspired by the University of Melbourne book. As discussion about LSU's 150th anniversary moved from talk to action, the proposal found momentum with the University Commission on the History of LSU as a possible legacy project. We are grateful for the guidance received from Dr. McAuliffe, director of the University of Melbourne's Ian Potter Museum of Art, who was extremely helpful and generous in giving us pointers and sharing information. We are also grateful for another book that served as a model, *The Rarest of the Rare: Stories behind the Treasures at the Harvard Museum of Natural History.*

Considered one of the top liturgical design consultants in the country, Marchita B. Mauck, professor and art historian, lent her writing and curatorial skills to the project. Yasmine Dabbous brought tremendous organizational skills, language acumen, and editorial ability. Professor Michael Desmond's knowledge of the historic campus and Professor Van Cox's insights about the landscaping elements guided the general content and direction of the book. Despite their busy schedule, Elaine Smyth, Head of Special Collections, LSU Libraries; Fran Huber, Assistant Director, LSU Museum of Art; and

Professor Paul Hoffman helped the committee with research and provided valuable advice. The Manship School of Mass Communication also deserves our thanks for its support by providing release time for the project director, office space and equipment, and cooperation in acquiring graduate-student assistance.

Our university photographers, Jim Zietz, Kevin Duffy, Jason R. Peak, and Eddy Perez, spent more than a year working with the editorial team to shoot, select, and prepare photographs for the essays. Their contributions to the book were invaluable. Finally, we are grateful to Director MaryKatherine Callaway, Acquisitions Editor Margaret Hart Lovecraft, Senior Editor Catherine L. Kadair, Assistant Director and Design and Production Manager Laura Gleason, and the rest of the LSU Press staff for their valued guidance and outstanding work in producing *Treasures of LSU.*

Introduction

The University's Collections

Treasures of LSU, the official book of Louisiana State University's sesquicentennial celebration, affirms the importance of LSU's cultural contributions to the world community. It also calls attention to the treasured works of quality and substance belonging to the university. But an even more crucial purpose underlies this project: the importance of continually developing coherent collections and advancing the inclusion of the university's collections in the central educational enterprise of the university. As LSU's treasures grow in relevance, value, and quantity for research and interpretation, LSU will also advance its critical role in the development of our state, region, and nation.

The result of decades of collecting and preserving objects for study and teaching, the artworks, research collections, scientific and cultural artifacts, and architectural highlights found in *Treasures* represent a small fraction of the thousands of objects that LSU faculty, staff, and students encounter, study, and preserve on a daily basis. They are *our* treasures; they play a large part in what research universities do and why they exist. They help us understand who we are and how we got here. They define our culture, uplift our spirits, and challenge our thinking. They have created their own myths—some of which will be challenged as a result of the essays found in this book.

It is fitting that Louisiana State University and Agricultural and Mechanical College produce this book to coincide with its 150th anniversary. LSU enrolls more than 28,000 students each fall who pursue degrees in 200 fields on the undergraduate and graduate levels. It is designated as the state's comprehensive research, land-grant, sea-grant, and space-grant institution. The university's influence is felt locally, nationally, and internationally through a broad range of research, teaching, and service and through more than 200,000 living alumni who have distinguished themselves in politics, agriculture, art and design, business, education, engineering, literature, science, sports, and entertainment.

Celebrating LSU

The sesquicentennial celebration continues a tradition of commemorating significant events in the history of LSU and chronicling the university's growth. The first commemorative event occurred on March 12, 1856, when Gen. G. Mason Graham, vice chairman of the board of trustees, gave the main address during the dedication and laying of the cornerstone for the Seminary of Learning of the State of Louisiana in Pineville, Louisiana. Graham noted that the inscribed marble stone would be a legacy, reminding students that the institution was made possible by the federal government of the United States: "This is one of the innumerable and untold blessings which they enjoy from the union of these states." This stone can be found today at the site of the original campus in Pineville.

For the fiftieth anniversary of the university, the downtown campus hosted visitors, dignitaries, and alumni January 2–4, 1910. Commemorating the semicentennial with academic processions, speakers, banquets, and special events, President Thomas D. Boyd noted in his "Summary—Retrospective and Prospective" that during the previous half-century, the campus had burned to the ground, moved three times, and now had 47 buildings, 50 faculty members, and 600 students. By the spring of 1926, LSU had moved to its current campus, sixty-six

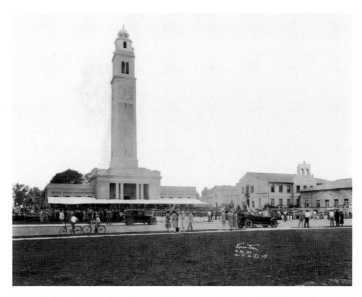

ABOVE: Dedication ceremonies of the new LSU campus, Baton Rouge, 1926. Photographer: Jasper Ewing. Jasper Ewing and Sons Photograph File, MSS 3141, Louisiana and Lower Mississippi Valley Collections, LSU Libraries, Baton Rouge.

years after the seminary had opened. The three-day celebration, held April 30–May 2 and planned by deans, directors, faculty, students, and board members, attracted more than 3,500 people, including distinguished leaders from all over the United States.[1] Boyd and other community leaders left the legacies of a master plan created by nationally acclaimed designers and a campus that would support the growth of a research university for decades to come.

The 1959–1960 centennial celebration also left its mark. The LSU Press published a book entitled *Louisiana State University: A Pictorial Record of the First Hundred Years*. In addition, the university published the pamphlet *Builders and Buildings*, which identified the buildings on campus and for whom they were named, and produced a thirty-minute film, *LSU: The Next One Hundred Years*.[2] In 1976, to celebrate the U.S. bicentennial and LSU's fiftieth anniversary at

its present site, Chancellor Paul W. Murrill asked Margaret Stones, internationally renowned botanical artist, to complete a six-drawing commission of botanical illustrations of Louisiana flora. Out of that relatively small endeavor came a greater one, a 200-drawing commission to be completed over the next ten years.

By 2000 it was clear that the campus had veered away from the original master plan and that the time had come to reassess its physical development. The "Diamond Jubilee," celebrating seventy-five years on the "new campus," focused on "building on the legacy of the past for the new century." Under the leadership of LSU System president William L. Jenkins and chancellors Mark Emmert (LSU), William Richardson (LSU Agricultural Center), and John Costonis (LSU Law Center), the university commissioned the national firm Smith Group JJR to develop a new master plan based on the original design of the campus.

BELOW: The 2003 master plan of the main campus. From http://masterplan.lsu.edu/.

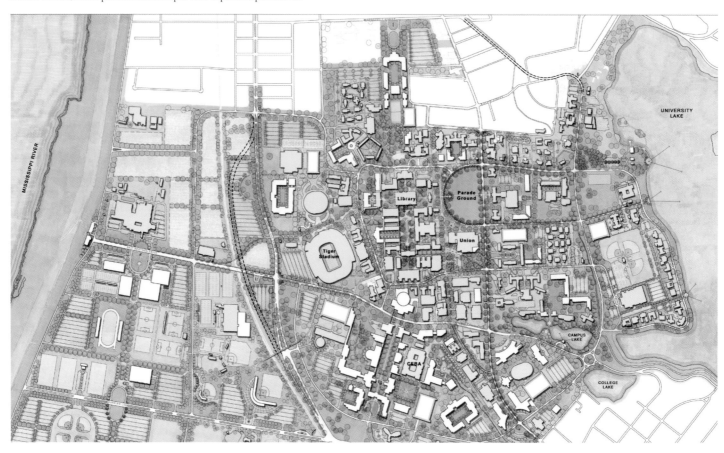

An Overview of LSU's History

The story of LSU's growth into a major state research and land-grant institution is financially and culturally grounded in several federal acts: the Morrill Acts of 1862 and 1890, the Hatch Act of 1887, and the Adams Act of 1906. Designed to support the expansion of higher education for the common citizen, stimulate creativity in agricultural research, and provide the resources necessary for both, the infusion of these federal funds at LSU in 1877, 1890, 1906–07, and 1912 allowed the campus to expand beyond the limits that had been set by the original endowments and the 1879–1904 constitutional limits on funding.

During the eighteenth and early nineteenth centuries, education in Louisiana was reserved for those who could afford special schools in the northern states or to send their children abroad. French and Spanish rule influenced this lack of educational opportunities by placing little importance on creating schools for the average citizen. Around the mid-nineteenth century, Americans began to recognize that economic reform was contingent on access for all citizens to educational opportunities beyond basic reading and writing skills. In the early 1840s, while similar discussions were going on in other parts of the nation, Gen. G. Mason Graham, a native Virginian and planter who owned Tyrone Plantation in Rapides Parish, lobbied the Louisiana General Assembly to provide an affordable education for young men who could not attend expensive American or European schools. In 1854, having received the assembly's nod for the Seminary of Learning of the State of Louisiana to be built in Pineville, Louisiana, Gov. Paul Hebert appointed a board to begin planning efforts.

Graham, believing in the importance of military training, thought the seminary should be modeled on a military institute such as the Virginia Military Institute.[3] A number of seminary board members and key faculty, including David F. Boyd, supported a liberal arts curriculum. This initial debate resulted in the traditional literary, scientific, engineering, and military training that remained the educational foundation for LSU through the first half of the twentieth century.

The seminary opened its doors on January 2, 1860, with William Tecumseh Sherman as its first superintendent. Sixty-six students enrolled by the middle of its first session. That winter, Sherman, who had strong Union ties, submitted a letter of resignation. The anticipated secession of Louisiana from the Union became a reality, and by spring 1861, many of the students and faculty had left to join the Confederate army. The campus closed on April 23, 1863, and managed to survive the Civil War—but only because Sherman directed that it, along with Tyrone plantation, be spared. Reopening October 2, 1865, under the leadership of David F. Boyd, the seminary graduated its first class in June 1869. Shortly thereafter, in another unfortunate turn of events, the main seminary building burned to the ground on October 15. Saved from the fire was a life-sized portrait of W. T. Sherman painted by Professor Samuel H. Lockett.[4] Less than a month later, the seminary moved to Baton Rouge, reopening with 170 cadets in the north wing of the State Institution for the Deaf. This beautiful building complex, torn down in the early twentieth century, was captured in an original painting by the famous architect Marie Adrien Persac. Donated to LSU by his descendants, it now resides in the LSU Museum of Art collections.

In 1870 the State General Assembly renamed the seminary Louisiana State University. Although the university tracked national trends in education, state funding had been and continued to be undependable. In 1875, because of lack of funding and the turmoil of Reconstruction, faculty at times taught without compensation. Enrollment that year dropped to eight students. In October 1877, with David Boyd as the prime advocate and after much controversy and several changes in state leadership, the Agricultural and Mechanical College located in New Orleans was moved to Baton Rouge and merged with LSU.[5] LSU was

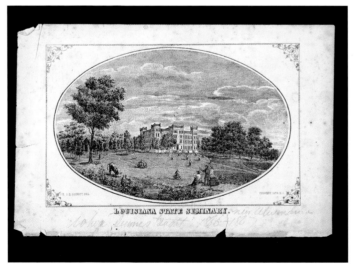

ABOVE: Lithograph of the Louisiana State Seminary at Pineville, 1866. LSU Photograph Collection, RG A5000, Louisiana State University Archives, LSU Libraries, Baton Rouge.

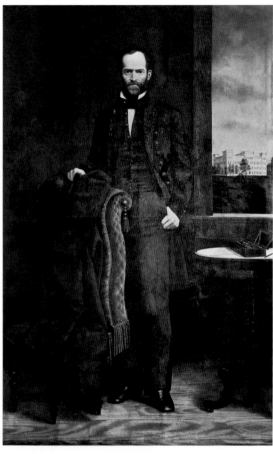

ABOVE: Gen. William T. Sherman. Office of the President Records, RG A5000.0002, Louisiana State University Archives, LSU Libraries, Baton Rouge.

of 1887, LSU added a second experiment station adjacent to the downtown campus.[6] More land was purchased in 1912.

In August 1896, Thomas Duckett Boyd accepted the presidency. He was David F. Boyd's younger brother, the former president of the State Normal School at Natchitoches, Louisiana, and a graduate of LSU. Enrollment stood at 220 male students. With the continued growth of the university, emphasis on agricultural research, and the limitations placed on its physical development because of surrounding community growth, Thomas Boyd pushed for new land that would accommodate a college farm. This objective became the impetus for the new campus. In 1918, Boyd invited legislators and prominent citizens to a barbecue at the Indian mounds on the Gartness property, then for sale, to encourage support for the purchase of the land. Convinced, a number of community leaders assumed the risk for purchasing the property until the legislature could pass and the governor sign the appropriations bill.[7] During Thomas Boyd's tenure as president, the university expanded enrollment to 1,712 students, developed the downtown campus, secured regular funding from the legislature, admitted women, and moved to the current campus.

Although credit is often given to Huey P. Long, it was Gov. John M. Parker (1920–1924) who shared Thomas Boyd's vision of a "greater LSU" and pledged to build the university into a major college campus. He succeeded in getting the state legislature to pass a severance tax to support higher education institutions in the state and sent an emissary

designated a Morrill Land Grant institution and received its current name, the Louisiana State University and Agricultural and Mechanical College. By 1878–79, enrollment had climbed to 189 students.

With a growing enrollment and limited space at the School for the Deaf, the university needed its own campus. Through General Sherman's influence with Congress, in the spring of 1886 the university gained temporary use of the grounds of the old Baton Rouge Arsenal, consisting of a little over two hundred acres with a four-building barracks, officers' homes, and other buildings that had been used for an army post. With this move, LSU became the largest higher education campus in the state. That same spring, LSU expanded to include a state experiment station; and the following fall, as a result of the Hatch Act

ABOVE: President Thomas D. Boyd addresses crowd at the ground-breaking of the Greater Agricultural College, 1922. Photographer: Jasper Ewing. Jasper Ewing and Sons Photograph File, MSS 3141, Louisiana and Lower Mississippi Valley Collections, LSU Libraries, Baton Rouge.

to New York to seek a grant from the Carnegie Foundation's General Education Board with the goal of making LSU a world-class agricultural research operation. Although unsuccessful in securing these funds, Parker sent a group of prominent community members to visit other land-grant universities to determine if the university and the agricultural college should remain together or be separated.[8] His vision and ability to secure financial support resulted in the building of the heart of the current physical campus.[9]

In 1925, when the "new" campus, including many of the early Italian Renaissance–style buildings, opened for students, Henry L. Fuqua was governor. Also completed by this time were portions of Tiger Stadium, the Stock Judging Pavilion, and the Pentagon Barracks. By 1926–27, 1,880 students (including 509 women) had enrolled at LSU. Along with its physical growth, the university experienced a cultural shift in enrollment, from sons of farmers to sons and daughters of the middle class. Although the consequence was less emphasis on agriculture as a part of the curriculum, the university continued to cultivate its work in extension and research.

Railroad commissioner (1918–1928), governor (1928–1932), and U.S. senator (1931–1935), Huey Pierce Long made his presence known at LSU on numerous fronts. Seven buildings were constructed on the main campus during the period he was governor and senator: the Huey P. Long Field House and Swimming Pool (1928–1929), Smith Hall (a women's dormitory later to be named Pleasant Hall, 1929), the Agricultural Administration Building (1935), the Gym-Armory (1930), the Music and Dramatic Arts Building (1932), Highland Hall (1935), and the French House (1935). Long also substantially increased the university's operating budget, and by 1934–35, LSU enrolled 4,454 students (1,146 of them women). During this period of growth, the Works Project Administration provided funds to complete the North Stadium and dormitories, Nicholson Hall, Alex Box Baseball Stadium, Parker Coliseum, Himes Hall, Allen Hall, and the Faculty Club.

Long's involvement with the football team and the LSU marching band are legendary. Photographs show him giving a sendoff to university students on their way by train to a football game, walking along the sidelines with the referees, marching with the drum majorettes, and posing with cheerleaders. His populist leanings continued to influence Louisianians throughout much of the twentieth century. LSU president James Monroe Smith and Gov. Oscar Kelly (O.K.) Allen were both hand-picked by Huey. His brother Earl Kemp Long inherited Huey's political machine and governed Louisiana in 1939–40 (the year Richard Leche resigned), 1948–1952, and 1956–1960. Huey's son Russell B. Long served in the U.S. Senate between 1948 and 1987. Governors John McKeithen (1964–1972) and Edwin Edwards (1972–1980, 1984–1988, and 1992–1996) carried on the populist agenda.[10]

A number of other milestones in the twentieth century changed the face and culture of the university. LSU admitted its first female student, Olivia Davis, in 1904. Davis was a teacher and a graduate of Newcomb College, which had a rich history of supporting the academic development of women, especially in the arts. In 1906, seventeen women, all graduates of Baton Rouge High School, entered LSU as undergraduates. One of these students was Annie Boyd, the daughter of President Thomas D. Boyd.

World War II brought both a dramatic decrease in enrollment—it dropped from more than 6,800 students to a little more than 3,000, less than half of what it was before the war—and a change in the makeup of the campus majority to women. The G.I. Bill of 1944 reversed these trends, supporting many of the 8,700 students who enrolled in the fall of 1946. In the 1950s, Nicholls, Northeast, and McNeese, junior colleges associated with LSU, became independent state universities, and LSU–New Orleans (the current University of New Orleans) opened as a four-year college.

Finally, and only because of a federal court order, Roy S. Wilson entered the Law School in 1950 and became the first black student to enroll at LSU, soon to be followed by many others in the LSU graduate programs. Then, after more than one hundred years, the university opened the undergraduate program to black students in 1964, and the once all-white male institution began to cultivate racial diversity as an important part of its identity.

Campus enrollment continued to grow, and by the 1970s the burgeoning student population had created a demand for new construction. Under the leadership of Chancellor Paul W. Murrill, the campus added a number of new academic buildings along with an assembly center. It was also during this period that the university became a sea-grant institution, an area of excellence focusing on coastal ecosystems and wetlands restoration.

By the mid-1980s the state and LSU began to experience a drop in state revenues. At the same time, the university community embraced

a strategic plan, shepherded by then-chancellor James H. Wharton and blessed by the LSU Board of Supervisors, that had two main thrusts: implement admission standards (LSU had open admissions prior to 1988) in order to increase retention and graduation rates, and focus on becoming a Research I institution based on the classification system of the Carnegie Foundation. As the result of a series of planning efforts and culminating with the 2010 Flagship Agenda implemented by the campus in 2003, LSU now ranks as one of the better public research institutions in the United States.[11]

Selecting Treasures

Selecting which objects to highlight as treasures in this book was not an easy task. A process had to be put in place to engage the campus community and determine which treasures would be included. The proposal presented to the administration by the University Commission on the History of LSU recommended a project director, an editorial committee, and an inclusive experience, inviting faculty, staff, and students to submit nominations. Then-chancellor Sean O'Keefe approved the proposal, and a project director and editorial committee began working in fall 2007. Although the committee anticipated the submission of a number of well-known treasures and in some cases solicited them, it also discovered that no one could have predicted what some of the treasures would be or where they would originate. What its members learned was that wherever faculty and students do research, there are treasures and stories to go with them. Committee members visiting with these scholar-collectors were intrigued by their depth of passion, commitment to research, and willingness to share their stories.

Treasures exist all over the LSU campus and in some surprising outlying areas. On the main campus, visitors can find rare objects in the LSU Libraries' collections at Middleton Library, Hill Memorial Library, and the Civil War Center. But stopping at the libraries would just scratch the surface—although one with literally millions of choices. Treading farther afield, one can discover treasures in Foster Hall, the Journalism Building, the LSU Union, the Human Ecology Building, Nicholson Hall, and the Life Sciences Annex, not to mention in faculty offices and laboratories. But visitors are not limited to the campus; the university expanded its cultural outreach outside the gates of the main campus through several magnificent gifts that allow community engagement at the Shaw Center for the Arts on Lafayette Street, the

Burden Center and Rural Life Museum off Essen Lane, the Hilltop Arboretum on Highland Road, and the Charles Barney LSU Geology Field Camp in Colorado.

In deciding which treasures to select, the breadth of the challenge was enormous. For starters, the LSU Libraries have a massive collection of more than 3 million volumes, a manuscript collection of more than 12 million items, almost 7 million microforms, and 321,000 maps. The Special Collections in Hill Memorial Library house the Louisiana and Lower Mississippi Valley Collections, documenting the history and culture of the region. In addition, the Rare Book Collection has as only part of its holdings works in eighteenth-century English literature and history, books on the history of the book, and works on New World exploration. An outstanding resource for ornithological and botanical

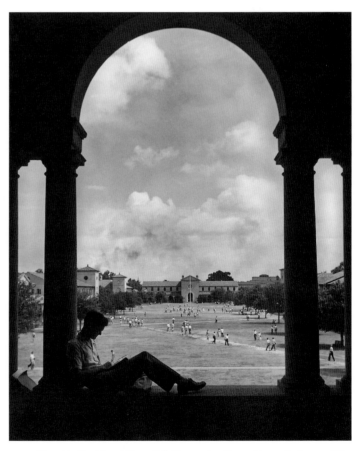

ABOVE: View of the Quad from Atkinson Hall. Photographer: Elemore Morgan, Sr. Courtesy Office of Communications and University Relations.

art is found in the E. A. McIlhenny Natural History Collection, which contains John James Audubon's double elephant folio *Birds of America* as well as the original watercolor drawings by famed botanical artist Margaret Stones.

Many of our treasures are visible around us; others are hidden in nooks and crannies all over the campus. The Student Union, an architectural treasure in itself, houses a number of artworks, including the sculptures *In Unity Ascending*, by Frank Hayden, and *Four Tigers*, by Robert A. Wiggs, which are easily accessed and enjoyed. The Jensen Holliday Forum in the Journalism Building displays two artists' visions of a free press and free expression: *Media Kaleidoscope*, by famed Georgian artist Gia Bugadze, and "*Yes, But . . .*," by New Orleans artist John T. Scott. But not so visible and just as noteworthy are the collections carefully tended by LSU faculty and staff. A stunning treasure that the committee literally stumbled upon is the Henry V. Howe Type Collection of shelled microorganisms. These beautiful microscopic organisms comprise one of the better university repositories of microfossils and an important resource for researchers in the United States and abroad.

Decidedly, research collections play a major role in the creation of campus treasures. The LSU Textile & Costume Museum, which had its beginnings in the 1930s as a teaching collection, is a case in point. It has since expanded to include conservation, research, and public exhibition facilities in the School of Human Ecology building. Today, the museum is Louisiana's only institution dedicated to the collection, preservation, research, and exhibition of textile artifacts. As a component of the Louisiana State Museum of Natural History at LSU, the museum's collections are global and comprised of prehistoric and ethnic textiles and costumes as well as contemporary high fashions and high-tech textiles. The museum preserves a vital part of our state's history, including the textile traditions of the early Louisiana Acadian culture and, in a noteworthy collection, the inaugural apparel and related memorabilia of our state's governors and their families. Its submissions for *Treasures of LSU*—an LSU cadet uniform, a hand-spun, hand-woven Acadian quilt, a woman's hat designed by Lilly Daché, an 1810s white cotton muslin dress, and a collection of nineteenth- and twentieth-century American gold pocket watches—are but a fraction of the holdings that are kept in climate-controlled storage and periodically displayed in its gallery.

A number of rare collections, because of their strength and breadth, presented challenges to the committee recommending selections for *Treasures of LSU*. For example, out of several hundred thousand specimens, only one was chosen to represent the LSU Herbarium. Begun only nine years after the original campus in Pineville opened, the herbarium's collection of preserved plant specimens is the oldest in the Gulf South and a tremendous resource for research, teaching, and public service. Working in tandem with the herbarium's own library, the LSU Middleton Library and Hill Memorial Library house important and rare botanical works.

The LSU Museum of Natural Science submitted a selection of treasures from its prized collections—Chitimacha baskets, Cashinahua headdresses, artwork by Douglas Pratt, its internationally recognized bird collection, a sabretooth cat fossil tooth, a mastodon fossil, and even an ancient whale fossil from the bank of the Red River near Montgomery, Louisiana. Created in 1936 when its first director, Boyd Professor George H. Lowery, Jr., assembled a few study specimens of birds in a classroom in Audubon Hall, the museum opened its public exhibit area on March 27, 1955, in Murphy J. Foster Hall. Since its move to Foster, the museum has continued to expand and is currently one of the nation's largest natural history museums. It houses the most active and fourth-largest university-based collection of birds in the world and the largest collection of bird genetic resources (DNA samples) in the world. Each year, more than 25,000 visitors view the museum's exhibits and benefit from informative tours and outreach programs.

The LSU Museum of Art and Rural Life Museum are good examples of how strong collections grow through the thoughtful support of LSU's graduates and friends. In 1959 an anonymous donor provided the gift that would create the foundation for the Anglo-American Art Museum, and in 1962 the museum opened its doors in the LSU Memorial Tower. Renamed and moved to the Shaw Center for the Arts in downtown Baton Rouge in 2005, today the LSU Museum of Art collections span many periods and genres. This book highlights a number of these special artworks and collections, including, among others, a portrait of faculty artist Caroline Durieux painted by Diego Rivera, Durieux's famed *Café Tupinamba*, a vase by George Edgar Ohr, pottery by Walter Anderson, portraits by William Hogarth and Joshua Reynolds, the largest collection anywhere of Newcomb pottery, and a famous photo of Muhammad Ali by Yousuf Karsh.

Near the heart of Baton Rouge, the Burden Center is the home of the LSU Rural Life Museum and Windrush Gardens. Encompassing almost 450 acres, the museum and former farm was the home of Pike, Steele, and Ione Burden, who began donating the property to LSU in 1966 and completed the donation in 1994. The museum incorporates the largest collection of Louisiana vernacular buildings in the region and the most extensive collection of material culture from eighteenth-, nineteenth-, and early twentieth-century rural Louisiana. Expansive fields under cultivation by the LSU Agricultural Center give way to historic architecture, including the Burden home. The historic house is surrounded by 25 acres of gardens and winding paths designed by Steele Burden, who worked for many years on the landscape design of LSU.

Some readers will be surprised to find 1,300 acres in the Front Range of the Rocky Mountains included in *Treasures*. Nestled in the foothills south of Colorado Springs, Colorado, this rustic camp has been a valued property for teaching geology to LSU students since 1928. A literal goldmine because of its diverse collection of rocks and minerals and because of its physical structure, the camp is a prime location for geological training and discovery.

As the committee reviewed its selections, it was apparent that LSU faculty artists created a significant number of the submissions for *Treasures*. To highlight their nominated works and recognize the regional, national, and international attention they have gained, they appear in various sections of the book. These talented professionals range from contemporary artists who are teaching at LSU today to artists from much earlier eras.

It was difficult to decide how to organize these treasures. The goal was to have themes woven throughout the book that create an interesting juxtaposition of objects but allow the reader to browse rather than follow a cover-to-cover story line. Interpretive essays by faculty, staff, and students provide the story behind each treasure and explain how LSU acquired it. The result of the efforts of thousands of faculty, staff, students, alumni, and donors who have made countless contributions over the last 150 years, *Treasures of LSU* helps chronicle the growth of a great university.

—LAURA F. LINDSAY

Notes 1. *The Reveille*, May 5, 1926, 1–2. The date of the celebration, April 30, was significant because Louisiana was admitted into the Union as a state on April 30, 1812.

2. All three can be found in Hill Memorial Library, LSU Libraries, Baton Rouge.

3. As vice chairman of the seminary's board of trustees, Graham held meetings at his plantation home in Rapides Parish. The house, built in 1843, is now a bed-and-breakfast inn. The chairman of the board was the governor, *ex officio*.

4. Unfortunately, this painting was one of four important paintings stolen from the campus in 1980 (Cheramie Sonnier, "Historic LSU Art Stolen," *Baton Rouge State Times*, March 31, 1980). The other stolen art included E. D. Fabrino Julio's copy of his equestrian portrait of the last meeting of Confederate generals Robert E. Lee and Thomas "Stonewall" Jackson on the eve of the battle of Chancellorsville, commissioned by David F. Boyd in spring 1886; a portrait of Gen. G. Mason Graham; and a portrait of George King Pratt, a medical doctor and member of the Board of Supervisors in the late 1800s. H. Parrott Bacot, then director of the Anglo-American Art Museum, valued the paintings at $60,000.

5. Signed into law by President Abraham Lincoln, the first Morrill land grants (July 2, 1862) played a primary role in keeping LSU's doors open. Emphasizing agriculture and the mechanical arts, the grants of federal aid to higher education focused on creating greater accessibility for farmers and working people. Each state representative and senator in Congress was granted 30,000 acres of public land in the form of "land scrip" certificates. In 1877 LSU was given the Agricultural and Mechanical College land grant, which had been created in 1874 with the Morrill Act funds and located at the University of Louisiana in New Orleans. Much later in its history, LSU was also awarded sea-grant (1966) and space-grant (1988) research programs.

6. The Hatch Act of 1887 allocated federal land grants for the creation of agricultural experiment stations typically associated with the land-grant colleges. The Adams Act of 1906 doubled appropriations for experiment stations and was the stimulus for President Thomas Boyd's search for more land for the university.

7. *New Orleans Times-Picayune*, May 23, 1918, 5. Community leaders Robert A. Hart, David M. Reymond, J. Allen Dougherty, Sabin J. Gianelloni, Ollie B. Steele, W. R. Dodson, J. H. Rubenstein, and Benjamin B. Taylor, through their willingness to sign a note to secure the purchase of the Gartness plantation until state monies could be approved, determined the future placement and growth of the new campus.

8. The institutions selected by President Boyd and visited by the team were Clemson University, the University of Illinois, the University of Minnesota, the University of South Carolina, the University of Tennessee, and the University of Wisconsin.

9. The *State Times*, April 30, 1926, announced on its front page, "New University, One of the Finest in the Land, built with Little Cost to Taxpayers of the State." The article notes that the new $5 million university was the dream of Gov. John. M. Parker.

10. Among the manuscript resources on the Long family in the LSU Libraries' Special Collections are bills pertaining to the Louisiana legislature, correspondence, speeches, films, transcripts, handbills, circulars, posters, cartoons, oral histories, sheet music, paintings, photographs, and scrapbooks.

11. LSU was ranked in the first tier of national colleges and universities in the 2009 edition of *U.S. News and World Report*'s "America's Best Colleges."

References *Annual Report of the President to the Governor and Members of the Legislature*, 1934. P. 18. Special Collections, LSU Libraries, Baton Rouge.

Biennial Report of the Board of Supervisors to the Governor and Members of the Legislature, 1935–1937, January 1938, vol. XXX, n.s., no. 1. Baton Rouge: Louisiana State University.

Biennial Report of the Louisiana State University and Agricultural & Mechanical College to the Legislature, July 1928, vol. XX, n.s., no. 5, pp. 7–8. Baton Rouge: Louisiana State University.

Boyd, David F. Memorandum, October 4, 1875. *Annual Report of the Supervisors of the Louisiana State University, for the Year Ending 1875*, 7.

Boyd, Thomas D. "Report of the President." *Report of the Board of Supervisors of the State University and Agricultural & Mechanical College to the General Assembly of the State of Louisiana for the Sessions 1896–97 and 1897–98*, 7.

———. "Report of the President." *Biennial Report of the Louisiana State University and Agricultural & Mechanical College to the General Assembly of the State of Louisiana*, May 1916, vol. VIII, n.s., no. 5, p. 13. Baton Rouge: Louisiana State University.

Cadet Roll. *Annual Report of the Supervisors of the Louisiana State University, for the Year Ending 1875*.

"A Few Facts: Enrollment, 1934." Pamphlet. LSU Board of Supervisor Records, A0003, Louisiana State University Archives, LSU Libraries, Baton Rouge.

Fleming, Walter L. *Louisiana State University, 1860–1896*. Baton Rouge: LSU Press, 1936.

"Geol 3666." Department of Geology and Geophysics Web site.

Graham, G. Mason. Report of the Board of Supervisors of the State Seminary of Learning to the Legislature of the State of Louisiana, January 24, 1860. LSU Board of Supervisor Records, A0003, Louisiana State University Archives, LSU Libraries, Baton Rouge.

Hargrave, W. Lee. *LSU Law: The Louisiana State University Law School from 1906 to 1977*. Baton Rouge: LSU Press, 2004. 151–52.

"Hatch Act of 1887." U.S. Department of Agriculture Cooperative State Research, Education and Extension Service Web site.

"History of the LSU Herbarium." Herbarium of Louisiana State University Web site.

Hoffman, Paul E. Interview, September 22, 2008.

"LSU Fall Facts 2008." LSU Office of Budget and Planning Web site.

LSU Foundation Alumni Database (accessed May 24, 2009).

"The LSU Libraries." LSU Libraries Web site.

LSU Listings of the National Register of Historic Places. 2009. LSU Facility Services.

LSU Master Plan, 2003. http://masterplan.lsu.edu/ (accessed May 19, 2009).

LSU Museum of Natural Science Web site.

"Mission." LSU Museum of Art Web site.

Registered Cadets and Accounts, 1859–1860. Louisiana State University Corps of Cadets, AO602.1, University Archives, LSU Libraries, Baton Rouge.

Ruffin, Thomas F. *Under Stately Oaks: A Pictorial History of LSU*. Rev. ed. Baton Rouge: LSU Press, 2006. 77–78, 94, 98.

Sherman, W. T., to G. Mason Graham. December 2, 1859. Walter L. Fleming Collection, Mss. 890, 893, Louisiana and Lower Mississippi Valley Collections, LSU Libraries, Baton Rouge.

Sonnier, Cheramie. "Historic LSU Art Stolen." *Baton Rouge State Times*, March 31, 1980.

Wilkerson, Marcus M. *Thomas Duckett Boyd: The Story of a Southern Educator*. Baton Rouge: LSU Press, 1935. 21, 59, 84–85, 217.

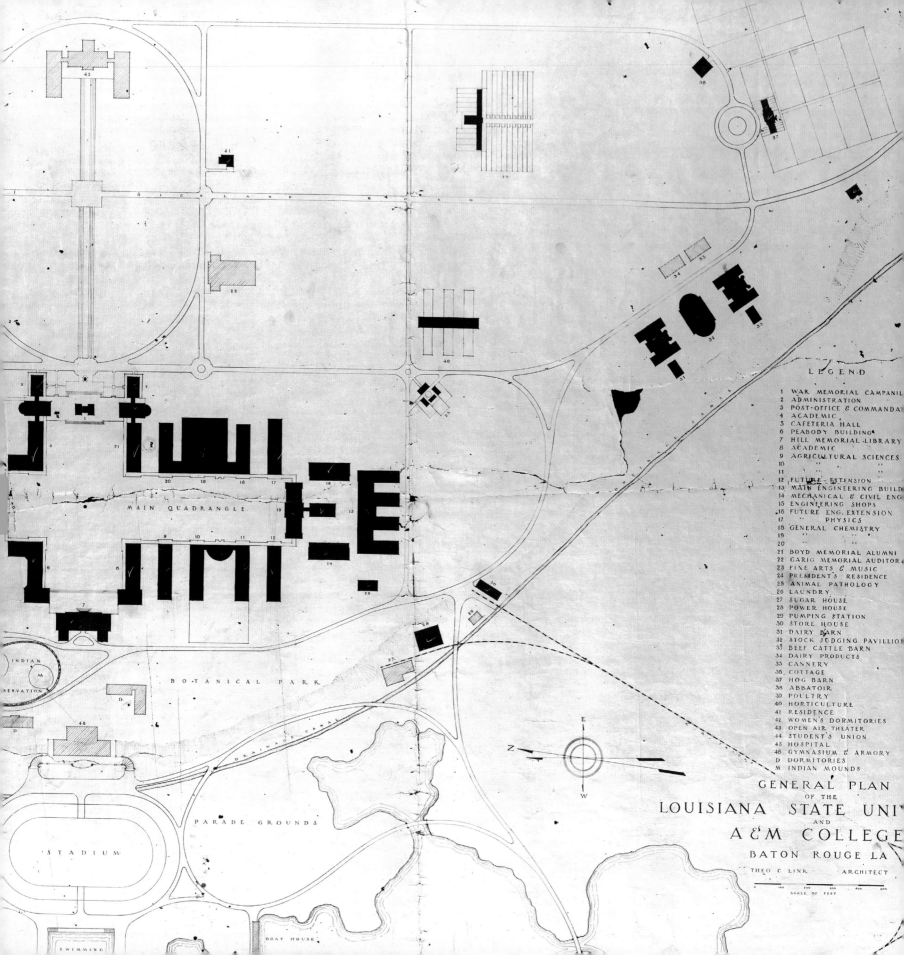

LEGEND

1 WAR MEMORIAL CAMPANILE
2 ADMINISTRATION
3 POST-OFFICE & COMMANDANT
4 ACADEMIC
5 CAFETERIA HALL
6 PEABODY BUILDING
7 HILL MEMORIAL LIBRARY
8 ACADEMIC
9 AGRICULTURAL SCIENCES
10 "
11 "
12 FUTURE EXTENSION
13 MAIN ENGINEERING BUILDING
14 MECHANICAL & CIVIL ENG
15 ENGINEERING SHOPS
16 FUTURE ENG. EXTENSION
17 PHYSICS
18 GENERAL CHEMISTRY
19 "
20 "
21 BOYD MEMORIAL ALUMNI
22 GARIG MEMORIAL AUDITORIUM
23 FINE ARTS & MUSIC
24 PRESIDENT'S RESIDENCE
25 ANIMAL PATHOLOGY
26 LAUNDRY
27 SUGAR HOUSE
28 POWER HOUSE
29 PUMPING STATION
30 STORE HOUSE
31 DAIRY BARN
32 STOCK JUDGING PAVILLION
33 BEEF CATTLE BARN
34 DAIRY PRODUCTS
35 CANNERY
36 COTTAGE
37 HOG BARN
38 ABBATOIR
39 POULTRY
40 HORTICULTURE
41 RESIDENCE
42 WOMEN'S DORMITORIES
43 OPEN AIR THEATER
44 STUDENT'S UNION
45 HOSPITAL
46 GYMNASIUM & ARMORY
D DORMITORIES
M INDIAN MOUNDS

GENERAL PLAN
OF THE
LOUISIANA STATE UNIVERSITY
AND
A&M COLLEGE
BATON ROUGE LA

THEO C LINK ARCHITECT

SCALE OF FEET

MAIN QUADRANGLE

BOTANICAL PARK

DRAINAGE CANAL

PARADE GROUNDS

STADIUM

BOAT HOUSE

SWIMMING

INDIAN RESERVATION

SHAPING SPACES

The Story of LSU's Southern Live Oak and
Other Facts about the "New" Campus

At the Heart of the LSU Campus
The "New Campus" Plan

Located on the last open plateau above the Mississippi River as it makes its way to the sea, the central historic core of the Louisiana State University campus is an architectural composition of unparalleled unity and grace. The design of the campus, by German architect and engineer Theodore C. Link (1850–1923) of St. Louis, was organized around two major planning axes. A sweeping semicircular arc embracing Highland Road defines the entry and public face of the university. It brings the student and visitor to the soaring vertical reach of the Soldiers and Sailors Memorial Tower. Conceived in 1923 as a tribute to Louisiana's veterans of the Great War, it is one of a number of such noteworthy monuments constructed around the nation during those postwar years. It acts as a gateway and symbolic anchor to the composition, invoking the sky and tying the plan to the timelessness of service and sacrifice. This campanile, together with the terrace, creates a gracious and open pedestrian entryway into the protected quadrangles of the state's major university.

In the original plan, as one mounted this terrace, the figure of the University's Hill Memorial Library appeared over seven hundred feet away in the distance, the two together defining a northern quadrangle laid out along this east-west axis of entry. The architectural form of Hill, derived from the then-revolutionary Boston Public Library, was

primarily horizontal in composition, in contrast to the vertical campanile, with its two large public reading rooms featured on the upper floor of the primary façade. It was situated at the termination of this axis, presenting the University as the repository of knowledge and collected wisdom, open to the people of the state. The surrounding buildings originally included the administration, law school, and a teaching college as well as various other traditional university disciplines.

This northern or entry quadrangle was crossed at its heart by a longer, more specifically academic, "southern" quadrangle of more than one thousand feet in length. At the northern end of this great academic space sat the Cafeteria, today known as Foster Hall. This building contained two large vaulted dining spaces, arcades along the quad, and a Roman temple–like central façade stepping out toward Atkinson Hall in the far distance. Atkinson, originally built as the Main Engineering Building, was designed as an expression of the bilateral symmetry common to the Palladian architecture of northern Italy. Again, the buildings defining the ends of this internal axis conceptually complement each other. The Cafeteria presents a forceful and upright solitary figure, sheltering a single open archway at its

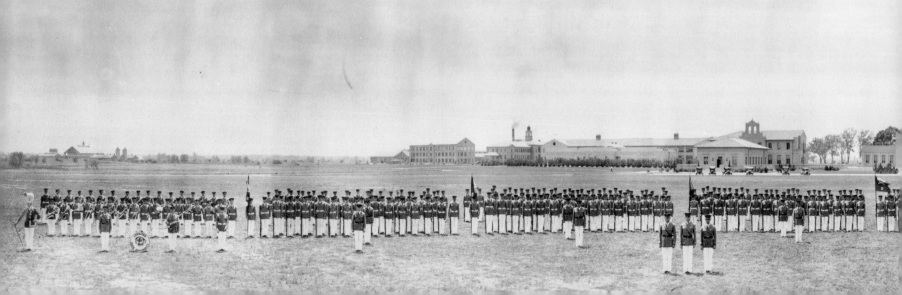

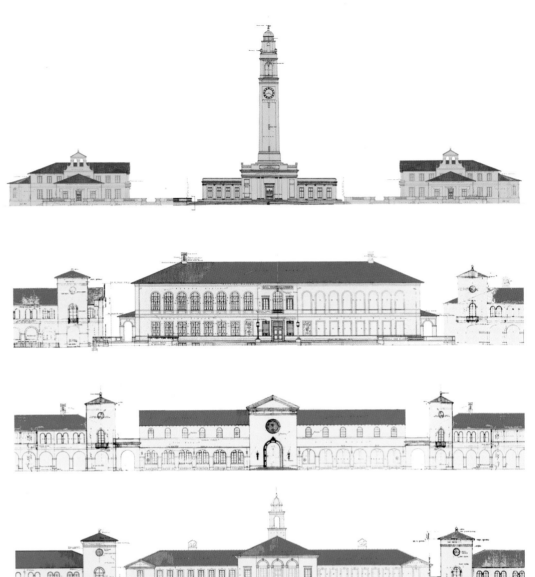

LEFT: Elevations of the buildings forming the LSU quadrangle (*top to bottom*): The Memorial Tower Group from the Parade Ground; the Hill Memorial Library Group from the east; the Cafeteria Hall Group from the south (Foster Hall); and the Main Engineering Building Group from the north (Atkinson Hall). These elevation drawings were derived from the original elevations of Theodore Link by LSU architecture graduate students Michael Roper and Anthony Threatt.

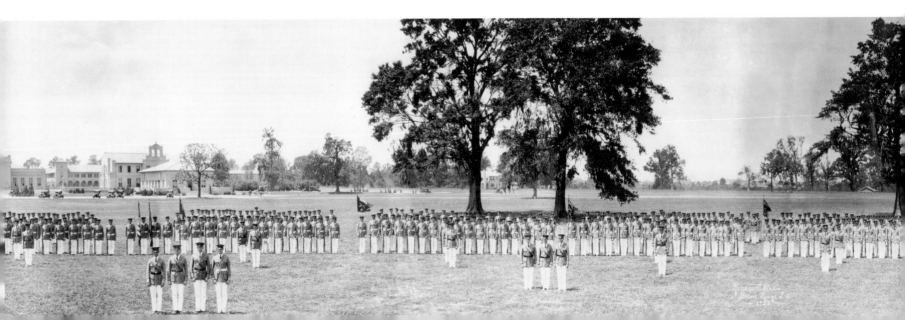

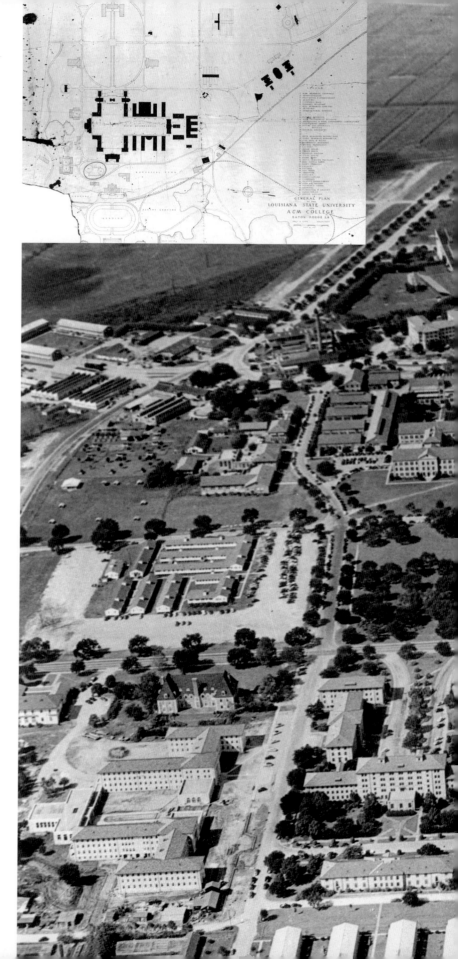

core. The Engineering Building stretches across the entire width of the Quad with a repetitive rhythm of classroom and faculty offices.

All of the buildings defining this great quadrangle were draped in a graceful Mediterranean style, not typical of campus design in those years. Following the experience of so many Americans during the war in Europe, many colleges were made to invoke the stone gothic or the more traditional English Georgian style. Here at LSU, the Italian is used with great restraint, presenting a manner of design and composition that utilizes a common campuswide language with detail and pronounced form to create emphasis.

Surrounding the quads, a gentle rhythm of arcaded passageways, similar to those found at Andrea Palladio's Villa Emo in the Veneto region of northern Italy, ties everything together, providing shade and protection from the Louisiana rains and creating a background against which the more articulate architectural façades of the specific academic buildings step forward to assert themselves. The common language of column, pilaster, pediment, and detail is used to create a syncopated march of disciplines along the sides, following the example of Jefferson's University of Virginia campus design.

The overall controlling diagram of major and minor axes crossing at right angles continues into the buildings at the culmination of these two axes, Hill, Foster, and Atkinson. In each of these buildings one would be drawn inside before being turned around and reintroduced to the greater campus plan beyond. One of the great beauties of this kind of plan is its ability to coordinate a large number of different activities into a single, easily understood diagram and master plan. It is a composition of subtlety, power, and expression.

—J. Michael Desmond

INSET: Theodore Link's plan for the new campus. LSU Catalog, 1925–26, n.p., LSU Archives, LSU Libraries, Baton Rouge. RIGHT: Aerial photo c. 1950 showing Theodore Link's Soldiers and Sailors Memorial Tower and its attendant quadrangles in the context of the growing LSU campus. Office of Public Relations Photographs, Jack Fiser Collection, RG #A5000.0020.1, Louisiana State University Archives, LSU Libraries, Baton Rouge.

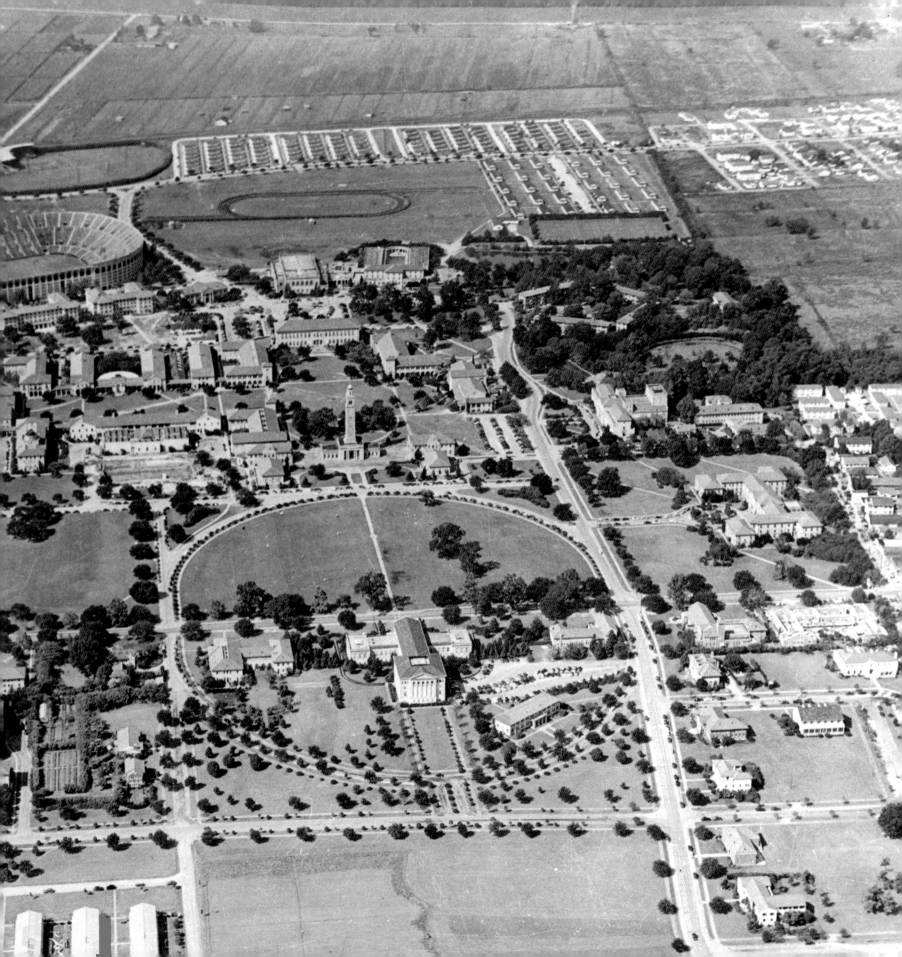

Fond Memories
The Quad

The Main Academic Quadrangle ("the Quad"), bounded by a combination of arcaded, Italianate architecture and parallel rows of spectacular seventy-year-old live oaks, is arguably the "jewel" of the campus landscape and surely one of the greatest of the university's "treasures." Located at the center point of LSU's historic academic core, the 3.5-acre Quad showcases both arches and live oaks—sacred icons of the physical setting for LSU.

Part of a larger, cruciform-shaped space created when the LSU campus was relocated to a rural plantation site in the 1920s, the Quad was surrounded by many of the university's earliest and most important structures (the Campanile, Himes, Coates, and Nicholson halls on the east side; Peabody Hall, Hill Memorial Library, Allen, Prescott, and Stubbs halls, Dodson Auditorium, Audubon Hall, and the Agricultural Administration Building on the west side; Foster Hall on the north side; and Atkinson Hall on the south side). The placement of the Middleton Library at the intersection of the cross axes in 1958, producing three other smaller quadrangles, defined the Quad as we know it today.

The Olmsted Brothers, noted landscape architects of the early twentieth century, conceived the preliminary design for the current LSU campus and the Quad, but the accepted layout came from architect Theodore Link, who worked at LSU from 1922 to 1923. In Link's plan, the Quad was centrally located and was actually the area of intersection of two quadrangles—a larger one with a north-south orientation and a smaller one with an east-west orientation. A flagpole was located at the intersection of the two quadrangles (where Middleton Library now stands). After Link's death in 1923, implementation of the early Quad space was largely the product of Dreyfus, Weiss & Seifert, architects from New Orleans (and designers for most of the early buildings, c. 1923–1940), and E. L. McIlhenny (c. 1920s–1930s) from Avery Island, Louisiana. Steele Burden, Baton Rouge native and longtime landscape designer for LSU, planted the live oaks within and around the Quad's perimeter, sometime between 1938 and 1939.

Under the direction of then-chancellor Paul W. Murrill (serving 1974–1980), the Quad later underwent a total landscape renovation. The original layout had included only a handful of narrow walkways, with mainly east-west orientations. Changing building and campus use patterns resulted in students walking in all directions, leaving the Quad a quagmire in the rain and a dust bowl when dry. By this time, the live oaks' trunks provided unity by repeating the forms of the arcades and the massive branches made a grand canopy, but a sense of "enclosure" could only be experienced by walking on what little turf was left. The revised design of the Quad (1974–1982) came from Baton Rouge landscape architects and LSU alumni Henslee-Thompson-Cox. The redesign preserved the original live oaks and made the Quad a more accessible, cohesive, and enjoyable space for the campus community. The design included introduction of wider and more practically located sidewalks, seating plazas of various elevations, sizes, and orientations, and numerous benches for enjoying fresh air, experiencing nature, and escaping the confines of the classroom or the nearby library. The result was an explosion of color, light, and activity throughout the year—to which people, and their movement through the space, added the final animated ingredient.

The Quad is still the central focus of campus activity. One of the most beautifully proportioned and historic spaces at LSU and perhaps in the United States (so-named in 1999 by the American Society of Landscape Architects), it is frequented by thousands on a daily basis, is a favorite meeting place for students, faculty, and staff, and is a showplace for visitors. The fine-textured aggregate façades, with their arches and beige coloring, offer wonderful backdrops for the sculptural oak branches and the resulting lighting effects—including shadow and sun-flecked patterns on the façades, pavement, and underlying ground cover. The Quad is a rare example of simple spatial quality that compares favorably with other University "treasures." Rather than an object, the Main Academic Quadrangle is a usable place of elegant simplicity and beauty. Together with the "stately oaks," it fosters the making of "fond memories" referred to in the lyrics of the LSU alma mater.

—Van L. Cox

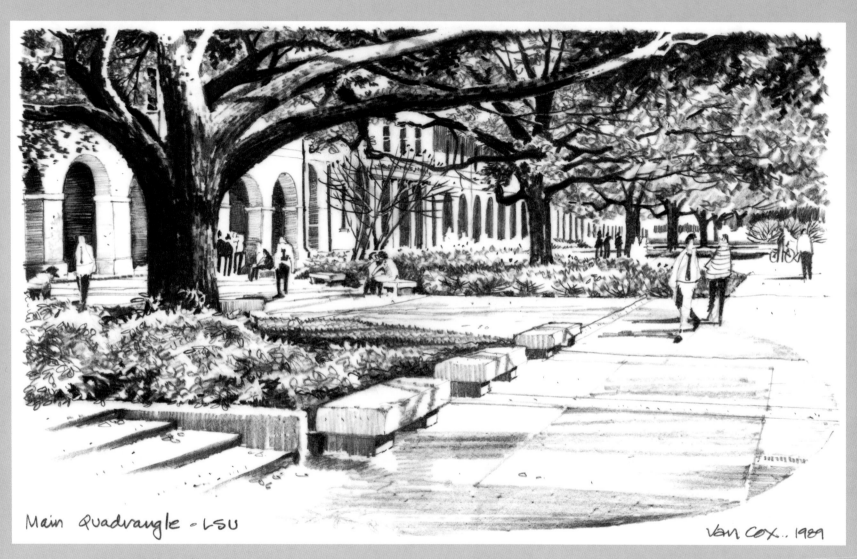

Main Quadrangle - LSU

Van Cox.. 1989

ABOVE: Rendering by Van Cox of the Quad at the main campus, Baton Rouge. The buildings pictured are Himes (*left*) and Coates halls.

Quercus Virginiana
The Southern Live Oak

The Southern Live Oak (*Quercus virginiana*) remains a venerable and treasured tree on campus and is now perhaps the most distinctive element overall, even more than the architecture, if for no other reason than because the foliage masses obscure most of the core campus buildings and dominate one's view. Toward the end of his life, Steele Burden (1900–1995), LSU supporter, benefactor, and landscape designer, was quoted as saying, "A Live Oak is the most beautiful thing to come out of the earth." If his statement is true (and surely many visitors to the LSU campus would agree), then LSU has well over a thousand of the most beautiful things on earth, and truly each is a "treasure."

Burden can be viewed as an authority on the subject, since he directed the planting of most of the live oaks existing at LSU today, as well as at City Park, just north of campus. As an indicator of how much he revered the live oak, after hearing of the possibility that the LSU Museum of Art might be relocated to the Burden Research Center, north of Interstate 10 and with entry off Essen Lane, Steele Burden quickly planted an alley of live oaks in anticipation of lining the proposed entry road.[1]

The live oak has always been one of the most visible landmarks on the LSU campus—even when it was located on the grounds of the New State Capitol in downtown Baton Rouge. By the time Burden became active on the current campus in the 1930s, the Memorial Oak Grove (south of the present-day Student Union building), commemorating alumni who died in World War I, had already been planted, and live oaks lined many of the campus streets. According to research by Professor Paul Hoffman, the earliest LSU live oaks were likely descendants of trees in Natchitoches.

Until the 1970s, the only planted live oaks not attributed to Burden were those in the Oak Grove and those along Highland Road. In fact, he mainly planted those along Dalrymple Drive and inside the Main Quadrangle. Burden was most proud, though, of the isolated specimen he planted west of the Bernie Moore Track Stadium and Athletic Field House near Nicholson Drive. It is the only one on campus maintaining a live oak's natural growth habit of the branches descending all the way to the ground. Although not officially designated as

such, it is affectionately known by some as the "Steele Burden Oak."

Regardless of who planted them, it is no mystery why the campus is today dominated by mature live oaks. The sacred nature of the live oaks is evidenced by the alma mater lyrics' reference to "stately Oaks." The slogan "Oaks and arches" can be found in much of the university's literature. Further, any removal of the mature live oaks must first be approved by a campus committee and replacements in kind made—usually consisting of multiple new trees. The LSU Live Oak Endowment Fund helps assure the live oaks' health and maintenance.

ABOVE: Steele Burden, who planted many of the live oaks on campus. Photographer: Jim Zietz, Office of Communications and University Relations.

Undeniably, LSU's oaks are stately and majestic in form. The dark canopies, the sculptural quality of the branching structure, and the massive, furrowed trunks are truly magnificent. The trunks provide unity to the physical setting of the campus by repeating the forms of the arcades, and the massive branches make a grand canopy. This powerful form inspired John Desmond, architect of the LSU Union, to design support columns that mimicked the arched branches—particularly important since the Union was located immediately adjacent to the Memorial Oak Grove.

The light and shade quality produced by the branches and foliage of the live oaks changes from month to month, day to day, and even from one moment to another. Welcoming dappled sunlight and shade patterns are visible on the paving and contrasting building façades in the summer, and there is a unique play of light quality under the oaks in the winter as the low-angled sunlight finally has a chance to penetrate the thick foliage. Perhaps one of their outstanding features is the ability of the live oaks to form an overhead canopy and spatial enclosure, which, as with architecture, provides the primal feeling of refuge. This characteristic produces a protective feeling to anyone passing underneath—probably the

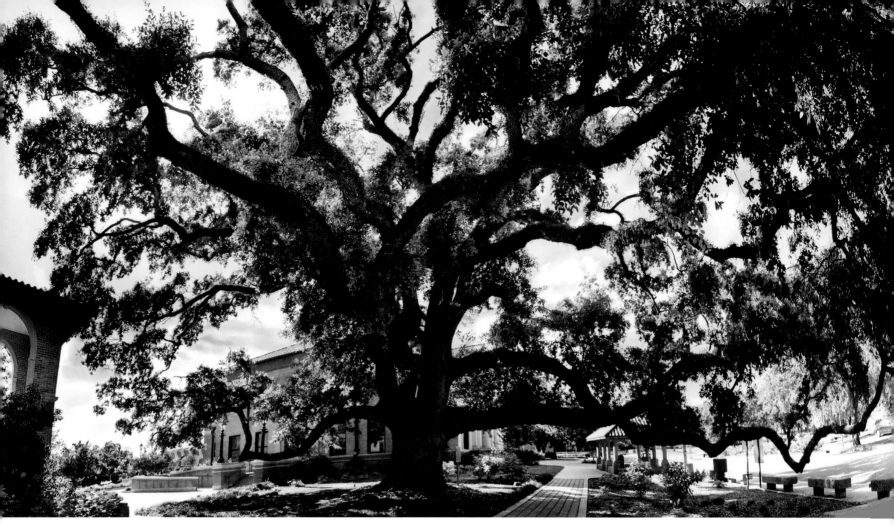

ABOVE: Bicentennial oak in front of the Journalism Building, main campus. Photographer: Eddy Perez, Public Affairs, Office of Communications and University Relations.

majority of people who ever set foot on the LSU campus. Ironically, the oaks are not considered good street trees, specifically because of the previously mentioned growth habit wherein the heavy branches droop down toward the ground at their perimeters. Most underplantings and certainly turf are difficult to maintain beneath the dark, shaded footprint of the oaks. Maintenance is full time to keep them pruned up, and their roots are so sensitive to compaction that LSU Facility Services had to develop mulching strategies to keep the roots moist and people away.

Yet the live oaks in the Quad and others Steele Burden planted alongside Dalrymple Drive are now approximately seventy years old and maturing, while most of the native trees have either died or been removed. There is even a "Bicentennial Oak" (over two hundred years old) southeast of the Journalism Building, which was there before the campus was relocated. One gets the impression that the live oaks on the LSU campus will endure forever. In addition to their many other benefits, they serve as a treasured symbol of the stability and consistency of the LSU spirit.

—Van L. Cox

Note 1. The museum was actually built in downtown Baton Rouge. These oaks were the last oak trees planted by Burden before he died.

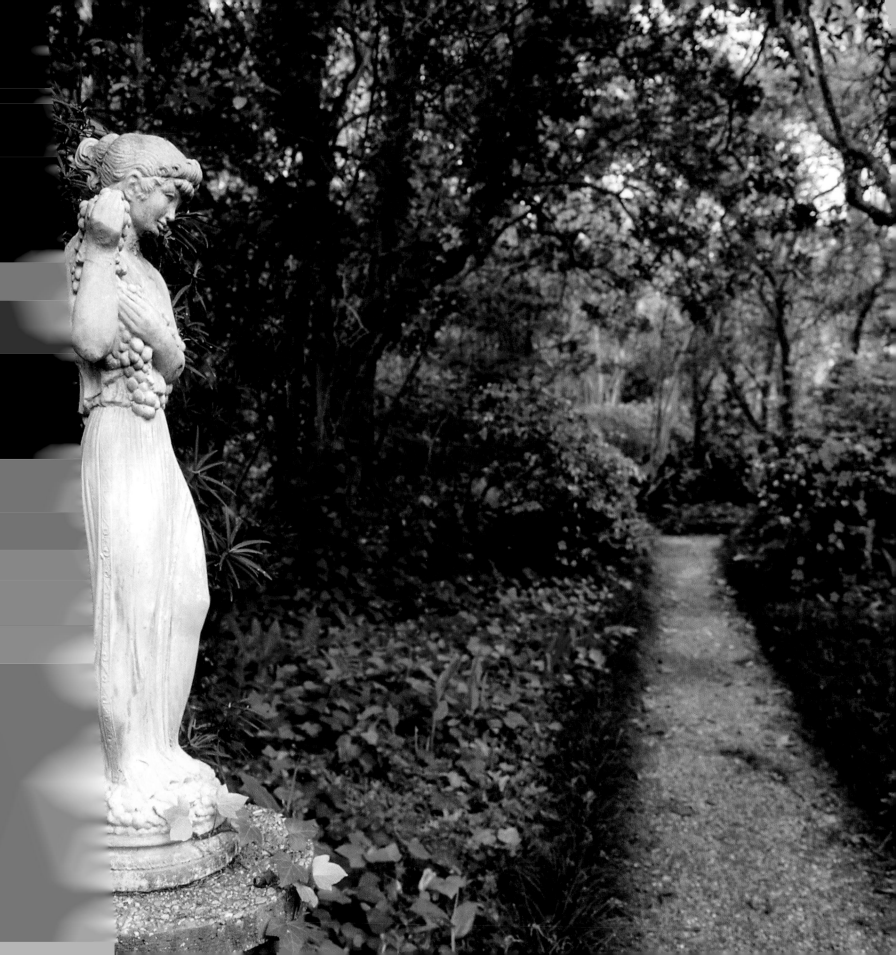

II

LANDMARKS AND LANDSCAPES

The Mystery of Ancient Mounds and Other Research Environments

Older than the Pyramids
The LSU Indian Mounds

Who might have imagined that the LSU campus would include large outdoor monuments that predate the Great Pyramids of Egypt? The LSU Campus Mounds rise mysteriously out of the landscape, providing a peek at the ancient society that built them. Standing a proud seventeen feet tall in the heart of the main campus opposite the Field House, these hills are not the result of natural geomorphologic processes. They are the product of the careful labor of a past Native American society that lived in Louisiana about five thousand years ago. It probably is no coincidence that the mounds are found on the highest part of the Baton Rouge bluffs closest to the Mississippi River, a place of unique significance in continental geography. Occupying the southernmost high ground adjacent to the most extensive river system in North America, they reach out to us from a time when this great waterway served as a primary means of travel and communication across the length and breadth of the continent.

Native Americans have lived in what is now Louisiana for at least twelve thousand years. They produced a wonderful array of tools, ornaments, and other artifacts, but only those made of stone, bone, shell, or clay generally survive to be discovered by archaeologists. Though most organic artifacts have disappeared, the remaining, more durable materials give us a glimpse of past social life and religion.

The earthen LSU Campus Mounds are one of the main architectural legacies of these past civilizations. Like artifacts, mound shape and size changed through time; their function and the meanings they had in the social landscape of the Native Americans changed as well.

The LSU Campus Mounds are among the earliest manmade structures ever built in the United States—the soils immediately below the mounds have been radiocarbon-dated to about five thousand years old. There are several other mound sites in southeastern Louisiana that are similar to the LSU Mounds—that is, sites with two conical mounds placed rather close together. One of these sites, the Monte Sano Bayou Mounds, which stood just north of the State Capitol on Monte Sano Bayou but has since been destroyed, is the oldest known mound complex, dating to some seven thousand years ago.

The function of these very early mounds is not known. During late prehistory, just prior to the arrival of Europeans, "platform" mounds provided the focus for social, political, and religious Native American life. Mounds built in these political and religious centers had flat tops, and generally supported temples or the houses of the societal elite. Elites were often buried under the floors of their houses, so flat-topped mounds sometimes contain burials. Earlier, however, beginning around the first century CE, and prior to the establishment of a permanent hierarchy, conical mounds were the locus of burial for most of the region's population.

Burials have never been found in mounds as early as the LSU Campus Mounds. It is possible that, as any other organic material, skeletons once buried in the mounds have eroded away; however, evidence that could remain, like the soil discoloration of burial pits, has not been found in any of these early mounds. It is more likely that the mounds provided a focal place for scattered groups to come together at particular times of the year for religious ceremony, information exchange, feasting and other celebrations, and to find mates. In his master's thesis, LSU student Jeffrey Homburg studied the soils in the mounds and concluded that the mounds were built up in a continuous fashion. A likely scenario would be that, during ceremonies, people would add basketloads of soil to the mounds as a civic duty; the resulting mound would represent the power and solidarity of the group.

In April 2009, a team of geologists and archaeologists drilled an approximately five-meter core into the mounds to sample their sediments and investigate a magnetic anomaly Dr. Brooks Elwood discovered during a geoarchaeology class exercise in the fall of 2008. The new cores are currently being examined to determine whether this anomaly represents an ancient hearth. Dr. Sophie Warny conducted a palynological study[1] on samples from these new cores, but plant remains were rare and all were highly oxidized. This high level of oxidation could be the result of intense bacterial activity or oxidation linked to fire.

Over seven hundred known mound sites exist in Louisiana, a testimony to the vigor and industry of the societies that lived here in the past. To enhance public appreciation of the mounds, the Louisiana Division

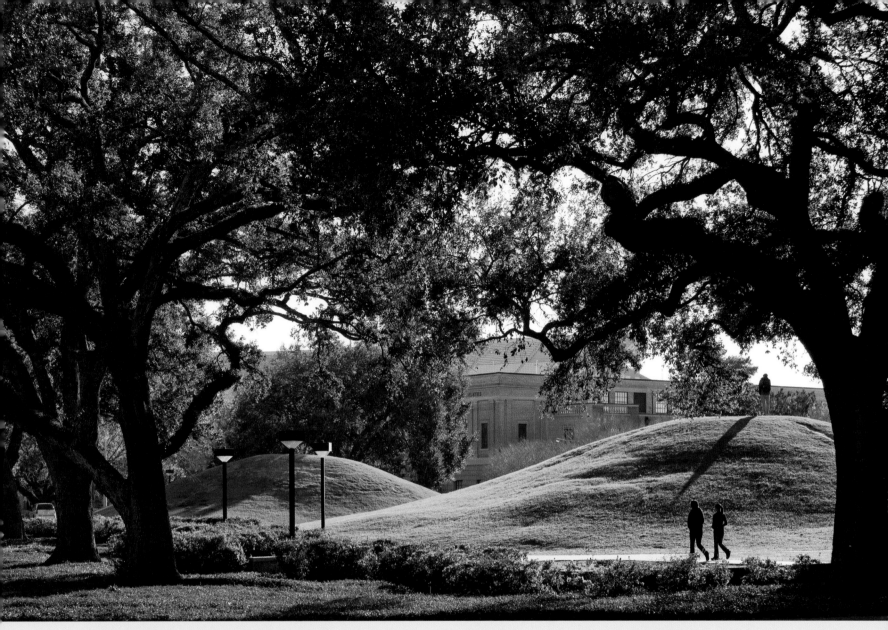

ABOVE: The Indian Mounds, main campus. Photographer: Jim Zietz, Office of Communications and University Relations.

of Archaeology has created a trail, the Louisiana Ancient Mounds Driving Trail, which consists of about forty mounds visible from roadways in northeast Louisiana. To help share the LSU Campus Mounds' unique historical significance, the LSU Museum of Natural History has created a permanent exhibit that provides information on mounds and on Louisiana Native American societies. The exhibit also includes examples of the durable objects used in everyday life, along with information on the organic items likely present in the mounds—everything from houses to baskets—that have disappeared.

—Sophie Warny and Rebecca Saunders

Note 1. A palynological study includes the analysis of microfossils of pollen and spores.
Reference Homburg, Jeffrey. "An Archaeological Investigation at the LSU Campus Mounds." Master's thesis, Louisiana State University, 1991.

The Inside Story
The Memorial Oak Grove Trees and Associated Fungi

P lanted in 1916, a year before our country entered World War I, the live oaks (*Quercus virginiana*) in the Memorial Oak Grove south of the LSU Union serve as a living research laboratory, playing host and providing habitat for myriad living organisms. Grown from acorns nurtured for ten years in Lafayette by Southwestern Louisiana Institute president Dr. Edwin Lewis Stephens, thirty trees were transported to Baton Rouge and planted on the grounds of the new campus.[1] The trees were dedicated in 1926. Each tree's commemorative plaque serves as a memorial to an LSU student or alumnus killed in the war.

Native evergreen hardwoods, live oaks have distinctive spreading branches that create a spectacular living quarters and canopy for birds and squirrels. In addition to these frequent associates, the visitor quickly detects Spanish and bald moss (relatives of the pineapple), true mosses, and resurrection ferns. But other organisms important to the life history of the trees go largely unnoticed most of the year. Growing through the soil in association with feeder roots of live oak trees are the threadlike bodies of fungi that imbibe water and minerals into the trees to enhance their growth. These mycorrhizal fungi, essential to the life of many plants, can be detected by spore-producing reproductive structures called mushrooms, which are visible in late summer and early fall. Squirrels, insects, and slugs feed on these mushrooms, evidenced by iridescent slug trails and insect holes over the mushrooms.

Grayish, lichen-forming fungi abound on roughened bark from the early years of the trees. As the trees age, they develop breaks in their protective bark—some by a lightening strike, others by insects, birds, and careless humans. Breaks in the bark are portals by which decay fungi enter to rot roots, trunk, branches, and bark. Several fungi that decay the bark of live oaks were first described from campus trees. Bark fungi can be viewed year-round as patches of flat whitish or wispy yellowish growths on lower branches and trunks. Over the nearly century-long

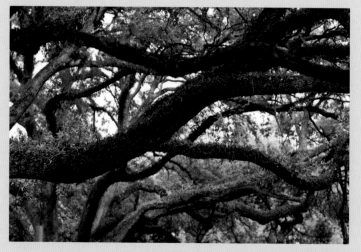

ABOVE: The spreading branches of the Memorial Oak Grove. Photographer: Jim Zietz, Office of Communications and University Relations. **RIGHT:** *Phellinus robustus* causes a heart rot in live oak trees throughout their range. Photographer: Jim Zietz, Office of Communications and University Relations.

life of the trees, a natural fungus-oak association has progressed as trees became infected with fungi in ecological succession. The fungal decay process will continue with branches pruned and tree holes formed to provide homes for cavity-nesting birds. In the past, a process of gentle decay could be predicted for the oaks for several hundred years. However, the recent spread of introduced tree diseases—oak wilt and sudden oak death—threatens the oaks with a more rapid decline. These challenges call for vigilance and sound ecological practices.

—MEREDITH BLACKWELL

Note 1. The Southwestern Louisiana Institute (SLI) is now the University of Louisiana, Lafayette.

References Alexopoulos, C. J., C. W. Mims, and M. Blackwell. 1996. *Introductory Mycology.* New York: John Wiley & Sons, Inc.

Louisiana Garden Club Federation, Inc. Web site. "Live Oak Society."

Louisiana State University Web site. "Highlights from the History of LSU: Military Memorials."

May, Robert Elliott. 1993. *Memoirs.* State Library of Louisiana. Baton Rouge: R. E. May.

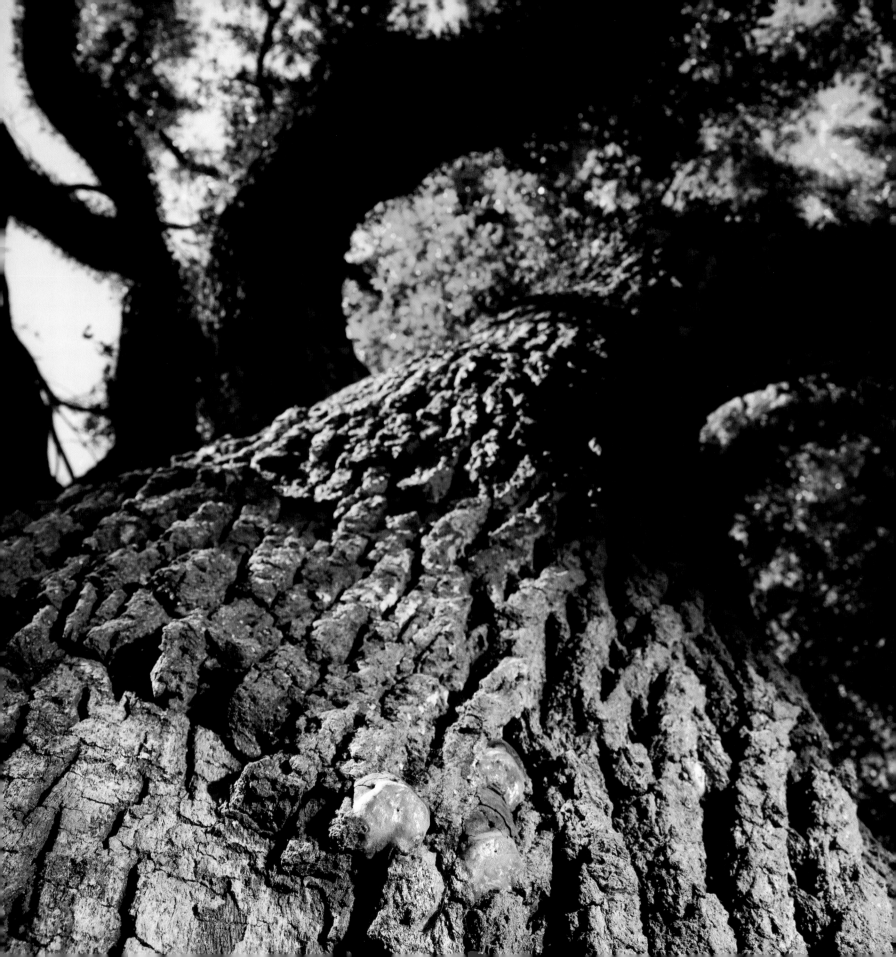

A Family Legacy
The Burden Property

Driving down Interstate 10 near the Essen Lane exit, one can hardly believe that, in a world of electronics and cyberspace, a beam steam engine, a sugar kettle, and an old mill still operate regularly less than a mile away, bringing the eighteenth and nineteenth centuries to life in a spacious green haven surrounded by a belt of native forest. On one side of the land, known as the Burden property, a pastoral oasis features settings and plants from antebellum Louisiana. Adjacent to it, a collection of plantation dwellings and historic houses from the state's rural areas celebrate eighteenth- and nineteenth-century culture and design. A few acres away, mules plow the fresh corn fields with vintage farm equipment while a diesel tractor works a plot of ground for an agricultural research project.

Extending over 450 acres, LSU's Burden property is often referred to as "the best-kept secret in Baton Rouge." Gift of the Burden siblings, Ione (1896–1983), Pike (1898–1965), and Steele (1900–1995), the land is valued at $270 million—the largest donation LSU ever received. The story of the land goes back more than two hundred years, when the Burden property belonged to Philemon Thomas, leader of the force that captured Baton Rouge and West Florida from the Spanish in 1810. William S. Pike, a local resident, later acquired the land in 1861. His niece Emma Barbee and her English husband, John Charles Burden, who lived on the property, named it Windrush after a small river in England. They lived there until Burden passed away in about 1870. The property also served as a refuge during the yellow fever epidemics of 1878. The Burden brothers and sister, who inherited the property from their father, made the land their family farm in 1921. They donated it to LSU in stages from 1966 through 1994.

The property includes the Burdens' old family home, Windrush House, the surrounding Windrush Gardens, the Rural Life Museum, and the Burden Center. Maintained by the LSU Agricultural Center, the latter makes up the bulk of the property (around 430 acres). It offers faculty and students an extraordinary opportunity to conduct agricultural, horticultural, and floricultural research and provides Baton Rouge residents with a green retreat in the middle of the city.

ABOVE: Steele and Ione Burden on the Burden property. Photographer: Jim Zietz, Office of Communications and University Relations.

The brainchild of Steele Burden, the Rural Life Museum occupies twenty-five acres of the Burden property. Voted in 1980 one of the "top ten museums in the world" by the British Museum, it originated in Burden's decision in 1969 to place one slave cabin on the property.[1] The museum quickly developed into a major institution with the largest collections of plantation buildings, vernacular architecture, and material culture from eighteenth- and nineteenth-century rural Louisiana in the United States. The museum offers enjoyment for visitors and unparalleled research resources for LSU's folk studies scholars, anthropologists, geographers, historians, architects, and entomologists. The LSU Rural Life Museum is among the first institutions in the United States to proclaim slavery and rural Louisiana as important historical subjects of research.

—DAVID FLOYD AND YASMINE DABBOUS

Note 1. The cabin Burden ultimately found was donated to him by the Keller family.
References "The Burden Family and the LSU Rural Life Museum." LSU Rural Life Museum Web site.
 Video interview with Steele Burden, 1994. LSU Rural Life Museum.

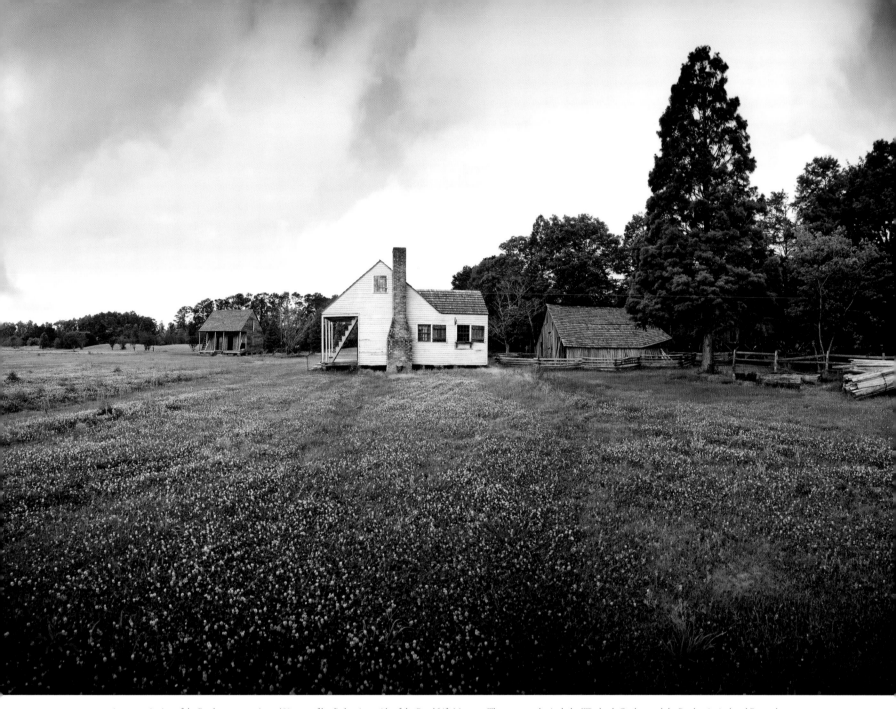

ABOVE: A panoramic view of the Burden property (over 450 acres of land) showing a side of the Rural Life Museum. The property also includes Windrush Gardens and the Burden Agricultural Research Center. Photographer: Eddy Perez, Public Affairs, Office of Communications and University Relations.

A Palette of Ardisia and Nandina
Windrush Gardens

Over forty years ago, the Burden family of Baton Rouge put into motion a major land and property donation to LSU. The Burden property, now an extensive pastoral oasis in the heart of the city, is the site of the LSU Rural Life Museum, as well as field trials of the Louisiana Agricultural Experiment Station. Some of the first landscape experiments staged on the Burden property were the designs of the young Steele Burden (1900–1995), who in 1921 began creating a series of formal garden rooms adjacent to his family home, Windrush Plantation. Windrush Gardens, as Burden's suite of gardens became known, represent the culmination of a lifetime of travel and work as a gardener and landscape designer, as well as the tastes and personal perspective of the connoisseur.

As a young man, Steele Burden booked passage on cargo ships to Europe and other ports of call, touring the great gardens of the world and collecting garden ornament, particularly bronze sculpture, along the way. One of his early jobs was as gardener at The Cottage plantation, where he was able to gain firsthand experience with the layouts and plants that typified traditional antebellum gardens of south Louisiana.[1] Through this work and travel to other Louisiana plantations, Burden assimilated the qualities of places that had become associated with the romance of the South.

The gardens that Burden saw were nearly a century old, so what had once been sunny parterres or patterned beds with floral color became, over time, mostly green patterns beneath the shade of the immense canopies of live oak trees. Where sun-loving bulbs and annuals originally prospered, now shrubs that needed shade, like camellias and azaleas, grew. So the inspiration for Burden's garden designs were primarily gardens of many evergreens. This palette of traditional plants in varying tones of green, accented with the blooms of azaleas and camellias, and the fruit of ardisia and nandina, became Burden's signature.

At the same time that Burden was developing Windrush Gardens, he worked in the landscape section of LSU campus development. As the campus grew in the late 1920s, he engaged in planting many of the trees and shrubs that today grace the various roadways and spaces between buildings. Because he spent so many years as a campus employee, he developed a certain kinship with the university; at the same time, his sister Ione Burden (1896–1983) served the university in several positions, including assistant dean of women and director of student affairs. In 1972, the twenty-five acres of Windrush Gardens were donated to LSU, along with Burden's Rural Life Museum. This gift complemented and completed the earlier donation of land for agricultural research.

Burden's talents as artist and designer were enormous. Perhaps most ingenious was his notion of combining the elements of horticulture, agriculture, and rural life in one large landscape, and then weaving these elements together with a system of roads lined by grids of tree plantings that recreate the sense of driving deep into the countryside. He employed a finely honed sense of spatial composition, scale, and proportion. In addition to his work on the LSU campus and at the Rural Life Museum, Burden developed a practice as a landscape designer with life experience in lieu of formal training and designed hundreds of gardens in the Baton Rouge area.

Burden was immersed in the visual arts, where his taste ranged from the vernacular to the high style. Throughout his career, he painted landscapes and sculpted whimsical clay figurines. The gardens of Windrush provide the opportunity to understand the private and reflective side of Burden as a landscape designer. Although he said that initially he created the garden rooms as settings for his sculpture collection, the experience of these spaces makes it evident that Burden understood the ability of nature and landscape space to speak to people in a profound way.

—Suzanne Turner

Note 1. Built in 1824, The Cottage, located on River Road south of Baton Rouge, was owned by the Conrad family. It burned to the ground in 1960.

References Burden, Steele. Oral history interviews by Kathy Grigsby (1994) and Suzanne Turner (1993). T. Harry Williams Center for Oral History, Louisiana State University, Baton Rouge.

Meek, A. J., and Suzanne Turner. *The Gardens of Louisiana: Places of Work and Wonder.* Baton Rouge: LSU Press, 1997.

Stakely, James Tracy. "Steele Burden and Windrush: A Historical Documentation of a Landscape Designer and His Garden." Master's thesis, Louisiana State University, 1997.

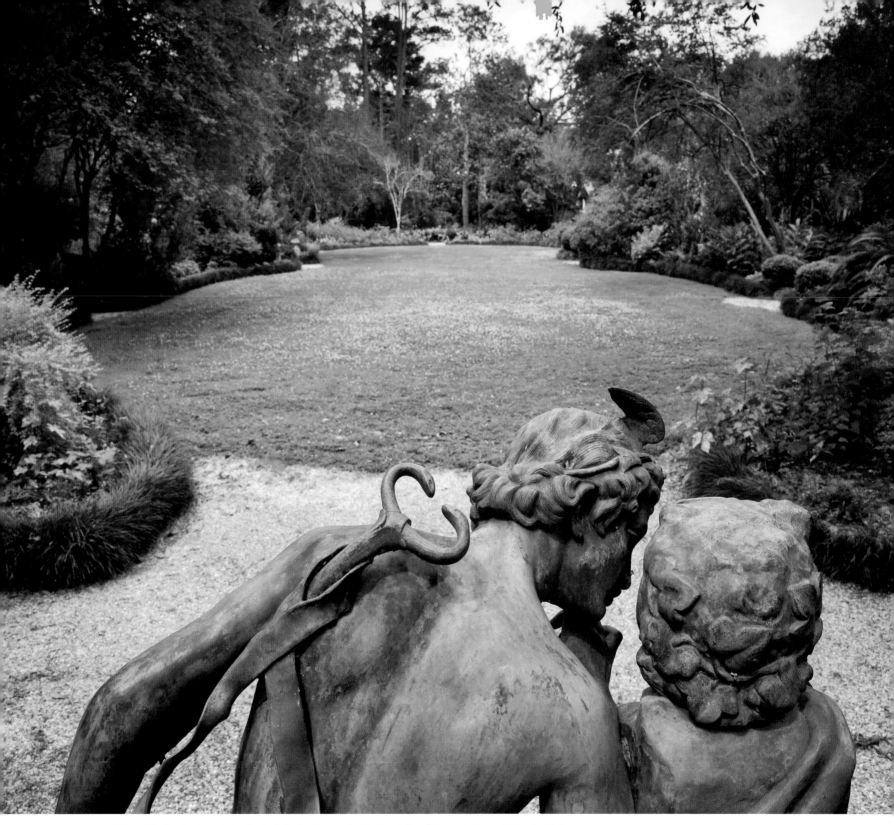

ABOVE: Windrush Gardens. Landscape designed by Steele Burden. Photographer: Jim Zietz, Office of Communications and University Relations.

On the Front Range

The LSU Geology Camp

Established in 1928, the LSU Geology Field Camp is located on 1,300 acres in the Front Range of the Colorado Rocky Mountains, a few miles southwest of Colorado Springs. The camp is one of a handful of all-inclusive geology field camps and the oldest continuously operating camp still operating in the United States. The core mission of the LSU Geology Field Camp is to provide rigorous training in field geology.

In 1871, the Keeton family homesteaded the land that became the LSU Geology Field Camp. The Keetons farmed and ranched as well as ran a small hotel and rental cabin business along the valley of Little Fountain Creek into the 1950s. At one time, a stagecoach line ran up this valley to the mining district of Cripple Creek. LSU started constructing camp buildings, including a mess hall and dormitories, in the 1930s and has added to that infrastructure periodically since then. This long history is evident in the buildings on site, many of which are still used.

Geology camp provided steady income for the Keeton family during the difficult years of the Great Depression. The strong relationship between LSU Geology and the Keeton family prompted their donation of two parcels of land for the geology field camp to the university in the late 1950s.

The region's diverse geology makes the camp an ideal location for field-geology programs. Rocks cropping out at camp yield everything from beautiful large crystals of quartz, feldspar, and mica to dinosaur footprints. The folding and faulting of rocks caused by uplift of the Rocky Mountains produces a challenging field area for students to study and a scenic place to live during their six-week course. In fact, the type, age, and deformation of rocks at camp are comparable to those at the famous Garden of the Gods Park in nearby Colorado Springs.

The field camp experience has been a critical component of undergraduate preparation for more than 2,500 LSU geology and petroleum engineering students. Many prominent and influential leaders in the oil and gas industry including Charles Barney, Frank Harrison, Jr., Clarence Cazalot, Robey Clark, and Lod Cook identify the LSU Geology Field Camp as having been pivotal in their lives and crucial to their academic and professional development. Programs currently using the facility include the Senior Field Camp for upperclassmen receiving advanced field experience and instruction in geologic mapping and the Freshman Field Camp, an introductory geology course that both the Geology & Geophysics and Petroleum Engineering departments use to recruit top high-school students.

Many alumni from both Geology & Geophysics and Petroleum Engineering have supported the camp with their gifts, culminating with a donation and pledge from Charles Barney in 2007 that will create an endowment to support the camp facilities, programs, and personnel.

—Laurie Anderson

RIGHT: Students examining outcrop of Dakota formation exhibiting dinosaur footprints at the LSU Geology Field Camp, 1,300 acres on the Front Range of the Colorado Rocky Mountains, Colorado Springs. Photograph provided courtesy of Laurie Anderson, Department of Geology.

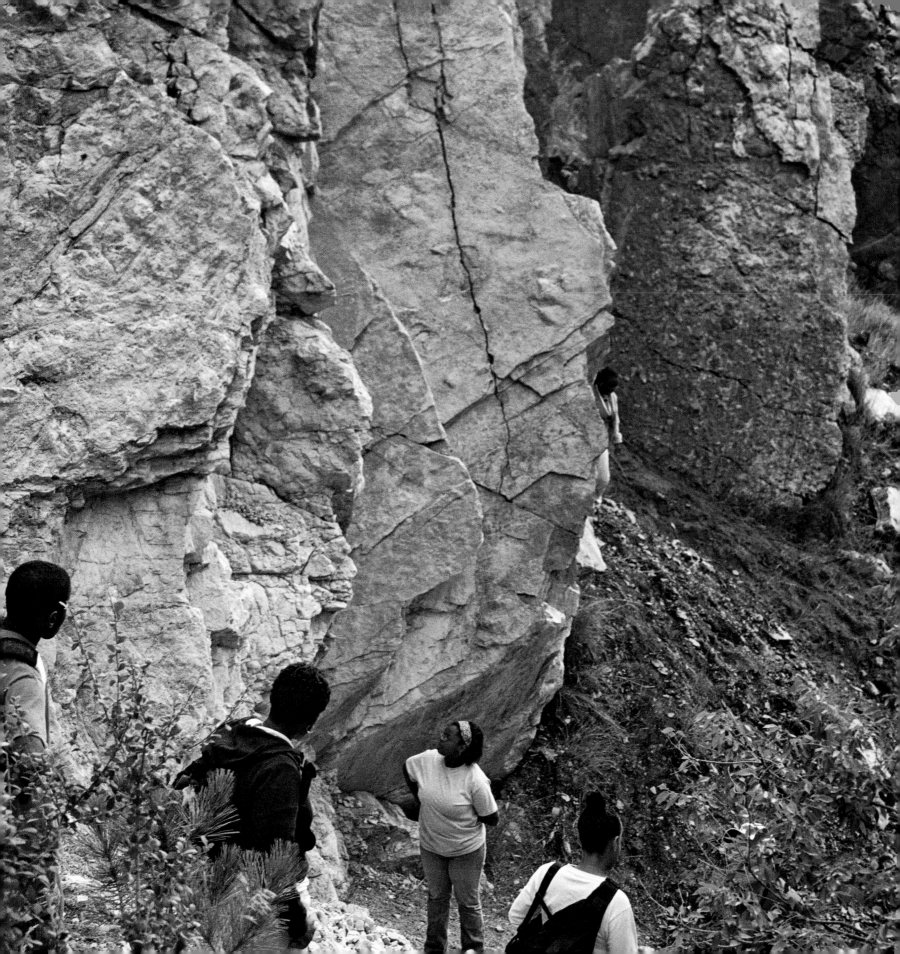

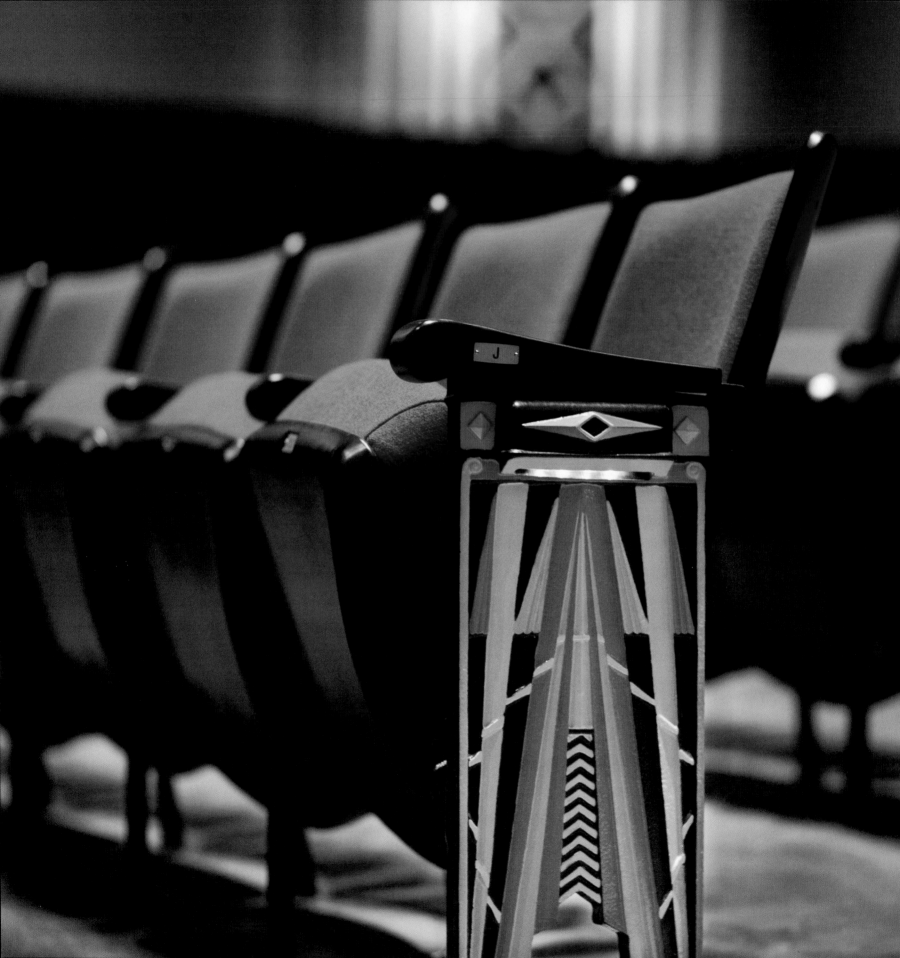

III

TREASURED
BUILDINGS

Historic Venues and
Award-Winning Architecture

The Campus Living Room
The LSU Union

The LSU Student Union boasts the busiest front doors in the state, providing room for some 1,400 social and cultural events each year. Completed in 1964, this award-winning building provides spaces for a wide array of campus and student services and activities, including a post office, bookstore, games area, art gallery, lounge, food court, dining room, ballroom, and meeting rooms, in addition to offices for administrative and student organizations. The grand Union Theater seats over 1,300.

The architectural challenge taken on by the architect John Desmond (1922–2008) was to provide a building of this size and flexibility that fit comfortably on its center campus site, was compatible with the traditional existing architecture, and also was expressive of the progressive spirit of its time. The typical college student union at midcentury was a solid brick box, with large blank walls punctured by small windows. Avoiding that sense of enclosure and separateness, this building literally turned itself inside out, opening the interior rooms outward so as to integrate fully the activities held within into the daily life of the campus. It was a building meant to be an open and permeable model for student life.

The Union does this by combining functional and aesthetic innovations, inviting ground-level access from all directions, bringing in students from their residence halls and classes for meals and for a wide range of activities, while surrounding itself with active spaces full of engaged students of all interests. Above this readily accessible ground floor hovers a modern "piano nobile," presenting an interpretation of the classical concept of the elevated base, or noble floor, as it reaches outward extending the feeling of the interior toward the great plane of the Parade Ground across the street.

The eloquent spaces of the front halls take their design cues from both the graceful LSU arcades nearby and the soaring open canopies of the surrounding grove of dedicated live oaks. There is in these public spaces a creative blending of emphasis between horizontal and vertical elements: the floating horizontal slab and upper balcony, the vertical columns to pull the eye upward, then, like the arches in a great cathedral, curving outward to connect the eye to a strong grid of ceiling beams, helping to emphasize the continuity between the overall space and the plane of the Parade Ground in the distance. The openness of the central stair court pulls those experiences right into the heart of the building so that one is constantly aware of the dynamic university campus all around.

Perhaps not every university building would benefit from such openness; for a dormitory or a classroom it might not work. But for the LSU Student Union, this has created a beautiful, contextually compatible design that fits in with but does not copy the more traditional formality of the original campus architecture. In doing so, the design lives up to the best ideals of modernism, even anticipating the "postmodern" concern with context and history while providing a vibrant and exciting living room for the university. It is one of the few examples of modern architecture in Louisiana to achieve widespread acclaim nationally, winning the American Institute of Architects Regional First Honor Award, and the only twentieth-century Louisiana building included in G. E. Kidder Smith's prestigious Architecture in America photographic collection.

—J. MICHAEL DESMOND

ABOVE: Students heading to the LSU Student Union in the 1960s. Photographer: Edgar Shore, LSU Public Relations.

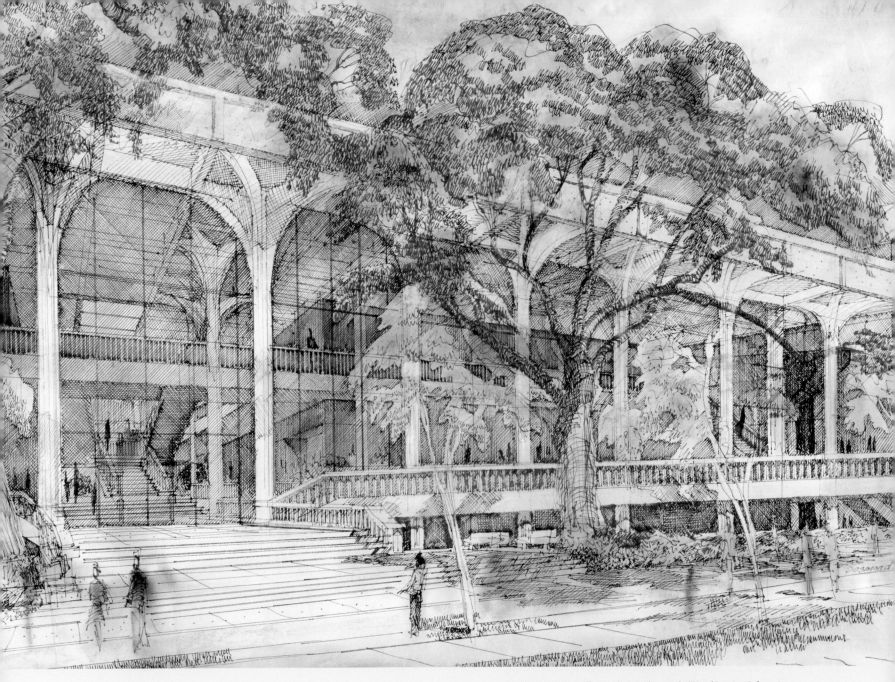

ABOVE: Rendering of the LSU Student Union. Watercolor painting by architect John Desmond (American, 1922–2008). Photographer: Kevin Duffy, Coordinator, Photography/Digital Imaging, Information Technology Services.

Brick by Brick
The Journalism Building

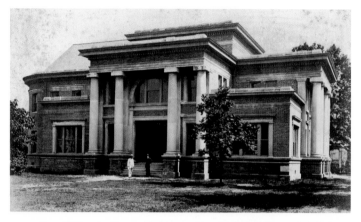

T he Journalism Building, sitting majestically atop an incline near Tiger Stadium, is arguably the most historic building on the LSU campus. Known as Alumni Memorial Hall (later shortened to Alumni Hall) when built, the structure that eventually became the Journalism Building appeared on LSU's "old" downtown campus. How Alumni Hall came to be and how its location changed make for a fascinating story.

Architect and LSU alumnus Charles Favrot originated the idea for building Alumni Hall in 1897 as a memorial to former LSU president David Boyd. The building also was meant to serve as a new library. Construction cost, estimated then at about fifteen thousand dollars, would be underwritten entirely by LSU alumni. When John Hill donated funds

in 1902 to construct a library to honor his deceased son, the purpose for Alumni Hall changed accordingly.

Alumni Hall's eventual purpose, however, was almost irrelevant once efforts to collect pledged funds for its construction stalled. A monumental fund-raising effort by Alumni Society president Lewis Graham finally succeeded. Even so, architects Charles Favrot and partner A. F. Livaudais refused any fees for planning Alumni Hall.

Alumni Hall ground-breaking occurred on September 19, 1903, and its cornerstone was laid on May 31, 1904. But continuing money woes delayed the building's completion until December 1909, at a final cost of approximately forty thousand dollars. With its prime location near the entrance to the LSU campus, Alumni Hall quickly became the hub of alumni activity. Several LSU administrative offices also were housed there, including that of President Thomas Boyd.

After LSU moved to its present site, buildings on the "old" campus were demolished—save one, Alumni Hall. The building remained standing until a decision was made in 1933 to disassemble and rebuild it on the new campus. Who made the decision and for what purpose remain uncertain. Presumably, alumni were determined to save their cherished building from the inevitable wrecking ball.

The job of reconstructing Alumni Hall went to the Dreyfus, Weiss & Seiferth architectural firm. A newspaper article from the period described the move this way: "As many features of the old building as possible have been included in the plans for the new building and according to Dean [of Administration] James F. Broussard, only those modifications demanded by the style of architecture

References "Alumni Hall Construction Is Going On." *The Reveille* (LSU), January 12, 1934.
"Alumni Hall First Planned To Be Regular Library." *The Daily Reveille*, April 5, 1938.
Blitzer, Carol Anne. "Alumni Hall." *The Advocate*, May 24, 1999.
Collins, Hubert. "University Records Call for Fireproofing; Alumni Hall to Switch Tenancy with Boyd." *The Summer Reveille*, June 22, 1948.
Graham, Lewis S. "Historical Sketch of the David F. Boyd Memorial." *The Reveille*, February 1, 1905.
"Journalism School Movement Finished." *The Daily Reveille*, September 17, 1948.
LSU General Catalog, 1928–1929, 46; *1929–1930*, 46.
Minutes of Regular Board Meeting, April 2, 1960, May 25, '59–Oct. 1, '60. Minutes, Board of Supervisors, Louisiana State University,
 Vol. 20, 178, Board of Supervisors Records, R.G. A0003, University Archives, LSU Libraries.
"Old Alumni Hall in Use since 1902 Being Razed and Will Be Rebuilt on New L.S.U. Campus." *Baton Rouge State Times*, January 5, 1934.
 (Note: The "1902" date in the article title is incorrect. Alumni Hall was not completed until 1909.)
"Offices Assigned in Alumni Hall." *The Reveille*, March 2, 1934.
Prescott, Arthur T. "Completion of Alumni Hall." *The Alumnus*, October 1909.
Wilkerson, Marcus. *Thomas Duckett Boyd*. Baton Rouge: LSU Press, 1935.

of the new campus will be made." The article went on to say, "Practically all the material in the old building will be used for the new one." The rebuilt Alumni Hall was ready for its new occupants—Alumni Federation personnel, the commandant of cadets, treasurer, bursar, and others—in May 1934.

A campus office shift in 1948 moved all administrative offices then occupying Alumni Hall to Thomas Boyd Hall and moved the Journalism School into vacated Alumni Hall. Alumni Hall soon came to be called the Journalism Building because of its new occupant. The name remained unofficial until April 1960, when the LSU Board of Supervisors honored the Alumni Federation's request to change Alumni Hall's name in order to prevent confusion over the Federation's newly named Alumni House located elsewhere on campus. The board's action made the unofficial "Journalism Building" name official.

The Journalism Building continues to house what now is the Manship School of Mass Communication. The building has undergone several cosmetic changes over the years, but a major renovation completed in 2003 transformed the venerable "Alumni Hall" into one of the most advanced laboratory/classroom facilities in America.

—RONALD GARAY

RIGHT: An aerial view of the Journalism Building, formerly known as the Alumni Memorial Hall. Design architects: Charles Favrot and A. F. Livaudais, New Orleans. Photographer: Eddy Perez, Public Affairs, Office of Communications and University Relations.

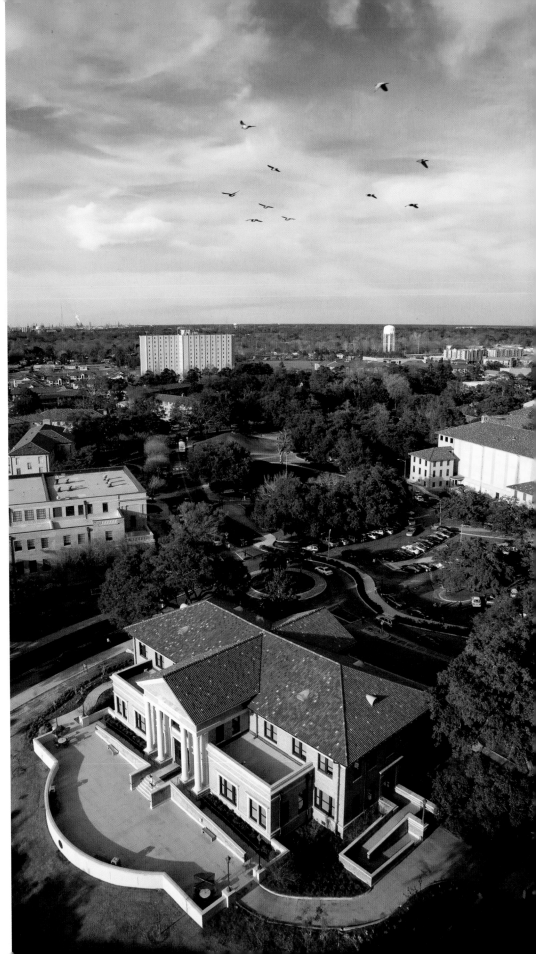

Art Deco Drama

The Claude L. Shaver Theatre

ABOVE: Indirect Art Deco uplights, commonly called "shadow boxes," extending from floor to ceiling in a musical-note design. Photographer: Jim Zietz, Office of Communications and University Relations.

Playwright Tennessee Williams wrote that "time goes by so fast. Nothin' can outrun it."[1] Yet standing in defiance of this axiom is the beautiful Claude L. Shaver Theatre, which opened its doors in 1932. It is now newly renovated and more dazzling than ever. As part of Governor Huey P. Long's $3 million building project, the theatre was one of the premiere collegiate houses in the country. Nearly eighty years later, the Shaver Theatre has been home to over three hundred productions and is once again a masterpiece after receiving major renovation, completed in 2009. The theatre is housed inside the Music and Dramatic Arts Building, which is among the oldest structures on the current campus. The building's exterior conforms to the early Italian Renaissance scheme familiar throughout the campus, but it is the beautiful Art Deco design of the interior that makes the Shaver Theatre a true treasure. In 1997, the theatre, originally called the University Theater, was officially named for beloved professor Claude L. Shaver (1905–1988), who came to LSU in 1928, became director of the theatre in 1937, and remained at that post until his retirement in 1973. He was known affectionately by his students and colleagues as "Prof."

Inside the auditorium, spectators are surrounded by elements of Art Deco, the "modern" art style that emerged in the 1920s and 1930s in response to the austerities of World War I. The style includes emphasis on geometric patterns such as stepped designs, sunbursts, and sinuous Art Nouveau plant forms, as well as other designs derived from exotic sources including Egyptian and Aztec motifs. The opulent decorative patterns reveal a postwar fascination with the energy and streamlined feel of a fast-paced era of new technologies. The proscenium arch is perhaps the most prominent Art Deco feature. Thirty-two feet wide and twenty feet high, the arch shows off a unique six-layered tropical floral pattern, extending out to both adjacent walls. Each layer creates a stair configuration over the arch, with a slightly different pattern facing the audience at the top. Adding to the Art Deco design on both sides of the house are indirect uplights, commonly called "shadow boxes," extending from floor to ceiling in a musical-note design, and creating a backlit shadow effect when illuminated. Black marble is used on the lower portion of the house walls, and on the molding around the exits.[2]

Footlights, border lights, and a new Wurlitzer organ in the orchestra pit completed the Shaver's original look.[3] Professor Shaver himself consulted with the building's designers and took great care to ensure that the theatre had excellent acoustics and audience-friendly sightlines for 574 spectators, including 132 balcony seats. Comfort was also of great importance; the red leather chairs, complete with hat racks, were spacious for the day, and "conditioned air" was a welcome inclusion, as many theatres at that time were thick with musty air from the lighting and close audiences.

The Music and Dramatic Arts Building restoration was completed in 2009. The walls in the Shaver auditorium now shine with gold, replacing the green paint that had covered the walls before. The Deco musical note designs and the uplights alternate in gold, bronze, and red tones. The seating configuration has also changed: The two aisles remain in the back of the house, while in front of the cross-aisle up to the stage there are only side aisles. The leather chairs have been replaced with raspberry plush seats, though the original Art Deco reliefs on the aisle chairs have been retained and restored to their original colors. The grand drape is also raspberry in color. The proscenium's overlapping planes, originally a light color with gradations to black at the rear, are now in gold and bronze at the top, fading to black in continuous gradation at thirteen feet. The carpeting complements the new colors and recreates the cube design on the tile floor in the lobby.

The Shaver Theatre has been an important part of the study of theatre and musical performance at LSU. It has served primarily as a

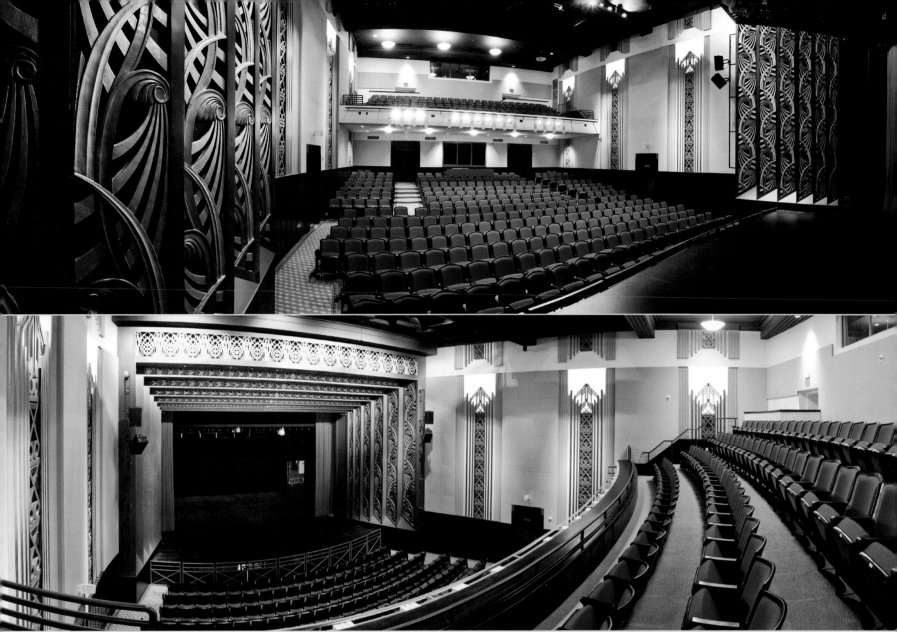

ABOVE: View of auditorium (*top*) and view of stage (*bottom*). Design architects: Dreyfus, Weiss & Seiferth, New Orleans. Photographer: Jim Zietz, Office of Communications and University Relations.

laboratory for the College of Music and Dramatic Arts' academic and production programs. Over the years, the Shaver has presented a wide variety of styles and forms of plays. The new look with the renovation and restoration of the Shaver Theatre is, in effect, a "curtain going up" for a new era of memorable music and dramatic performances.

—Chris Nelson

Notes 1. Big Mama said this in *Cat on a Hot Tin Roof*.
2. The architects for the building were Dreyfus, Weiss & Seiferth of New Orleans. They also designed the Art Deco Louisiana State Capitol, which was dedicated in 1932.
3. The organ has since been removed, as have the footlights.

References Shaver, C. L., and C. M. Wise. "A University Theatre." *Players' Magazine* 9, no. 1 (January–February 1933): 9–10, 12, 25.
White, Richard D., Jr. *Kingfish: The Reign of Huey P. Long.* New York: Random House, 2006.

Leche Hall

The Hebert Law Center

Claiming its place among majestic live oaks lining Highland Road, the "old" Law School building, formerly Leche Hall, caused considerable controversy at the time of its construction. The architect surmised that creating a visual separation of the Paul M. Hebert Law Center from the rest of LSU's buildings added contrast to its surroundings.

Based on the design of the U.S. Supreme Court and completed in 1937, the structure's white stone surface and massive columns did not blend with the Mediterranean style of the core campus buildings. It is not clear who was responsible for the law building's final design. Some give credit to Frederick Beutel, then dean of the Law School, while others point to LSU president James Monroe Smith. It is certain, however, that Leon Weiss of the New Orleans architectural firm Dreyfus, Weiss & Seiferth drew up the plans. The building had many quirks. For example, it was impossible to move from the front to the back of the building without passing through the auditorium, a flaw finally rectified in the 2003 renovation.

Another controversy arose shortly after the building opened. When university officials broke ground in the fall of 1936, they proclaimed that, to recognize his contributions, the new hall would be named after Gov. Richard W. Leche, who oversaw construction efforts. The university had his name carved on the pediment above the main entrance and placed a bronze plaque with his image over the main door. Three years later, however, because of his part in the "Louisiana Scandals," Leche was indicted and then convicted for mail fraud and on other corruption charges.[1] Had he visited the Law School after that date, Leche would have found both his name and image missing: the university reversed the stones and sandblasted the façade to remove any traces of the alteration.

The old law building was not the Law School's first home on this campus. Between 1926 and December 1937, law classes convened in Thomas Boyd Hall. In the early 1930s, however, these spaces became insufficient for the rapidly growing staff and the law library. Construction of the new building proceeded quickly, and in December 1937, the university relocated the Law School to the Highland Road site. Faculty, staff, and students never fully occupied its space. Several other LSU departments occupied the lower floor over the years, and during the 1940s, the basement floor of the law library housed the Louisiana State Archives.

The original façade of the law building is still dominated by life-sized carvings on the pediment: a soldier, a jurist, and a laborer. The soldier represents those who enforce the rule of law; the jurist represents those who uphold the rule of law; and the laborer symbolizes those who prosper under such a system. Renovations made in the 1950s, 1970, and 2003 added air conditioning, appended offices and classrooms to the original structure, and remodeled interior spaces.

—James Wade

Note 1. Leche was sentenced to ten years in prison, released on parole in 1945, and pardoned by President Harry S. Truman in 1953.
Reference "Truman Gave Pardon to Huey Long 'Heir.'" *New York Times* Archives, January 24, 1953.

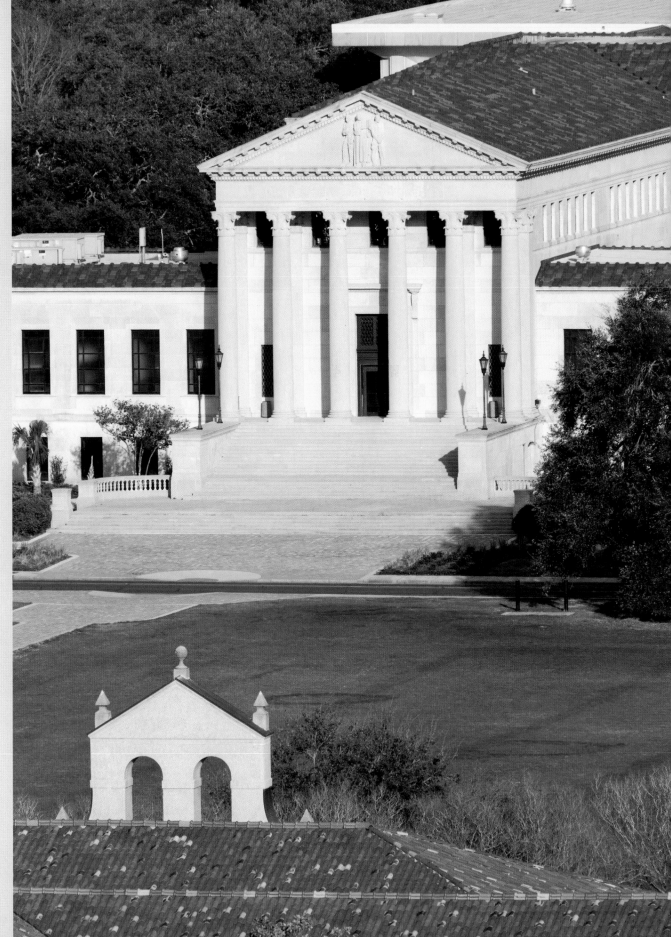

RIGHT: The old Law School building, formerly known as Leche Hall. Design architect: Leon Weiss of Dreyfus, Weiss & Seiferth, New Orleans. Photographer: Jim Zietz, Office of Communications and University Relations.

La Maison Française
The Honors College

Everything about the French House was planned to be special...Every Wednesday brought formal dinner night, and an evening of French conversation would be followed the next week by one in Spanish and then by an Italian evening. It was a glittering way to learn.

—Chatelaine Anita Olivier Morrison

La Maison Française—the French House—opened to LSU students in the fall of 1935. The dream of Professor James Broussard (1881–1942), Dean of Administration, the French House was built as a center for the study of the French, Spanish, and Italian languages. Professor Broussard envisioned not only a place of study but also a home and environment in which students would immerse themselves in French culture and heritage. Using concepts and images acquired by Broussard on his many travels abroad, New Orleans architecture firm Dreyfus, Weiss & Seiferth designed the French Renaissance–style building. Ground was broken on April 5, 1935, in conjunction with LSU's seventy-fifth anniversary. With all of the pomp and circumstance befitting such an occasion, the cornerstone was laid by French ambassador André de Laboulaye and included a piece of wood from the first French settlement in Louisiana, Fort de la Boulaye. Construction was completed in September of 1935, creating a seventeenth-century French château amid a campus of Italian Renaissance architecture.

Under the guidance of Chatelaine Anita Olivier Morrison, "Mistress of the Château," the French House became home to forty to fifty students living the Gallic tradition. Ballgowns, formal dining, and gourmet meals were the order of the day. Furnishings included the mural *Île de la Cité, Paris* donated by the French government, Louis IV and XVI style furniture, and a piano used by Enrico Caruso. The main public room, the Grand Salon, was designated as the university's "living room," hosting formal entertainment and esteemed guests such as Charlotte, Grand Duchess of Luxembourg.

The French House filled many university needs before its rebirth in 1999 as home to the LSU Honors College. In the war years, the French House became a club for the officers of the U.S. Army Administration School (located at LSU), and the building eventually was used as housing for servicemen's wives. Between 1947 and 1958 language majors again occupied the building until it was opened as housing for all students. Sadly, in 1968, the French House was closed and left vacant for over a decade. It reopened in 1981 following a $1.4 million renovation. On April 3, 1981, Professor Broussard's grandson, James Frederick Broussard, and French ambassador François de Laboulaye, son of the French ambassador who helped lay the original cornerstone, attended the French House rededication. Both LSU Press and Phi Kappa Phi Honor Society occupied the French House before it became the home of the LSU Honors College.

Today, classes for the 1,500 students enrolled in the LSU Honors College are held daily in the French House, which is adjacent to their residence hall (Laville). Recognized in the National Register of Historic Places, the French House remains the only example of French Renaissance–inspired architecture on the campus. The Foundation for Historical Louisiana named it one of the top ten buildings of historic significance in the state.

—TIA EMBAUGH

References Blitzer, Carol Ann. "The French House." *Baton Rouge Morning Advocate*, October 26, 1998.
Jacobs, Howard. "Remoulade." *New Orleans Times Picayune*, December 8, 1965.
Segar, Jamie. "French Chateau, Louisiana Style." *LSU Magazine*, Summer 2001.

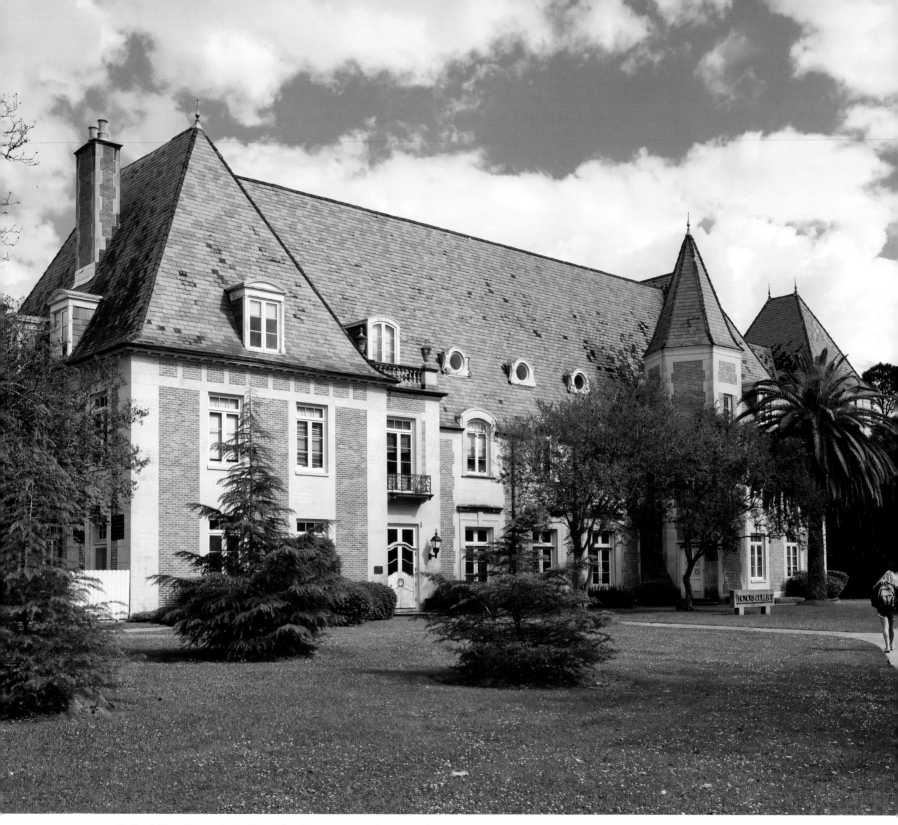

33

Casa de las Americas
Acadian Hall

ABOVE: The door of the "Old" Acadian Hall, evidence of the Spanish influence on the architectural design of the building. Photographer: Jim Zietz, Office of Communications and University Relations.

Although the name evokes a French heritage, Acadian Hall is a somewhat obscure treasure of LSU with a surprisingly Spanish flavor. Featuring colonial Spanish architecture, the building was originally called the Casa de las Americas, or "Pan American House," when it was officially dedicated on October 12, 1942, the 450th anniversary of the discovery of America by Columbus.

Chiefly because of Louisiana's location at the upper-central reach of the Gulf of Mexico, LSU has always had a strong relationship with South America, and has attracted a great number of students from Caribbean and other Latin American countries. The Casa de las Americas originally was intended to assist Latin American students (and those from other foreign countries) attending LSU's Audubon Sugar School. Designed by Wogan & Bernard, architects of many of the early campus structures, it was built prior to World War II as a residence hall for international male students. In a unique effort to integrate the international community at LSU, administrators experimented in promoting a better understanding between cultures by teaming up students—one from North America and one from South America—in each of the original twelve rooms. In the late 1950s and early 1960s, the increase in female students at LSU demanded a quick housing solution, and in 1961 a four-story annex was constructed and the newly named Acadian Hall began serving coeds. Today, Acadian Hall is a mixed-gender facility housing 212 students and consisting of "Old Acadian" (24 students) and "New Acadian" (188 students). It is located adjacent to the Honors College, and most of the students living in Acadian Hall are either in the honors program or have honors program roommates.

Old Acadian Hall is today the only building on campus built around a tiled, open-air patio with a central fountain and ornately carved, wooden double-entrance doors. The doors are aging (they were once a dark mahogany color), but each still clearly features half-round wood strips arranged in interesting diamond patterns. Above is a painted concrete bas-relief globe depicting the two continents beneath a clam-shell niche. Approaching the flagstone entry plaza from Highland Road, one encounters a starkly simple (reminiscent of the Alamo in Texas) light beige stucco façade with the wooden gateway at the center. The façade features small windows shrouded with iron grillwork, a slightly curving, scrolled frieze, and a coral orange–tinted, aggregate cap. Today the doors are kept closed, but originally they were left open to the street. One could see the patio space within and catch a glimpse of the spurting fountain jet and the glazed, blue- and ochre-colored, floral-patterned tiles on the basin surround.

Traversing several steps and passing through a dark vestibule (brightened by the same luminous decorative tiles from floor to ceiling on the walls), one emerges into the sunlit patio space. Mahogany-colored, exposed wooden post and beam porches surround the patio on three sides and support terra-cotta tile roofs. Wooden, wrought iron, and contemporary benches, tables, and chairs are scattered around for resident use and offer shaded vantage points toward the octagonal-shaped fountain at the patio center. A low, stucco seat wall, punctuated by main and side entrances, separates the porches from the courtyard. The porchless façade, opposite the entrance vestibule, features a magnificent fan-shaped window above glazed double doors. Upon entry through these doors, one finds a large public lounge and to the left a private lounge area. Oversized, glazed white floor tiles with smaller blue-tile accents in both lounges recall the ornate patterns of the patio.

The patio is made richer by red-orange quarry tile surfacing, set in a basket-weave pattern and accented by small, bright blue, glazed tile squares. At each of the four corners of the patio are planters, defined by box hedges and rounded curbs which match colors of the roof tiles and the fountain basin top and drain. The planters are filled with lush tropical plants such as banana, fan palm, hibiscus, hydrangea, azalea, iris, aucuba, aspidistra, and various ferns. The darkened glass of the lobby doors provides a marvelous backdrop for the splashed foliage, flowers, and water.

The fountain itself is perhaps the real "treasure" of this Treasure.

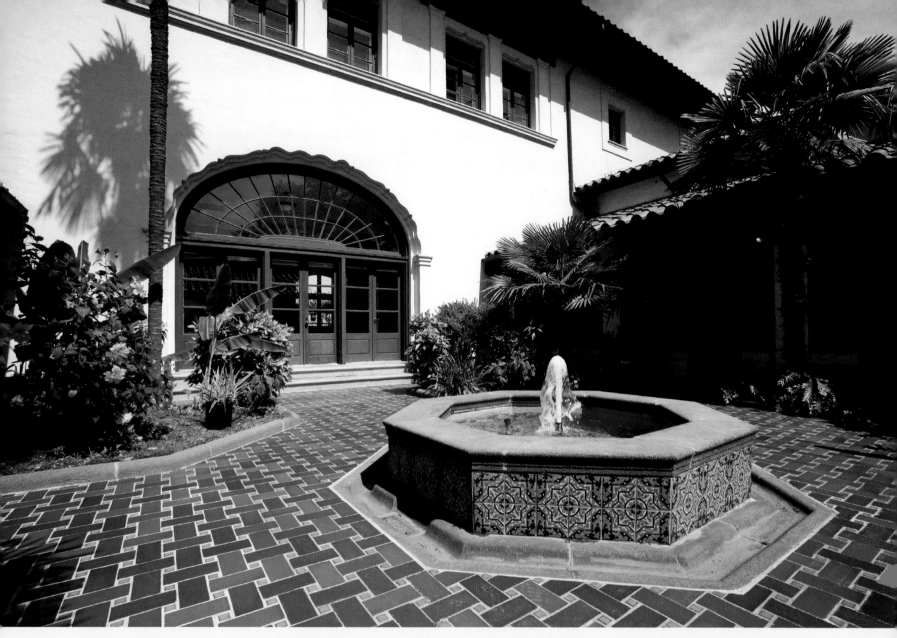

ABOVE: The tiled, open-air patio of the "Old" Acadian Hall, including the original fountain. Designed by Wogan & Bernard. Photographer: Jim Zietz, Office of Communications and University Relations.

The brightly colored basin tiles contrast nicely with the explosion of green in the surrounding planters, and the aqua-tinted interior complements the surround and paving tiles and adds to the cool, tropical feeling. Rounding out the sensory experience is the sound of spurting water. The simple jet sends water upwards, just high enough to be illuminated by the sun against the shaded porches and lobby façade, and the splashing sound permeates the intimate environment. When the doors are closed, as they most often are, the sounds of the water and chirping birds dominate. Visually and aurally, the jet provides a final hint as to how nice this secluded setting must have been (and still is) for those students living there.

—Van L. Cox

Reference Jay High, personal communication, May 2009.

From Cattle to Curtain Calls
The Reilly Theatre

A ctors often refer to announcements for auditions as "cattle calls," but real cattle and other livestock preceded those who today audition for roles in the Reilly Theatre. Before its transformation into a theatre, this large, stately building was the first home of the LSU College of Agriculture, the State Agricultural Center, and the State Agricultural Extension Service, but its principal function was as a judging pavilion and auction house. For over seventy years, it was known as the Stock Judging Pavilion. Until it acquired its new identity as a theatre, it was the oldest building on campus that survived in its original, unaltered condition. By the 1970s, the building had fallen into disuse and decay, occasionally housing visiting Clydesdale horses, students decorating homecoming floats, or a student-directed theatre production.

Erected in 1923 at a cost of $62,492, the Stock Judging Pavilion was one of the original buildings on the "new" LSU campus designed by architect Theodore C. Link of St. Louis, Missouri, and dedicated on April 30, 1926. Original plans located the Pavilion on the east side of Highland Road near the present site of Parker Coliseum. The building committee of the LSU Board of Supervisors, however, determined that the cattle barns and the Stock Pavilion should be located more prominently and chose instead the bluff overlooking what is now Nicholson Extension. By dominating the landscape in this striking location, the building could assure citizens of LSU's land-grant status and its accompanying agricultural extension services.

The grand, unusual building is a unique architectural example of Beaux Arts eclecticism, for which Link was widely recognized. With its long rectangular hall (which rises to fifty-five feet) that terminates in an apse at each end, the building imitates models of civic basilicas such as the early second-century Basilica Ulpia in the Roman Forum. Elaborately framed lateral entrances dominate the long sides of the rectangular hall. These side entrances open to corridors that divide stadium seating into two equal parts originally accommodating 1,280 patrons. A Roman-style clerestory with a curious cupola perched on top and glass walls that fill the entire upper gable above the apses admit light to the interior. The restoration and conversion of the building, which began in 1997, retained the unusual basic features of the building. The vast rectangular performance space can be utilized in its entirety or can be arranged into smaller, more traditional units. One of the apses serves as a lobby and ticket office and the other as a backstage scene shop. Huge curtains can be lowered over the cathedral windows for dramatic effect or dimming purposes.

The impetus to convert the abandoned building into a theatre came when Barry Kyle, a former associate director with the Royal Shakespeare Company, joined the faculty in 1991 and together with his wife, Lucy Maycock, Vice Chancellor Carolyn Hargrave, the Department of Theatre, Jensen Holliday, Jennifer Eplett Reilly, and other civic leaders founded a nonprofit professional theatre company designed to serve the local community and the state and to support the educational mission of the Department of Theatre. In a citywide search, Kyle discovered the historic building in the heart of the campus on Tower Drive. Dazzled by the unusual features of the building and their dramatic potential, Kyle knew he had found a home for the company, which soon became

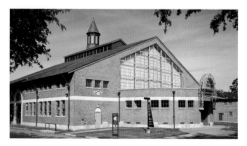

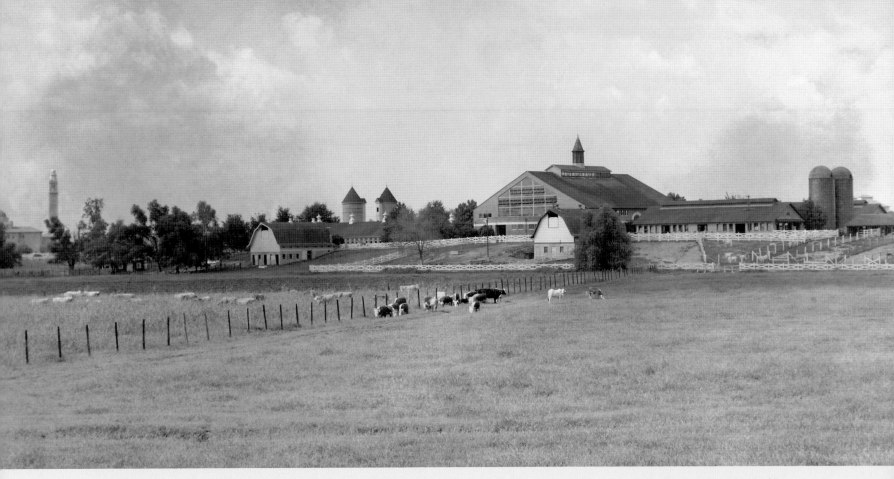

ABOVE: An early twentieth-century photograph of the Stock Judging Pavilion, main campus. Design architect: Theodore C. Link, St. Louis, Missouri. Photographer: Jasper Ewing. Jasper Ewing and Sons Photograph File, MSS 3141, Louisiana and Lower Mississippi Valley Collections, LSU Libraries, Baton Rouge.

identified as Swine Palace Productions (later shortened to Swine Palace) in honor of the building that became its official residence.

Funded in part by the state with additional generous financial support from the Kevin Reilly, Sr., family, the Reilly Theatre officially opened in February 2000 with Kyle's inaugural production of Shakespeare's *A Midsummer Night's Dream*. Once again the building became a space for live performers. The 400-seat flexible theatre continues to showcase Swine Palace, an affiliate equity theatre company, and its mission of presenting bold, innovative, and thought-provoking theatre.

Under the leadership of Artistic Director Michael Tick and Managing Director Kristin Sosnowsky, Swine Palace received the Governor's Arts Award for Outstanding Large Arts Organization in 2006 and has secured nationally competitive grants from the National Endowment for the Arts, the Schubert Foundation, and the EST/Sloan Project.

—GRESDNA A. DOTY AND MARCHITA B. MAUCK

References "Dedication Exercises of the New Campus and Buildings, Louisiana State University and Agricultural and Mechanical College, April 30–May 2, 1926, Baton Rouge." Program. Hill Memorial Library, LSU Libraries, Baton Rouge.

Louisiana Heritage InfoNet. "LSU Livestock Judging Pavilion."

"New Campus Buildings at Louisiana State University." Vertical File. Hill Memorial Library, LSU Libraries, Baton Rouge.

Soloski, Alexis. "The Sky Above, the Mudbelow." *American Theatre* 17 (September 2000).

Swine Palace Web page.

A Light on the River
The LSU Museum of Art, Shaw Center for the Arts

I n March 2005, after more than seven years of design concept and development that involved one change in venue, eight master plan options, and the eventual input of more than thirty public and private participants, LSU reestablished its presence in downtown Baton Rouge, literally moving the LSU Museum of Art "out of the ivory tower" and into the award-winning Shaw Center for the Arts. The development and evolution of the LSU Museum of Art at the Shaw Center for the Arts is the story of an unprecedented community collaboration and architectural partnership culminating in a design that marries the rich history of downtown Baton Rouge with a bold and futuristic vision. The building was designed by Schwartz/ Silver Architects of Boston, working with New Orleans–based Eskew+Dumez+Ripple as executive architects in association with architects Jerry M. Campbell & Associates in Baton Rouge.

The museum originally opened its doors in 1962 in the LSU Memorial Tower as the Anglo-American Museum of Art with the goal of illustrating the British and Continental influence on American art and culture. Accumulating an impressive collection of fine and decorative arts, in the early 1990s the museum began to expand its holdings to include all cultures, places, and times. In an effort to provide greater access to its diverse art collection, changing exhibitions, education programs, and special events, the university and the LSU Foundation launched a capital campaign to raise funds for a new museum complex.

The museum's design team, led by Schwartz/Silver, set out to create a home for the museum on the Burden property. At the same time, the city of Baton Rouge was engaged in Plan Baton Rouge, a multi-year revitalization plan. Collaborative opportunities developed, and LSU challenged Schwartz/Silver to create a design for the museum that could be part of a master plan for an "Arts Block" in downtown Baton Rouge. Through a partnership with the Baton Rouge Area Foundation, the State of Louisiana, the City-Parish of Baton Rouge, and the LSU Foundation, the plans for the Shaw Center for the Arts took form.

When the center was completed in 2005, the museum's staff moved more than 4,000 objects, stored in the LSU Memorial Tower and multiple locations across the main campus, to its new home—a 50,000-square-foot complex including fourteen galleries with soaring

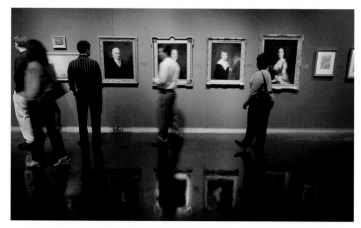

ABOVE: Interior of LSU Museum of Art gallery. Photographer: Jim Zietz, Office of Communications and University Relations.

sixteen-foot ceilings, a museum store, a rooftop sculpture garden and restaurant, administrative offices, a climate-controlled storage facility, and a loading dock. In addition to the LSU Museum of Art, the center is home for the Manship Theatre complex, the LSU School of Art's Alfred C. Glassell, Jr., Gallery and art classrooms, the LSU Laboratory for Creative Arts and Technology, a commercial art gallery, two restaurants, a coffee shop and administrative offices for the center, and other arts organizations. The fourth- and sixth-floor outdoor terraces provide views of the Gothic Revival architecture of the Old State Capitol, downtown Baton Rouge, and the Mississippi River bridge.

Located on a bluff overlooking the Mississippi River, the building is a three-dimensional matrix of horizontal and vertical lines. Interplaying masses and voids, each section and level perform key functional and aesthetic roles. The building wraps around and frames the vertical line of the old Baton Rouge water tower and helps to turn this traditional structure into a symbol of the great river beyond. The museum's cantilevered galleries, poised almost seventy feet above ground, demonstrate the design principle of interconnectivity by linking the 1930s brick Auto Hotel with the Manship Theatre complex. The building's façade, consisting of thousands of multilength sections of translucent channel-glass, reflects sunlight by day and at night serves as a canvas for light installations.[1] The four-story glass atrium lobby provides access to

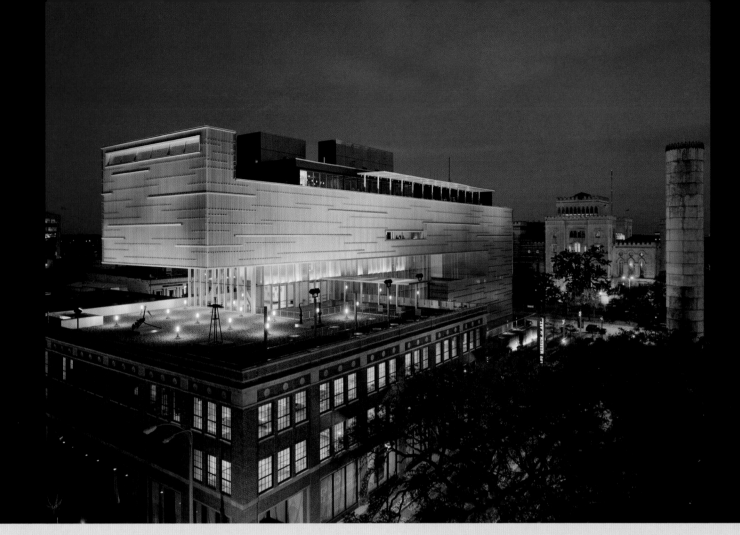

ABOVE: LSU Museum of Art and LSU School of Art Sculpture Garden, Shaw Center for the Arts. Design architects: Schwartz/Silver, Boston, Mass. Project team: Warren R. Schwartz, FAIA; Christopher Ingersoll, AIA; Philip Chen, AIA; and Richard Lee. In association with the Louisiana firms of Eskew+Dumez+Ripple, New Orleans, and Jerry M. Campbell & Associates, Baton Rouge. Photographer: Timothy Hursley.

a public plaza on one side and Third Street on the other, linking the excitement of the plaza's interactive fountains and the Mississippi River traffic with a prime commercial street. Across North Boulevard, the Old State Capitol, one of the most significant buildings along the entire length of the Mississippi River, juxtaposes a historic iconic space with this contemporary arts facility.

In January 2008, the American Institute of Architects selected the Shaw Center from almost eight hundred entries to receive a National Honor Award for Excellence in Architecture.[2] According to the AIA's announcement, "The jury called the Shaw Center a 'touchstone of the urban redevelopment in the city.' The building glows at night, serving both as a metaphor for a revitalized urban district and a 'lantern on the levee,' or a symbol of the illuminating power of the arts."[3] In addition to its AIA award, the facility has won recognition for architectural excellence from publications including *Christie's Artinfo* newsletter, *Architecture Magazine*, and *Architectural Record*.

—LAURA F. LINDSAY

Notes 1. The center uses cast-glass channels made in Germany as a rain-screen. The glass cladding, or finished covering of the exterior wall of the frame building, is suspended in front of the building's weather-tight corrugated aluminum wall system. The building can withstand winds of 100 miles per hour.

2. The National Honor Award is the profession's highest recognition of works that exemplify excellence in architecture, interior architecture, and urban design.

3. Peter Kuttner, FAIA, president of Cambridge Seven Associates, Inc., official spokesman for the jury.

A Tiger in His Element
Mike the Tiger's Habitat

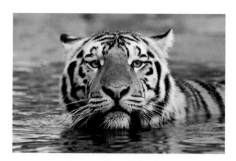

ABOVE: LSU's current mascot, Mike VI. Photographer: Jim Zietz, Office of Communications and University Relations.

Mike the Tiger's habitat is not your grandfather's recollection of Mike's original 1937 home. Since that time, both the LSU tiger cage and ideas in the zoological world about providing for the welfare of wild animals have undergone radical shifts. Today Mike resides in over 15,000 square feet of indoor and outdoor space, one of the most visited places on campus. His amenities include large grassy areas with a live oak tree, and a remarkable waterfall cascading from rocks into a large pool below. On a hot day Mike is often seen serenely sitting in the water on one of the terraced levels of the waterfall, or paddling in the glass-enclosed pool that affords aquarium-like underwater views to visitors. An open arcade echoing the architecture of the main LSU quadrangle surrounds the site, while a sixty-foot-tall campanile visually anchors the sprawling habitat located across the street from Tiger Stadium.

In the 1970s, lavish natural settings began to replace sterile hard-surface zoo facilities throughout the nation, and LSU followed suit in 1981with a renovation tripling the size of Mike's environment to some 2,000 square feet, adding a pool and climbing rocks, and providing a giant scratching post. Animal behavioral experts and veterinarians meanwhile focused research on the need for animals to have behavioral choices, with possibilities for variety and novelty. Such research led to startling innovations in the design of animal habitats. In some zoos, animals are allowed to hunt in natural habitats for their food. At the National Zoological Park in Washington, D.C., ropes strung above the zoo allow orangutans to cross the site and visit friends.

In response to the emerging scholarship on caring for wild animals, LSU wanted to demonstrate no less than the best in modeling world-class care for its Bengal mascot. The Tiger Athletic Foundation began a capital fund-raising campaign in 2001 to provide for a new habitat incorporating the latest in animal husbandry and conservation principles. A grass-roots campaign called "I Like Mike" raised the approximately three-million-dollar cost of the new tiger habitat. DeLaine Emmert, wife of then-chancellor Mark Emmert, and Bill Hulsey, former president of the Tiger Athletic Foundation's board of directors, headed the original committee that collaborated with student organizations. Funds were collected at all LSU home football games, and bricks were sold to be engraved with names and set into the walkway around the habitat. No state funds were used.

The university had only to look in its own backyard to find LSU alumnus and internationally recognized zoo designer Ace Torre to provide the design for a state-of-the art new facility for Mike the Tiger. Torre's New Orleans architectural design and planning firm, Torre Design Consortium Ltd., specializes in zoological design. With some thirty years' experience in almost every state in the United States, as well as abroad, Torre's firm has amassed numerous awards in recognition of its design excellence. Mike the Tiger's new habitat, completed in 2005, is smaller yet no less significant than more expansive zoo projects in furthering knowledge and experience in the responsible nurturing and conservation of endangered animal species in zoos around the world.

Torre's expertise has contributed to award-winning projects at zoos including the Atlanta Zoo, Brookfield Zoo in Chicago, the Palm Beach Zoo, the Birmingham Zoological Garden, the Minneapolis Zoo and Aquarium, and the Assineboine Zoo in Winnipeg, Manitoba, Canada. His firm has also produced large projects for zoos in Tampa, Norfolk, Fort Worth, and Oklahoma City.

—MARCHITA B. MAUCK

Reference Nolen, R. Scott. "Designing Zoo Habitats That Promote Animal Well-Being." *Journal of the American Veterinary Medical Association* 221 (December 2002): 1534.

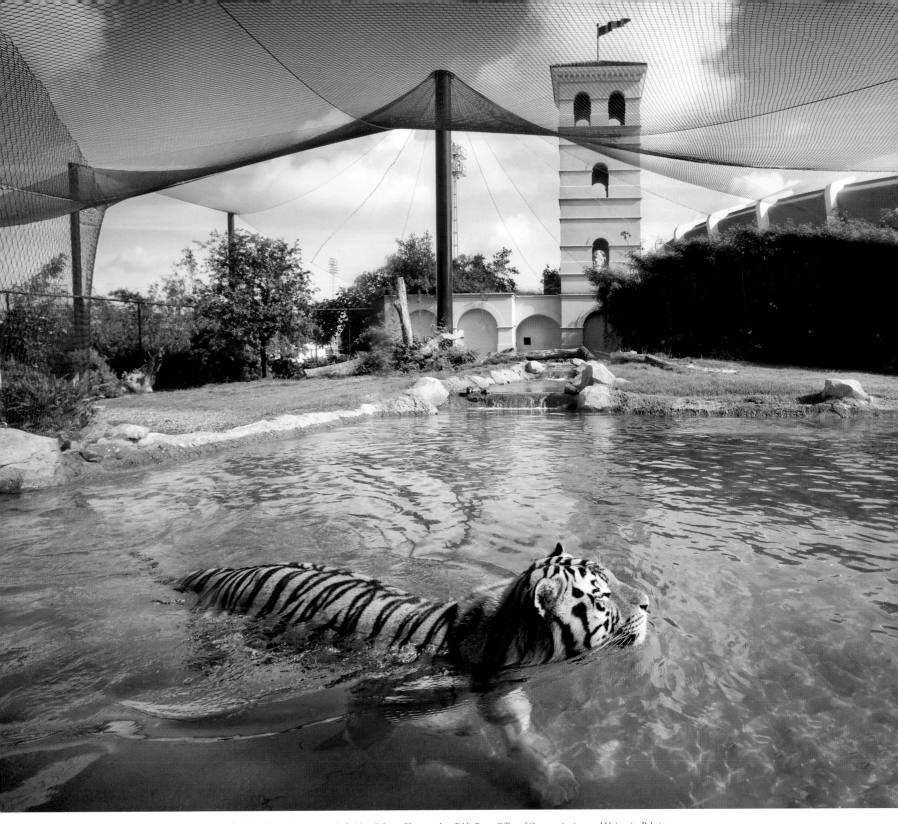

ABOVE: Mike the Tiger's habitat. Designed by Torre Design Consortium Ltd., New Orleans. Photographer: Eddy Perez, Office of Communications and University Relations.

A Walk Through Louisiana's Architectural Heritage
Vernacular Architecture

ABOVE: An overall view of the dogtrot house. Photographer: Jim Zietz, Office of Communications and University Relations.

One can almost hear the conversation and the laughter emanating from the central breezeway of the dogtrot house, as the family gathers to share the day's events. Separating yet connecting the two main living areas of the house, this functional covered porch provided additional space for myriad activities, storage, and social gatherings, and allowed families to escape the heat in an era predating electricity. Constructed during the 1860s in Rapides Parish west of Alexandria, Louisiana, the dogtrot house at the open-air Rural Life Museum provides an actual example of this type of housing common in the state until the 1930s.

Representative of the upland South culture of north Louisiana, dogtrot houses include two rooms of equal size, separated by an open hallway. The two rooms share a common roof and floor, and usually each room features a chimney. Unlike other house types of eighteenth- and nineteenth-century Louisiana, mostly inspired by European architecture, dogtrot houses are an American invention. People of the times built them using traditional techniques learned from their ancestors. The Rural Life Museum acquired its own dogtrot house in 1979 from the descendants of Thomas Neal, who first occupied the house in the 1870s.

The museum includes more than thirty other specimens of historic buildings documenting the structural designs and lifestyle of eighteenth- and nineteenth-century Louisiana. They make up the most extensive vernacular architecture collection of Louisiana dwellings. Coined by Boyd Professor Fred Kniffen (1901–1993), the term *vernacular architecture* refers to the study of architecture as a cultural phenomenon. In fact, it was Kniffen himself who encouraged the Rural Life Museum to begin collecting examples of the state's historic buildings. Since then, the museum has become a leader in the field, providing enjoyment for visitors and significant research opportunities for architects, anthropologists, historians, and geographers.

The historic buildings at the Rural Life Museum include a pioneer cabin, a corncrib, a potato house, a jail, a shotgun house, a post office, a Baptist church, a stoker barn, an Acadian house, and a commissary, all moved to the museum from their original locations spread across rural Louisiana. Orphans all, they would have been destroyed if the museum had not acquired them. To quote the establishment's staff, the Rural Life Museum is still "in collecting mood" today.

Fred Kniffen is nationally acknowledged to be the father of the vernacular architecture movement. He was among the first scholars to recognize the cultural worth of rural architectural designs and to name the different building types of the state's eighteenth- and nineteenth-century structures. His legacy at the LSU Department of Geography and Anthropology is a vernacular architecture program of national stature, working in coordination with the Rural Life Museum and the Historic Architecture Building Survey (HABS).[1]

—DAVID FLOYD AND YASMINE DABBOUS

Note 1. HABS is a federal program established by President Franklin D. Roosevelt as part of the New Deal initiatives. It documents historic architectural designs in the United States.

References Hyde, Samuel C., ed. *Plain Folk of the South Revisited*. Baton Rouge: LSU Press, 1997.

Poesch, Jessie, and Barbara SoRelle Bacot, eds. *Louisiana Buildings, 1720–1940: The Historic American Buildings Survey*. Baton Rouge: LSU Press, 1997.

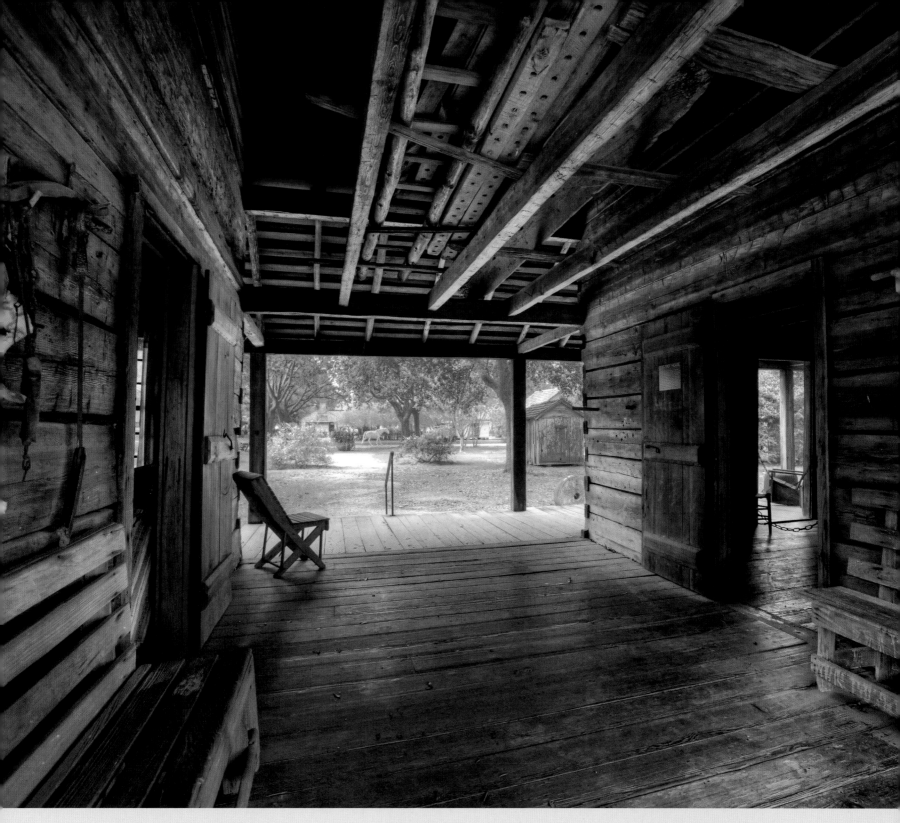

ABOVE: The dogtrot house (c. 1860s) at the Rural Life Museum. Originally built in Rapides Parish west of Alexandria, La. Photographer: Jim Zietz, Office of Communications and University Relations.

A Retreat in the Country
Hilltop Arboretum

When the time came to design a new main building for LSU's Hilltop Arboretum, it was clear that the structure had to nestle comfortably in its rural environment, yet model best practice in terms of environmental concerns and sustainability. Connecting spaces in the way that galleries of traditional Louisiana architecture do, the award-winning building at Hilltop uses a pole frame that recalls the trunks of trees, as well as the local building tradition of pole barns and columned plantation homes.[1] The entire building is raised off the ground, to protect it from the damp earth and at the same time minimize disturbance to the site. The open-assembly pavilion is built over a portion of a constructed pond, creating views over water, reflections, and opportunities for wetland exhibits. The building is extremely narrow and long, and divides the arboretum landscape from the parking area and the neighborhood beyond. The resulting composition of spaces captured under one long roof includes open walkways that house program and meeting spaces, administrative offices, a gift shop, a library, and visitor facilities. The Friends of Hilltop completed a successful capital campaign to build a visitor's center in 2002. The university hired the Texas architectural firm Lake|Flato, recognized nationally for its sensibility to vernacular structures, to design the building.[2]

The walls of the Lake|Flato building are of recycled cypress, metal siding, and translucent acrylic siding, all materials with sustainable qualities and that contribute to the vernacular feel of the structure. A breezeway, not unlike that of a dogtrot house, separates the gift shop and the library, and leads the visitor down a long bridge that terminates at the beginning of a pathway to the forest edge. From there, one leaves behind the built and designed, and enters the zone of the natural, with areas ranging from the ravine bottoms to a bamboo grove to the "cathedral"—a clearing in the woods surrounded by mature hardwoods—to the humble

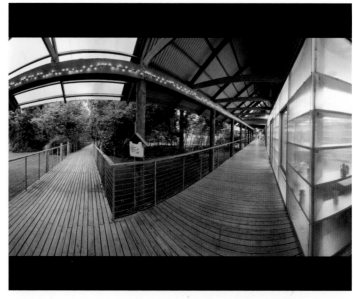

ABOVE: Hilltop panorama. Photographer: Jim Zietz, Office of Communications and University Relations.

cottage inhabited by the original owners and finally to the nursery operated by volunteers who continue the Hilltop tradition of selling native plants to encourage their use in the home landscape.

In a sense, the building itself and the way that the arboretum is used today echo the patterns established by Lionel Emory Smith (1891–1988) and his wife Annette (1892–1980), who bought the property in 1929 as a country retreat and spent their lives in this landscape learning about the native plants that inhabited its slopes and ravines. Smith botanized with colleagues, including Dr. Robert Reich, founder of LSU's School of Landscape Architecture, and collected native plants to add to the woods of his land. Annette Smith began a nursery where she grew seedling native trees, and soon the couple was selling native plants to the public. Emory Smith built their home of recycled materials.

Notes 1. The building received the 2002 Louisiana Associated Builders and Contractors Pelican Chapter Award, the 2004 Texas Society of Architects Design Award, and the 2004 San Antonio American Institute of Architects Award.
2. In 2004, Lake|Flato was selected as the American Institute of Architects' Firm of the Year.

References Ojeda, Oscar Riera, ed. *Lake|Flato: Buildings and Landscapes*. Gloucester, MA: Rockport Publishers, 2005.
Smith, Emory. *Hilltop*. Self-published, n.d.

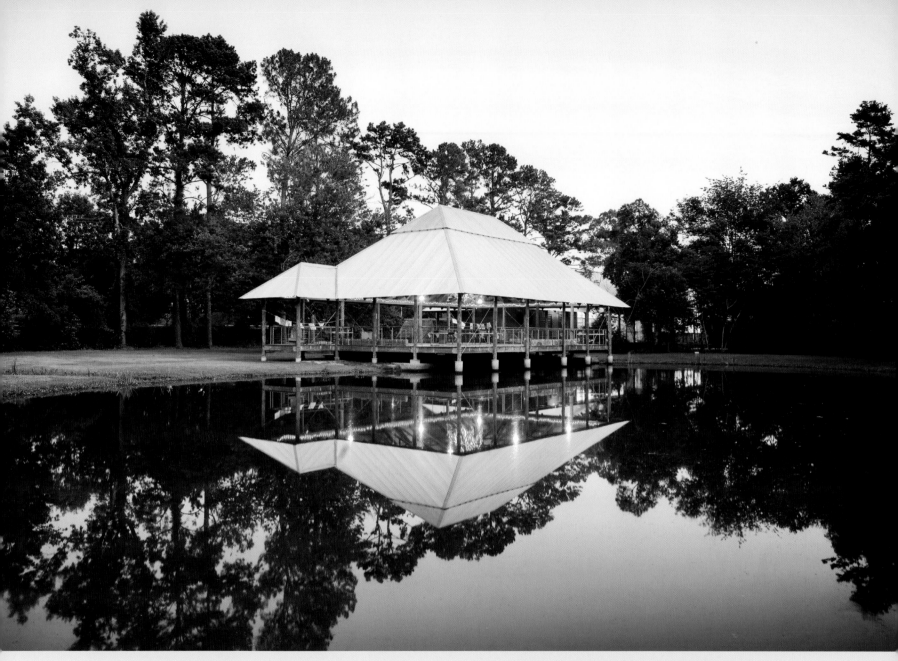

ABOVE: LSU's Hilltop Arboretum. Baton Rouge. Visitor center designed by Lake|Flato architectural firm, San Antonio, Tex. Donated to LSU by Mr. and Mrs. Emory Smith. Photographer: Jim Zietz, Office of Communications and University Relations.

In 1981, what had been a rural location about seven miles south of LSU was now surrounded by suburbia and the fast-moving traffic on Highland Road. In order to ensure that this fragile fourteen acres of Mississippi River terrace escarpment would survive to teach others about natural systems, plants, and landscape design as it had taught him so well, ninety-year-old Emory Smith donated his property to LSU, to be used as a teaching laboratory for the university and the community. Through its programs and facilities, Hilltop plays a pivotal role in coursework for the Robert Reich School of Landscape Architecture.

—SUZANNE TURNER

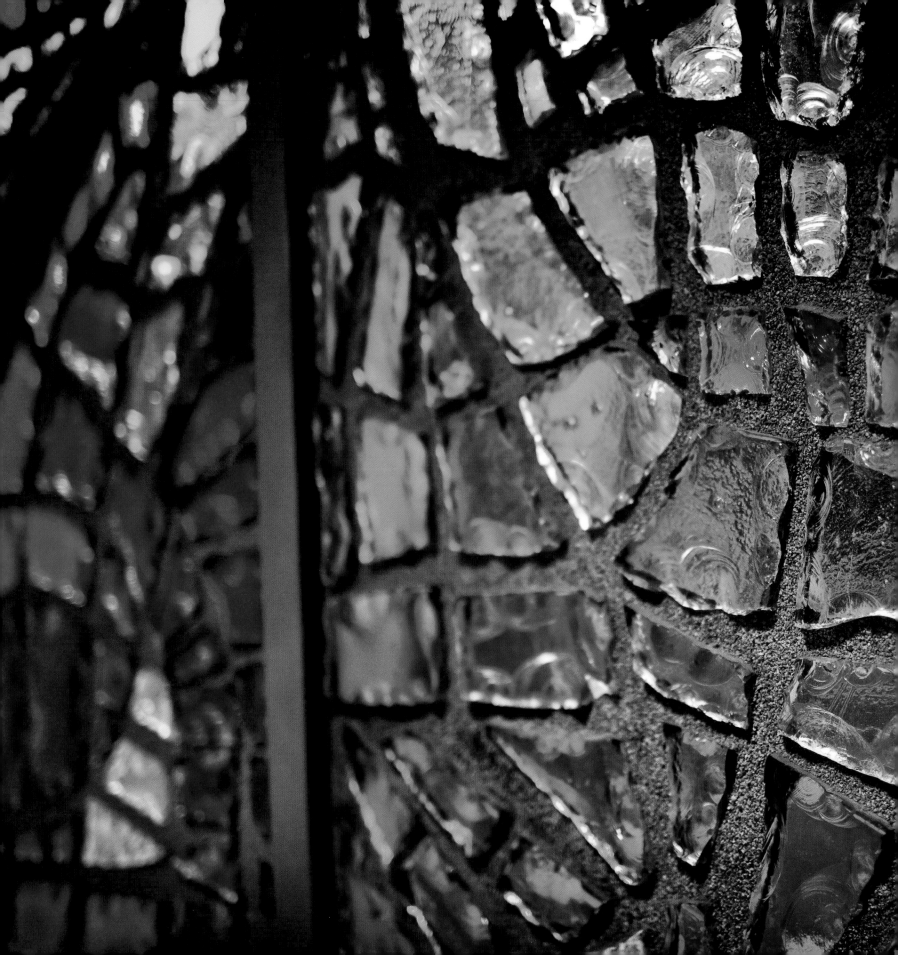

IV

DESTINATIONS

Encountering Russell Long
and Other Accessible Icons

Mind If I Join You?

Russell B. Long Statue

Capturing the essence of one of Louisiana's most prominent sons, U.S. Senator Russell B. Long (1918–2003), was the challenge given to Stephen M. Gibson, a bronze artist from Ponchatoula, Louisiana.[1] The Law Center, in collaboration with family and friends of the senator, asked the artist to create a likeness that reflected the senator's passion for the law while also making the piece approachable and part of the day-to-day life of those at the Law Center. "I admired Senator Long, and I wanted to sculpt an engaging portrait of him. That is the kind of person he was," commented Gibson. The result is a near life-sized likeness of the senator engaged in reading a legal text while casually seated on the fountain wall.

Located at the East Campus Drive entrance to the 1969 law building and creating the centerpiece of the Paul M. Hebert Law Center's Centennial Plaza, the Russell Billiu Long Memorial Fountain and Bronze serves as the focal point for the student-friendly courtyard, an inviting location that pays tribute to the senator's significant contributions to Louisiana, the legal profession, and LSU history. The fountain and bronze, dedicated in March 2006 as part of the LSU Law Center's yearlong centennial anniversary celebration, define the link between the school's history of accomplishments and its aspirations for the future, and honor one of the Law Center's most notable graduates.

Roy T. Dufreche of Roy T. Dufreche & Associates from Hammond, Louisiana, and Dennis Mitchell, LSU campus landscape architect and project manager, designed the Centennial Plaza and Memorial Fountain.[2] The granite and slate fountain incorporates a design found in the architecture of the old 1936 law building. The fountain, shaped like a lotus flower, mimics the architectural carvings located on the façade of the historic law building. A nearby bronze plaque chronicles the senator's life and contributions.

Russell Long represented Louisiana in the U.S. Senate for a record seven terms between 1948 and 1987. The *Shreveport Journal* once referred to him as "the ideal senator," noting that he knew the parliamentary procedures of the Senate thoroughly, worked harder than his colleagues, and knew how to help other people.

The son of legendary Louisiana governor and U.S. senator Huey Pierce Long and Rose McConnell Long, Russell Long was a champion of the poor, disadvantaged, and working American. He served as chairman of the powerful Senate Finance Committee between 1965 and 1981, and during that time, more than half of all federal legislation passed under his gavel.

As an undergraduate, Long was LSU student-body president. He graduated third in his 1942 law class, was associate editor of the student-produced *Louisiana Law Review*, graduated within the top 10 percent of his class (known as The Order of the Coif), and was a moot court winner in mock law competitions. As a navy lieutenant, he was awarded four battle stars for his World War II service. He practiced law in Baton Rouge before his election at age twenty-nine to the U.S. Senate.

Senator Long honored the Law Center with its first-ever endowed chair, the Russell B. Long Eminent Scholars Academic Chair. His estate, along with family and friends, has supported dozens of academic units and programs throughout the LSU campus.

—KAREN M. SONIAT

RIGHT: Stephen M. Gibson (American, b. 1953). Russell Billiu Long Memorial Fountain and Bronze (c. 2006). Located in Paul M. Hebert Law Center's Centennial Plaza. Centennial Plaza and Memorial Fountain designed by Roy T. Dufreche of Roy T. Dufreche & Associates, Hammond, La., and Dennis Mitchell, LSU campus landscape architect. Photographer: Eddy Perez, Office of Communications and University Relations.

Notes 1. Stephen Gibson earned a bachelor of fine arts degree from LSU. Primarily a figurative sculptor, Gibson has his artwork exclusively featured in the New Orleans Musical Legends Park. Life-size bronze statues by Gibson include internationally renowned entertainers Fats Domino, Al Hirt, and Pete Fountain. His work can be found in collections across the United States and abroad.

2. Roy T. Dufreche is owner of Roy T. Dufreche & Associates, LLC, a landscape architectural and planning firm. He completed his landscape architecture degree at LSU in 1984. Dennis Mitchell is a 1989 graduate of the LSU School of Landscape Architecture and currently serves as landscape architect for the LSU campus. He served as project manager for the Centennial Plaza and Memorial Fountain and collaborated on the design and landscape plan.

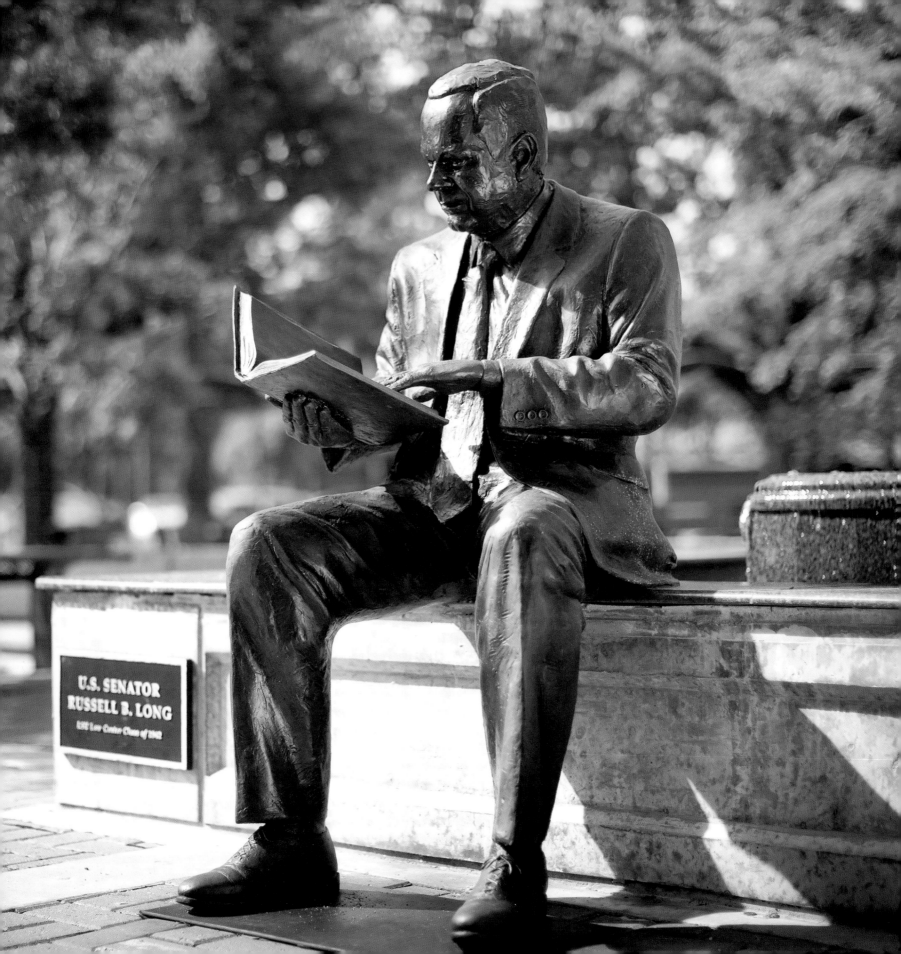

U.S. SENATOR
RUSSELL B. LONG
LSU Law Center Class of 1942

If Walls Could Talk
Allen Hall Murals

Decorating the corridors of Allen Hall are heroic-scale figures of workers industriously turning valves and wielding tools, students conducting research in laboratories, a professor instructing art students, and parents with a small child reclining under a magnolia tree. These are but a few of the many inhabitants of a series of remarkable frescoes celebrating Louisiana lifestyles, activities, and culture painted by art students. These paintings celebrate a Louisiana where Huey Long would have "every man a king."

Four students from the class of 1937—Jean Birkland (1917–), Sue Brown (1917–2008), Roy Henderson (1916–1959), and Anne Woolfolk (1915–1997)—painted their perspectives of the world around them onto the walls in the stairwell and around the northeast end of then recently opened Allen Hall.[1] The medium they used was fresco, the classical technique of painting into wet plaster so that the mural literally becomes part of the surface of the wall. The style they adopted was consistent with that of other muralists of the period; but the themes they chose were uniquely their own. Each student artist celebrated the rich diversity of Louisiana's culture and resources, and together they produced an important body of work almost unique in United States art.

Birkland created a painting within a painting that shows her art professor, Conrad Albrizio (1894–1973), demonstrating a technique to a student. In the same fresco, two observers discuss the content of a completed section of the mural depicting U.S. government experimental farms in action.[2] Brown filled her composition with students engaged in various academic endeavors: listening to a professor, looking up references, performing experiments, examining a specimen under a microscope. Henderson showed a family reclining under a magnolia tree with a montage of Louisiana's natural and industrial resources in the background. Woolfolk took advantage of the oddly shaped space over the windows on the east wall of the building to give perspective to her portrayal of workers packing produce on a farm.

Three of the four—Brown, Henderson, and Woolfolk—continued their studies and completed additional murals as part of their master's theses. These more extensive works develop themes similar to those of the undergraduate murals, but are separated in space and distinctive in style and format.

A fifth student, Ben Watkins (1913–1997), accomplished his only mural in fresco as a graduate student. The political climate of the late 1930s motivated Watkins to use the opportunity to represent his indictment of Hitler and the Fascist ideology raging in Europe at the time. Unfortunately, his efforts were misunderstood, and a year later administrators ordered the removal of his work in the northwest archway facing Hill Memorial Library, believing that he used anti-military imagery.

Woolfolk's mural covers the upper portion of the interior east corridor wall of Allen Hall, a space 66.5 feet long and 5.5 feet high. A series of vignettes depicts the varied activities of the state from the port of New Orleans to the farms of north Louisiana. Color and form unify the scenes, but the unusual proportions of the space invite viewers, who might pause at any point along the corridor, to examine each section independently.

Both Brown's and Henderson's thesis murals were painted over at some point after their creation. The mystery of the missing murals was partially resolved when a project to restore the frescoes was undertaken in 2000–2001 as part of the seventy-fifth anniversary of the present campus.[3] LSU commissioned fresco restorer Cheryl Elise Grenier, an alumna who had been inspired by the murals when she was a student, to clean and repair the visible murals and to search for the hidden ones, known only by the evidence of the artists' theses. Testing revealed that both murals still existed.

Brown's mural, 18.5 feet wide and 14 feet high, is in the northeast portico of Allen Hall. Grenier uncovered it and found it to be in remarkable condition, requiring only minor repairs. It incorporates elements of science and industry along with those of agriculture as background elements, but its most impressive features are the heroic-sized figures, two men, a woman, and a child.

Test patches revealed tantalizing glimpses of Henderson's graduate thesis project, which decorates the stairwell in the west end of Allen Hall. It pays homage to both the arts and the sciences. Recovering this mural, however, will require more than simply uncovering and cleaning

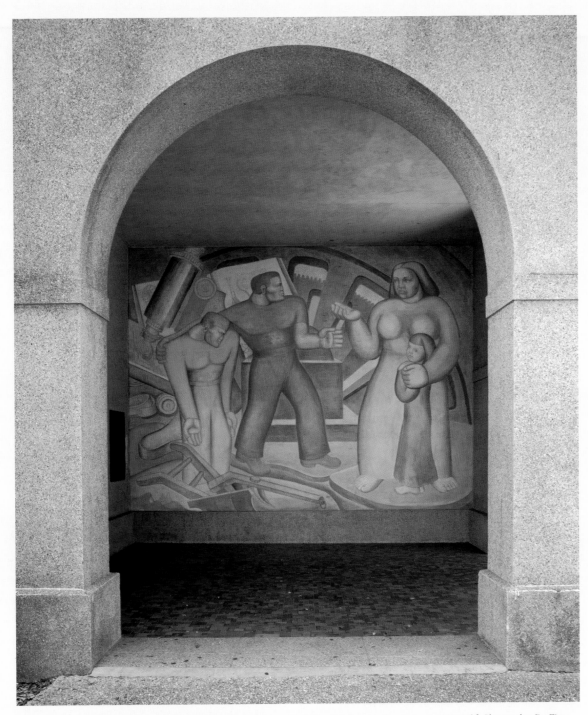

ABOVE: Sue Brown (American, 1917–2008). Fresco mural in the northeast portico of Allen Hall, Louisiana State University. 18.5 x 14 ft. Photographer: Jim Zietz, Office of Communications and University Relations.

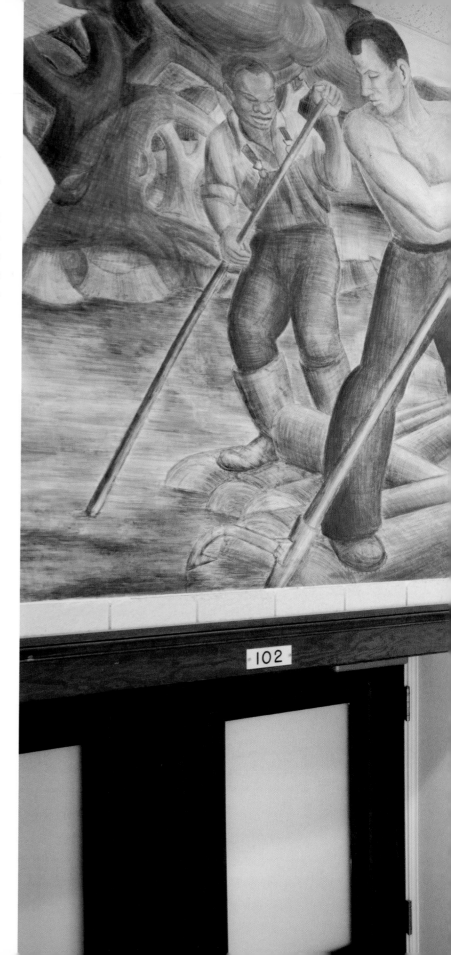

RIGHT: Anne Woolfolk (American, 1915–1997). Fresco mural in the east corridor of Allen Hall, Louisiana State University. 66.5 x 5.5 ft. Photographer: Jim Zietz, Office of Communications and University Relations.

it; such a project must include relocation of the staircase from the second to the third floor of Allen Hall as well as other construction.

Grenier has worked for over twenty years in Italy and the United States restoring frescoes. She has said that those in Allen Hall, while distinctively American in theme and style, rival the best European frescoes in technique and execution. Thus, both the medium chosen for the creation of the murals and the excellence of their realization made the restoration worthwhile.

Almost three-quarters of a century ago, during a time filled with turmoil and anxiety, LSU art students responded to the world around them with enduring expressions of optimism that still inspire their audience.

—ELEANOR BARNETT HOWES

Notes 1. Each of the women who participated in the mural project later married. The names with which their work is signed are used throughout this essay.

2. Albrizio, LSU's first professor of painting, came to LSU in 1935. He was already well established as a muralist and master of fresco.

3. The mural restoration project was directed by Bill Eskew, then facilities director at LSU. Funds for the project were provided by generous donations from Paula G. Manship and Emogene Pliner.

References Brown, Sue Eleanor. "Execution of an Exterior Mural in Fresco." Master's thesis, Louisiana State University, 1940.

Cruse, Douglas M. "The Art of Social Consciousness," *LSU Magazine*, Winter 1990, 40–44.

Dietrich, Sue Eleanor Brown. Personal interview, May 2001.

Grenier, Cheryl Elise. Personal interview, Spring 2001.

Henderson, Roy Buchanan. "Execution of a Mural in Fresco." Master's thesis, Louisiana State University, 1939.

McCandless, Jean Birkland. Personal interview, May 2001.

Watkins, Ben Porter. "Execution of an Exterior Mural in Fresco." Master's thesis, Louisiana State University, 1940.

Woolfolk, Anne. "Execution of a Mural in Fresco." Master's thesis, Louisiana State University, 1940.

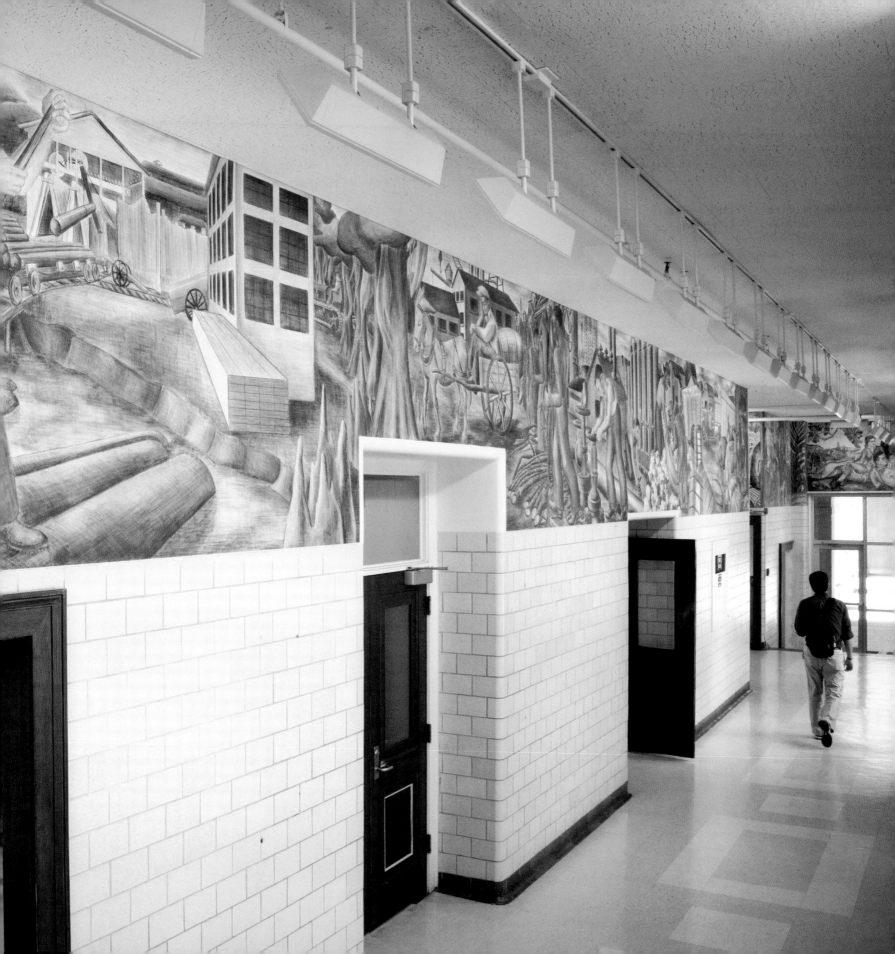

Mistaken Identity

Historic Bronze Cannons

Celebrating the military tradition of the "ole war skule," the two bronze cannons at the LSU Department of Military Science are steeped in southern history and culture. Once convenient equipment to train the LSU cadets, the two 1861 pieces survive today as the subject of an enduring university legend.

The cannons are 3.8-inch James rifles, type 2, series 3, a historically rare breed. Bronze-based missile launchers such as these were quickly dismissed because their delicate tubes could not resist the pressure of firing projectiles. The military briefly engaged the James rifles, type 2, series 3, during combat. Only nine pieces of their kind survive.

Rhode Island militia general Charles T. James (1805–1862) designed the cannons. A self-educated carpenter and mechanic, James quickly became a successful cotton manufacturer. At thirty-three, he received an honorary M.A. degree from Brown University for his contributions to the field. James also served as a Rhode Island senator between 1851 and 1857 and as major general in the state's militia by 1860. Upon his retirement from public life, James worked on the development and promotion of rifle cannons. The Ames Manufacturing Company in Chicopee, Massachusetts, built all James rifles, including the two cannons at LSU.

The LSU cannons' svelte bronze tube is sixty-five inches in length and weighs 928 pounds. According to university legend, reinforced by the plaques decorating the rifles, the two pieces "fired at Fort Sumter and [were] presented to the University by General William T. Sherman after the Civil War."

In reality, historians and experts on Civil War cannons resolutely affirm that the two rifles were not a gift of General Sherman and could not have fired at Fort Sumter.[1] The two James rifles were probably bought by LSU president David F. Boyd (1834–1899) in 1870 or by LSU president James W. Nicholson (1844–1917) in 1890.

ABOVE: Engraving on the rifles referring to their manufacturers. Photographer: Jim Zietz, Office of Communications and University Relations. RIGHT: James rifles, type 2, series 3 (c. 1861). Designed by Rhode Island militia general Charles T. James (1805–1862) and built by the Ames Manufacturing Company, Chicopee, Mass. Located at the door of the LSU Department of Military Science. Photographer: Jim Zietz, Office of Communications and University Relations.

The misconception about the rifles' origin derives from a published report stating that "a friend of LSU" offered the cannons to the school.[2] Boyd always referred to Sherman using this expression, so later generations believed the general donated the two cannons to LSU. But a close inspection of university records suggests otherwise. As for the Fort Sumter story, it reflects a romantic nostalgia about Civil War bravery but could not be accurate. The two cannons had not been manufactured when the Fort Sumter battle took place.

Regardless of their origin, the two James rifles have become part of the university's history. First located at the Deaf, Dumb and Blind Institute, then at the Garrison Grounds in downtown Baton Rouge, the two pieces were eventually placed in front of the Department of Military Science building sometime between 1921 and 1926 and have been there since. Air force and army cadets, who maintain them, proudly recall LSU's military tradition and the valor of its cadets.

—YASMINE DABBOUS

Notes 1. Wayne Stark, Personal communication, April 26, 2002.

2. David F. Boyd was an English professor at LSU when General Sherman served as the university's first president in 1860. When Boyd later served as major in the Confederate "Tiger Brigade," he was captured by the Union army, only to discover that Sherman was one of their generals. The latter recognized him and exchanged him for two federal officers of the same rank.

References "Fourteen-Pounder James Rifle." Gettysburg Artillery Park Web site.

"The Boyd Brothers." *LSU Highlights*, 2004.

Hazlett, James C., Edwin Olmstead, and M. Hume Parks, *Field Artillery Weapons of the Civil War*. Newark, NJ: University of Delaware Press, 2004.

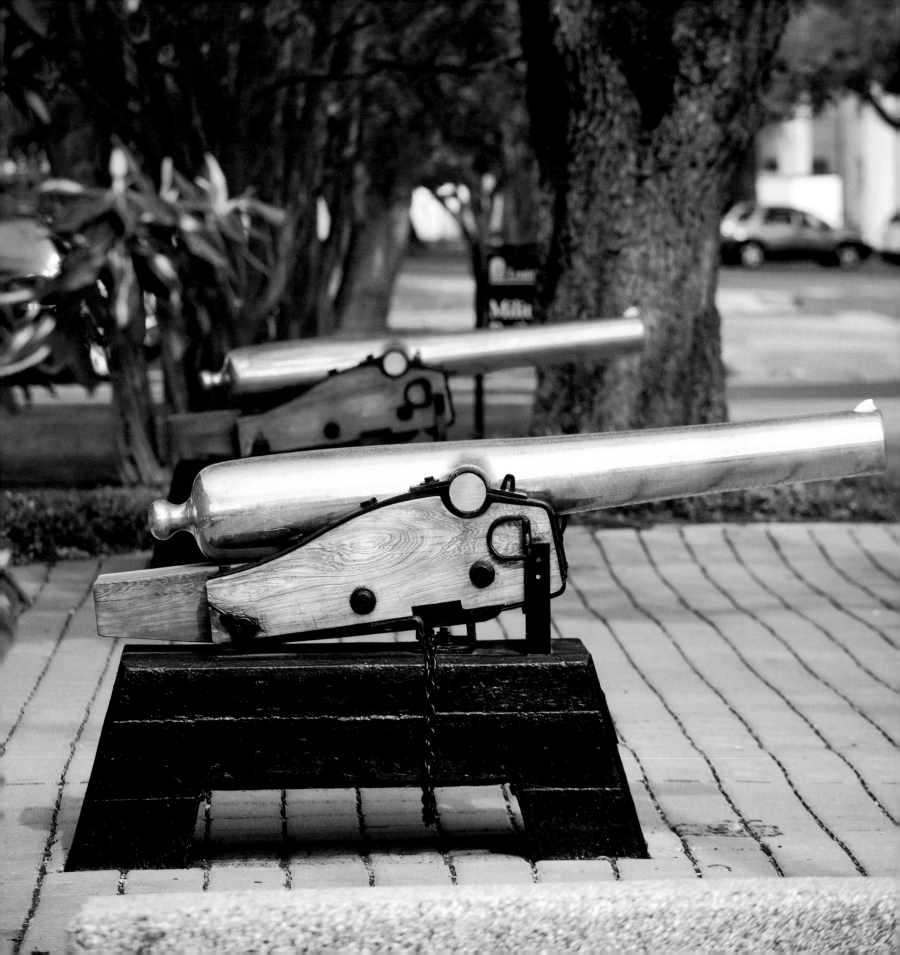

Yes, But . . .

Sculpture by John T. Scott

On the soaring north wall of the Holliday Forum in the Journalism Building hangs a colorful, two-part, cut-aluminum polychrome sculpture titled *Yes, But. . . .* It is a dramatic, whimsical, yet deadly serious work that represents a visual interpretation of freedom of the press and freedom of expression through the creative artistry of John Scott.

John T. Scott (1940–2007) was an African American painter, sculptor, printmaker, and teacher (forty years on the faculty of Xavier University). His highly regarded body of work combined visual metaphors from his ethnic heritage with a creative aesthetic influenced by the rich cultural heritage of his native New Orleans. Scott's unique style and expression of social philosophy earned him great acclaim and many national honors, including the prestigious John D. MacArthur Fellowship in 1992.

Yes, But . . . was executed in 2004, one of a pair of artworks commissioned by and for the LSU School of Mass Communication to enhance the Holliday Forum, a bold, new domed space added to the oldest building on campus during its 2003–2004 renovation. The Forum, reflecting the school's academic focus, was envisioned to be a meeting place for students and faculty from across the campus as well as a venue for engaging public dialogues and thought-provoking lectures, speakers, and panels, many dedicated to the subject of media and their role in society and the interaction of media and public affairs.

To fulfill the LSU commission, Scott studied the Bill of Rights and read historical and contemporary sources relating to the press and its principles. From these, he extracted relevant ideas and concepts, adding them to his own knowledge about the challenges experienced by African Americans and others sometimes beyond the reach of these ideals.

In *Yes, But . . .*, the upper sculpture represents historical context, using images such as a king, the figure of liberty, a printing press, the U.S. Constitution, and more. The lower piece conveys contemporary observation with recognizable images such as a photographer, a talking head, a winged newspaper, and a hip-hop figure. Each section of the sculpture is interwoven with its own images and symbolism while the two parts together create a unified and continuous narrative, a commentary about the strengths and challenges of the freedoms of press and expression.

To explicate the artist's intent, a diagrammatic rendering of the artwork based on Scott's descriptions is available in the Forum. When John Scott came to LSU to hang the work, he commented that "the sculpture hints at ideas," but he hoped that viewers would bring their own experiences to understanding the sculpture, "to imagine what they will." The key to the interaction between viewer and sculpture, Scott said, "is believing what these ideals are about."[1]

On the facing wall, in counterpoint to John Scott's perspective and experience, hangs an installation of twelve brightly colored, interrelated oil paintings on canvas. The work is entitled *Media Kaleidoscope*. The artist, Gia Bugadze, is considered the national artist of the Republic of Georgia and is the director of the Fine Art Academy of Georgia. Bugadze's work expresses a perspective of freedom of the press reflecting the challenges faced by a society in evolving from an ancient culture that was subsumed for many years in communism but has become a newly emergent democracy. Through a style that employs symbolism and magical realism, Bugadze conveys an idealistic interpretation of democratic rights.

"I am telling a story [through the series]," Bugadze explained. "Each piece has a different theme but everything is united [together]."[2] An explication of *Media Kaleidoscope*, in the words of the artist, is also available in the Forum.

—Mary Ann Sternberg

RIGHT: John T. Scott (American, 1940–2007). *Yes, But . . .* (c. 2004). Cut-aluminum polychrome sculpture. Jensen Holliday Forum, Journalism Building. Photographer: Kevin Duffy, Information Technology Services.

Notes 1. John Scott, personal communication, March 2004.

2. Interview with Gia Bugadze, March 25, 2004. Translator: Marina Vashakmadze.

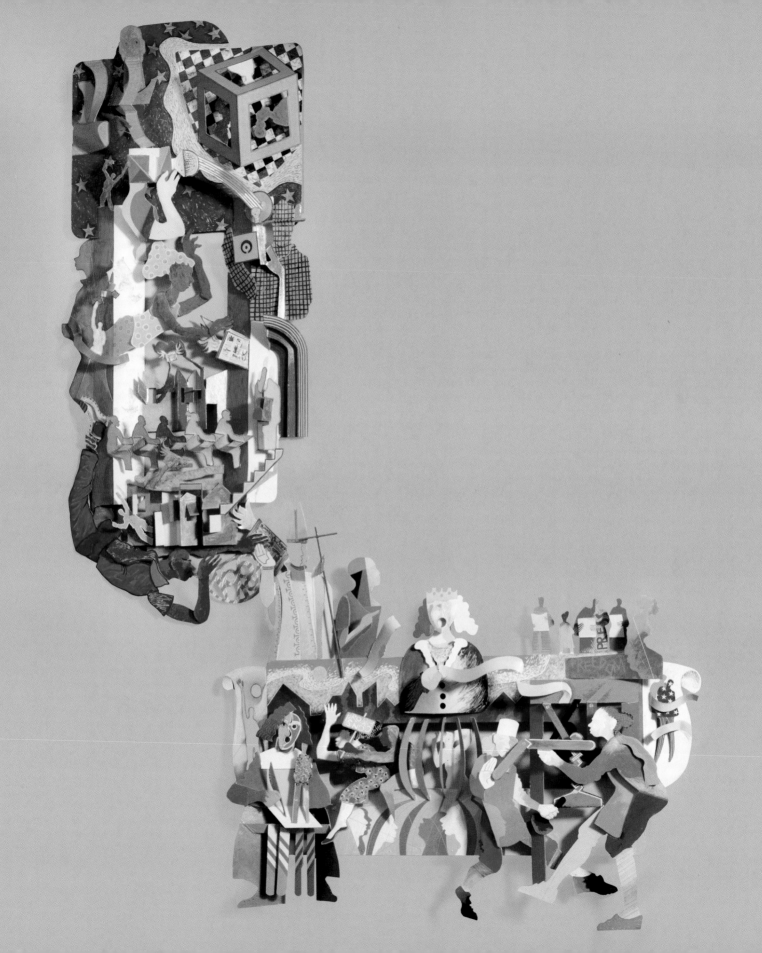

RIGHT: Gia Bugadze (Republic of Georgia, b. 1956). *Media Kaleidoscope* (c. 2004). Jensen Holliday Forum, Journalism Building. Photographer: Kevin Duffy, Information Technology Services.

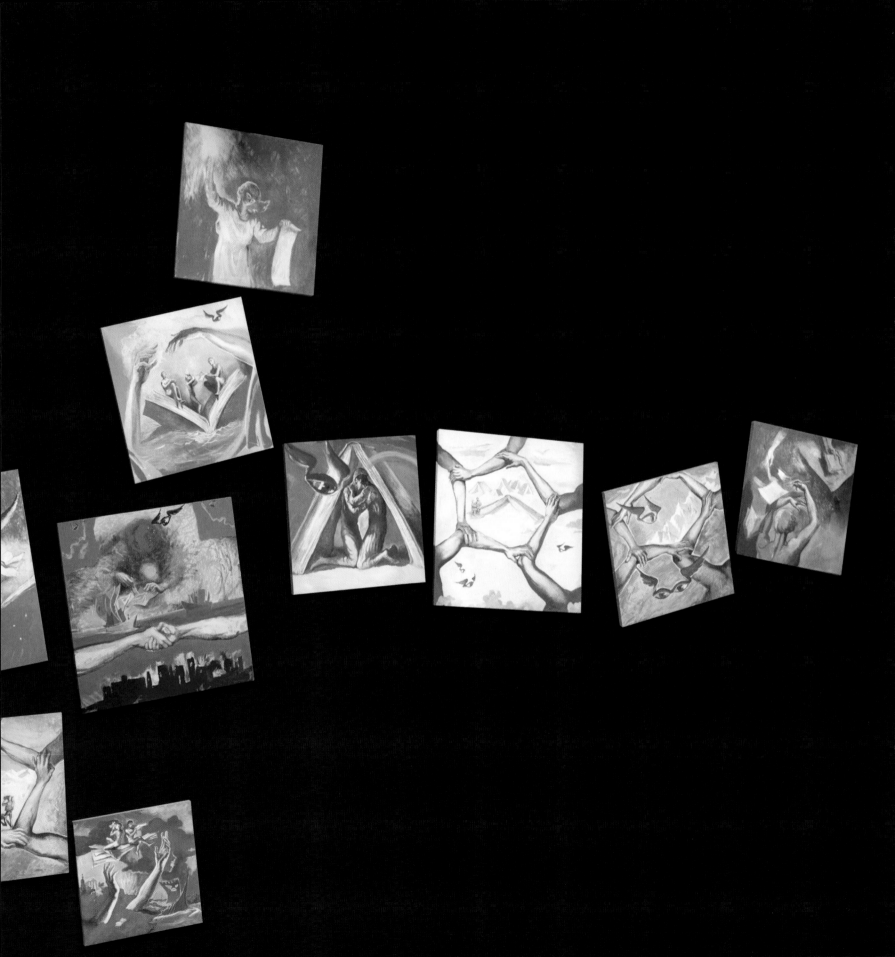

Sweet Discovery
Boré Sugar Kettle

I t works!" This was the phrase uttered by a helper of Jean-Étienne de Boré in 1795 the first time sugarcane was successfully granulated into sugar. This one solitary event revolutionized not only the sugar-manufacturing industry but the Louisiana economy as well. The kettle de Boré used for this experiment currently sits outside the front entrance of the Chemical Engineering Building (Jesse Coates Hall).

Prior to this successful experiment, the main crop in southeastern Louisiana was indigo. In the early 1790s a series of droughts and an influx of a new pest completely devastated the indigo crops and left many near bankruptcy, including de Boré (1742–1820). In an attempt to recover financially, de Boré used all of his remaining funds to purchase and cultivate sugarcane, which until this time had not done well in the state. He then began working on techniques to granulate the cane into sugar. Once de Boré proved his theories and techniques regarding sugar granulation, a new industry was born and Louisiana became its epicenter. To this day, sugar production is a major component of the south Louisiana economy, and the LSU sugar kettle stands as a reminder of the industry's origin.

The kettle's origins are obscure, though it appears to have come from New Orleans in the 1790s. For decades it sat on the estate of de Boré, who died in 1820. Sometime before the start of the Civil War, de Boré's descendants gave the sugar kettle to the state. There it fell into obscurity again. It is rumored that during the war, Gen. Ulysses Grant's brother-in-law used the kettle as part of a distillery. After the war, the kettle fell into the hands of a junk dealer and was sold as scrap metal to John Hill, a West Baton Rouge planter and prominent LSU benefactor.[1] Upon learning of its historical importance, Hill gave the kettle to LSU, where it has resided ever since.

The exact date of this donation is not known, but it is believed to have been made to the university at the old downtown campus by 1894. In an account written by William R. Dodson, William C. Stubbs states that the kettle was on campus when he arrived in 1894. The sugar kettle can be seen in photos taken of the downtown campus. It sat on a small mound of earth in the middle of a row of stately live oak trees. It resided near the entrance to the Chemistry Building and within view of the Pentagon Barracks.

The sugar kettle was probably moved to the current campus upon completion of the Audubon Sugar School. A photo from around 1930 shows the sugar kettle outside of the building. By the 1960s, the kettle sat as it does today on a base of bricks, upside down, in the midst of a small garden. The addition to the Chemical Engineering Building completed in 1970 was, presumably, situated in the kettle's former garden.

In 1972, the Louisiana Tourist Commission named the Jean-Étienne De Boré Sugar Kettle as a state historical marker. Descendants of John Hill, among others, attended the dedication ceremony.

Sam Mims wrote of the sugar kettle that it is a "symbol of tenacity. It is a token, an emblem and a relic." The Jean-Étienne de Boré Sugar Kettle represents a historical breakthrough as well as an industry that played a principal role in creating a unique national program at LSU in sugar engineering.

—MELANIE MONCE McCANDLESS

Note 1. Hill Memorial Library was built with a donation from John Hill, made in honor of his deceased son.
References Mims, Sam. *Trail to a Pot of Gold.* Houma, LA: *Guardian-Journal*, 1967.
 Stacey, Truman. "Etienne de Boré." Southwest Louisiana Historical Association Web site.

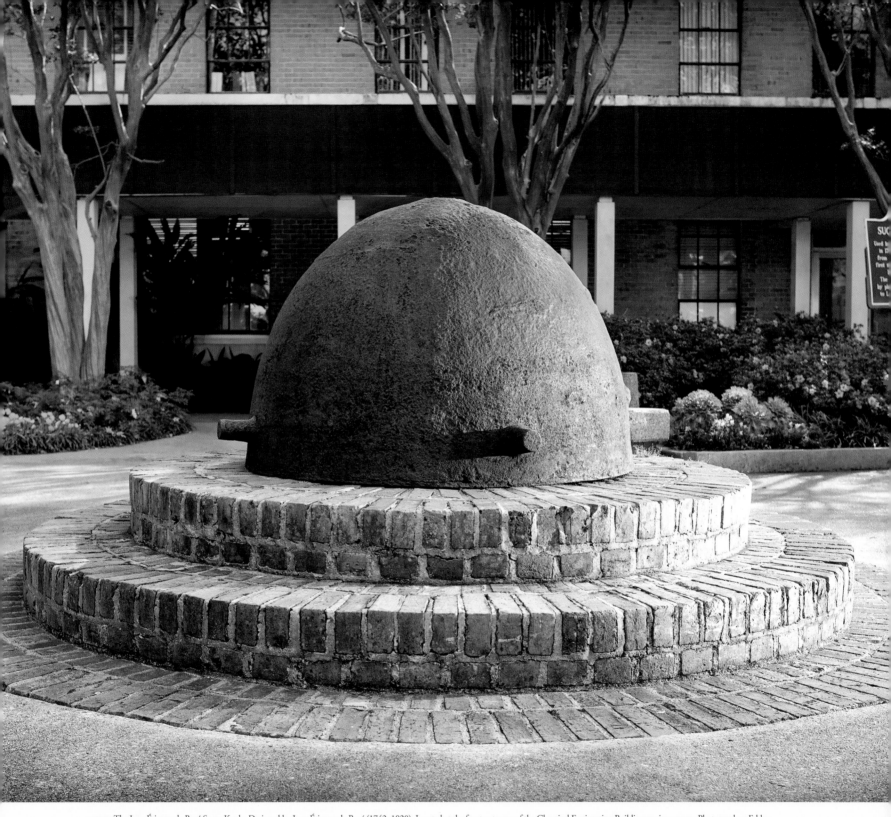

ABOVE: The Jean-Étienne de Boré Sugar Kettle. Designed by Jean-Étienne de Boré (1742–1820). Located at the front entrance of the Chemical Engineering Building, main campus. Photographer: Eddy Perez, Office of Communications and University Relations.

Radiance
Night Sculpture by James Sanborn

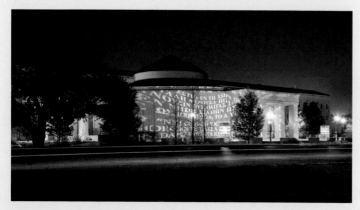

ABOVE: The Energy, Coast & Environment Building as it appears at night from a distance. Photographer: Eddy Perez, Office of Communications and University Relations.

During the day, *Radiance* by James Sanborn may look like a simple bronze cylinder. At night the sculpture comes to life, spiraling words concerning human interaction with the environment across the façade of the LSU Energy, Coast & Environment Building's rotunda terrace. A dazzling script, made entirely of light, addresses the forces of nature and arouses a sense of awe and wonder, transforming the night view into a vision of great beauty.

Radiance consists of bronze circular elements up to eight feet high, placed near the four entryways to the building's rotunda. Water-jet cut passages of text in several languages perforate the bronze pieces, which are illuminated internally and project the text images onto the façade of the building and walkways at night. The passages reflect themes such as exploration, the environment, earth science, plate tectonics, oil, and early inhabitants. The result is a spectacular image, beaming passages about our relationship to this earth and its history.

The Energy, Coast & Environment Building, completed in 2003, benefited from the Louisiana Percent for Art program, a law passed in 1999 mandating that 1 percent of the cost of every state building

costing over two million dollars be spent on art for that building. A committee of building representatives, LSU community members, state planners, and facilities representatives, and the architectural firms Post Architects and Coleman and Associates, selected James Sanborn from among several artists to create the artwork for the Energy, Coast & Environment Building.

An internationally renowned sculptor from Alexandria, Virginia, noted for his work with American stone and related materials, Sanborn has exhibited his work at the High Museum of Art in Atlanta, the Los Angeles County Museum of Art, the Phillips Collection in Washington, D.C., and the Hirshhorn Museum and Sculpture Garden, a part of the Smithsonian Museum. Sanborn was also commissioned to create artwork for the Massachusetts Institute of Technology and the National Oceanic and Atmospheric Administration. His most well known creation is the *Kryptos* sculpture at the Central Intelligence Agency headquarters in Langley, Virginia. Like *Radiance*, many of Sanborn's pieces are based on the interplay of light and encrypted metal. Sanborn received a bachelor of arts degree in paleontology, fine arts, and social anthropology from Randolph-Macon College in Ashland, Virginia, and a master of fine arts degree in sculpture from the Pratt Institute in Brooklyn, New York.

The Energy, Coast & Environment Building is home to the Center for Energy Studies as well as the School of the Coast and Environment. The spacious building dominating the juncture of two main campus arteries, Nicholson Extension and Nicholson Drive, emphasizes the importance of the university's energy, environmental, and coastal programs. Sanborn's piece adds even more depth and meaning, providing a spectacular visual display, one that reflects the missions of the departments housed within the building.

—EMILY TURNER

References "Energy, Coast and Environment Building Achieves 'Radiance.'" *LSU Highlights*, 2008.
"James Sanborn." *NNDB* Web site.

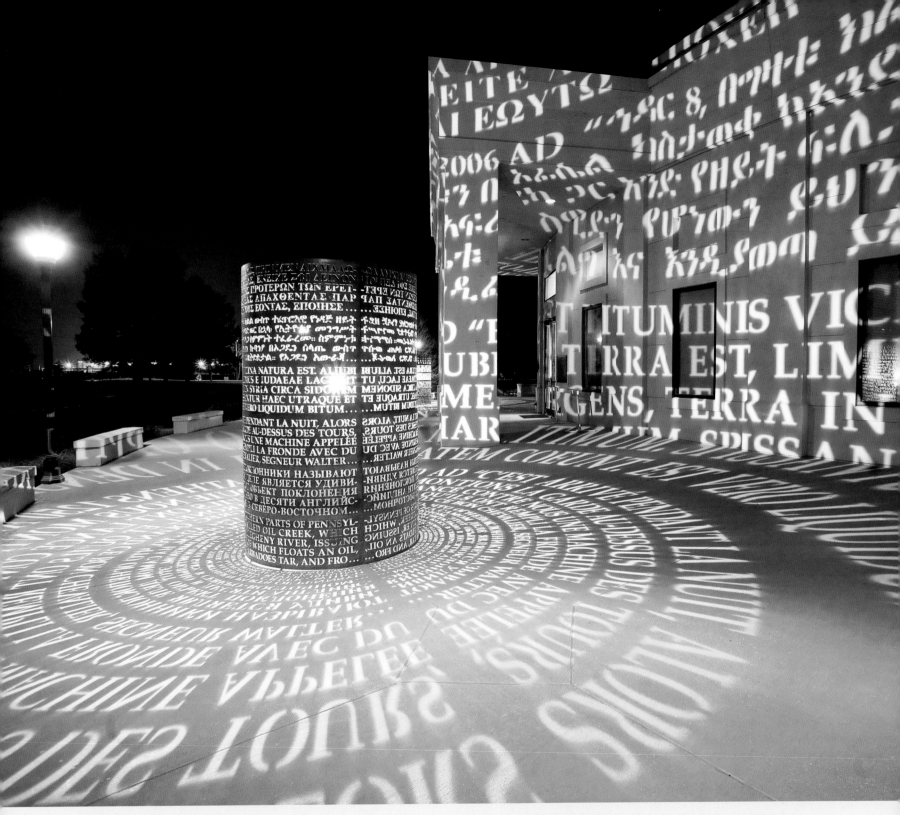

ABOVE: James Sanborn (American, b. 1945). *Radiance* (c. 2008). Internally illuminated eight-foot bronze circular elements. Energy, Coast & Environment Building, main campus. Photographer: Eddy Perez, Office of Communications and University Relations.

Proud Golden Lady

Lyon & Healy Harp

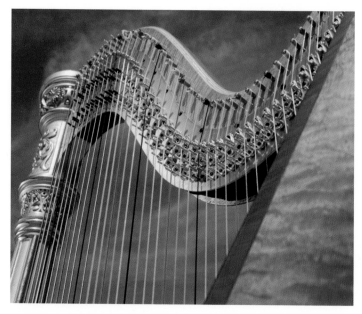

ABOVE: Lyon & Healy harp, Style 23 concert grand (c. 1923). Located at the LSU School of Music. Photographer: Kevin Duffy, Information Technology Services. **RIGHT:** Detail of the ornamentation in the Lyon & Healy harp, Style 23 concert grand. Photographer: Kevin Duffy, Information Technology Services.

Her gold tattered, her crown knocked off, this proud lady still stands tall, thrilling performers and audiences alike after almost seventy-eight years at LSU. And, as in many of the stories about the musical and literary happenings at LSU, Governor Huey P. Long played a role in her history. Acting on his belief that LSU should have the best of everything available to its students, he reportedly purchased two gold Lyon & Healy harps for the School of Music in the 1930s. The first, a semi-grand, has since then broken beyond repair, but the Lyon and Healy Style 23 concert grand remains in use today, almost intact.

Established in 1889 and headquartered in Chicago, Illinois, Lyon & Healy epitomize the highest standard of harp making. The company still manufactures fine harps today, including the Style 23. LSU's harp, manufactured in 1915, documents the evolution of harp making since the beginning of the twentieth century. New harps are taller and heavier, the decorative carving does not have the same detail, and the relatively large distance between the strings of the old Style 23, called "wide-spacing," is not standard today.

Unlike other string instruments whose old age is greatly prized, harps tend to develop structural problems with time. They either become unplayable or are rebuilt, evolving into new instruments with old frames. Because this harp has the original sounding board, it offers a rich and resonant sound and rings loudly enough to easily fill a concert hall. Despite traces of time, it is still an excellent performance instrument for faculty and guest artists. Some of the world's most accomplished harpists have played her strings, including Isabelle Perrin of the Paris Conservatory and Carrol McLaughlin of the University of Arizona.

The harp has also played a role in the studies and personal lives of the students of LSU's School of Music. Bette Vidrene of the class of 1965, in a personal interview, confirmed the Huey P. Long story. She tells how this harp gave her access to her lifelong dream of playing the harp. She was the only harpist at the school at the time, and the administration had to hire a teacher for her. After studying the harp for only a few months, she was placed in the LSU orchestra to play for the opera. It is stories such as this that illustrate how a musical instrument can be much more than just a piece of university equipment, more than a study tool. LSU's Lyon & Healy harp has enriched the lives of the students who have been privileged to touch her strings.

—KIMBERLY HOUSER

Reference Bette Vidrene, personal communication, August 2008.

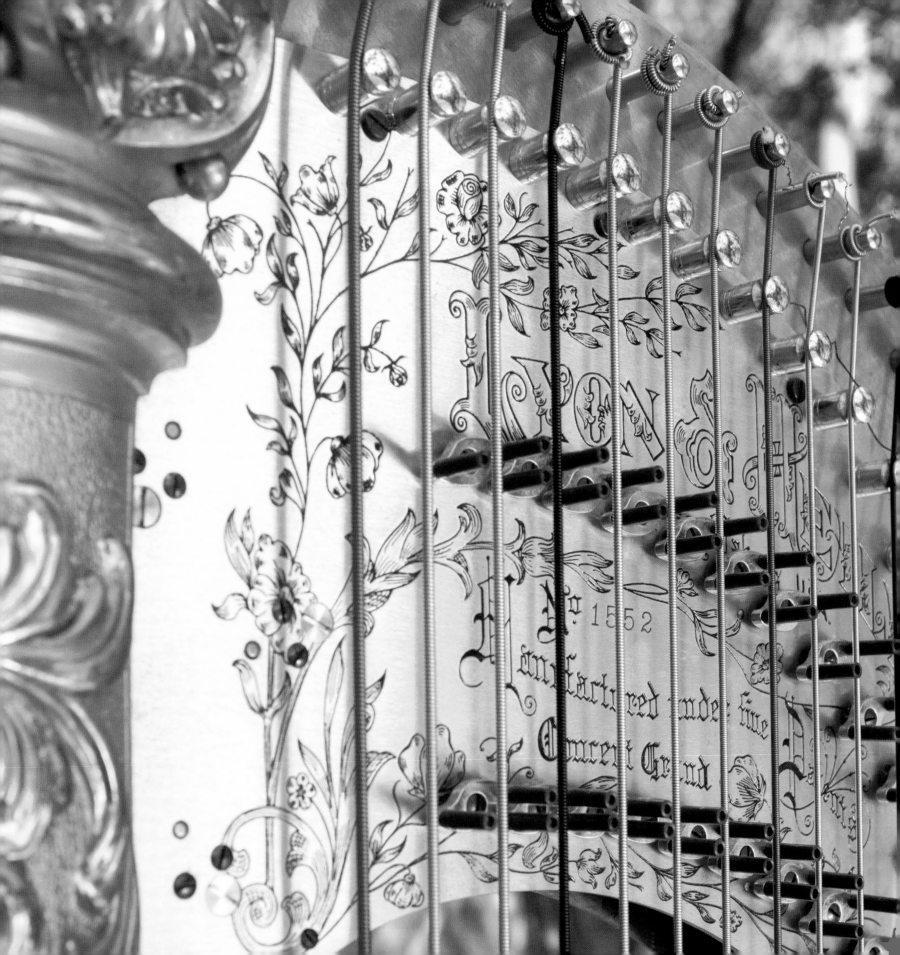

Shimmering Jewels
Stained Glass by Adalié Brent

ABOVE: Detail from the Law Center Stained Glass Panels. Photographer: Kevin Duffy, Information Technology Services.

A wall of glittering, colorful glass has graced LSU's law building for almost four decades, adding a rich, vibrant note to a serious academic environment. Designed by Baton Rouge artist Adalié Brent (1920–1993), the nineteen stained-glass panels form the backdrop of the renovated Paul M. Hebert Law Center student lounge.

Originally located on the ground floor of the 1969 law building, the structure includes two sets of double doors and measures approximately fifty-five feet in width and eight feet, six inches in height. The glass mosaic, crafted in a free-form style, sweeps skyward and fills the full length and height of the wall. The colors, as in all Brent's works, are deep and pure. The doors incorporate a stylized fleur de lis, scales of justice, a law book, and a pelican.

The panels are an example of *dalle de verre*, or "faceted glass." Thick chunks of glass are set into a cast-concrete (or more recently epoxy) matrix, a technique quite different from traditional, leaded stained glass. *Dalle de verre* glass appeared first in the work of Auguste Labouret, a French artist who exhibited a faceted-glass window in the Pavilion of Glass at the Paris Exhibition of 1937.

One of the most famous installations of *dalle de verre*, a stunning wall by Fernand Léger in the Chapel of the Sacred Heart in Audincourt, France, in the early 1950s, began a post–World War II fascination with the new medium. The *dalle de verre* technique does not lend itself to narrative or detail, thus challenging the artist to think conceptually of shimmering color integrated into massive wall forms.

Adalié Brent brought to Baton Rouge the sophistication of the French experiments. Her work characteristically incorporated deep, jewel tones of the chunky faceted glass to maximize the dramatic visual effect of color piercing thick slab walls, an effect wonderfully achieved in the Law Center's panels.

Well known in the Baton Rouge area for her artistic talents as well as her roles as teacher and community leader, Brent received her degree in art education in California, taught at LSU in the early fifties, and continued to share her knowledge and talents as a high school teacher at St. Joseph's Academy. She served as the first director of the Louisiana Arts and Science Center.

Brent was part of the committee that developed the downtown Centroplex (now River Center), governmental buildings, library, and performing arts theater. She received the Mayor-President's Award for Excellence in the Arts in 1989. Her work, including stained glass, paintings, and tapestries, is included in many private, corporate, and public collections. She is widely recognized for her numerous commissioned religious works in places of worship, hospitals, parochial schools, and at the Baton Rouge Catholic Life Center.

Jules F. Landry and his wife, Frances Leggio Landry, both graduates of the LSU Law School, donated the *dalle de verre* structure to their alma mater. The Landrys were pioneering preservationists as well as supporters of the arts in the Baton Rouge community. They practiced law together for more than fifty years in their Landry & Landry law practice. Frances, the only female student at the Law School the year she graduated, was a pioneer for women in the law.

—KAREN M. SONIAT

References Hargrave, W. Lee. *LSU Law: The Louisiana State University Law School from 1906 to 1977*. Baton Rouge: LSU Press, 2004.

Price, Anne. "Jules and Frances Landry: Pioneering Preservationists." *Baton Rouge Sunday Advocate Magazine*, May 31, 1987.

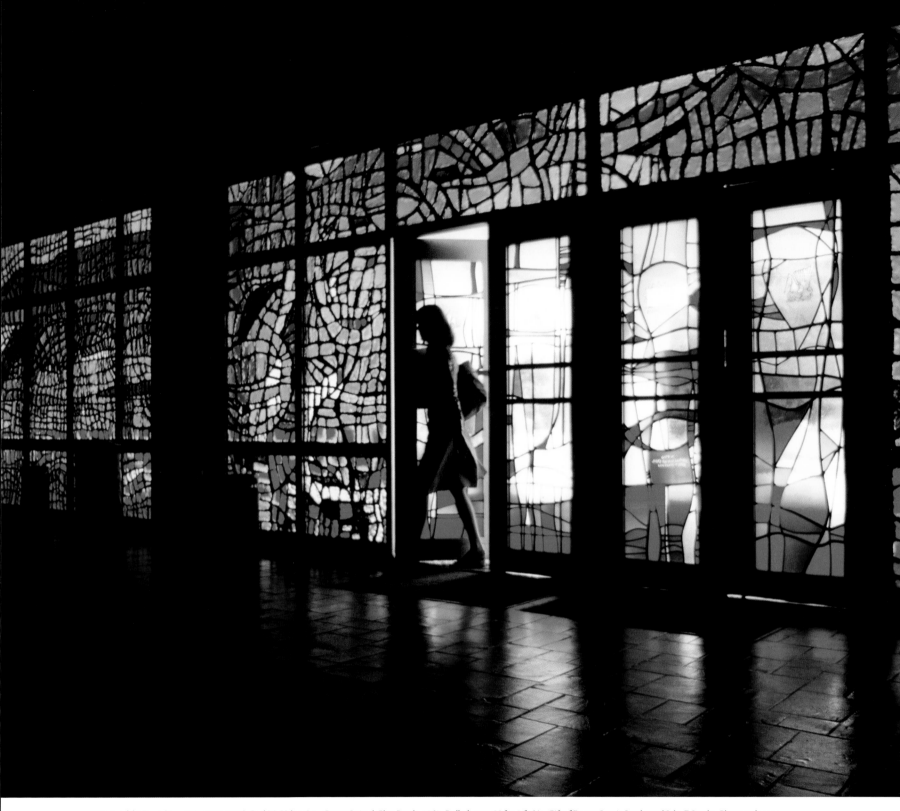

ABOVE: Adalié Brent (American, 1920–1993). Paul M. Hebert Law Center Stained Glass Panels, 1969. *Dalle de verre*. 55 ft x 8 ft 6 in. Gift of Frances Leggio Landry and Jules F. Landry. Photographer unknown. LSU Office of Communications and University Relations.

In Unity Ascending

Sculpture by Frank Hayden

The burden upon me as a sculptor is to some way bring to bear the richness of insight, experience as a human being and a sculptor, and to choose as a forum something significant. . . . I run to the struggle, I run to the torment, I run to the anguish. I run to the work, the labor, everything it takes. All of this to bring about something that didn't exist before, to create.

—Frank Hayden

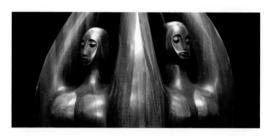

ABOVE: A closer perspective of Hayden's piece. Photographer: Kevin Duffy, Information Technology Services. **RIGHT:** Frank Hayden (American, 1934–1988). *In Unity Ascending* (c. 1975). Laminated mahogany. 5 in. with a circumference of 8 in. Permanent collection, LSU Student Union, Baton Rouge. Photographer: Kevin Duffy, Information Technology Services.

The monumentality and sensuousness of *In Unity Ascending* startle first-time viewers of the work in the LSU Student Union. In this massive sculpture, Frank Hayden (1934–1988) explores feminine sensuality. Composed of four identically carved female shapes, the sculpture demonstrates the artist's admiration of strong, healthy women. Sleek, modern streamlined curves bulge and swell. The figure reminds one of the women found in Peter Paul Rubens' paintings and Gaston Lachaise's sculptures.[1] Behind these smooth surfaces is a feeling of taut energy. In this sculpture, Hayden's aesthetic goals are reflected: simplicity, unity, and order.

Alumnae of the Phi Gamma Chapter of Chi Omega Sorority in 1974 commissioned Hayden to create a sculpture personifying the sorority's nurturing spirit during their past fifty years of service to Louisiana State University. Presented to the university in 1975, the sculpture has become a focal point of the LSU Student Union central lobby.

Born into poverty, Hayden grew up in Memphis, Tennessee. During his youth, his mother instilled in him deep beliefs in the Roman Catholic faith, which permeate many of his works. Hayden began his art training as an undergraduate at Xavier University in New Orleans. He continued his studies at the University of Notre Dame in South Bend, Indiana, where he was a student of the renowned Croatian sculptor Ivan Mestrovic, also noted for his religious sculptures. Hayden spent additional years at the Munich Academy on a Fulbright Fellowship. In 1961, he joined the fine arts faculty at Southern University in Baton Rouge and became the university's first Distinguished Professor

in 1985. He quickly became recognized for his compelling sculptures.

Hayden's works can be seen in churches, synagogues, banks, corporate lobbies, and on university campuses around Louisiana. Some of his public commissions in the Baton Rouge area include *The Red Stick* (1976); *Lift Every Voice* (1979) and *A. W. Mumford* (1984) at Southern University; *Alleluia* (1970); *The Word Was Made Flesh* (n.d.) and *No Greater Love* (n.d.) at the St. Joseph Chapel, Southern University; *We* (1978), *Manna* (1979), and *Mayor Dumas* (1980) at the Theater for Performing Arts; and *Oliver Pollock Monument* (1979) and *Oliver Pollock Fountain* (1979) at the Galvez Plaza, adjacent to the Old State Capitol.

Hayden's choice of themes reveals his strong personal and religious convictions, always with keen and empathetic insight into the human condition. He was a disciple of Constantin Brancusi's "truth to materials" doctrine.[2] His art media included alabaster, marble, cast bronze, and wood. Hayden's respect for his materials and the creative process is seen in his quiet reflection: "My art does not recognize a hierarchy of ideas and materials. It simply saturates existence into a significant form. That form has been achieved through long and difficult reflection or drawing from the possibilities and concerns of the moment. In either case, the prospect of beauty is constant and is all that is needed to guide my hand and heart."

—JUDITH R. STAHL

Notes 1. Peter Paul Rubens (1577–1640) was a prolific Flemish Baroque painter and Gaston Lachaise (1882–1935) a noted French-born American sculptor. Both were famous for their female nudes.

2. Constantin Brancusi (1876–1957) was a renowned Romanian sculptor who encouraged artists to be inspired by their materials rather than to force an image onto them.

Reference Cox, Richard. *Frank Hayden*. Baton Rouge: Baton Rouge Art Gallery, 1996.

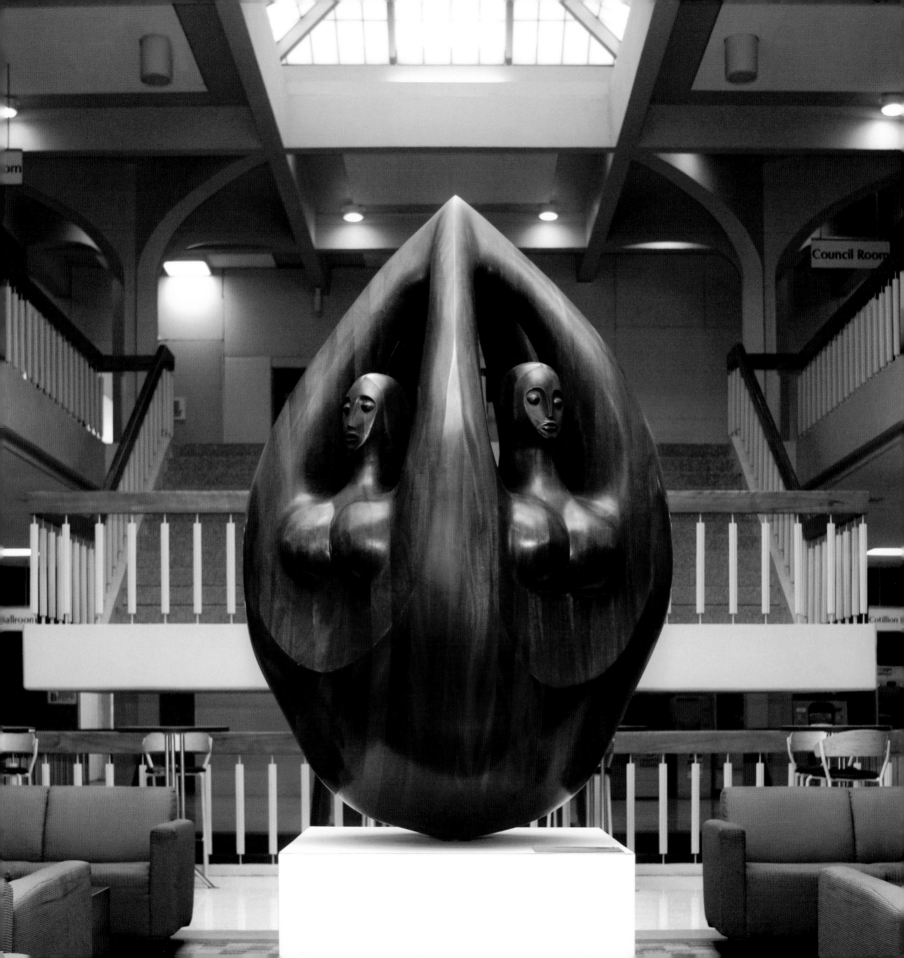

Tiger Lair Mascots
Sculpture by Robert A. Wiggs

Four Tigers, a wood sculpture by the artist and former LSU professor Robert A. Wiggs, might very well be the inaugural image of the tiger for most LSU students. Year after year, thousands of students eagerly begin their freshman orientation under these figures' watchful gaze. For the past several years, the *Four Tigers* have made their home in the LSU Student Union Cotillion Ballroom, where they hover proudly over center stage and preside over incoming students and alumni alike. Originally, however, these iconic visages of the LSU mascot were hung in 1967 in the aptly named Tiger Lair.

A massive and imposing wooden relief sculpture measuring twenty feet long by four feet wide, *Four Tigers* is composed of various individually carved wooden blocks, which are purposefully scattered across a large, clear-heart redwood beam. At first glance, the arrangement may seem incoherent or arbitrary, but after a few moments, four noble faces emerge from the abstract shapes. For Wiggs, the empty spaces or junctures between the shapes are just as significant as the shapes themselves. In this particular piece, the dark wood background is just as fundamental to the work as the sculpted elements affixed to the front. The faces of the *Four Tigers*, and the details of their stripes, eyes, and muzzles, would not be recognizable as such without seeing the spaces in between. This essential relationship between figure and ground, between substance and void, defines the image that we ultimately recognize.

A committee chaired by Professor Don Bruce of the School of Art and Robert Heck, then head of the School of Architecture, commissioned Wiggs to create the sculpture. Wiggs spent much of his academic career investigating the fundamental aspects of shape and form. A native of Illinois, Wiggs studied sculpture at Southern Illinois University and the University of Iowa, where he received his MFA degree. Since 1965, he has served on arts faculties at the University of Kentucky, Louisiana State University, and the University of Louisiana

BELOW: Robert A. Wiggs (American, b. 1922). *Four Tigers* (c. 1967). Wooden relief sculpture. 12 x 3 ft. Permanent collection, LSU Student Union, Baton Rouge. Photographer: Kevin Duffy, Information Technology Services.

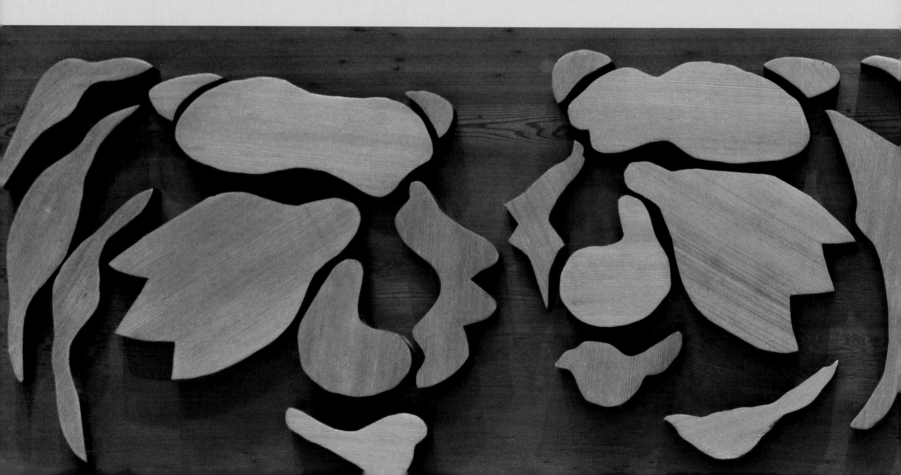

at Lafayette. Wiggs has published a number of articles that document his research in the area of form and polyhedral generation. His seminal article in the publication *Leonardo* detailed his discovery of the "twist octahedron," a polyhedron that could pack indefinitely in such a way that all available space is filled without any gaps. The twist octahedron is the ninth octahedron discovered; five were discovered by the ancient Greeks and the others by Lord Kelvin and Buckminster Fuller. Wiggs's artworks illuminate this research. By studying the inconspicuous shapes and patterns that occur naturally in the world around us, like the complex array of diamonds that make up a pine cone, Wiggs develops new and unique forms that are still intuitively familiar.

Set within the bustling LSU Student Union, *Four Tigers* signifies the intricate and complex relationship between all of us Tigers. We too are defined by the space that surrounds us, whether it is the convivial lobbies of the Student Union or the roaring bleachers in Tiger Stadium. Just like the myriad of uniquely shaped blocks that contribute to the iconic image of *Four Tigers*, each student, faculty, and staff member, every alum, and every LSU Tiger fan relate to one another and to the space around us so as to ultimately sculpt the image of Louisiana State University.

—MICHAEL LONG

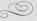

References Wiggs, Robert A. "Lines and Junctions and the Topology of Space." *Leonardo* 20, no. 1 (1987): 65–70.
———. "A Study of Symmetry in Nature and the Generation, Transformation, and Analysis of Polyhedra through the Application of Suture Mechanics." www.wiggspolysutures.com.
Wiggs, Robert and Betty. E-mails to author, September 28, 2008, and October 2, 2008.

Untutored Perspective
Oil Painting by Clementine Hunter

When Clementine Hunter (1886–1988) liked the subjects she painted, she made them disproportionately larger than the rest of the characters in her paintings. When she disliked them, she made them smaller. This perhaps explains why the two altar women in *Baptizing* (c. 1960s) at LSU's Rural Life Museum are significantly taller than the five Baptist ushers standing behind them.

Born to former slaves, Hunter lived most of her life at Melrose plantation near Natchitoches, Louisiana, picking cotton and helping with housework. A self-taught artist, she began painting in 1939 with encouragement from a French literary man living in the art and writing colony at Melrose. Her colorful oil works use the naive style to depict the everyday life of the plantation's black community. Most of the subjects in her more than four thousand works of art were black women.

Hunter did not always have canvas, so she painted on bottles, window shades, glass vases, clay pots, and other media. Her work has been recognized or featured in publications such as *Encyclopaedia Britannica* and *Look* and *Ebony* magazines. In appreciation of her creativity, President Jimmy Carter invited her to the White House and Northwestern State University granted her an honorary doctorate of fine arts in 1986.

The Rural Life Museum has among its holdings over two hundred folk art pieces from the nineteenth and twentieth centuries by other artists such as Albert McKinsey, Colette Heldner, Don Wright, Chris Davis, Allen Crochet, and Francisco Vargas. They represent the creativity of working-class people and provide vivid examples of everyday life in rural Louisiana.

The Rural Life Museum also features an array of paintings and statuettes by Steele Burden, the museum's founder and sponsor. Burden's paintings, sometimes sketched on canvas and sometimes on the wall of the museum's main barn, reflect his personal interpretation of items in the collections. Above the cotton section, for example, Burden hung his four large acrylic paintings featuring scenes of plowing and picking cotton. On the wall above the medicine section, he used a colored pen to depict a doctor in a carriage racing to see a patient. Above the doctor is a stork holding a bundle, suggesting the doctor was on his way to deliver a baby. The Rural Life Museum also owns about 150 clay figurines Burden designed during his ninety-five years. From cockfighting scenes to men sleeping under a tree (with a sign that says "men working"), the figurines illustrate Burden's humorous interpretation of Louisiana rural life.

—DAVID FLOYD AND YASMINE DABBOUS

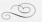

References Blokhuis-Mulder, Jantje. "Clementine Hunter: Louisiana's Most Famous Folk Artist." *Folk Art Life* Web page.

Wilson, James L. *Clementine Hunter: American Folk Artist*. Gretna, LA: Pelican Publishing Co., 1988.

FINE ARTS

"Native Flora" and Other Acquisitions

Magnolia Macrophylla

Watercolor Drawings by Margaret Stones

Bigleaf magnolia, an uncommon tree of the moist, rich woods . . . in central and southeastern Louisiana, is spectacular in having leaves as long as three feet supported in umbrella-like clusters at the branch tips. . . . Creamy white flowers one foot long open in late spring and would hold the undisputed title of our largest native flower, if there were such a designation.

—Lowell Urbatsch, botanical description in
Flora of Louisiana, by Margaret Stones

L ike the plant it portrays, Margaret Stones's watercolor drawing of the *Magnolia macrophylla*, or bigleaf magnolia, is unusual. One of 232 drawings belonging to LSU's Native Flora of Louisiana collection, the bigleaf magnolia is the largest drawing in the collection and the only one with a horizontal format.

Accuracy in depicting the bigleaf magnolia demanded a bold and animated design. The artist did two large working drawings that show her careful planning and placement of the leaves, blossoms, and fruit (added when it matured three months later) as she

ABOVE: Margaret Stones on the Burden property (n.d.). Photographer: Jim Zietz, Office of Communications and University Relations.

worked toward the vivid representation achieved in the final drawing. Reminding us that Stones worked only from living specimens, Irena Zdanowicz noted that the working drawings document "the slight but unmistakable movement of leaves and buds over a short period of time—differences of detail which otherwise could, erroneously, be seen as a case of artistic license."[1] In this truthful rendition, the flamboyant beauty of the tree comes through in one of Stones's most dramatic renderings.

The drawings of the *Magnolia macrophylla* are part of a much larger treasure held for the people of Louisiana by the LSU Libraries. In 1976, LSU chancellor Paul W. Murrill commissioned Margaret Stones to create six watercolor drawings of Louisiana native flora to be a lasting legacy of the university's bicentennial celebration. Encouraged by the enthusiastic response to the project, Murrill enlarged the commission to 200 drawings, which Stones completed by 1991. The collection is unmatched in any other state.

In 1976, Margaret Stones was already a botanical artist of world renown. A native of Australia, she moved to England in 1951, and by 1958 was principal contributing artist to *Curtis's Botanical Magazine*. In 1961, she began work on another major project, the *Endemic Flora of Tasmania*. Working from specimens air-freighted from Tasmania to the Royal Botanic Gardens, Kew, near her home, she created 254 drawings for the highly acclaimed six-volume work with botanical commentary by Dr. Winifred Curtis.

As the Tasmanian project ended, the Louisiana project began. Unlike the tough Tasmanian flora, Louisiana native plants could not survive air shipment. Stones worked only from live plant material, so she began to visit Louisiana regularly. Working in close consultation with Lowell Urbatsch, a member of LSU's botany faculty, she created an unmatched collection of botanical art. She also formed many enduring friendships, as collecting trips took the artist and her hosts on adventures throughout the state.

The project brought together hundreds of Louisianians who volunteered their time and effort, and contributed funding as well. It raised awareness of the state's natural richness and inspired new scientific interest in its flora, leading to the discovery of rare and

TOP: First working drawing for *Magnolia macrophylla*, or bigleaf magnolia (1978). Brown chalk squared for transfer, with pencil on paper (1978). **MIDDLE:** Second working drawing for Magnolia macrophylla (1978). Watercolor and pencil on paper. **BOTTOM:** Finished drawing of Magnolia macrophylla (c. 1978). Watercolor and pencil on paper. Native Flora of Louisiana watercolor drawings by Margaret Stones (Australian, 1920–), E. A. McIlhenny Natural History Collection, LSU Libraries, Baton Rouge. Photographer: Kevin Duffy, Information Technology Services.

endangered species formerly unknown in the state. Drawings from the Native Flora collection—including the dramatic *Magnolia macrophylla*—have been widely exhibited in Louisiana and throughout the world,[2] acting as our state's ambassadors to communicate the beauty and value of Louisiana's natural heritage.

—ELAINE SMYTH

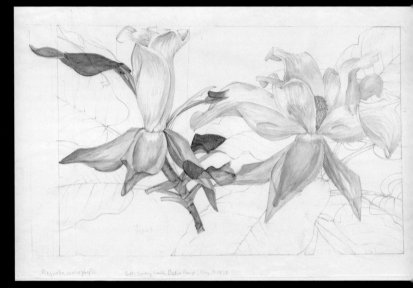

Notes 1. *Beauty in Truth* (Melbourne: National Gallery of Victoria, 1996), 20.

2. Selected drawings from the Native Flora of Louisiana collection have been exhibited at the Smithsonian Institution, Washington, D.C.; the Fitzwilliam Museum, Cambridge; the Ashmolean, Oxford; the Royal Botanic Gardens, Edinburgh; and the National Gallery of Victoria, Melbourne.

References *Beauty in Truth*. Melbourne: National Gallery of Victoria, 1996.

Stones, Margaret. *Flora of Louisiana: Watercolor Drawings*. Baton Rouge: LSU Press, 1991.

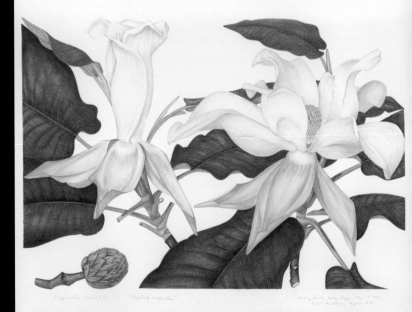

Pillow, Crouching Boy
Jade Carving

Jade is the fairest of stones. It is endowed with five virtues. Charity is typified by its luster, bright yet warm; rectitude by its translucency, revealing the color and markings within; wisdom by the purity and penetrating quality of its note when the stone is struck; courage in that it may be broken but cannot be bent; equity, in that it has sharp angles, which yet injure none.

—Barry Till and Paula Swart, "The Chinese Love of Jade," in *Jade: The Ultimate Treasure of Ancient China*

Intended for use in a bedroom setting, a young, plump boy as a choice of subject matter makes this luminous green jadeite carving's symbolism rather overt. Both beautiful and functional, the jade "pillow" served as a headrest for taking short naps without disturbing the traditional Chinese hair style.

Long considered a magical and mysterious stone, jade has endured through the centuries as the imperial gem. Chinese traditions have espoused a son's responsibilities of obedience to his parents, caring for them in their old age, and continuing the family lineage through the birth of further male heirs. From the Qianlong period (1736–1795) of the Qing Dynasty (1644–1911), jade carvings such as *Pillow, Crouching Boy*, referencing fertility and specifically invoking wishes for many sons, were typical wedding gifts.

Jade carvings can be found in the form of jadeite or nephrite. Available in large quantities, nephrite is a fine-grained, calcium-rich, magnesium, iron, aluminous amphibole commonly used in jewelry. Jadeite, much rarer and more valuable, commonly ranges in color from white to pale apple green and deep jade green; but it can also be blue-green, pink, lavender, and a multitude of other rare colors. Color is largely affected by the presence of trace elements such as chromium and iron. Its translucence can be anywhere from entirely solid through opaque to almost clear. Typically, the most highly valued colors of jadeite are the most intensely green, translucent varieties. Variations in color and translucence are often found even within a single specimen, as in *Pillow, Crouching Boy*.

Featured in the 1915 Burlington Fine Arts Exhibition in London and in the great 1935–1936 Chinese Exhibition in London, *Pillow, Crouching Boy* was donated to the LSU Museum of Art by James R. and Ann A. Peltier. In order to foster a passion for collecting and appreciation of jade carving, the Peltiers have chosen to donate their collection to various institutions, including LSU, making these rare and beautiful forms more accessible to the public.

—Erika Katayama

RIGHT: *Pillow, Crouching Boy*. China, Qianlong period (1736–1795). Jadeite. 8.75 x 5.25 x 11.75 in. Gift of Dr. James R. and Ann A. Peltier. LSU Museum of Art, 2005.5.3. Photographer: Jason R. Peak, Information Technology Services.

References Bernstein, Sam. "Selections from the James R. and Ann A. Peltier Collection: Jades at Louisiana State University Museum of Art." *Arts of Asia* 35, no. 6 (November–December 2005): 94.

McAlear, Donna, ed. *Collecting Passions: Highlights from the LSU Museum of Art Collection*. Baton Rouge: LSU Museum of Art, 2005.

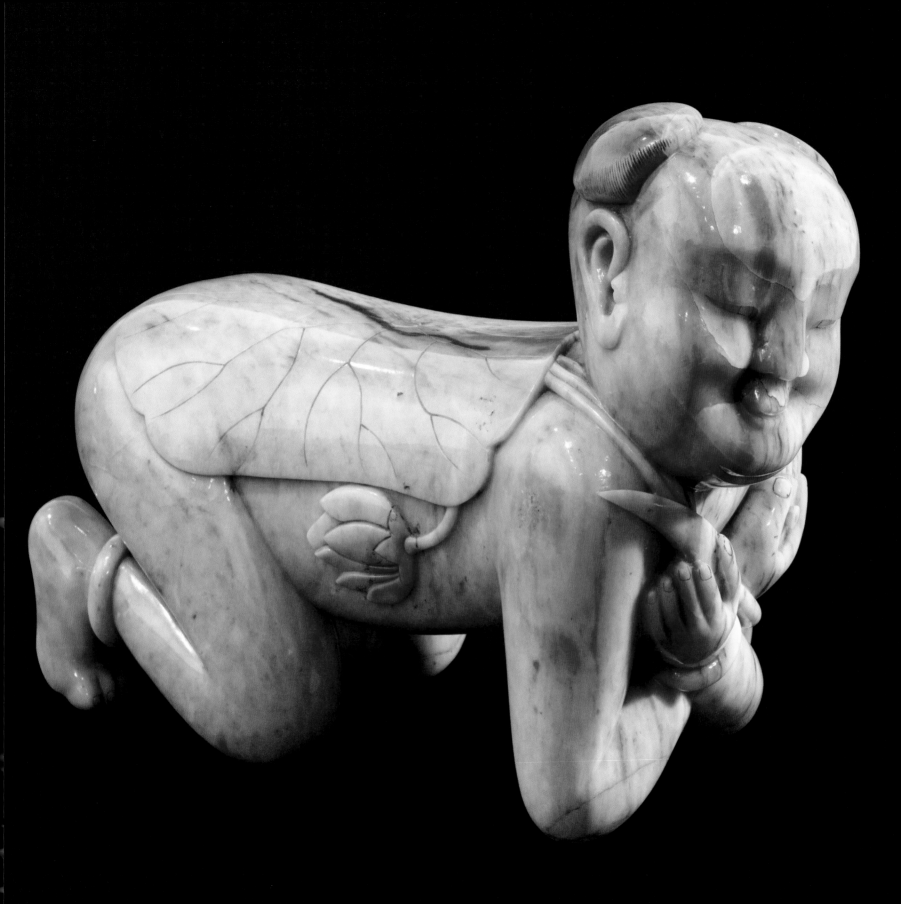

In "Grand Style"
Oil Portrait by Sir Joshua Reynolds

One of the LSU Museum of Art's significant early acquisitions, Sir Joshua Reynolds's *Portrait of Maria Walpole, Countess Waldegrave*, holds a remarkable provenance. Believed to be originally from the collection of the Duke of Cambridge (cousin to England's Queen Victoria), this portrait was one of only a handful of items from the Duke's collection not to be handed down directly to the Queen. Instead it was sold in 1904 to the Duke's niece, with whom it remained until the museum acquired it in the early 1960s. The portrait was displayed at the Royal Academy in London, one of the most significant professional art societies in Europe, shortly after Reynolds was declared the Royal Academy's first president in 1768.

Reynolds (1723–1792) painted the Countess seven times during his artistic career. The museum's painting is thought to be the original portrait from the Countess's first marriage to James, the second earl of Waldegrave (1715–1763). Even though Reynolds's style illustrates his concern for approximating the sitter's likeness, he captured his subjects through idealization, rather than naturalistic replication. In his *Discourses on Art*, a series of lectures presented at the Royal Academy between 1769 and 1790, Reynolds introduced and promoted the "Grand Style." The term refers to an idealized style derived from classical art, and describes paintings that incorporate visual metaphors to suggest nobility.

Reynolds posed Countess Waldegrave (1736–1807) in a calculated manner for this portrait, indicative of the Grand Style. Although the Countess was known for her beauty, at the time of the portrait's creation, rumors spread throughout England about her lack of personality and intelligence. As a way to avoid the Countess's displeasure at his depiction and a way to quiet her critics, Reynolds chose to illustrate her in profile. By doing so, Reynolds avoided the difficult task of trying to reveal Countess Waldegrave's inner character, focusing instead on

enhancing her reputation for beauty and extravagance. He depicted her wearing a luxuriant dress with golden appliquéd designs, full sleeves and plunging neckline, jeweled brooch, and aristocratic turban with a peacock plume.

One of the most influential and prolific eighteenth-century British portrait painters, Reynolds created more than two thousand portraits during his lifetime. His career and style excited and influenced generations of young American artists, including Benjamin West (1738–1820). Reynolds is best known for his mastery of capturing the sitter's age, sex, social or political position, and character. During his artistic career, Reynolds experimented with painting pigments. Over time, many of his portraits lightened and changed colors, resulting in the term "white paintings." The museum's portrait is in excellent condition. Although the Countess's flesh tones have "whitened" or faded over time, the overall coloration of the work is largely original, something quite rare in Reynolds's paintings.

—NATALIE MAULT

RIGHT: Sir Joshua Reynolds (English, 1723–1792). *Portrait of Maria Walpole, Countess Waldegrave* (c. 1760). Oil on canvas. 29.5 x 24 in. Anonymous Donor's Purchase Fund. LSU Museum of Art, 64.1. Photographer: Kevin Duffy, Information Technology Services.

References Gallati, Barbara Dayer. "Anglo-American Portraits." In *Collecting Passions: Highlights from the LSU Museum of Art Collection*, ed. Donna McAlear. Baton Rouge: LSU Museum of Art, 2005. 26–29.

Mannings, David. *Sir Joshua Reynolds: A Complete Catalogue of His Paintings*. London: Paul Mellon Centre, 2000.

Reynolds, Joshua. *Discourses on Art*. Ed. Robert R. Wark. New Haven: Published for the Paul Mellon Centre, London, by Yale University Press, 1997.

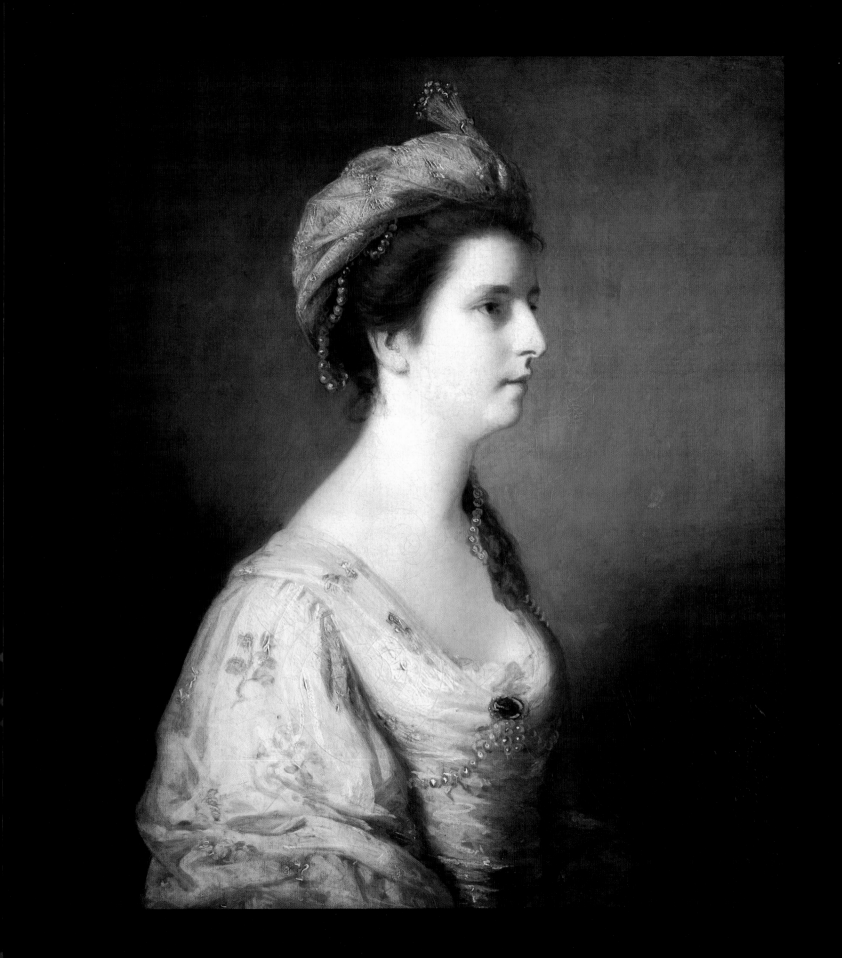

Portrait of a Lady
Oil Painting by William Hogarth

With a growing bourgeois eager for material goods that enhanced the perception of wealth and status, eighteenth-century Britain was a hospitable environment for paintings such as William Hogarth's *Portrait of a Lady*. The identity of the woman in *Portrait of a Lady* is unknown, although art historians speculate that it is the artist's sister, Ann Hogarth. William Hogarth (1697–1764) painted portraits of middle-class subjects, but is best known for his portrayals of British aristocracy. *Portrait of a Lady* exemplifies the type of work he produced that stimulated a new taste for portraiture among the British middle classes and illustrates Hogarth's talent as a portrait artist.

Portraits of nonaristocratic subjects became increasingly popular in eighteenth-century England and provided Hogarth a pragmatic means of supporting his artistic talent. He began his career as an apprentice at sixteen, working with Ellis Gamble, a silver-plate engraver. By 1720, Hogarth had his own business engraving book plates and painting small portraits. Hogarth's artistic method relied on observation of nature, which he reflected in both his philosophy and technique. He painted his subjects in costumes and settings with expressions and gestures that portrayed elevated states of mind and manner. *Portrait of a Lady* is a good example of his technique. In this portrait he highlights the softness of the sitter's ensemble with prim bonnet, strong frontal gaze, and slight curving smile in a half-length portrayal.

Perhaps best known for his satirical prints, Hogarth portrayed middle-class life with wry wit and careful observation. Adept at self-promotion, he fueled his popularity through sales of his prints, which he sold in editions and by subscription. Hogarth became one of the most popular British caricaturists and portrait artists of all time.

—Erika Katayama

RIGHT: William Hogarth (English, 1697–1764). *Portrait of a Lady*, c. 1740. Oil on canvas, 30 x 25 in. Anonymous Donor's Purchase Fund. LSU Museum of Art, 59.2.2. Photographer: Kevin Duffy, Information Technology Services.

Reference McAlear, Donna, ed. *Collecting Passions: Highlights from the LSU Museum of Art Collection.* Baton Rouge: LSU Museum of Art, 2005.

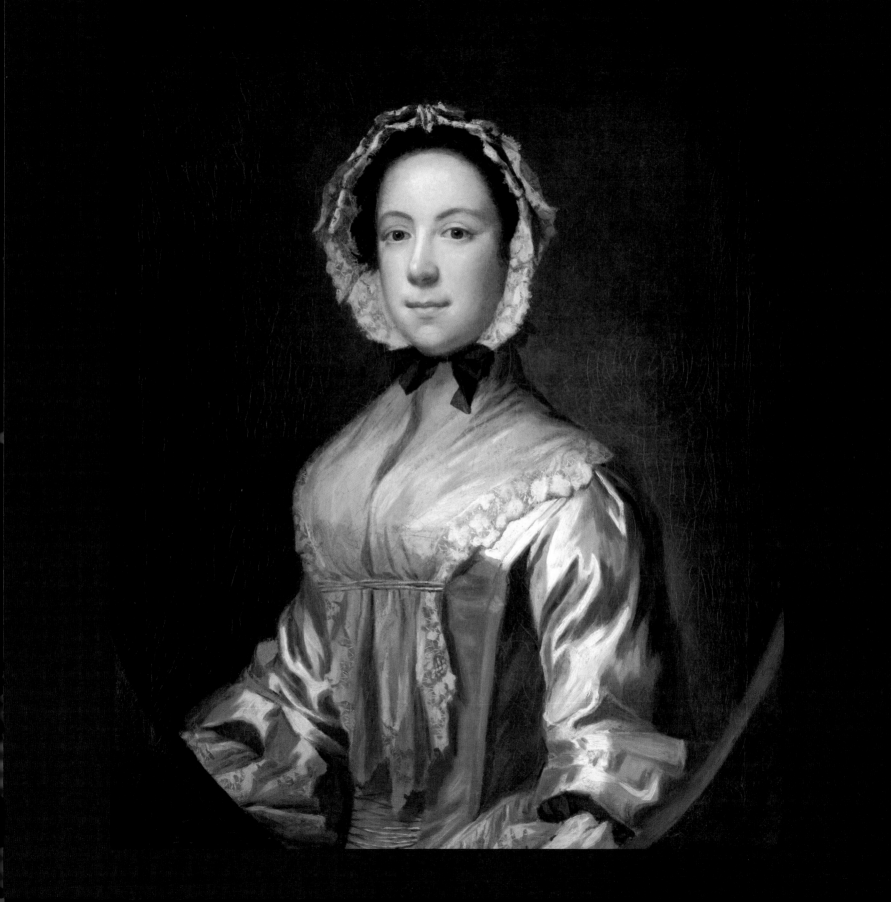

Marriage à la Mode
Engraving by William Hogarth

A human skeleton makes sexual advances to a preserved cadaver; bodiless heads of noblemen sit on display in a doctor's office; and a young woman hides the syphilitic sore on her lip with a handkerchief. With such depictions, William Hogarth portrayed eighteenth-century London, the city, its people, and its politics as a response to what he referred to as "the highest and the lowest of life." Although it was not a pretty place, his world defined a distinct period of British history that continues to intrigue and surprise viewers almost three hundred years after he originally created his works. Except for the costumes and historical elements, Hogarth's commentaries on humanity are not far removed from society today.

Hogarth's work was popular in part because of his talent for composing complex scenes filled with amusing events and realistic details. *Marriage à la Mode* is a moralistic warning that satirizes the notion of an arranged marriage for money. In the series, Hogarth mocks the perceived lives of a wealthy upper-class couple, their friends, and their family by showing them at their worst. In *Marriage à la Mode*, Plate III, pictured here, Hogarth pictures the newly married husband at the establishment of a quack doctor, surrounded by skeletons, heads, mummies, and objects of the occult. Although married, the main character seeks the cure for a venereal disease for himself and his mistress, depicted upset and crying. Also in the scene is the madam of a brothel holding a knife, obviously upset by the doctor's diagnosis.

Hogarth began his career as an apprentice to a silver-plate engraver. Silver-plate engraving is a form of printmaking where a flat silver plate is carved, inked, and stamped to create an image. In 1732, *The Harlot's Progress*, a series of six prints based upon his paintings of the same subject, sold to 1,200 subscribers, sparking Hogarth's popularity. *The Rake's Progress*, a similar series, appeared through subscription sales in 1735, and the series *Marriage à la Mode* debuted in 1745, ensuring Hogarth's status as one of Britain's most popular artists and caricaturists.

—Natalie Mault

RIGHT: William Hogarth (English, 1697–1764). *Marriage à la Mode*. Plate III, 1745. Etched and engraved from a painting. 13 x 17 in. Anonymous Donor's Purchase Fund. LSU Museum of Art, 62.8.60. Photographer: Kevin Duffy, Information Technology Services.

References Gallati, Barbara Dayer. "Anglo-American Portraits." In *Collecting Passions: Highlights from the LSU Museum of Art Collection*, ed. Donna McAlear. Baton Rouge: LSU Museum of Art, 2005. 22–26.
Hallett, Mark. *Hogarth*. London: Phaidon Press, 2000.

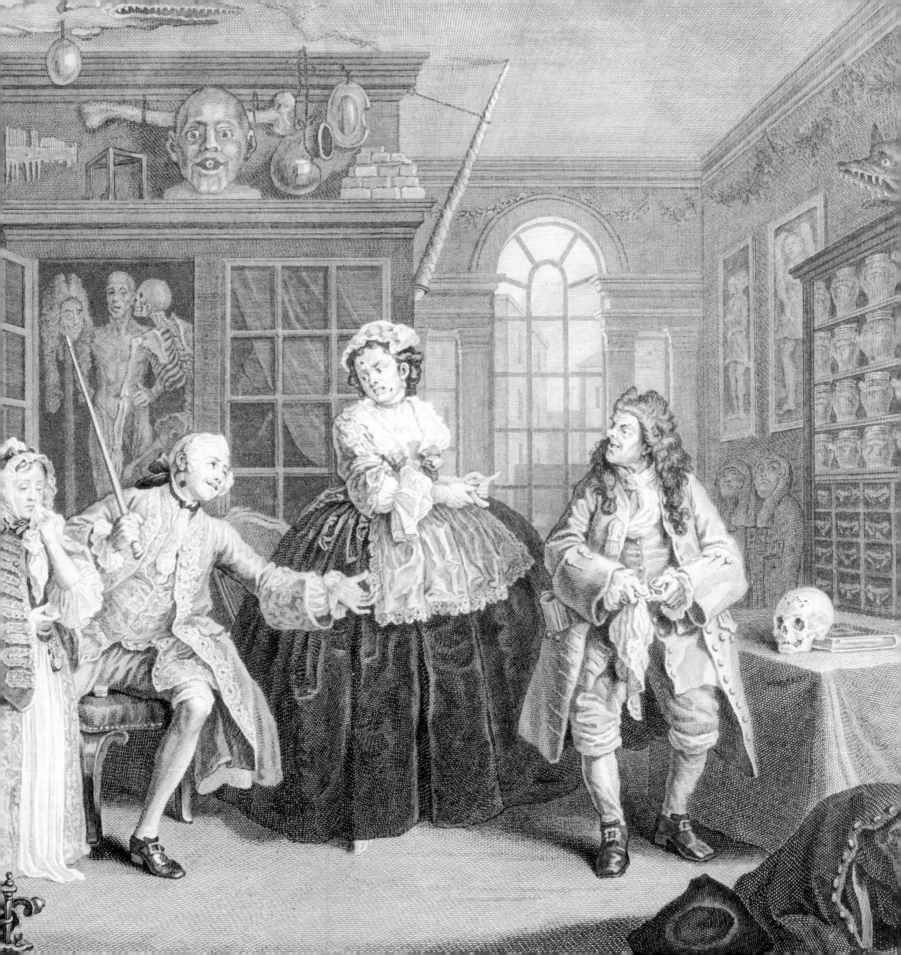

From French Louisiana to Revolutionary Mexico

Portrait of Caroline Durieux by Diego Rivera

Diego Rivera's *Portrait of Caroline Wogan Durieux* not only illustrates the personality of former LSU professor and New Orleans artist Caroline Durieux, but also manages to capture one of the most pivotal moments in Durieux's artistic career: her time in Mexico. Rivera (1886–1957) had very close ties with Durieux and held her in high regard, much to the displeasure of Frida Kahlo (1907–1954), who openly disliked Durieux. The year of Rivera and Kahlo's wedding, and of the publication of Rivera's article about Durieux, Rivera painted the highly idealized *Portrait of Caroline Wogan Durieux* to show his appreciation of the artist.[1]

Rivera was not an artist who depicted his sitters through naturalistic replication. He focused instead on characteristics of each individual's personality and exaggerated specific body parts for expressive effect. Rivera employed an inexactness of proportions in his *Portrait of Caroline Wogan Durieux*, resulting in a remarkable visual impact. In the portrait, Durieux's wide eyes and inquisitive features suggest a childlike bewilderment, a characteristic reminiscent of Rivera's paintings of children. Durieux's delicate, transparent skin and rose cheeks are offset by the dark background. As was common in Rivera's portraits, Durieux's dress suggests her role as well as his views of the sitter. Here, Durieux is in typical Mexican costume, alluding to Rivera's admiration of the artist for her agreement with many of his socialist views.

Diego Rivera is one of the most significant Mexican muralists of the early twentieth century. He combined the styles of modern European art, socialist ideals, and pre-Columbian culture to create mural paintings that expressed a pride in his Mexican heritage. Although Rivera is best known for these murals, his portrait paintings reveal imagery rarely found in his murals, yet analysis of his portraits is often avoided.

In 2000, Paula Garvey Manship donated *Portrait of Caroline Wogan Durieux* to the LSU Museum of Art. The museum owns the most comprehensive collection of Durieux's artwork, and a selection of her personal and professional correspondence is held by Special Collections, LSU Libraries. Among the Special Collections' holdings are four additional portraits and several photographs of Durieux. Manship's gift further enhanced LSU's and the museum's extensive collection of Caroline Durieux by presenting a unique and unusual perspective of the artist through the eyes of an internationally celebrated artist, Diego Rivera.

—Natalie Mault

RIGHT: Diego Rivera (Mexican, 1886–1957). *Portrait of Caroline Wogan Durieux*, 1929. Oil on canvas. 25.25 x 20.9 in. Gift of Mrs. Paula Garvey Manship. LSU Museum of Art, 2000.2. © 2010 Banco de México Diego Rivera Frida Kahlo Museums Trust, Mexico, D. F./Artists Rights Society (ARS). Photographer: Kevin Duffy, Information Technology Services.

Note 1. Diego Rivera, "On the Work of Caroline Durieux," *Mexican Folkways* 5 (1929): 158.

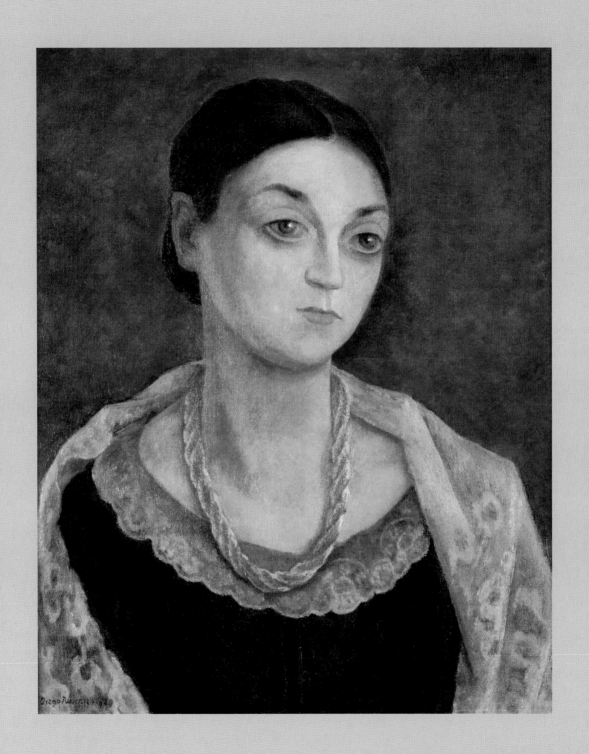

Colette on the Balcony

Oil Painting by Knute Heldner

Combining sorrow with solace, *Colette on the Balcony* by Knute Heldner (1877–1952) provides an intriguing presentation of Heldner's wife, Colette Pope Heldner, also an artist, after the death of one of the Heldners' children. Colette is captured in a poignant moment, perhaps remembering her late son, Sebastian. Sitting lost in thought on a New Orleans balcony, she holds a mirror with a coffee mug near her right hand, her left hand lying across her lap.

The unusual juxtaposition of the Minnesota landscape in the background with the New Orleans foreground depicts a blending of Heldner's dual fondness for the places that permeated his life. Born in Vederslov Smoland, Sweden, he began his formal art training at Karlskrona Technical School and the National Royal Academy of Stockholm. At the age of twelve, Heldner joined the Swedish Royal Navy. In 1902, he immigrated to the Great Lakes region, where he studied art education at the Minneapolis School of Fine Art.

Heldner fell in love with New Orleans and the Louisiana landscape after a visit to the city in 1923. His later work reflected his admiration for this area, and he gained enormous acclaim for his representations of Louisiana bayou scenes. Active in local art communities in both New Orleans and Duluth, Minnesota, he joined the Southern States Art Union in New Orleans and was a charter member of the New Orleans Art League. His first one-man show, hung at the Isaac Delgado Museum of Art in New Orleans in 1926, was instrumental in establishing Louisiana's southern regional art movement. Heldner also taught painting at the New Orleans Art School and was involved in the thriving French Quarter art colony.

A distinctly southern regional character defined Louisiana artists' paintings during the first half of the twentieth century. Although influenced by trends originating from artistic hubs in New York and California, many artists also adopted the South's own distinctive artistic style, influenced by its unique culture, traditions, and environment.

Dr. Mary Lynn Johnson Grant, a specialist in English Romantic poetry who taught at LSU between 1960 and 1962, donated *Colette on the Balcony* to the LSU Museum of Art. Heldner's son Franz was one of her students. Heldner's papers are part of the Special Collections of the LSU Libraries.

—Erika Katayama

RIGHT: Knute Heldner (Swedish-American, 1877–1952). *Colette on the Balcony* (c. 1930). Oil on canvas. 30.25 x 28 in. Gift of Dr. Mary Lynn Johnson Grant. LSU Museum of Art, 2005.1. Photographer: Kevin Duffy, Information Technology Services.

References McAlear, Donna, ed. *Collecting Passions: Highlights from the LSU Museum of Art Collection*. Baton Rouge: LSU Museum of Art, 2005.

Pennington, Estill Curtis. *Downriver: Currents of Style in Louisiana Painting, 1800–1950*. Gretna, LA: Pelican Publishing Co., 1991.

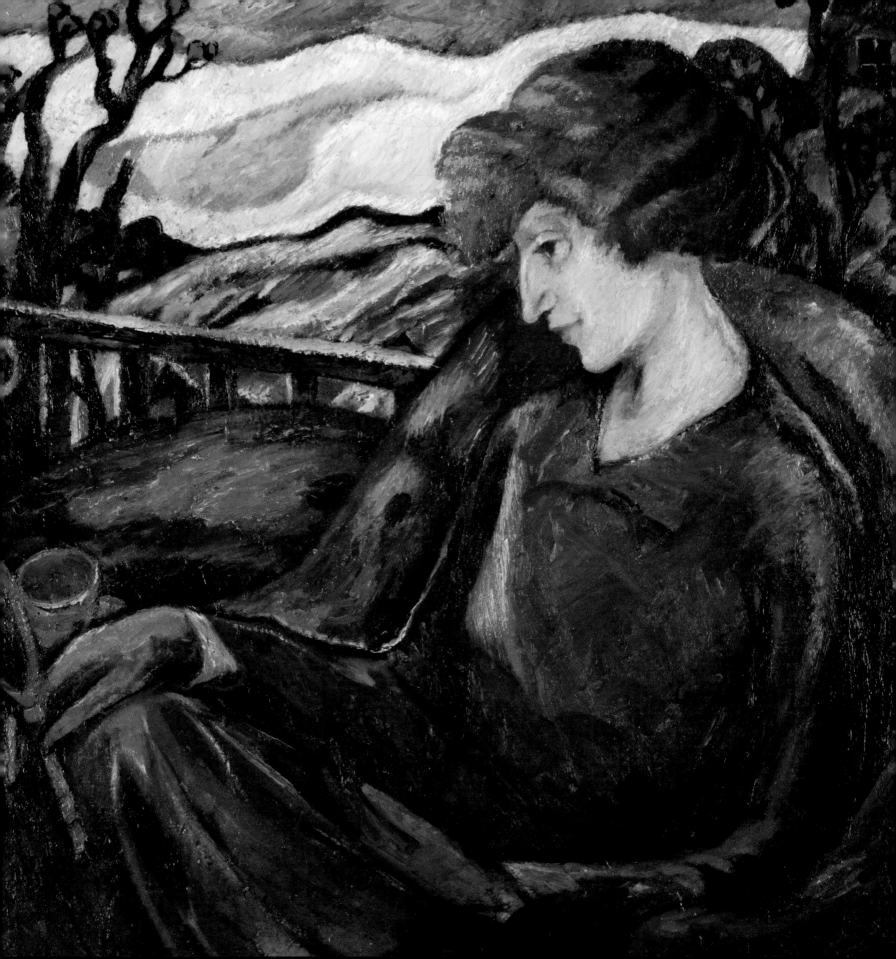

The "Mad Potter of Biloxi"
Vase by George E. Ohr

Considered an eccentric personality, George E. Ohr (1857–1918) called himself the "mad potter of Biloxi." Believing he was the "greatest potter on earth," Ohr produced many highly innovative pottery pieces, including the *Vase* (c. 1890). With a high-glazed brown, blue, and red clay composition in an Art Nouveau style, the *Vase* has a whimsically applied snake decoration, a common motif during this era.

Hailing from Biloxi, Mississippi, Ohr took his inspiration from nature, utilizing clay from the local Tchoutacabouffa River and creating glazes with organic qualities such as earthy colors and tones. Coincidentally, the word "Tchoutacabouffa" means "broken pot" in the native Biloxi tribal language. Ohr liked to experiment with porcelain-thin walls and unusual glazes, features that modern-day potters still admire.

Ohr's training as a potter began at a young age when he was apprenticed to family friend Joseph Meyer, a French immigrant living in New Orleans. Together, the two produced tourist and utilitarian items using indigenous materials and Old World techniques of glazing. Both men later became affiliated with Newcomb Pottery and Crafts, and Ohr adopted a policy of "no two alike" in creating his works. He followed this creed even after returning to his own style of pottery, the Biloxi Art and Novelty Pottery, in 1890.

Ohr's contemporaries criticized him for his unconventional approach toward pottery. He experienced little widespread success during his lifetime, possibly because of his nonconformist attitude and potting style. He was extremely prolific, producing over 10,000 works, although most remained hidden until 1972, when two of Ohr's sons sold a collection of pieces that had been stored in an attic.

The Arts and Crafts movement in the United States was a romantic idealization of craftsmanship and refers to the movement that influenced British and American architecture, decorative arts, cabinet making, graphic design, and crafts, primarily between 1880 and 1910. Ohr was an example of an artist outside traditional Arts and Crafts circles, but who did use local materials, found beauty in the labor of his work, and strived toward innovation within his craft.

The Ohr-O'Keefe Museum of Art in Biloxi has a large permanent collection of Ohr's work. A new museum building for the Ohr-O'Keefe designed by architect Frank Gehry was scheduled to open in July 2006, but sustained heavy damage during Hurricane Katrina. Construction to restore the museum is ongoing.

—Erika Katayama

RIGHT: George E. Ohr (American, 1857–1918), *Vase* (c. 1890). 5.25 x 3.25 in. Clay with high glaze. Gift of the Friends of LSU Museum of Art. LSU Museum of Art, 87.21.2. Photographer: Kevin Duffy, Information Technology Services.

References Clark, Garth, Robert A. Ellison, and Eugene Hecht. *The Mad Potter of Biloxi: The Art and Life of George E. Ohr.* Abbeville, NY: Abbeville Press, 1989.
Ellison, Robert A. *George Ohr, Art Potter: The Apostle of Individuality.* London: Scala Publishers, 2006.

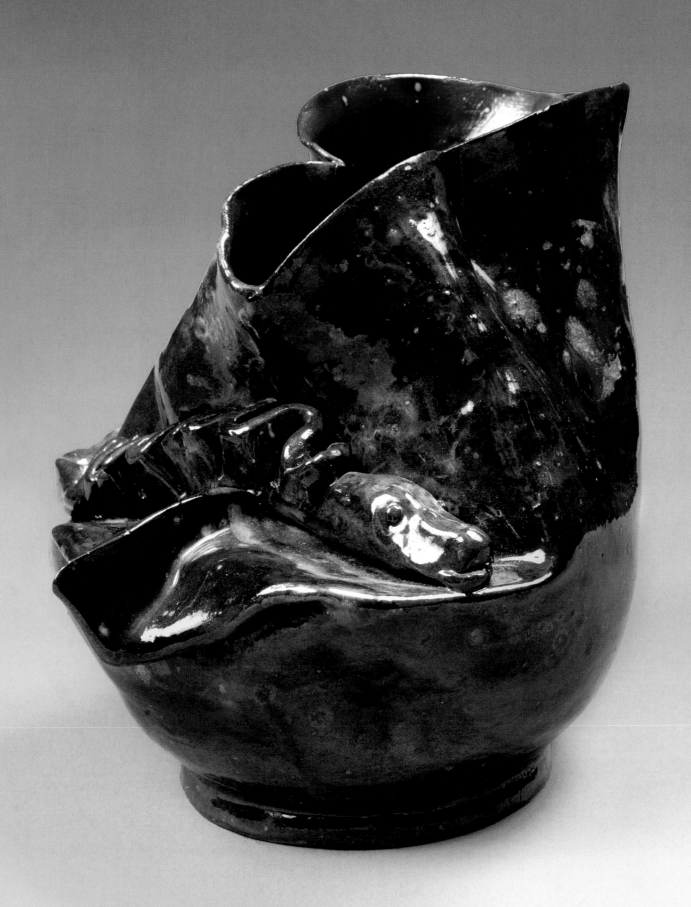

Sheer Whimsy
Shearwater Pottery by Walter Anderson

ABOVE: Detail from *Sitting Cat*. Photographer: Kevin Duffy, Information Technology Services.
RIGHT: Walter Inglis Anderson (American, 1903–1965). *Sitting Cat* (c. 1948). High-glaze ceramic. 11.625 x 12.5 x 5.25 in. Gift of Mrs. Nina Nichols Pugh. LSU Museum of Art, 97.4. Photographer: Kevin Duffy, Information Technology Services.

Sheer whimsy animates Walter Inglis Anderson's (1903–1965) *Sitting Cat*, a seemingly surprising expression from a reclusive Mississippi artist. Among a series of resting, sitting, geometric, and rounded ceramic cats Anderson designed at Shearwater Pottery, *Sitting Cat* reveals the artist's early preference for stylized decoration and his unique talent for capturing movement and animal behavior.

Best known for his vibrant watercolor paintings, pottery, and sculpture, and passionate depictions of Gulf Coast nature and animals, Anderson is distinctive among the Shearwater potters.[1] Anderson commonly carved and painted whimsical and colorful decoration, inspired by children's books, mythology, and the Gulf Coast environment, onto his pottery. Anderson later wrote and illustrated *Robinson: The Pleasant History of an Unusual Cat*, a story about a stray cat transformed by a saucer of magical milk into a musical prodigy who performs at Carnegie Hall. The illustrated cat in the story has swirl, half-circle, and zigzag patterns similar to those of the regally posed ceramic *Sitting Cat* from the LSU Museum of Art collection.

Nina Nichols Pugh purchased *Sitting Cat* directly from the artist around 1948 and gave it to the LSU Museum of Art in 1997. About the same time, Anderson, who had been diagnosed with mental illness, embarked on a private and solitary life. He left his family and lived alone at the Shearwater complex. He often traveled in a small boat to uninhabited Horn Island along the Mississippi Gulf Coast. Anderson's simple lifestyle included a minimal amount of necessities and his art supplies. He endured harsh weather conditions and braved everything from hurricanes to freezing rains. All the while, he painted and drew the island's vegetation, animals, birds, and insects. His eccentric obsession resulted in evocative, unique works of art.

In 2005, Hurricane Katrina destroyed twelve of Shearwater Pottery's fifteen buildings, along with the collection of pottery housed on the twenty-four-acre site. Although Shearwater has rebuilt since the hurricane, many of the pottery's original molds were destroyed, making Walter Anderson's *Sitting Cat* even more rare and precious.

—NATALIE MAULT

Note 1. Peter Anderson (1902–1984), Walter's older brother, established the Shearwater Pottery in 1928, almost thirty-five years after the founding of the Arts and Crafts–based Newcomb Pottery in New Orleans. Peter's mother, a graduate of Newcomb College, introduced Peter to the American Arts and Crafts movement and the art program teachings of Newcomb, which became a strong inspiration for the founding of Shearwater Pottery.

References Anderson, Walter. *Robinson: The Pleasant History of an Unusual Cat*. Jackson, MS: University Press of Mississippi, 1945.

Pickard, Mary Anderson, and Patricia Pinson. *Form and Fantasy: The Block Prints of Walter Anderson*. Jackson, MS: University Press of Mississippi, 2007.

Pinson, Patricia, ed. *The Art of Walter Anderson*. Jackson, MS: University Press of Mississippi, 2003.

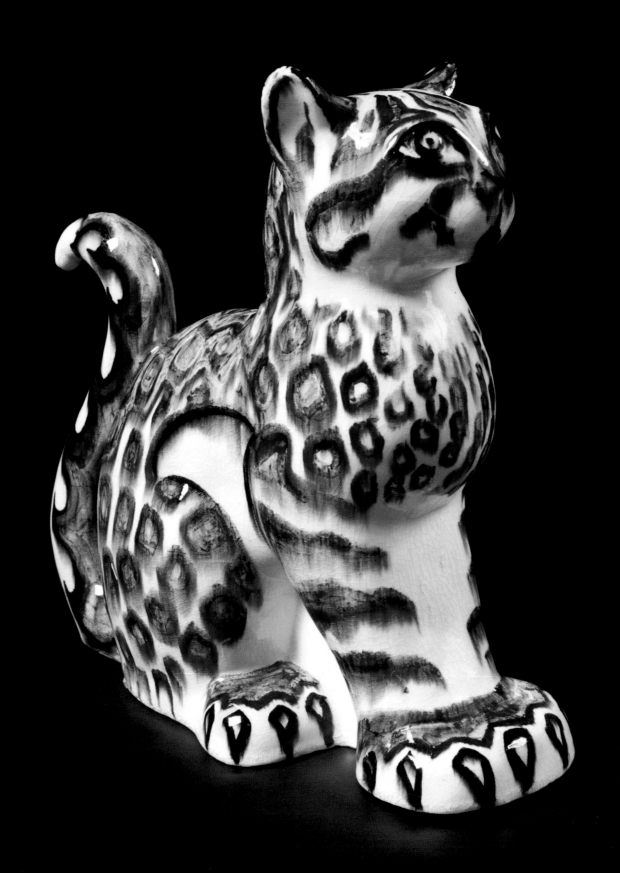

Behind the Scenes

Photograph of Muhammad Ali by Yousuf Karsh

Muhammad Ali taunted George Foreman before their October 30, 1974, Zaire boxing match with the statement, "Now you see me, now you don't"—fitting words, even in reference to photographer Yousuf Karsh's portrait of Muhammad Ali.[1] Known for his ability to capture the essence of his sitters, Karsh found himself challenged by Ali, who presented himself to Karsh as the person he wanted others to see, rather than the person he was beyond the public arena.

Yousuf Karsh (1908–2002) photographed three-time world professional heavyweight champion Muhammad Ali in 1970 as part of a series of young people for Look magazine. Karsh captured Ali wearing a tailored, pinstriped suit, with his hands on his hips and a serious expression on his face. Karsh often lit his subject's hands separately, believing that they were an integral part of a person's character. Here, this technique brings a secondary focal point to the photograph.

Throughout the session, Karsh and Ali talked, but Karsh felt that there was no real connection. Karsh believed that his purpose as a photographer was to use the camera to portray the famous "both as they appeared to me and as they impressed themselves on their generation,"[2] but Karsh thought that the portrait captured only the iconic persona Ali wished to portray. His portrait of Ali was one of his least favorite because the suit that Ali selected, to command the respect Ali felt he deserved, did not reflect the real Ali. Ali later reaffirmed Karsh's notion when he stated, "During my boxing career, you did not see the real Muhammad Ali. . . .The outgoing and spontaneous person that the world knew while I was boxing was a persona that I created to sell tickets and promote my career."[3]

During a career of more than sixty years, Karsh held 15,312 sittings and produced over 150,000 negatives. He is recognized as one of the greatest portrait photographers in the history of photography because his images successfully captured the character of prominent men and women who shaped the twentieth century. His subjects included politicians, artists, musicians, writers, sports figures, academicians, and international leaders and are among the most reproduced and recognizable images of these famous individuals.

Karsh was born in Turkish Armenia in 1908. Shortly thereafter his family fled to Syria to escape war. In 1924, Karsh immigrated to Canada to live and work with his uncle George Nakash, a photographer in Quebec. Recognizing his talent, Nakash sent Karsh to Boston in 1928 to study with John H. Garo, one of the top portrait photographers in the United States. His exposure to the powerful and famous in Garo's studio and the paintings of the old masters in the Boston museums left a lasting impression on Karsh. He returned to Canada in 1932 and built a photography studio in Ottawa. He began photographing Canadian dignitaries in 1936 and cemented his reputation in 1941 when he photographed British prime minister Winston Churchill. In 1945, Karsh's "Sir Winston Churchill" appeared on the cover of Life magazine. Today, "Sir Winston Churchill" is said to be the most reproduced photographic portrait in history.

In 2005, LSU alumni Dr. William Richard Smith and his wife, Judith Ann Smith, gave the LSU Museum of Art a portfolio of photographic portraits by Karsh. In addition to the Churchill portrait mentioned above, the portfolio includes Albert Einstein, Helen Keller, Jacques Cousteau, Ernest Hemingway, Pablo Picasso, Edward Steichen, Jean Sibelius, George Bernard Shaw, Georgia O'Keeffe, Joan Miro, and Albert Schweitzer, as well as the one of Muhammad Ali.

—Natalie Mault

RIGHT: Yousuf Karsh (Canadian, b. Armenia, 1908–2002). *Muhammad Ali*, 1970, printed 1983. Gelatin silver print 69/100. 24 x 20 in. Gift of William Richard and Judith Ann Smith. LSU Museum of Art, 2005.4.1.1. Photographer: Kevin Duffy, Information Technology Services.

Notes 1. The quotation is taken from Thomas Hauser, *Muhammad Ali: His Life and Times* (New York: Simon & Schuster, 1991), 269.

2. Yousuf Karsh, *Faces of Destiny: Portraits by Karsh* (Chicago: Ziff-Davis Publishing Co., 1946), 6.

3. Muhammad Ali with Hana Yasmeen Ali, *The Soul of a Butterfly: Reflections on Life's Journey* (New York: Simon & Schuster, 2004), xv, 70.

References "Karsh of Ottawa!" *2007 International Art Treasures Web Magazine*, February 2007.

"Life and Times: Canada's Premiere Biography Series." *Canadian Broadcasting*, July 2002.

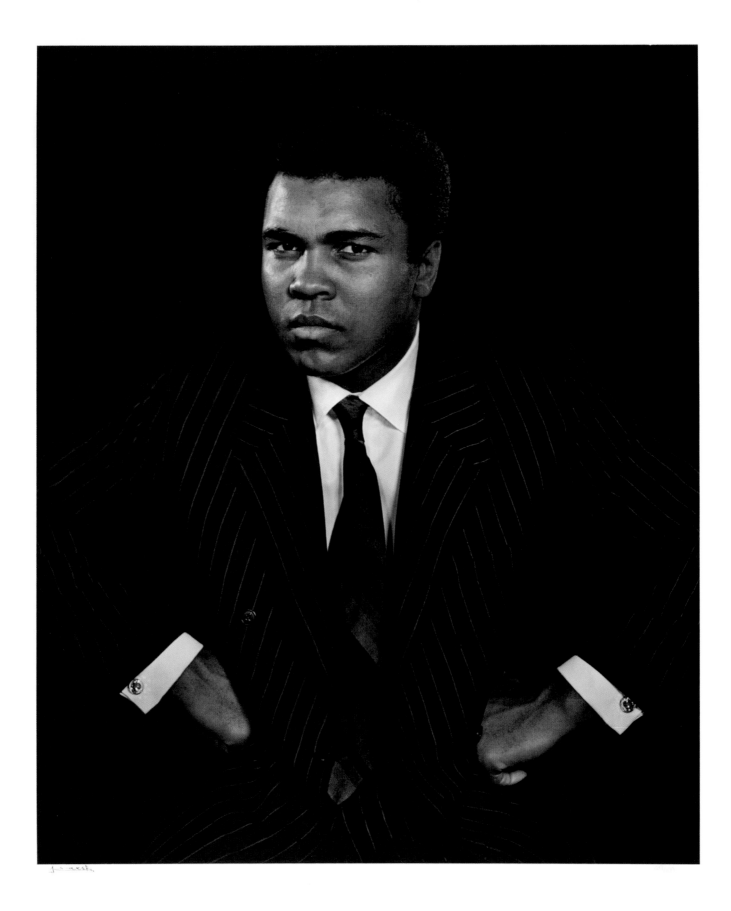

The Mind of the Artist
Studies for the New Orleans Union Passenger Terminal by Conrad Albrizio

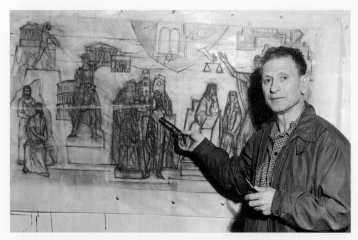

When the New Orleans Union Passenger Terminal opened in 1954, it replaced five depots scattered throughout the city. Massive frescoes approximately eight by sixty feet, representing almost four hundred years of Louisiana history, graced its walls. Painstakingly created by former LSU School of Art professor Conrad Albrizio (1874–1973) and his assistant, James Fisher, the frescoes illustrate forces that shaped Louisiana's progress.[1] In 2005, the LSU Museum of Art purchased twenty-two sketches that reconstruct the intense process Albrizio used to design the New Orleans Union Passenger Terminal murals. They offer a glimpse into fresco painting, an artistic method rarely seen (since very few artists' sketches survive), and provide an explanation for the murals' subjects.

Albrizio's sketches reveal his dilemma in deciding which historic events to include and how to group them, finally settling on the *Age of Exploration, Age of Colonization, Age of Struggle,* and the *Modern Age.* Many of the sketches have been so worked and reworked that the events are unidentifiable. For example, the *Age of Exploration* sketches would be impossible to identify without the central image: a figure of an Indian whose outstretched arms radiate the sun's rays. In the *Age of Colonization,* Albrizio emphasized Louisiana's strong links to the Mississippi River and the Gulf of Mexico. The blue areas, representing water, wind throughout the image, pictorially separating historical events such as the Louisiana Purchase and the Great New Orleans Fire of 1788. The *Age of Struggle* depicts the Spanish possession of Louisiana, the French revolt, the slave revolt, and the establishment of the College of Orleans (Louisiana's first institution of higher learning, opened in 1811), scenes identifiable only through Albrizio's hand-written notes. Albrizio intended the *Modern Age* to illustrate three aspects of man: the material, the spiritual, and the creative. It begins with the struggles of the aftermath of the Civil War and ends with symbols of industry and atomic power. Emphasizing the sciences, the most dominant image is the nuclear symbol of an atom skewered by an arrow.

The drawings conceptualize the final images that Albrizio intended to capture on the walls of the passenger terminal, and document the evolution of his ideas as they took form through color, shape, design, and arrangement. From these studies, he sketched the plan on the walls, and then applied pigments to wet plaster. Once the plaster hardened, the murals became part of the walls.[2] Over time, the changes in temperature and humidity, settling of the structure, and the addition of dust and grime necessitated the restoration of the murals. Many of Albrizio's frescoes in the Louisiana State Capitol, his first big commission from Governor Huey P. Long, do not exist today because of the failure to conserve them in the mid-1950s and because of new trends and preservation interests. In the case of the passenger terminal, both Albrizio's studies and his final work can be viewed, making this treasure an invaluable research tool for art students and patrons.

Born and trained as an architect in New York City, Albrizio moved to New Orleans in 1921. He took up painting, returned to New York, and traveled to Paris and Rome, where he studied fresco painting. From 1935 until his retirement in 1954, he taught art at LSU, returning to New York in 1943 for a sabbatical. He was awarded the Rosenwald Fellowship to continue his work on easel painting, which led to a one-man exhibition in 1946 at the Passedoit Gallery in New York. A major contributor to public art in the South,

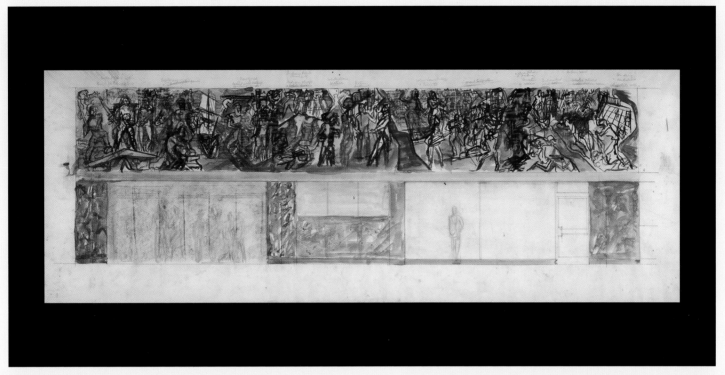

Albrizio produced work for many Louisiana buildings, including the Supreme Court Building in New Orleans, the Louisiana State Capitol Annex, B'nai Israel Synagogue in Baton Rouge, the post office in DeRidder, the courthouse in Gretna, the City National Bank in Houma, and the Exposition Building at the State Fairgrounds in Shreveport. Among his works located outside of Louisiana and supported by the Works Projects Administration (WPA) are murals in the Waterman Steamship Company building, Mobile, Alabama; the lobby of the University of South Alabama Medical Center; the Mobile County Courthouse; and Pomona College in Claremont, California. Albrizio died in Baton Rouge in 1973.

—NATALIE MAULT

Notes 1. The Louisiana Historical Photographs collection at the State Library in Baton Rouge has a black-and-white photograph depicting Albrizio and Fisher painting a mural in the New Orleans Union Passenger Terminal, c. 1954.

 2. Vincent F. Kubly, who documented the work of the former professor of art history at LSU, includes a section on Albrizio's murals in the State Capitol. Originally published in 1977, his findings are based on interviews, reviews of newspaper articles, and old photos.

References Kheel, Claudia. "Louisiana Art in the Early to Mid-Twentieth Century." In *Collecting Passions: Highlights from the LSU Museum of Art Collection*, ed. Donna McAlear. Baton Rouge: LSU Museum of Art, 2005. 58–60.

 Kubly, Vincent F. *The Louisiana Capitol: Its Art and Architecture*. Gretna, LA: Pelican Publishing Co., 1995.

 Duplechain, Josh. "LSU Artist Leaves Behind Large Body of Work." *LSU Highlights*, 2005.

Café Tupinamba
Oil Painting by Caroline Durieux

Since she has lived among us, she has developed a close spiritual rapport with the country and simultaneously there grown in her a painter's mature power of expression. Not only does her painting show her love of . . . the beauty of the peasants . . . but she has also seen our mongrel, perverted, and deformed bourgeoisie, with the clear eye of a Mexican mountaineer, and yet with all the urbanity, the culture, and the occidental sophistication which are Caroline's.

—Diego Rivera, "On the Work of Caroline Durieux"

One of Caroline Wogan Durieux's (1896–1989) few oil paintings, *Café Tupinamba* (1934) depicts, in all of their absurdities, four well-dressed Mexican businessmen, sitting, drinking, and smoking at Café Tupinamba, a favorite gathering spot for Mexico City's journalists, politicians, actors, bookies, bullfighters, and the general elite. In this unique artwork, Durieux expresses her satirical disdain for four members of the upper class, while humorously exposing the habits and customs of the Mexican wealthy as a whole. Durieux stylized and exaggerated a common, everyday gathering to enhance the absurdity of the situation and the characters. The oversized figures dominating the scene and the exaggerated facial features of the four businessmen give the overall image a bizarre quality. This satirical presentation evokes laughter from the viewer—laughter that "springs from contempt of a thing we hate and fear."[1]

The LSU Museum of Art also owns a preliminary drawing for this painting, making *Café Tupinamba* that much more of a treasure. Although an elaborate explanation is not needed in order to appreciate Durieux's social criticism, *Café Tupinamba* is best understood through a comparison of the original sketch to the final painting. These comparisons reveal differences between the four businessmen who are the main subjects in the foreground and the figures at the bar in the background. In the painting, the figures at the bar have been diminished to place emphasis on the businessmen and their enhanced, piglike features. As a result of these changes, the painting makes a greater satirical comment on the individuals' personalities and a stronger statement about the Mexican elite.

Of Creole descent, Durieux grew up in the French Quarter of New Orleans. In 1926, she moved to Mexico City with her husband, Pierre Durieux, the Latin American corporate representative of General Motors, and remained there until 1936. In Mexico, she met the artists Diego Rivera (1886–1957) and Frida Kahlo (1907–1954). Upon her meeting with Rivera, Durieux knew that she would follow her desire to be an artist. Owing in part to his encouragement, Durieux developed the exaggerated, socially conscious, satirical style for which she is best known. Her experiences with the working-class poor and the Mexican and American privileged inspired her, and her observations are reflected in many of the artworks she created while in Mexico City, including *Café Tupinamba*.

In 1936, Durieux returned to the United States. She taught at Newcomb College until 1943, when she was hired by LSU as an instructor in painting and drawing, eventually receiving her M.F.A. in 1949. Well recognized as a painter and printmaker, she founded the printmaking program at LSU. Her research there resulted in a new printmaking process involving radioactive ink, which she named electron printing. This process earned Durieux widespread acclaim. She taught as a professor at LSU until 1963.

The LSU Museum of Art owns the most comprehensive collection of artwork by Durieux, including 80 electron prints, 146 additional prints, and 9 works on paper. Although Durieux produced many prints, her oil paintings on canvas, like *Café Tupinamba*, are extremely rare, with less than a dozen made during her career.

—Natalie Mault

Note 1. Caroline Durieux, "An Inquiry into the Nature of Satire: Twenty-four Satirical Lithographs" (master's thesis, Louisiana State University, 1949), 25.

Reference Kheel, Claudia. "Louisiana Art in the Early to Mid-Twentieth Century." In *Collecting Passions: Highlights from the LSU Museum of Art Collection*, ed. Donna McAlear. Baton Rouge: LSU Museum of Art, 2005. 60–61.

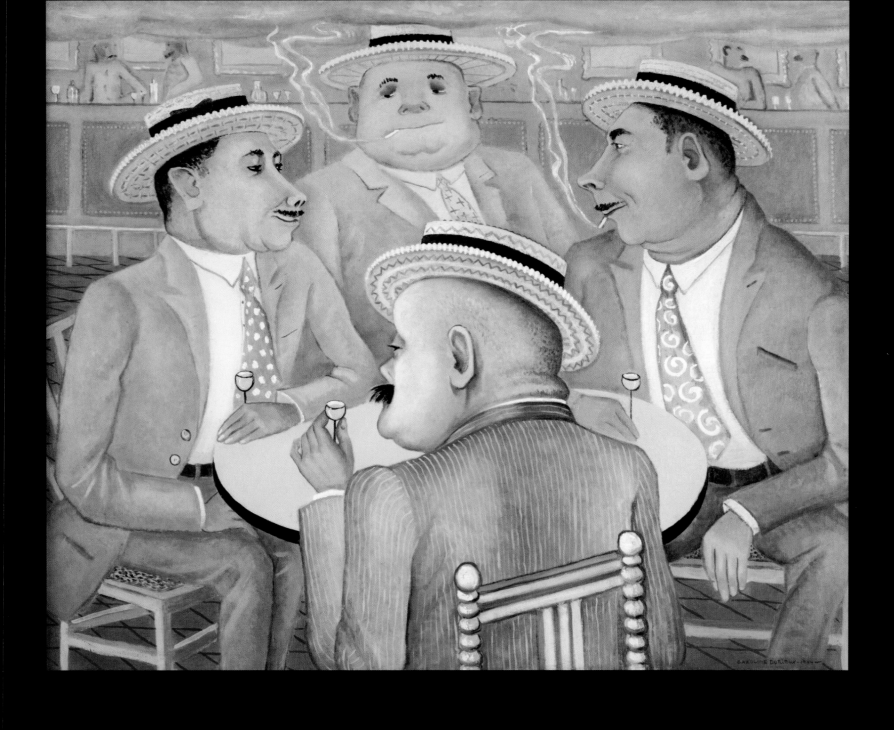

Pompeian #2

Oil Painting by Ida Kohlmeyer

After World War II, New York became the center for artistic development, surpassing Paris and producing some of the most influential art movements of the twentieth century. Encountering a significant abstract artist outside of New York seemed unusual at the time. And yet New Orleans–born and raised Ida Rittenberg Kohlmeyer (1912–1997) succeeded in establishing a major career outside of New York—a task few artists accomplished. *Pompeian #2* by Kohlmeyer illustrates the influence of modern trends established by the New York art scene and the artist's personal experimentation with style through color and line.

Despite the odds of living and working in the South, Kohlmeyer enjoyed both national and international recognition. She attended summer art classes in Massachusetts, studying under Hans Hoffman (1880–1966), abstract Expressionist painter and member of the Art Students League of New York. Kohlmeyer absorbed Hoffman's philosophy that painting was a spiritual activity driven by a subconscious reality rather than the visible world. The impact of Hoffman's ideas and styles on Kohlmeyer was reinforced by the artist Mark Rothko (1903–1970), also a member of the Art Students League of New York, who came to New Orleans in 1957 as a visiting artist at Tulane University. While in New Orleans, Rothko lived in the Kohlmeyers' family home and used the garage as a studio. Kohlmeyer came to adopt Rothko's abstract style of color field painting, characterized by large areas of color and wide-sweeping, gestural brushstrokes.

During the 1960s and early 1970s, Kohlmeyer struggled to break from her mentors' artistic styles and define her own style. She replaced the Rothko-inspired color field with a neutral canvas. The effect heightened the divide between the formal and expressive qualities of her abstract paintings. Her works created in the late 1960s incorporated grids of bright colors over organically formed structures. The result, as seen in *Pompeian #2*, was a self-defined example of abstract art that catapulted Kohlmeyer into a unique abstract art world beyond New York.

After graduating from Newcomb College with her B.A. degree in English literature in 1933, Kohlmeyer attended the John McCrady

ABOVE: Detail from *Pompeian #2*. Photographer: Kevin Duffy, Information Technology Services.

Art School and then returned to Newcomb. She received her M.F.A. from Newcomb in 1956 and proceeded to teach drawing and painting at the Newcomb Art School. In 1966, the Peace Corps commissioned her to make a painting for its retiring director, Sargent Shriver. Kohlmeyer was appointed an associate professor of art at the University of New Orleans in 1973, and in 1980 she received the Annual Award for Outstanding Achievement in the Visual Arts from the National Women's Caucus for Art. She became an honorary life member of that organization in 1982. By 1976, she was included in "Who's Who in American Art." Her works are in many private collections, appear in public commissions, and have been exhibited at a number of national and regional museums, including the National

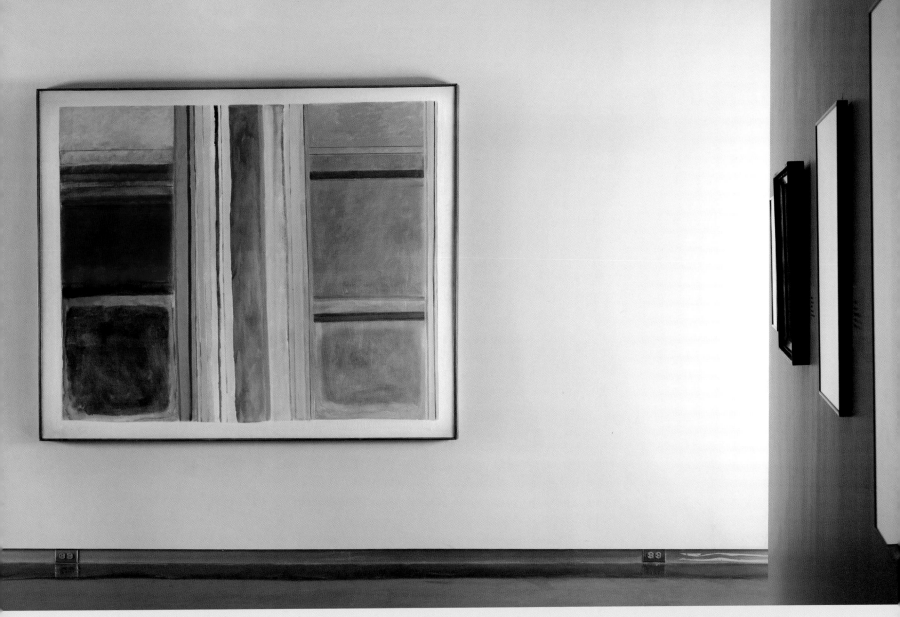

ABOVE: Ida Rittenberg Kohlmeyer (American, 1912–1997). *Pompeian #2* (c. 1967). Oil on canvas. 70 x 80 in. Gift of JPMorgan Chase. LSU Museum of Art, 2006.5. Photographer: Kevin Duffy, Information Technology Services.

Museum of Women, Washington, D.C.; the Smithsonian American Art Museum, Washington, D.C.; the New Orleans Museum of Art; and the High Museum of Art, Atlanta, Georgia.

A gift from one of the largest and oldest corporate art collections, JPMorgan Chase, *Pompeian #2* is a central work in the collection of modern and contemporary American and Louisiana painting at the LSU Museum of Art.

—NATALIE MAULT

References "Ida Kohlmeyer." Arthur Roger Gallery Web site.

"Ida Rittenberg Kohlmeyer." Artnet: The Art World Online Web site.

"Union List of Artist Names." Getty on-line research library.

Spring Run
Oil Painting by Tom Cavanaugh

Seven breathless runners, adrenaline racing, face the viewer as they approach the finish line. The partial figure located in the lower-center foreground, the apparent winner, thrusts his arm upward in triumph with two of his fingers forming a "V," claiming victory. This figure invites viewers to step into the center of the painting. In the background, one hears the pounding of the runners' feet hitting the red dirt, while the athletes exhale between gasped breaths. One feels the tightness of their lungs and the blood pulsating through their veins as they anxiously approach the finish line.

Like many of Tom Cavanaugh's paintings, *Spring Run* captures a mood and a place in time. It is a carefully developed composition, well balanced with well-plotted figures that draw one into the image. *Spring Run* may be viewed not only as a reflection of young men running in a track meet but also as a metaphor about the rhythms and the race of life.

Though many of Cavanaugh's works depict misty, delicate, nostalgic themes, the crisp clarity and luminosity of *Spring Run*, with its rich glaring reds and classically designed composition, hint at the vast painterly skills of this artist. To create his painting, Cavanaugh first attended track meets and watched the runners compete in their practice races. He photographed them as they ended their daily practice, and then returned to his studio to develop his composition.

Located in the LSU Student Union, *Spring Run* was unveiled on October 23, 1969, as part of a ceremony to honor the retiring Union director Carl Maddox, who left his post at the Union to assume the role of LSU athletic director. The selection committee—composed of Don Bruce, a faculty member from the College of Art and Design, and Robert Heck, professor of architecture—chose the painting out of fifty entries submitted to an art competition sponsored by the LSU Union. In honor of Maddox's new post, sponsors chose athletics as the contest's theme.

Cavanaugh was a member of the LSU School of Art faculty between 1957 and 1983. He served for sixteen years as the area head for painting and drawing. Throughout his career, Cavanaugh participated in many art competitions and invitationals. His work may be found at the Joslyn Museum of Art, Omaha, Nebraska; the Whitney Museum of Art, New York; and the New Orleans Museum of Art. A 1947 graduate of the University of Illinois with a B.F.A. degree, Cavanaugh currently lives in Boothbay Harbor, Maine, and Navarre Beach, Florida. Many of his paintings can be seen in Baton Rouge, including his large mural *Up River*, located in the lobby of City Hall (formerly known as the Governmental Building).

—JUDITH R. STAHL

RIGHT: Tom Richard Cavanaugh (American, b. 1923). *Spring Run* (c. 1969). Oil on canvas. 60 x 47.5 in. Permanent collection, LSU Student Union, Baton Rouge. Photographer: Kevin Duffy, Information Technology Services.

Reference Tom Cavanaugh, personal communication, February 2008.

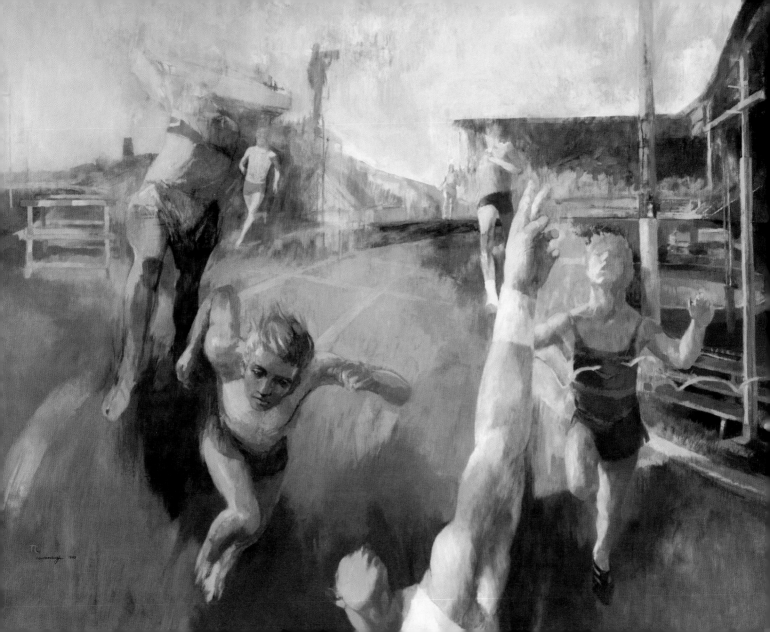

Brown House, Long Island
Oil Painting by Jack Wilkinson

Visible brushstrokes carefully build *Brown House, Long Island* and the surrounding landscape. The painting by Jack Wilkinson reveals an Americanized post-Impressionist style shaped by the impact of the artist's studies in Paris just on the verge of Europe's plunge into war in 1938 and 1939. Supported in Europe on the J. D. Phelan Traveling Scholarship from the California School of Fine Arts, Wilkinson established a studio in Paris and painted prolifically in an environment in which Picasso, Matisse, Braque, and Léger were still alive and working. Stimulated by the heady artistic milieu, Wilkinson drank in all he observed, harboring and pondering images, processes, and ideas that would become the core of his teaching philosophy of painting as an intellectual discipline. His primary model became the structural and mathematical order of Cézanne's painting, a model whose legacy is evident in *Brown House, Long Island*.

The Brown House was a whaling barn constructed by shipbuilders, bought by Wilkinson for a case of Scotch, and moved to his property at East Hampton on Long Island for the sum of one dollar. The renovated barn not only became a summer residence for Wilkinson and his family, but offered studio space for extended periods for many students and colleagues over the years, including those from LSU. Artist friends ensconced themselves among hundreds of Wilkinson's paintings stacked everywhere, watched Abstract Expressionist Willem de Kooning ride by on his bike at three in the afternoon every day, and mingled with Wilkinson's famous friends, including luminaries such as Paul Georges. It was Georges, a former visiting artist at LSU, who recommended Wilkinson for the position of director of the School of Art when that position became available.

Wilkinson came to LSU in 1968, serving until his untimely death in 1974. He had previously headed the art department at the University of Oregon between 1941 and 1968, where he began one of the first basic design programs in the United States. At LSU, he instituted basic foundation painting and drawing courses, founded the visiting artist program—continuing to the present as a significant contribution to the experience of LSU art students—and established the M.F.A. program. Wilkinson was so passionate about painting that he painted in class with his students and invited them to extra sessions on weekends for which he provided models. He read widely and was fascinated by complex philosophical constructs. A close friend and admirer of Buckminster Fuller, inventor of the geodesic dome, Wilkinson formulated his own rather inscrutable but inspiring quadrant orientation based on cause, agent, process, and effect. Students and colleagues speak of Wilkinson as always the painter first, carefully crafting his paintings with spontaneous, exuberant verve, a limited palette, and a strong sense of tonal value. Dalmatians at his side and a parrot on his shoulder were always part of the image of Wilkinson. Award-winning filmmaker and director James Ivory, whose films include *A Room with a View* and *Howards End*, credited Wilkinson, along with another art professor at the University of Oregon, with training his eye for visual images. Ivory speaks for countless students of Wilkinson in acknowledging this gift of the consummate teacher.

—MARCHITA B. MAUCK

References Crespo, Michael. Personal communication, January 2009.
"Exhibit Offers Insight into the Filmmaking of James Ivory." Press release from University of Oregon Libraries, May 16, 2006.
O'Connell, Kenneth R. *Jack Wilkinson: Artist-Philosopher, 1913–1974*. Eugene, OR: University of Oregon Department of Fine and Applied Arts, 1990.
Pramuk, Edward. Personal communication, January 2009.

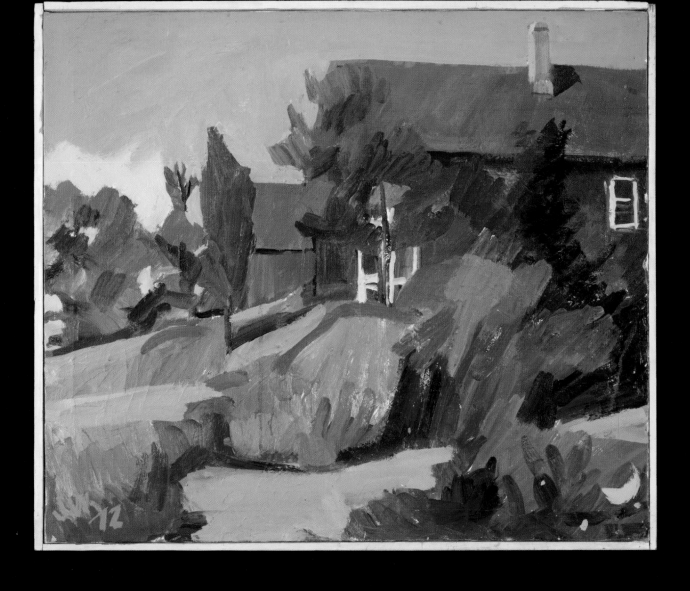

ABOVE: Jack Wilkinson (American, 1913–1974). *Brown House, Long Island* (c. 1972). Oil on canvas. 32 x 27.25 in. Permanent collection, LSU Student Union, Baton Rouge. Photographer: Kevin Duffy, Information Technology Services.

Between East and West

Sumi-e Ink Painting by Paul Dufour

ABOVE: Paul Dufour at his studio. Photographer unknown, Office of Communications and University Relations.

LSU School of Art professor emeritus Paul Arthur Dufour (1922–2008) had a style of art that is difficult to pin down. Throughout his prolific career, he continuously redefined his artistic idiom and worked in a wide range of media, including oil painting, watercolor, printmaking, sculpture, metal, photography, and glass. His *Hambidge Suite #4: Scylla and Charybdis* alone combines an East Asian type of painting with a Western method of collage, mathematical theories with mythological themes, and abstract imagery with realistic subjects.

Dufour's ongoing investigation of art and constant reinvention of himself as an artist led him to travels in France, Germany, Italy, and Japan. After his 1964 trip to Tokyo and Kyoto, his work evolved conceptually and technically. He experimented with *sumi-e* ink wash paintings, a Chinese painting style introduced into Japan in the fourteenth century. *Sumi-e* painting by master artists is revered because these artists concentrated on expressing not just the appearance of things but their very essence, qualities not visible to the eye. Captivated by the discipline as well as expressive capacity of *sumi-e* painting,

Dufour continued to incorporate Japanese wave imagery throughout the remainder of his career. His painting masters named him *Paru Assa Dufuru*: "keep the rain jewel and bring forth the morning."

In the late 1980s, Dufour created a series of ten *sumi-e* and collage paintings combining wave and storm imagery with Hambidge's theories of dynamic symmetry. Jay Hambidge (1867–1924), an American artist, theorized that balance and proportion found in nature formed the basis of designs in Greek architecture, sculpture, and ceramics. The fourth work of Dufour's Hambidge Series, *Scylla and Charybdis*, cleverly employs the Hambidge principles. A wave of lighter color on the left stands out from the composition, dividing the work so that the smaller area is perfectly proportional to the larger and to the composition as a whole. The title refers to mythological sea monsters that guarded the Strait of Messina. If passing sailors tried to evade Charybdis, they would venture too close to Scylla and vice versa. The work, a gift from the artist, is central to the museum's collection of Louisiana modern and contemporary art.

After serving in the armed forces, Dufour attended Yale University, where he studied with masters Willem de Kooning and Josef Albers. He moved to Baton Rouge in 1959 to teach at LSU. Finding very few resources for studying glass as an artistic medium, Dufour researched and developed his own techniques. He founded an innovative stained glass curriculum, making LSU one of the premier glass schools in America until his retirement in 1985. His mastery of color theory, dedication to conceptual depth, and precise technical execution inspired numerous contemporary artists and made him highly influential in the Baton Rouge art community. His many commissioned works can be found in churches and private collections throughout the region as well as in the Corning Museum of Glass in Corning, New York.

—Natalie Mault and Kristin Malia Krolak

References Hambidge, Jay. *The Elements of Dynamic Symmetry*. Mineola, NY: Dover Publications, 1967.

Krolak, Kristin M. "Collecting Raindrops: Investigating Multiplicity in the Work of Paul Arthur Dufour." Master's thesis, Louisiana State University, 2002.

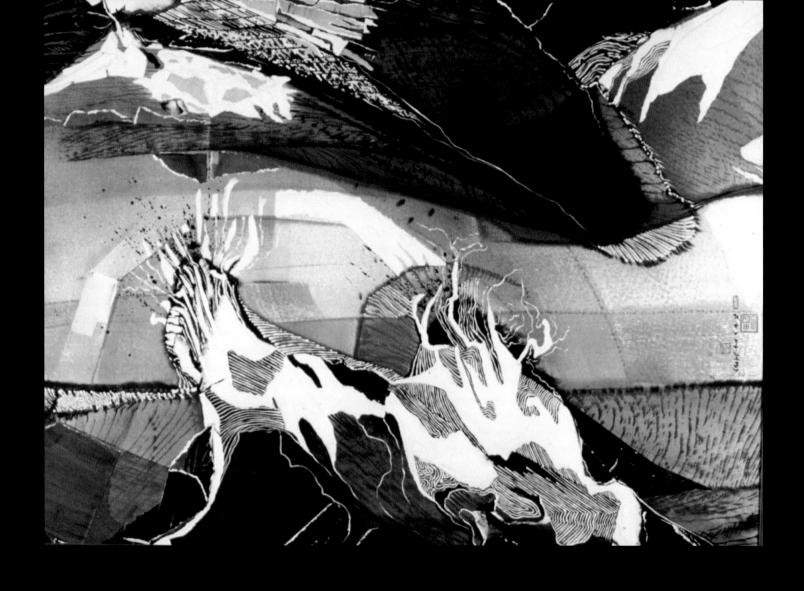

ABOVE: Paul Arthur Dufour (American, 1922–2008). *Hambidge Suite #4: Scylla and Charybdis* (c. 1988). *Sumi-e* ink and wash painting and collage. 34 x 45.75 in. Gift of the artist. LSU Museum of Art, 91.6. Photographer: Kevin Duffy, Information Technology Services.

Monument (for My Father)
Oil Painting by Edward Pramuk

Touched again and again by new intersections of memory and his own experiences, a grown son painted a tribute to his father. This son, Edward Pramuk, is a Louisiana original with a love for jazz as much as painting. During his thirty-five years with the LSU School of Art, Pramuk specialized in teaching an interdisciplinary approach to art. Music, poetry, and drama intermingled with the application of paint on canvas. In *Monument (for My Father)*, Pramuk successfully leaves a monument that is part painting, part jazz, and part poetry. We can practically hear the music, and can certainly see the intent of the artist to provide a lasting tribute to his father.

The painting has two dates. Pramuk began the work in 1974, set the painting aside, and went back to it in 1986, inspired by a poem from Emily Dickinson entitled "There's a certain Slant of light." The final verse of the poem reads: "When it comes, the Landscape listens— / Shadows—hold their breath— / When it goes, 'tis like the Distance / On the look of Death." Pramuk's father had died in 1975, and the painting remained stored until the artist chose to revamp the foreground. Pramuk painted out two arches and added the "quietest green I could find to symbolize a verdant-field beneath the monument-forms and the crushing dark diagonal slab." As Pramuk walked to his father's grave, there was a slight incline that impressed him so profoundly that it too is incorporated into the work.

The eye is immediately drawn toward the center of the painting, where the well of white light is intersected by a triangle of brilliant yellow. At the bottom of the painting and rising to each side is a very deliberate, deep-ocean blue-green that serves to contain the huge mass of "quiet" green. This effect could be termed *repoussoir* and was frequently used to direct and focus the viewer toward the subject matter at hand by framing the composition. Dutch artists of the seventeenth century implemented this technique, and it continued to be used well into the nineteenth century. Pramuk makes use of any number of traditional painting methods, and while his message may be abstract, his technique is profoundly rooted in the masters of the past.

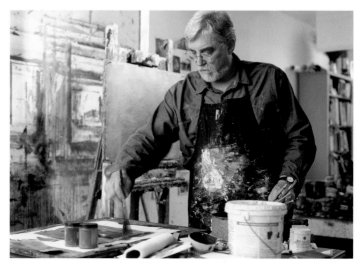

ABOVE: Edward Pramuk at his studio. Photographer: Jim Zietz, Office of Communications and University Relations.

Most important is the fact that the artist has lived with the painting, altered it with the passage of time to suit new emotions and events, and finally parted with it. One suspects that if it were to land back at the artist's studio tomorrow, it would be reworked yet again, to reflect another stage of life, another emotion or resolve. The end result of this work is far from a somber monument, but a happy (and rather large) "thank you" card that is a reflection of light, color, music, and just a hint of nineteenth-century poetry.

—THOMAS A. LIVESAY

Reference Pramuk, Edward. Personal communication, July 2008.

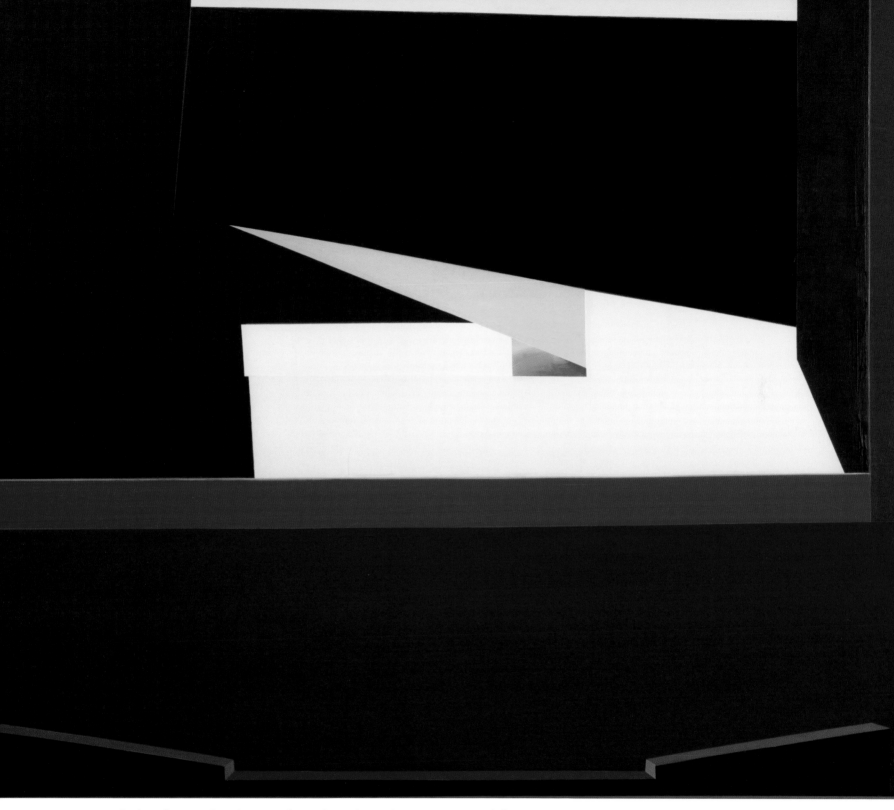

ABOVE: Edward Pramuk (American, b. 1936), *Monument (for My Father)*, 1974–86. Acrylic on canvas. 85 x 115 in. Gift of Michael D. Robinson and Donald J. Boutté. LSU Museum of Art, 2006.6. Photographer: Kevin Duffy, Information Technology Services.

Raging Chaos

Photographs by A. J. Meek

ABOVE: A. J. Meek. Photographer: Jim Zietz, Office of Communications and University Relations.

It was the day before Christmas, the tree was decorated with gifts underneath, and the artist reclined on the couch in old clothes, watching TV. Suddenly a loud kaboom rattled the windows. What was that! he exclaimed. So begins A. J. Meek's account of the origins of his photograph "Exxon Fire and Explosion, Christmas Eve, Baton Rouge, Louisiana, 1989." A vast roiling plume of oily black smoke smudged the bright sky, confirming that something at the Exxon refinery in north Baton Rouge had exploded. Urged on by his daughter, Meek quickly loaded his heavy 8 x 20 banquet camera[1] and tripod into his car, and set out with his daughter to find a safe but good vantage point to make a photograph. He drove west, crossing the Mississippi, away from the prevailing winds blowing the now-multiple smoky plumes east. From Port Allen, Louisiana, he had a panoramic view of the scene, including the State Capitol. From there he made four exposures, including the one reproduced here. Later that evening he made two night exposures of the apocalyptic fire that burned through the night, visually engulfing the city and costing the lives of two Exxon employees. The story made the *New York Times* front page for two days in a row.

One year later Meek returned to the same location to photograph a new disaster threatening the city, this time the catastrophic flooding of the Mississippi River. This photograph, "High Water, Mississippi River, Baton Rouge, Louisiana, 1990," captures the same vista, with the State Capitol once more standing sentinel at the far right of the frame. The strong vertical of the Capitol building rises as a bulwark against raging chaos in both images. In Meek's words, "Seen together they symbolically represent the destructive power of fire and water, and graphically, positive and negative tones."

Having learned photography while serving in the U.S. Air Force, Meek earned his B.F.A. with honors at the Art Center College of Design in Los Angeles. There he studied with Todd Walker and Phil Cohen. He completed his thesis at Ohio University with Arnold Gassan and graduated with an M.F.A. degree in 1972. His early influences were Alfred Stieglitz, Minor White, and Paul Caponigro. Meek was interested in White's inner spiritual journey and the symbolic visual nature of light and dark along with Caponigro's love of nature and form. Later, the documentary work of Walker Evans and the French photographer Eugène Atget became important considerations for his work.

Meek is best known for his elegant toned silver gelatin contact prints made with an 8 x 20 banquet camera of landscapes in Louisiana and the American West. He is the coauthor of one and the author of five photography books: *Sacred Light: Holy Places in Louisiana* (2010); *Clarence John Laughlin: Prophet Without Honor* (2007); *Gettysburg to Vicksburg: The Five Original Civil War Battlefield Parks* (2001); *The Gardens of Louisiana: Places of Work and Wonder* (1997); and *Red Pepper Paradise: Avery Island, Louisiana* (1986). His work is in several private and public collections, including the Houston Museum of Art, the New Orleans Museum of Art, and the Chrysler Museum of Art.

—MARCHITA B. MAUCK

Note 1. Banquet cameras are antique, extra-wide-angle cameras.
Reference Meek, A. J. Personal communication, summer 2008.

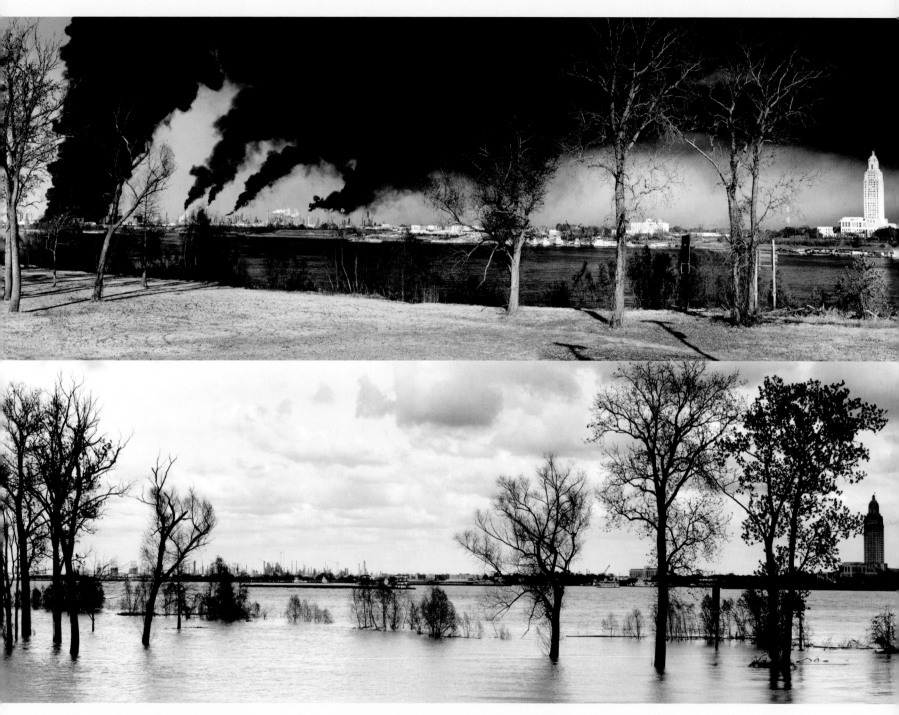

ABOVE: A. J. Meek (American, b. 1941). "Exxon Fire and Explosion, Christmas Eve, Baton Rouge, Louisiana, 1989" (c. 1989) and "High Water, Mississippi River, Baton Rouge, Louisiana, 1990" (c. 1990). A. J. Meek Photograph Collection, MSS 4726, Louisiana and Lower Mississippi Valley Collections, LSU Libraries, Baton Rouge.

Shore of Dreams
Oil Painting by Michael Crespo

One might think this painting represents just a large red heifer, for such a realistic painting style seduces viewers into a satisfying affirmation of the familiar. But such realism can turn subversive, as in this case in which a seemingly ordinary cow wears a wreath of rosebuds. Michael Crespo's painting *Shore of Dreams* entices one into the realm of paradox by its unexpected weaving of the familiar with the symbolic and mystical.

This is the second painting Crespo has done of a red heifer. He reminisced: "When I painted my first red calf, it was simply a remembrance of a red calf that my grandfather had raised. I loved that animal. I rode her back from the levee every afternoon where she had been grazing with her mother. I painted her as a friend of childhood."[1] Viewing this painting in Crespo's studio, a friend recounted the Old Testament account of the red heifer without blemish that is slain, and its ashes mixed with pure water (Numbers 19). This water is used to purify persons who have been contaminated by contact with a corpse. Such purification is a prerequisite for performing Temple rituals.

At this point, Jewish ritual and volatile modern Middle Eastern politics converge. If the perfect heifer can be found, a controversial sect of orthodox Jews believes the Temple in Jerusalem can be rebuilt on the present site of the ancient Muslim Al-Aqsa mosque on Temple Mount, and sacrifice once more offered, fulfilling requirements for the coming of the long-awaited messiah, and the end of time.

With the knowledge of the Jewish story, Crespo said that his childhood matured instantly. The apocalyptic implications of the finding of the perfect red heifer for sacrifice are belied by the stoic calm of Crespo's calf. His animals often stand expectantly in his paintings, seeming to comfort the viewer with their quiet patience. Crespo is fascinated with sacrificial animals that are innocent creatures. Their destiny sets in motion a story that is capable of cosmic implications. Although the animal cannot possibly know what is coming, Crespo's images imbue the creatures with a senescent wisdom. Their patience

ABOVE: Michael Crespo at his studio on the main campus in 1998. Photographer: Jim Zietz, Office of Communications and University Relations. RIGHT: Michael Crespo (American, b. 1947). *Shore of Dreams*, 2008. Oil on canvas. Gift of Michael Crespo. LSU Museum of Art, 2009.3. Photographer: Kevin Duffy, Information Technology Services.

is not resignation, but assent. They have crossed over into the spiritual realm and taken on a religious presence.

This new version of the red heifer stands, as Crespo puts it, "on the shore of dreams, once sacrificed, always sacrificed, continually, to somehow purify inevitable death. So here in this painting triangulating, are me, the powerful beast of purification, and the sweet roses on her head."

Crespo earned his undergraduate degree at LSU and his M.F.A. degree at the City University of New York. Since 1971 he has served as professor of painting and drawing at LSU and was awarded an endowed Alumni Professorship in 2000. He frequently teaches at workshops around the world and has published a series of painting instruction manuals used in classrooms today. For over thirty years his paintings and watercolors have been exhibited across the country, with his work belonging to numerous important public and private collections. Crespo lives, teaches, plays music, and paints in Baton Rouge.

—MARCHITA B. MAUCK

Note 1. Both quotations in this essay are from a personal communication with Michael Crespo, March 5, 2009.
Reference Burrell, David B., and Yehezkel Landau. *Voices from Jerusalem: Jews and Christians Reflect on the Holy Land.* Mahwah, NJ: Paulist Press, 1992.

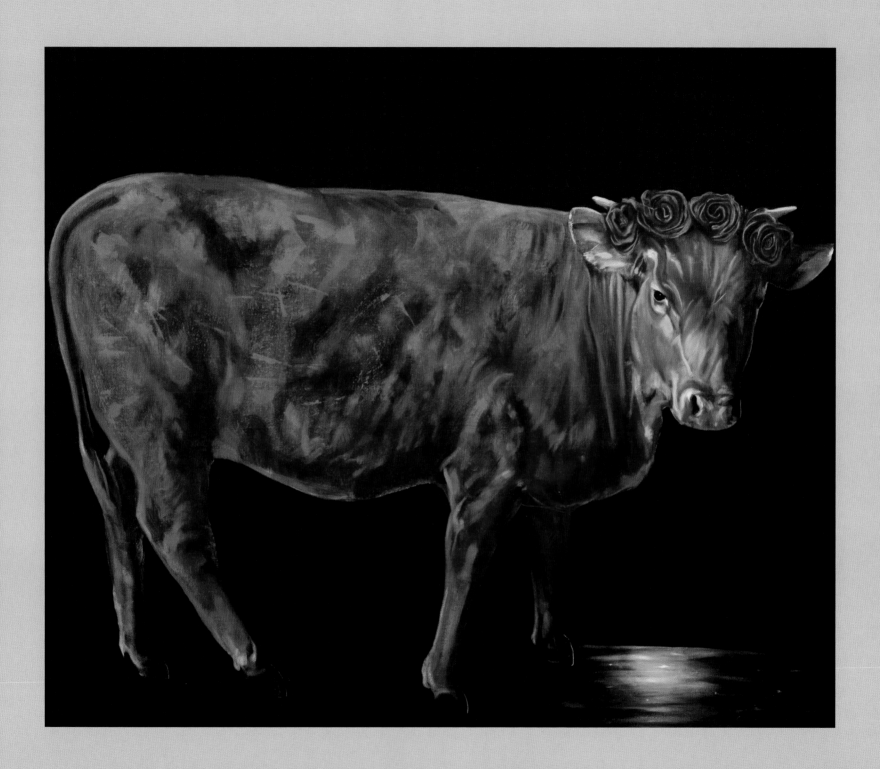

Landscape II
Engraving by James Burke

James Burke's engraving *Landscape II* serves as one of those seminal works in an artist's career that in hindsight can be seen as the impetus for hundreds of images in the decades that follow. This work was born in the days shortly after Hurricane Betsy devastated New Orleans in 1965. Burke distinctly remembers making the first mark on the plate for the engraving. He recounted: "I was in my carport with a makeshift table supported on saw horses, and the surface of the 36 x 24 inch copper sheet was a perfect blemish-free mirror. Somewhere near the middle of the plate I made a deep cut with the burin from top to bottom. Now, no turning back—there was nothing to do but to finish it."[1] Finishing the work took several years before the final state seen here was achieved.

This composition, like most of Burke's work throughout his career, is based on what he calls "life forms," and describes as including "all those tree-like, limb-like, or body-like shapes that allude to as much of animate nature one's imagination can summon." With these shapes as his vocabulary, Burke continues to visually write landscapes, and muses that "though I take liberties with horizons and such notions as up and down, and never feel obligated to observe any rules of spatial logic except those which are visual in origin, I always feel that my work is very much 'of the world'—as I see it, and as I experience it."

For Burke, *Landscape II* exudes the energy and satisfaction that he felt in making it over forty years ago. The lure of engraving that seduced him at the beginning of his career continues to engage him. For him, "pushing a burin through copper is a wonderfully satisfying business. It is a physical and almost sensual undertaking. Engraving requires time, lots of it—both to acquire the skill to make a decent cut, and then to execute even the smallest line (which paradoxically looks to have been made in an instant). Engravings can't be hurried, and the process is time intensive and demanding. The burin will cut only when it's sharp, and held just so. And be convinced of the mark you're making, for even the lightest of lines can betray the insecurity of its maker." In *Landscape II*, Burke was able to hold the burin just so, and initiate years of exploration of his landscape theme.

ABOVE: James Burke. Photographer: Jim Zietz, Office of Communications and University Relations.

James A. Burke was born in Minneapolis in 1935 and earned his B.A. from St. John's University in Collegeville, Minnesota, before serving in the U.S. Army. In 1963 he graduated from the University of Iowa with an M.F.A. degree and moved to Baton Rouge to teach at LSU. Between 1964 and 1995, he taught printmaking in the LSU School of Art and showed his work locally, regionally, and nationally. While teaching at LSU, he worked with several artists to found the Unit 8 Gallery, which later became the Baton Rouge Gallery, to showcase the work of regional professional artists.

Burke has received numerous grants and awards, including the Louis Comfort Tiffany Award for Printmaking. His works are featured in private and public collections including those of the Wichita Art Association, Wichita, Kansas; the Delgado Museum of Art in New Orleans; the Dulin Gallery in Knoxville, Tennessee; the Mint Museum in Charlotte, North Carolina; New York University at Potsdam; the North Country Museum of Arts in Park Rapids, Minnesota; and the LSU Museum of Art in Baton Rouge. Burke lives in Baton Rouge, actively producing and exhibiting his work.

—Kristin Malia Krolak

Note 1. All quotations in this essay are from a personal communication with James Burke, October 2008.

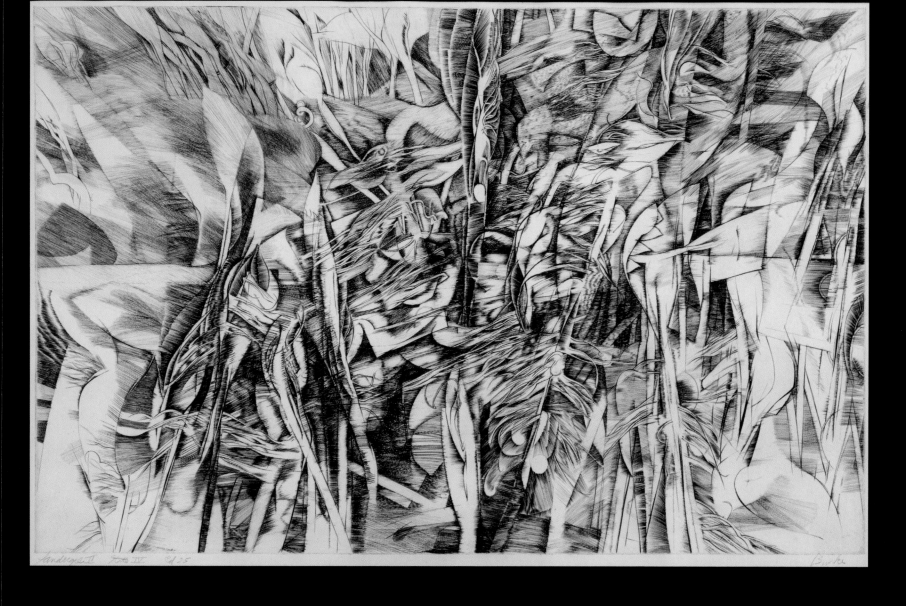

Bermuda Shorts in Panama

Gouache Painting by Robert Warrens

Although currently best known for his autobiographical works illustrating his experiences during Hurricane Katrina, acclaimed New Orleans painter, sculptor, printmaker, and former LSU School of Art professor Robert Warrens has had an extensive artistic career dating back to the early 1960s. His works over the past five decades are defined by their outward playfulness and sense of whimsy, blended with implicit themes exploring societal ills and the effects of pollution on the environment. *Bermuda Shorts in Panama* from the LSU Museum of Art's collection draws in viewers, like Alice through the looking-glass, with its colorful, cartoonlike creatures. Warrens' bizarre and magical fantasy world initially conjures up a sense of humor and absurdity. Contained within a pictorial window frame that further emphasizes the sense of amusement, the whimsical figures are reminiscent of those at Lewis Carroll's "Mad Tea-Party." A large black and red creature seems to soar over a river that zigzags through the center of the picture plane; a horned, cowlike figure stands with its hands on its hips; the rear end of an unidentifiable animal leaves the scene on the left side; an elephant steps outside from the right side of the window frame; two small boats dwarfed by the size of the animals float down the river; fish out of water lie on the windowsill below.

At first glance, the world that Warrens presents is one of merriment, until one wonders what the apparently playful creatures are up to. The piece then evokes a sense of uneasiness. The characters are at first humorous, but it is obvious that Warrens has a more ambitious plan than just humor. Viewers are confronted with the direct gaze and eerily judgmental stance of the horned, cowlike figure, the devilish grin of the elephant, and the misshapen, squinting eyes of the black and red hovering creature. The fish, elephant, and black and red creature intrude upon our world, suspended between the frame of the painted windowsill and the actual picture frame, crossing into our reality, impelling us to take action. But what action should we consider?

As is often the case with Warrens' artworks, this painting contains complex, satirical imagery that is entertaining and enchanting while simultaneously puzzling and passionate. Nothing is what it seems at first glance. *Bermuda Shorts in Panama* refers to relations between Panama and the United States and the struggle for political control of the Panama Canal during the 1970s. U.S. control of the Panama Canal was met by increased disapproval among many Panamanians, culminating with student protests and increased military presence during the mid-1970s. Negotiations between the two countries began in 1974, and a treaty was signed in 1977 granting Panama control of the canal.

Warrens does not necessarily reveal his opinions on social and political issues in his artwork. Certainly *Bermuda Shorts in Panama* does not implicitly disclose his beliefs regarding the situation in Panama during the 1970s, but it does suggest the artist's displeasure, perhaps more so with the treatment of the environment and wildlife in the Panama Canal Zone than with either government or the overall political situation. Through humor and sarcasm, Warrens hopes to draw attention to social ills and environmental issues. By allowing viewers to form their own opinions, assigning their own meaning and interpretation to his work, Warrens makes us a part of the work ourselves, stuck in the middle ground between the world around us and Warrens' fantasy.

Warrens melds cartoon imagery with social commentary, striking back at society's ills through weapons used in advertising and popular culture—exaggeration, distortion of scale, contrast, and acid-hued colors. His works reveal a passion for society, the agonies of personal experience, a cartoonist's instincts, and a love of a vivid color palette. These characteristics combine to create some of the most stimulating, amusing, and slyly intellectual works by a Louisiana artist.

—NATALIE MAULT

References Kemp, John R. "Serious Fantasy." *Louisiana Life* (Fall 2007).

Lindsay-Poland, John. *Emperors in the Jungle: The Hidden History of the U.S. in Panama*. Durham, NC: Duke University Press, 2003.

ABOVE: Robert Warrens with one of his creations. Photographer: Jim Zietz, Office of Communications and University Relations. **RIGHT:** Robert Warrens (American, b. 1933). *Bermuda Shorts in Panama*, from the series *The Panama Canal*, 1973. Gouache on paper. 36.25 x 28.25 in. Michael Frederic Daugherty Collection, bequeathed by Andrea Mills Daugherty. LSU Museum of Art, 2008.2.24. Photographer: Kevin Duffy, Information Technology Services.

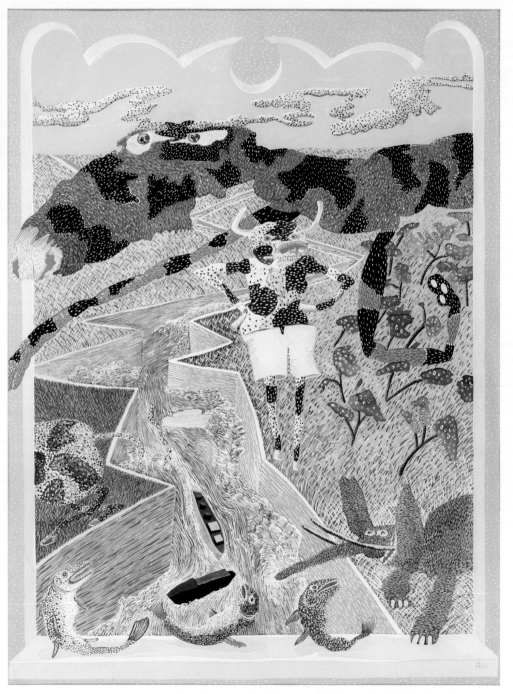

VI

LOUISIANA LEGACY

Interior of a Steamboat and Other
Glimpses into Southern Arts and Culture

An Eye for Detail

Interior of a Steamboat by Marie Adrien Persac

More than a century before luxury cruise ships became a common sight in New Orleans, steamboats took honeymooners and vacationers up and down the Mississippi River between Saint Louis, Missouri, and New Orleans, Louisiana. With sumptuous meals and romantic, moonlit promenades on deck, these boats fueled literary imaginations from Mark Twain to Margaret Mitchell. Unfortunately, there were no camcorders or digital cameras to record the experience. Only one painting survives to show the interior of one of these pre–Civil War ships, *Interior of the Main Cabin of the Steamboat Princess/Imperial*, by Marie Adrien Persac (1823–1873). It is one of the treasures of the LSU Museum of Art collection. A detailed image of gouache on paper with collage figures, the work was signed by the artist in 1861.

Persac carefully recorded details of the ship's architecture, the food, the bar, even the clerk's office. The spacious Gothic Revival interior is complete with stained-glass clerestory windows and quatrefoil medallions. Below the immense ceiling, the floor is covered in two different materials. Nearest the entrances the floor appears to be either a floor cloth or painted diamond pattern, whereas farther back, under the banquet table, guests walk on the less durable, floral-patterned Brussels carpet. On the table, a feast worthy of the wealthy guests includes a variety of meat and seafood dishes.

The painting also provides a visual record of the etiquette and customs of the times. At the bar, which is fully stocked with a variety of identifiable libations, two men in hats chat; at the same time, men in the dining area are without hats, having placed them on nearby tables. Three cuspidors (fancy spittoons) appear in the foreground to accommodate the fashionable habit of tobacco chewing. Persac drew the figures, which he then cut out and applied to the gouache as collage, a method he used frequently when adding figures to his architectural works.

This unique work is one of seven by Persac in the collection of the LSU Museum of Art. Born in France, Marie Adrien Persac moved to the United States as a young man. He married a Louisiana native and settled on Bayou Manchac in the 1850s. He frequently visited Baton

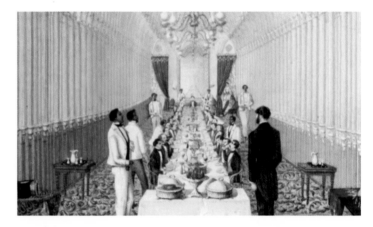

ABOVE: Detail from *Interior of the Main Cabin of the Steamboat Princess/Imperial.*

Rouge and painted many views of the growing town. By 1859, records indicate that Persac had moved to New Orleans, where he appears to have remained for the rest of his life.

The artist lived at a critical time for Louisiana, when there was rapid growth in industry and in the cities of the southeastern portion of the state. His paintings often record architecture that has long since disappeared from Baton Rouge and New Orleans. As an architect himself, Persac was able to record the minute details of plantation architecture, government buildings, and city residences. The artist often populated his paintings with figures, and in this case, he included a self-portrait of himself and his wife. In fact, according to family lore, this painting has a personal connection, representing the couple on their honeymoon cruise aboard the *Princess* in 1851. They sailed from Baton Rouge, where they married, to New Orleans. The work remained in the family until it was donated to the museum by the artist's granddaughter, Mamie Persac Lusk.

—Victoria Cooke

Reference Bacot, H. Parrott. *Marie Adrien Persac: Louisiana Artist*. Baton Rouge: LSU Press, 2000.

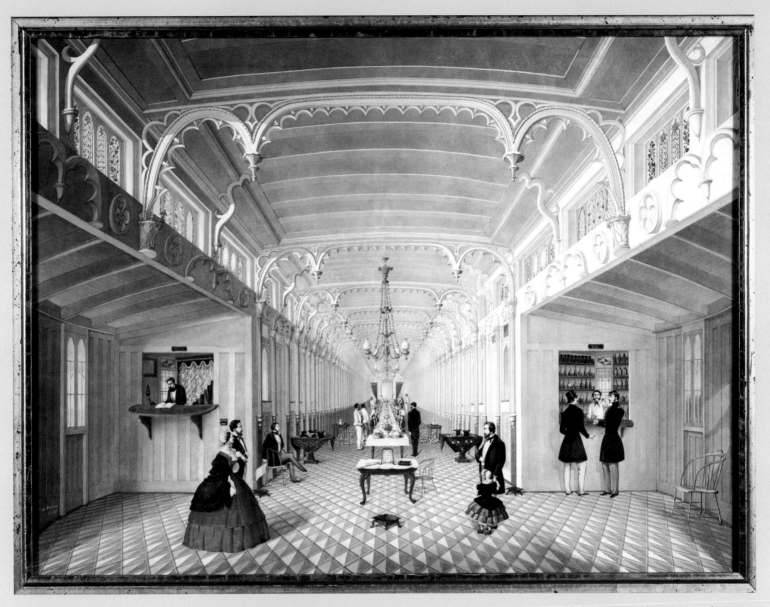

ABOVE: Marie Adrien Persac (1823–1873). *Interior of the Main Cabin of the Steamboat Princess/Imperial*, 1861. Gouache and collage on paper. 17 x 22.9 in. Gift of Mamie Persac Lusk. LSU Museum of Art, 75.8. Photographer: Jim Zietz, Office of Communications and University Relations.

Privilege and Style

Louisiana Armoire

The rococo armoire (c. 1800–1825) at the LSU Museum of Art is reminiscent of a time when these large wooden cabinets were a mark of social prestige, a lucky bride's dowry, and the primary storage areas for clothing and household goods. It is the "only known armoire on cabriole legs to be fitted with side closets and wooden cloak pins."[1]

Made from Santo Domingo mahogany, Spanish cedar, walnut, and poplar, the armoire has a brass rim lock, the largest known on any Louisiana-made armoire. In addition to the belt of three drawers, the armoire has three sliding linen shelves, seen on only one other cabriolet-leg armoire of Louisiana origin. Unique in Louisiana-made furniture, the drawers have secret, snap-action mahogany latches underneath, perhaps to hide away valuables or sensitive documents. Embossed with mariner's stars, the drawers and linen shelves have their original English-made oval brasses, surrounded by a Greek key border.

At the beginning of the eighteenth century, armoires replaced the less convenient *coffres*, or chests, in France as well as in Louisiana Creole houses. Every substantial house had one or more, for these large furniture pieces served as symbols of prestige. The craftsmanship, type of materials, and artistic flourishes on the armoires all contributed to the status of their owners. Often perfumed with aromatic herbs to protect their contents from insects, armoires only gave way to modern-day closets in the late 1800s, when people in the area learned to hang their clothes rather than fold them.

Early furniture from the lower Mississippi Valley continues to be highly sought after in the antiques market. Pieces from the Early Republic period (1803–1830) reflect European tastes for Neoclassical Revival styles. The discoveries of ancient cultures abounded in Europe during this time and surfaced in furniture designs, particularly in France and in the United States. The influence of French preferences on Louisiana furniture remained well into the Victorian era. Though much of Louisiana-made furniture was purchased in New Orleans,

ABOVE: Detail of drawer pull from armoire. Photographer: Jim Zietz, Office of Communications and University Relations.

the major center for finely crafted pieces was in Thibodaux, Louisiana. The origin of the armoire remains unknown, though materials and technique indicate a distinctly Louisiana work.

The armoire was donated in 1979 by the late Emile N. Kuntz, a native of New Orleans, in memory of his brother, Felix. A business and civic leader, Kuntz attended Tulane University and was involved in the insurance and realty industries. His efforts and personal love for early American furniture helped to establish the Federal period and Louisiana rooms at the New Orleans Museum of Art. The LSU Museum of Art's furniture collections are limited, yet represent the finest examples of early local furniture, making the armoire a true treasure of LSU.

—ERIKA KATAYAMA

Note 1. H. Parrot Bacot, "Early Louisiana Furniture and Other American Furniture," in *Collecting Passions: Highlights from the LSU Museum of Art Collection*, ed. Donna McAlear (Baton Rouge: LSU Museum of Art, 2005), 70.

References McAlear, Donna, ed. *Collecting Passions: Highlights from the LSU Museum of Art Collection*. Baton Rouge: LSU Museum of Art, 2005.

Poesch, Jessie J. *Early Furniture of Louisiana, 1750–1830*. New Orleans: Louisiana State Museum, 1972.

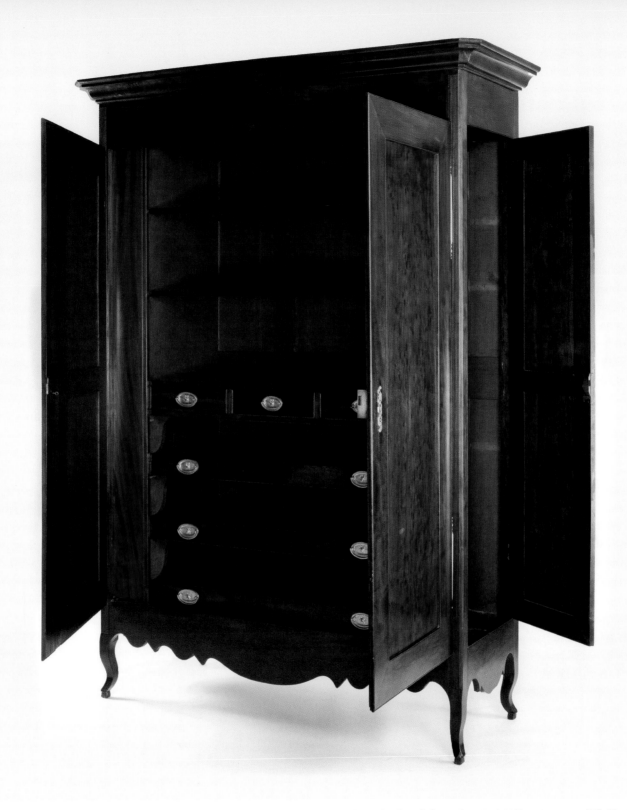

The Collector
Mercer Bookcase

Although the number of book collections held by private owners had increased by the nineteenth century, the illiteracy rate, especially in the southern United States, remained high. In the late 1800s, almost half of all Americans signed their marriage certificates with a mark rather than a signature. By the 1900s, the illiteracy rate in the North was only 13.7 percent; in contrast, the illiteracy rate in the South was almost 75 percent. It is not surprising, then, that there were few privately owned collections of books in nineteenth-century Louisiana. Most of the people who owned books stored them in armoires. However, by the 1820s, freestanding bookcases became more common fixtures in the homes of wealthy southern families. This massive, three-section bookcase, made in New Orleans from American walnut, mahogany, and Louisiana cypress woods, reflects wealth, personal taste, and a desire to care for a treasured personal collection of books.

William Newton Mercer, M.D. (1792–1874), of Adams County, Mississippi, and New Orleans commissioned this rare, Louisiana-made nineteenth-century bookcase and two smaller matching bookcases in the early to mid 1800s. The Mercer bookcase is one of only a limited number of bookcases made in New Orleans prior to 1845. The bookcase consists of six windowed cupboards, with a mahogany band on the edge of the lower case. The secondary woods are cypress and tulip poplar, which support the New Orleans attribution. The lower half extends beyond the top portion to accommodate oversized books. Significantly, the Mercer bookcase still has all but one of its original six decorative French-made keys, one for each cupboard.

Mercer was one of the most important civic leaders in the lower Mississippi River valley. Born and reared in Maryland, Mercer married into the Butler family of Louisiana. Before he died in 1874, he owned five plantations below Natchez, Mississippi, including Laurel Hill plantation. His collection of treasured books included John James Audubon's elephant folio *The Birds of America*.

Fortunately, before Laurel Hill burned in 1917, there had been a division of the estate, and a number of the best furnishings went to Little Laurel Hill, a house built about 1911–1912. This is where the bookcase was located until the LSU Museum of Art acquired it in the late 1990s. The Grecian-style bookcase remains an important part of the LSU Museum of Art's rare collection of early Louisiana-made furniture.

—Natalie Mault

References Bacot, H. Parrott. "Early Louisiana Furniture and Other American Furniture." In *Collecting Passions: Highlights from the LSU Museum of Art Collection*, ed. Donna McAlear. Baton Rouge: LSU Museum of Art, 2005. 72–73.
"The Canal Street Historic District." City of New Orleans Web page.

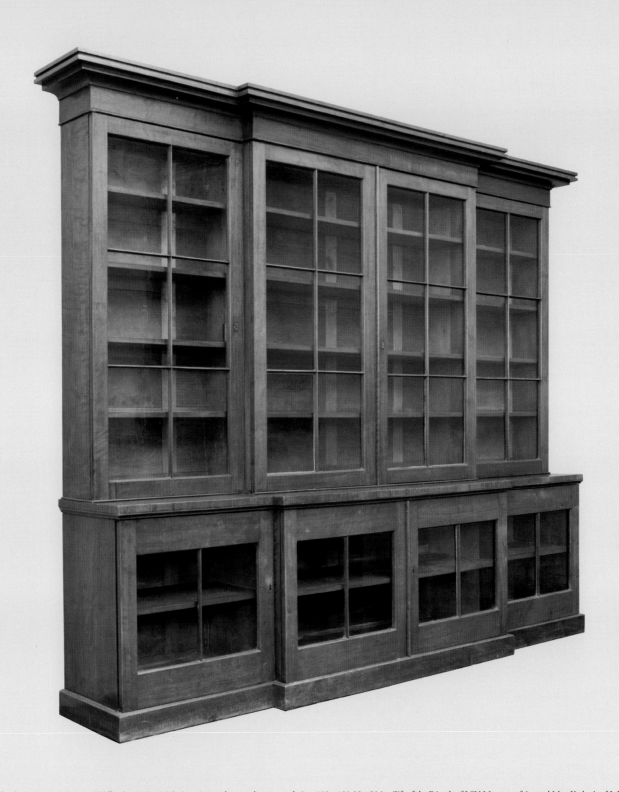

ABOVE: Mercer bookcase, Lower Mississippi Valley (c. 1835–1850). American walnut, mahogany, and pine. 103 x 129.25 x 23 in. Gift of the Friends of LSU Museum of Art and Mrs. Katherine H. Long. LSU Museum of Art, 98.4. Photographer: Kevin Duffy, Information Technology Services.

Have a Seat

Campeachy Chair

It may be hard to imagine, but long before recliners and chairs with adjustable back- and footrests, Louisianians found great comfort in the high-back, slightly curved profile of the campeachy chair. Each component of the campeachy chair, from the curvilinear legs that create a continuous shape for the seat or back, to the wood and materials used for the seat, combines with the others to form a chair that was designed for the basic purpose of relaxation.

Although not originally American in design, the campeachy chair grew in popularity in Louisiana in the nineteenth century, and chair makers in and around New Orleans began to copy the sling style. The LSU Museum of Art's early nineteenth-century campeachy chair, made in New Orleans, is one of the most unique items in the museum's collection; and its decoration makes it one of the most distinctive campeachy chairs originating in Louisiana. Although mahogany was a material commonly used to make campeachy chairs in the South, the crest on the headrest of the museum's chair is uniquely inlaid with southern white oak and surrounded with a band of either satinwood or possibly native holly wood.

French and Anglo-American styles dominated early Louisiana furniture design, even though most furniture from this time was created during Spain's governance of the Louisiana Territory (1763–1803). Spain did, however, introduce Louisiana to a significant piece of furniture called the *butaque* or *butaca*. During the 1600s, the *butaca* grew in popularity in Spain owing in part to its unique reclining shape. Many of these chairs were later made in regions of Mexico, including the district of Mexico known as Campeche, which inspired the anglicized name "campeachy." The museum's chair is distinctive in its decoration. Overall, the piece features the Spanish influence, but the crest reflects Anglo-American taste and further exemplifies the multiple influences on Louisiana style.

Campeachy chairs became so popular during Louisiana's colonial period that Thomas Jefferson requested one from a friend in New Orleans in 1819. He described his campeachy chair (often referred to by Jefferson as his "campeachy hammock," "lolling chair," or "siesta chair") as one of his favorites for relaxation. In his later years, suffering from rheumatism, Jefferson was seen lounging often in his campeachy chair. He once commented, "Age, its infirmities and frequent illnesses have rendered indulgence in that easy kind of chair truly acceptable."[1] The first chair Jefferson ordered was lost in a shipwreck, and the second one arrived ten years later. A nineteenth-century, Virginia-made replica of his campeachy chair (similar in shape and design to the LSU Museum of Art's example) remains in the parlor room at his home Monticello. Jefferson also ordered copies for James Madison, Thomas Mann Randolph, and Eliza House Trist, making it a fashionable item among the Virginian intelligentsia.

Today campeachy chairs are still in production, although contemporary versions have bigger or smaller armrests and varying tilts to the backrest. Originally, campeachy chairs were commonly made from mahogany and leather, but today they are found in teak, cedar, or pine woods and sometimes even various metals.

—Natalie Mault

Note 1. Thomas Jefferson to Thomas B. Robertson, November 7, 1819, American Memory Project—Thomas Jefferson Papers.

References Bacot, H. Parrott. "Early Louisiana Furniture and Other American Furniture." In *Collecting Passions: Highlights from the LSU Museum of Art Collection*, ed. Donna McAlear. Baton Rouge: LSU Museum of Art, 2005.

Beiswanger, William L. *Thomas Jefferson's Monticello*. Chapel Hill, NC: University of North Carolina Press, 2002.

Evans, Nancy. *Windsor-Chair Making in America: From Craft Shop to Consumer*. Lebanon, NH: University Press of New England, 2006.

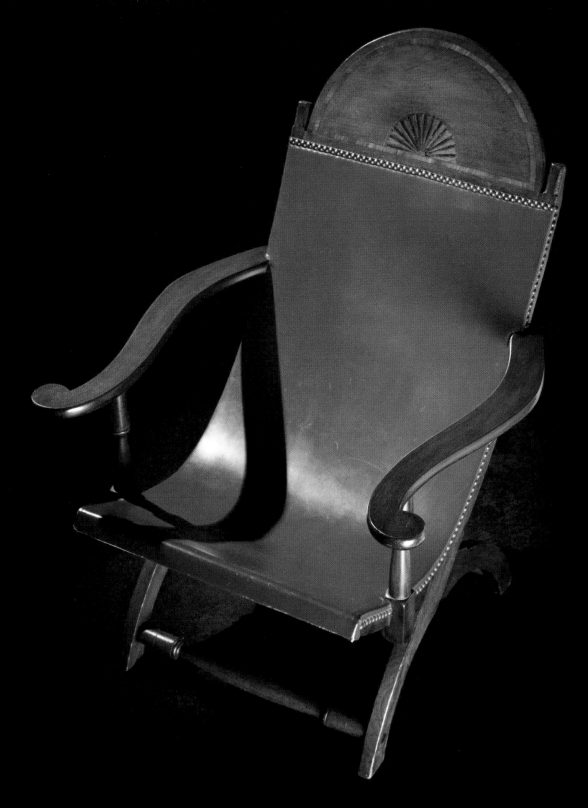

ABOVE: Campeachy chair (c. 1810–1825), probably New Orleans. Mahogany with white oak and satinwood inlay, leather, and nails. 37 x 26.375 x 27.5 in. Gift of D. Benjamin Kleinpeter. LSU Museum of Art, 96.13.3. Photographer: Kevin Duffy, Information Technology Services.

Antebellum Coin Silver
Nineteenth-Century Egg Boiler

Between 1830 and 1861, New Orleans distinguished itself as an important center for American silversmiths. Although Louisiana has no silver mines, local manufacturers melted silver coins for materials, resulting in the term *coin silver*. The LSU Museum of Art's pre–Civil War coin-silver egg boiler, marked with the initials of the silversmiths, K&H, is the only presently known egg boiler made south of Baltimore. It consists of five intricate and separate parts: a rectangular frame on cabriole legs, a spirit lamp, a boiler, a frame for holding the eggs, and a footed waiter. The highly decorative rectangular frame holds the spirit lamp and boiler. The boiler has a divided lid, which opens to reveal a frame with twelve rings to hold the eggs. The frame has a central vertical handle with a loop at the top to lift the eggs from the water. The finial on the handle is in the form of a boy holding a hoop. On the footed waiter is the retail mark Hyde & Goodrich.

New Orleans silver evolved from three overlapping traditions: French, British, and German. The most prolific of the German silversmiths working in New Orleans were Adolphe Himmel (1825/26–1877) and Christopf Christian Küchler (dates unknown). Working together in a short-lived partnership between 1852 and 1853, they produced silver pieces marked "K&H." Many of their jointly produced works were sold through Hyde & Goodrich, New Orleans' largest fancy goods store, which sold silver goods from northeastern states and local craftsmen. The museum's egg boiler, created in 1852–1853, was among the pieces Hyde & Goodrich sold.

The LSU Museum of Art owns the largest collection of nineteenth-century New Orleans–made silver, including silverware, cups, serving utensils, and other once-functional objects. One of the unusual items in its collection, the egg boiler holds a rare and solid provenance. Once owned by prominent cotton planter John Alexander Buckner

(1832–1903) of Mounds plantation in East Carroll Parish, Louisiana, it descended through the Buckner family until the LSU Museum of Art acquired it in 1984.

—NATALIE MAULT

RIGHT: Adolphe Himmel (German-American, 1826–1877) and Christopf Christian Küchler (German-American, active in New Orleans 1852–1870) for Hyde & Goodrich, New Orleans. Egg boiler on serving tray (c. 1852–1853). Coin silver. 16 x 8.25 x 4.625 in. Gift of the Friends of LSU Museum of Art. LSU Museum of Art, 84.31.1. Photographer: Kevin Duffy, Information Technology Services.

References Bacot, H. Parrott. "New Orleans Silver." In *Collecting Passions: Highlights from the LSU Museum of Art Collection*, ed. Donna McAlear. Baton Rouge: LSU Museum of Art, 2005. 87–89.
Crescent City Silver. New Orleans: Historic New Orleans Collection, 1980.

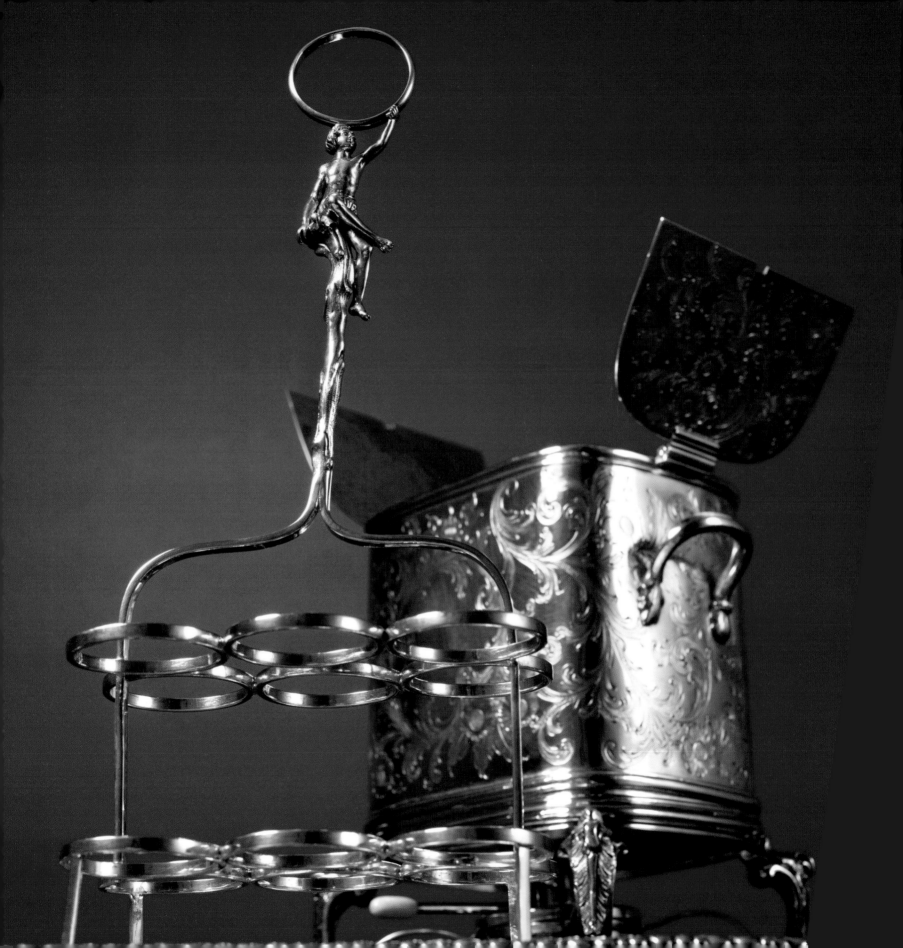

Portrait of a Gentlewoman
Oil Painting by Guillaume Lucien Amans

Decorating drawing rooms and hallways in most grand southern residences in the mid 1800s, proudly hung family portraits indicated prosperity and status. In Louisiana, portraiture dominated painting subject matter during the first half of the century in both urban areas and plantation country. *Portrait of a Gentlewoman*, painted in the early 1840s, is typical of Jacques Guillaume Lucien Amans' (1801–1888) Neoclassical portraits that allude to social status through clothing, accessories, and domestic furnishings. The unidentified woman in the portrait wears an intricate lace collar and elaborate bonnet, indicative of wealthier social status. The three-quarter-length figure set against a plain background is characteristic of the elegant portraiture that was preferred for grand homes during the antebellum period.

From the initial period of colonization through the Louisiana Purchase and finally statehood, the majority of Louisiana's population was French. As a result, French artists such as Amans, schooled in the academies of their native country, led the antebellum period in painting. Characteristics of these portraits include overall realism, refined draftsmanship, and highlighted personal features with modest background detail.

One of the most notable southern portraitists of the 1830s and 1840s, Amans came to Louisiana in 1836. He left France with compatriot and fellow painter Jean Joseph Vaudechamp (1790–1866), and they established studios in the same block of Royal Street in the Vieux Carré district of New Orleans. Amans married Marguerite Azoline Landreaux, the daughter of a St. Charles Parish sugar planter, in the mid 1840s and bought Trinity plantation on Bayou Lafourche as a summer residence; he painted in New Orleans during the winter months. Although Vaudechamp is considered the leading portraitist in New Orleans in the 1830s, Amans' skill and local connections brought him commissions from the late 1830s until 1856, when he returned to France. Amans' many lower Mississippi valley clients included Gen. Zachary Taylor, Andrew Jackson, fellow artist A. C. Jaume, and his own father-in-law, Pierre Landreaux. His expertise in portraiture is particularly evident in the rendering of the hands and the subtle modeling of the face, though Amans' works are more generalized and softer-edged than Vaudechamp's.

The preference for portraiture continued until Reconstruction, when the comparatively more economical daguerreotype and a growing appreciation of Louisiana's scenic views, especially the distinctive characteristics of its swamplands, increased in popularity.

Mr. and Mrs. William E. Groves of New Orleans donated *Portrait of a Gentlewoman* to the LSU Museum of Art in 1960.

—Erika Katayama

Reference Bonner, Judith H. "Portraiture, Landscapes, and Marine Scenes in Nineteenth-Century Louisiana."
In *Collecting Passions: Highlights from the LSU Museum of Art Collection*, ed. Donna McAlear.
Baton Rouge: LSU Museum of Art, 2005.

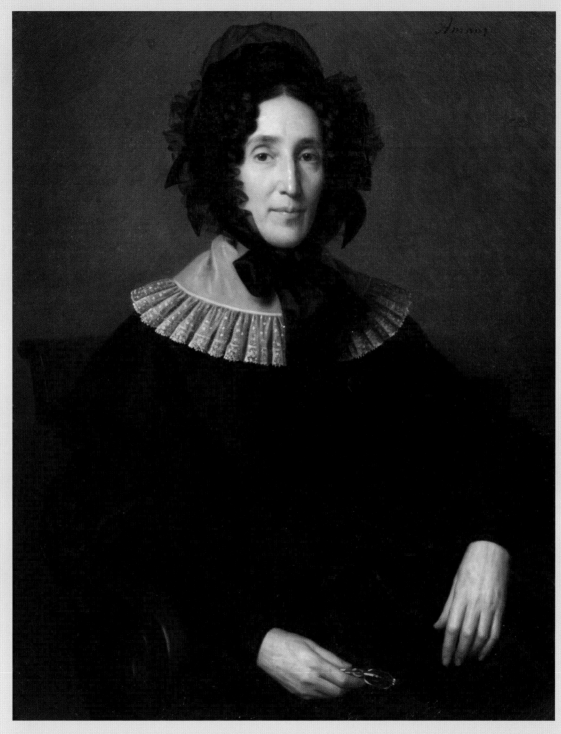

ABOVE: Jacques Guillaume Lucien Amans (Franco-American, born Belgium, 1801–1888), *Portrait of a Gentlewoman* (c. 1840–1845). Oil on canvas. Gift of Mr. and Mrs. W. E. Groves. LSU Museum of Art, 60.2.1. Photographer: Kevin Duffy, Information Technology Services.

Empowered Women
The Newcomb Collection

ABOVE: Detail of vase.
Photographer: Kevin Duffy,
Information Technology Services.

The tall Louisiana iris flowers and use of blues and greens exemplify regional influences. In keeping with the traditions of the Arts and Crafts movement, characterized by hand-crafted objects, romanticized design, and local materials, Newcomb pottery capitalized on the resources and subject matter of the area, including clay from Lake Pontchartrain and plants and animals indigenous to Louisiana.

Considered to be one of the most remarkable American art potteries of the first half of the twentieth century, Newcomb Pottery and Crafts of Tulane University's Sophie Newcomb Memorial College is distinguished by its unique, southern regional character. The LSU Museum of Art has the largest public collection of Newcomb pottery and owns examples from the school's entire span of production (1894/5–1940), including this turn-of-the-century, high-glaze vase with Louisiana irises, decorated by Irene Borden Keep (1876–1970) and Mary Wolcott Richardson (dates unknown) and crafted by Joseph Fortune Meyer (1848–1931).

Crawfish, egrets, pelicans, and moss-draped live oak trees were often incorporated into the designs. Newcomb College determined certain standards for the pottery's form and structure. This ceramic vase retains a traditional shape, ideal for the proportion of the overall design. The World's Industrial and Cotton Centennial Exposition, held in New Orleans in 1884, introduced the Arts and Crafts movement to Louisiana. The popularity of the Exposition's display of pottery, needlework, fabric designs, and furniture by female students from northern schools of design prompted Tulane University to offer free lectures and art courses for women. Two years later, Josephine Louise Newcomb (1816–1901) gave a donation to Tulane University, establishing the nation's first coordinate women's school.

Around the same time, Tulane University hired Ellsworth Woodward (1861–1939) to head the art department. Woodward had attended the Rhode Island School of Design and was educated in the Arts and Crafts movement. In 1895, Woodward, troubled at the lack of opportunities women had to apply their fine arts skills after graduation, established Newcomb Pottery and Crafts. Coinciding also with the women's movement, Newcomb Pottery and Crafts gave female graduates new opportunities for training and future creative avenues of employment beyond teaching.

Female students attending Newcomb College were responsible for the overall shape and decoration, but professional, male potters did the dirty work, including creating pottery on the wheel. Joseph Fortune Meyer, who built the original kilns at Newcomb, worked as the Newcomb potter from 1897 to 1927, when Newcomb Pottery and Crafts was at its height of national acclaim. Irene Borden Keep became a "special art student" in 1900, demonstrating her great artistic skill in the use of bold designs and color combinations. Borden Keep worked as a decorator at Newcomb Pottery and Crafts until 1904, but her time there was brief, resulting in a finite amount of surviving works marked with the initials I.B.K. Mary Wolcott Richardson graduated from Tulane in 1901 with a degree in fine arts. She completed her graduate studies in 1902, and worked at Newcomb Pottery and Crafts from 1898 until 1902.

—Natalie Mault

RIGHT: Irene Borden Keep (American, 1876–1970), decorator; Mary Wolcott Richardson (American, unknown dates), decorator; Joseph Fortune Meyer (Franco-American, 1848–1931), potter. Vase (c. 1904). High glaze on buff clay body. 13 x 8 x 4.5 in. Gift of the Friends of LSU Museum of Art. LSU Museum of Art, 84.14. Photographer: Kevin Duffy, Information Technology Services.

References Poesch, Jessie. "Newcomb Pottery and Crafts." In *Collecting Passions: Highlights from the LSU Museum of Art Collection*, ed. Donna McAlear. Baton Rouge: LSU Museum of Art, 2005. 92–102.

Poesch, Jessie, and Sally Main. *Newcomb Pottery & Crafts: An Educational Enterprise for Women, 1895–1940.* Atglen, PA: Schiffer, 2003.

Poesch, Jessie, Sally Main, and Walter Bob. *Newcomb Pottery: An Enterprise for Southern Women.* Exton, PA: Schiffer, 1984.

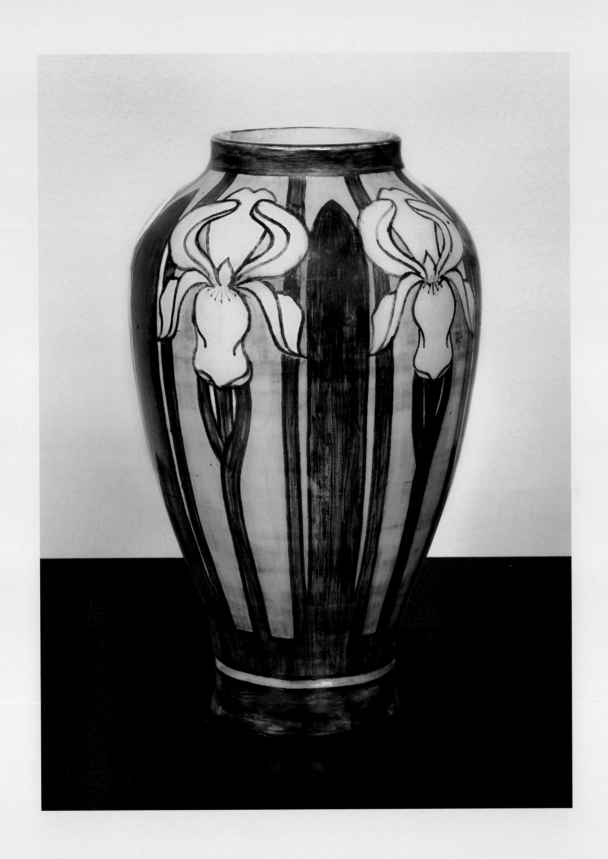

Bourbon Street, New Orleans
Lithograph by Caroline Durieux

The scene is a nightclub on Bourbon Street filled with sailors and soldiers listening to the performance of two female singers. The singers radiate the lively rhythm of the popular 1940s swing music. A strategic port, New Orleans often played host to servicemen seeking rest and relaxation before going to war. The stars on the sleeve and bodice of the left-hand singer are an obvious reference to the American flag. The atmosphere is joyous and optimistic about the country's prospects for victory in this new world war.

In 1942, the New York Graphic Society sent an exhibition called "Artists for Victory" throughout the South Pacific. Among the artists asked to participate was Louisiana printmaker Caroline Durieux (1896–1989), who contributed the lithograph *Bourbon Street, New Orleans*. The wife of the commander of a PT boat (a motor torpedo boat) eventually bought the print and presented it to her husband, who carried it with him throughout his tour of duty.

This print is one of over two hundred by Caroline Durieux owned by the LSU Museum of Art. Many were donated by the artist herself, who taught in the university's School of Art for many years. The museum's collection represents the full scope of a remarkable career, from Durieux's early, satirical images of New Orleans high society to her later, experimental work. Born and reared in New Orleans, Durieux studied art at Newcomb College with Ellsworth Woodward (1861–1939) and at the prestigious Pennsylvania Academy of Fine Arts. In the 1920s, she and her husband, Pierre Durieux, lived in Cuba and Mexico. She became part of the influential Mexican printmaking movement and a friend of muralist Diego Rivera (1886–1957). There she studied the customs of the Mexican upper classes and the Americans in their midst.

After Durieux returned to the United States, her work continued to express biting social commentary, which she softened through satire. She was the director of the Louisiana Federal Art Project of the WPA and an influential member of the local arts community. During the two decades she spent as a professor at LSU (1942–1963), Durieux continued to work with traditional graphic techniques such as lithography. It was her experimentation with methods to produce prints, however, that became her greatest contributions to the art world. In 1952, she

ABOVE: Photograph of Caroline Durieux during the late 1970s. Photographer: Jim Zietz, Office of Communications and University Relations. RIGHT: Caroline Wogan Durieux (American, 1891–1989). *Bourbon Street, New Orleans*, 1942. Black lithograph on paper. 10 x 10 in. Gift of the artist. LSU Museum of Art, 68.9.18. Photographer: Kevin Duffy, Information Technology Services.

invented a way to create prints using a radioactive ink. At the same time, she explored a technique favored by the Barbizon painters called *cliché verre*. This is a method of printmaking on a transparent surface that affords variety of shading and line. Durieux perfected a method for adding color.

Throughout her career, Durieux addressed social concerns ranging from war and hunger to the use of recreational drugs and environmental destruction. A dedicated teacher, she left her legacy in the continuing tradition of printmaking at LSU. *Bourbon Street, New Orleans* is just one example from the extensive collection of Durieux's works at the LSU Museum of Art.

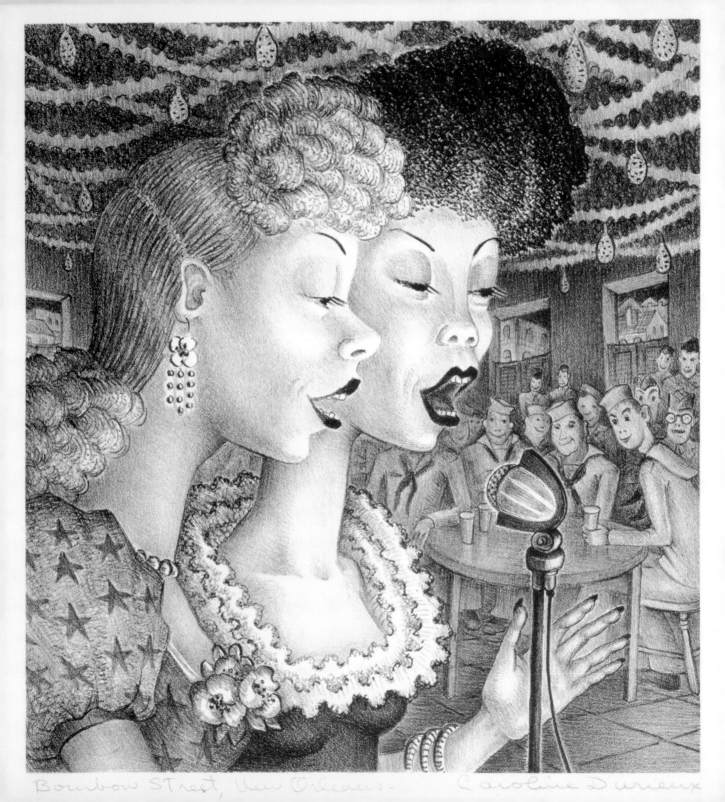

Bourbon Street, New Orleans. Caroline Durieux

Blues Poem

Woodblock Print by John T. Scott

New Orleans is the only city that I've been in that if you listen the sidewalks will speak to you.

—John T. Scott, radio interview, 2002

A stop sign sinks behind the grille of an upturned car, and caution signs warn the viewer against approaching the precariously piled wreckage of a once-vibrant city. In 2002 and 2003, African American artist and New Orleans native John T. Scott (1940–2008) expressed his concerns over urban violence and inner-city decay in a series of large-format woodcuts. Called collectively *Blues Poem for the Urban Landscape*, the prints show mass destruction of deserted city neighborhoods with buildings in decay and the accessories of modern life reduced to heaps of rubble. Two years later, Scott's Gentilly neighborhood in New Orleans laid waste by Hurricane Katrina's floodwaters and his studio ransacked by copper thieves, these prints took on a new meaning. Instead of urban violence and ruin brought on by neglect, the prints seemed to predict the violence of Katrina's winds and the destruction caused by outdated levees.

The LSU Museum of Art purchased *Blues Poem for the Urban Landscape: Stop Sign* (2003) shortly after John Scott's death in 2008. The woodblock print is an arresting image that seems to plead with the viewer for a cessation to the destruction surrounding the stop sign, a symbol of order. There is a pile of debris under a balcony including automobile parts and architectural elements such as shutters and street lamps. The print's large size, over three feet tall and five feet wide, adds to its impact. Scott used a chainsaw to force the image out of the woodblock. In a 2004 interview he explained: "It dawned on me that the only time you can have control over anything is when you realize you don't have control. So I chose the chainsaw. I wanted to give up the facileness that I know I have with tools to get a combination of material and tool that was not that compatible and not that easy to control."[1]

Few Louisiana artists have attained the national acclaim of John T. Scott without leaving home. He is best known for his sculpture, from wall-hung, multicolored kinetic pieces to house-sized public monuments. He was also a painter and a printmaker. His inspiration came from the music and the black culture of New Orleans, particularly the blues and jazz. He left the city to earn his M.F.A. at the University of Michigan, then returned to teach at his undergraduate alma mater, Xavier University, for forty years. He won many awards during his career, including the distinguished John D. MacArthur Fellowship in 1992.

While Scott's art was always accessible, he was an intellectual artist who studied cultures, not only that of New Orleans but also his ancestral culture in Africa. His explanations of his subjects can lead you into anthropological studies of Yoruba tradition, the philosophy of improvisational jazz or contemporary trends in American "gangsta" rap, or political debates over inner-city youth crime. This multicultural fusion of past and present in Scott's work is as New Orleanian as the artist was himself.

—Victoria Cooke

RIGHT: John T. Scott (American, 1940–2008). *Blues Poem for the Urban Landscape: Stop Sign* (c. 2003). Woodcut. 4/10, 39.25 x 59.25 in. Purchased with funds from the Friends of LSU Museum of Art Endowment Society and members of the LSU Museum of Art Advisory Board and staff. LSU Museum of Art, 2008.1. Photographer: Kevin Duffy, Information Technology Services.

Note 1. "Playing It Straight, Upside-Down, and Backwards: A Conversation with John Scott," interview by Hilary Stunda in *Sculpture* (October, 2004): 36–37.

LIBRARIES AND LITERATURE

Bonaparte's *l'Égypte* and Other Rare Items

Description de l'Égypte
Napoleon's Recorded Findings

Napoleon Bonaparte's (1769–1821) occupation of Egypt between 1798 and 1801 was a colonial conquest that endeavored to bring the Enlightenment to the Orient. The French invasion was justified exclusively by the assumed superiority of the Western value system, "liberating" the Orient from the yoke of barbaric Islamic despots.

For the first time in military history, an army set forth with academic as well as martial intentions. For this purpose, more than 160 scholars were selected to accompany the army to Egypt. They would later form the Institute of Egypt (Institut d'Égypte) in Cairo, many members of which would subsequently work on the completion of the *Description*, the first comprehensive survey (cultural, geographical, and social) of Egypt ever undertaken.

In August 1799, Bonaparte and a select few of his generals departed secretly from Alexandria to return to France, where they were celebrated and shortly thereafter overthrew the Directory government. The French expedition to Egypt itself ended in a humanitarian disaster and a military defeat. However, it proved to be a powerful influence upon nineteenth-century European culture. France embraced a fashion for all things Egyptian, which only deepened the Orientalist stereotypes held by the West and shifted attention away from the abandoned soldiers and the failure of the Egyptian expedition. This enthusiasm for Egyptian paraphernalia became known as "Egyptomania."

Bonaparte realized the political potential of Egyptomania and decided to use it to recast the outcome of the expedition. He ordered a large-scale project to publish all the recorded findings of the scientists and scholars who had accompanied him to Egypt. These documents were collected into a huge luxury edition, which appeared between 1809 and 1822 under the title *Description de l'Égypte*. The *Description* was made up of some twenty volumes, half of which contained mostly oversized engravings, which were explained in accompanying text volumes. Despite its being a monument to Napoleon's megalomania, the *Description* was completed under his successor, the Bourbon king Louis XVIII.

Only one thousand copies of the *Description* were printed in the first edition, and complete sets are exceedingly rare today. LSU owns all the volumes of plates, drawn exclusively from the precious and historically important first edition. LSU's copy of the *Description* includes many hand-colored prints, which were produced for only a few discerning collectors as a special edition.

Nothing specific is known about the provenance of the LSU set of the *Description*. Hill Memorial Library's records show that the volumes already belonged to the university in the nineteenth century, and they may have been part of the very first holdings of LSU's library. Given the strong ties that have always existed between Louisiana and France, it is plausible that the volumes were brought to Louisiana directly from their country of origin by private individuals around the middle of the nineteenth century and were subsequently given to the library.

—Darius A. Spieth

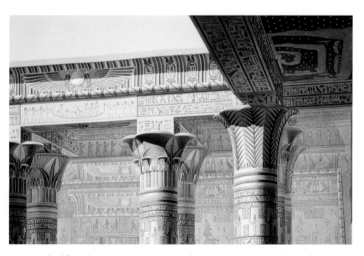

ABOVE: A detail from the *Vue perspective intérieure coloriée, prise sous le portique du Grand Temple*. Photographer: Kevin Duffy, Information Technology Services.

Reference Russell, Terence M., ed. *The Napoleonic Survey of Egypt: Description de l'Égypte: The Monuments and Customs of Egypt. Selected Engravings and Texts*. Aldershot, UK: Ashgate, 2001.

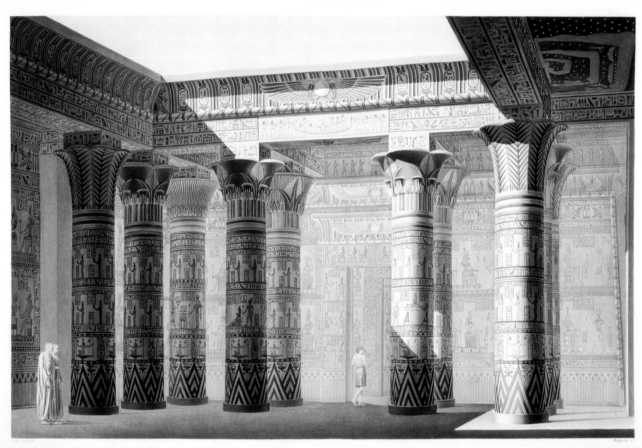

ABOVE: Jean Baptiste Le Père (French, 1761–1844). *Vue perspective intérieure coloriée, prise sous le portique du Grand Temple* [The Hypostyle of the Main Temple of Philae, Perspective View] (c. 1809). Color engraving. 35.6 x 54.5 cm. Hill Memorial Library, Rare Flat DT46 F8. Photographer: Kevin Duffy, Information Technology Services.

141

The Book Beautiful
Doves Press Bible

The whole duty of Typography, as of Calligraphy, is to communicate to the imagination, without loss by the way, the thought or image intended to be communicated by the Author.

—T. J. Cobden-Sanderson, *The Ideal Book or Book Beautiful*

Printed on creamy hand-made paper, with striking calligraphy, an elegant typeface, and a spare design, the five-volume Doves Press Bible, completed in 1905, is a beautiful and desirable book. Coveted by collectors and connoisseurs, it exerted tremendous influence on contemporary book and type designers such as Bruce Rogers (1870–1957) and Eric Gill (1882–1940), who in turn still influence typography and graphic design today.

The nineteenth century saw a remarkable change in the technology of book production. Rising literacy increased the demand for books, while the mechanization of printing, papermaking, and bookbinding made it possible to produce large quantities of inexpensive books rapidly. Cheap, acidic wood-pulp paper replaced the durable, hand-made rag paper which had been the norm during the first four hundred years of book printing. The quality of printing, design, and binding materials often suffered.

Against this backdrop, a countering movement developed. In England, a group of artists, craftsmen, and social reformers reacted against the human consequences and mass-produced products of the industrial revolution. William Morris (1834–1896), a member of the Pre-Raphaelites, was foremost among them. His founding of the Kelmscott Press in 1891 both inspired and brought considerable attention to a group of typographers and craftsmen, including Emery Walker (1851–1933) and T. J. Cobden-Sanderson (1840–1922), who in 1900 founded their own press, called "Doves" after Doves Place, where their offices were located in Hammersmith on the Thames River. Like Morris, they turned away from mechanization and back to the technology of hand-set type, printed using a hand press on hand-made paper. In his manifesto on the Doves Press and Bindery, Cobden-Sanderson articulated the results they sought: "the creation of the Book Beautiful, a threefold symbol of the universe, of order and delight."[1]

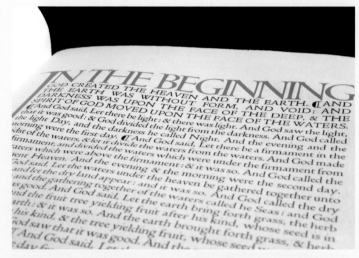

ABOVE: The first page of Genesis as printed in the Doves Press Bible. Photographer: Kevin Duffy, Information Technology Services.

Certainly the Doves Press Bible approaches that ideal. In his book *The Private Presses*, Colin Franklin asserts that Cobden-Sanderson was "alone among the arts-and-crafts printers—perhaps among any in the five centuries of printing—in seeing so seriously the link of idealism between a finely made book and religious thought." On December 11, 1898, Cobden-Sanderson wrote in his journal, "I must, before I die, create the type for to-day of 'The Book Beautiful,' and actualize it—paper, ink, writing, printing, ornament and binding." Creating a new typeface was the first step. Based on Nicholas Jenson's fifteenth-century types used in Venice, each individual letter of the Doves type was painstakingly drawn, revised, cut, and cast in 1898 and 1899. For decoration, Cobden-Sanderson enlisted the help of Edward Johnston (1872–1944), the remarkable artist who led the modern revival of calligraphy and whose work includes the sans-serif alphabet used for the London underground railways. Relief metal engravings made from Johnston's calligraphy were used to print the book, which appeared in a limited edition of five hundred copies on paper, all of which were sold before the book was completed. As Marian Tidcombe wrote in her book on the press, "The opening page of *The English Bible* has received more praise than any other

ABOVE: T. J. Cobden-Sanderson and Emery Walker. *The English Bible* (c. 1903). Five-volume Bible printed at the Doves Press in Hammersmith, England, bound in limp vellum. Hill Memorial Library, Rare BS185 1903 H3 1903 FLAT. Photographer: Kevin Duffy, Information Technology Services.

page printed at the Doves Press, and it is admired as much today as it was a hundred years ago."

Sadly, Cobden-Sanderson fell out with Emery Walker. With the dissolution of their partnership in 1908, Walker claimed half interest in the beautiful Doves type. Cobden-Sanderson resolved to destroy the type rather than let its use pass out of his control. In his journal entry for June 11, 1911, he wrote: "To the Bed of the River Thames, the river

on whose banks I have printed all my . . . books, I bequeath The Doves Press Fount of Type . . . and may the river in its tides and flow pass over them to and from the great sea for ever and for ever."

—ELAINE SMYTH

Note 1. Reprinted in Marianne Tidcombe, *The Doves Press* (London: British Library, 2002), 1–2. Subsequent quotations in this essay are from the same source, 13–14.

The World as It Once Was

Dunn Atlas

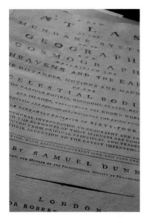

ABOVE: The opening page of the Dunn Atlas. Photographer: Kevin Duffy, Information Technology Services.

Because of the generosity of a former instructor and cartographer, LSU has an extraordinary atlas dating to the late eighteenth century. Published in 1787, the *New Atlas of the Mundane System* (2nd ed.) testifies to the exquisite beauty of hand-engraved cartography and provides a window into the century's geographic understanding. The work of famous American cartographer Samuel Dunn (1723–1794), the volume features a thirteen-state America, leaving most of the continent blank. Baton Rouge is vaguely demarcated as part of Spanish Florida; New Orleans is located in French Louisiana.

Housed in Hill Memorial Library, the atlas is intact despite its age. Its front and back covers are still attached. The volume includes forty-two plates of the known world and several solar system diagrams based on Newtonian calculations. Maps are delicately printed in black, while country and state borders are outlined by hand in colored ink. The result is a remarkable piece of art, as well as collection of maps.

LSU faculty member Philip Larimore, Jr. (1925–2003), donated the atlas to the LSU Department of Geography and Anthropology in 2001. Larimore came to LSU as a student and remained as an instructor of hand cartography. A World War II veteran, he was one of Louisiana's most decorated army officers. The story goes that Larimore visited the department's Cartographic Information Center six years after his retirement in 1995. He left a pile of old and new maps on a table, asking a graduate student to "take care of them." Among the charts was this invaluable atlas. Larimore never pointed it out or said a word about it.

Perhaps because it was printed in London, the atlas features several maps of England and the British Isles. It includes a clear outline of various European states but leaves a largely vacant Africa with sketches of Egypt, Ethiopia, and Abyssinia. The volume virtually ignores Canada's western and northern territories and refers to Australia as "New Holland." Attesting to the era's interest in religion, it pays particular attention to the Middle East, home of the Holy Land. There is also a map of countries named in the New Testament.

Samuel Dunn was an astronomer, geographer, cartographer, writer, and teacher of mathematics and navigation. It is not clear whether he himself drew the volume's maps or commissioned a local artist to do so. Although a Philadelphia native, Dunn spent most of his life in London, where he established his own school and worked with the East India Company. He is credited for several inventions including the sextant, an instrument that helps navigators determine their location in reference to stars. One of his finest works, the *New Atlas of the Mundane System*, appeared in at least six editions—the last in the early nineteenth century. The atlas owned by LSU comes from the second edition.

Robert Sayer (1724/5–1794), the atlas's publisher, was an equally famous man. Known for producing pictures of British royalty, he used a printing press comparable to the technology Benjamin Franklin operated. To print the atlas, he worked on each paper separately, later attaching the various maps together. He inked the large copper plates, where borders and rivers were carved by hand in reverse, covered each with a large blank paper, and pressed with a giant press. Indentation from the heavy bronze plates still shows on the atlas pages today.

—Yasmine Dabbous

References "A New Atlas of the Mundane System." Philadelphia Print Shop Web page.
"Robert Sayer." National Portrait Gallery Web page.
"Samuel Dunn." Heard Family of Mid-Devon Web page.

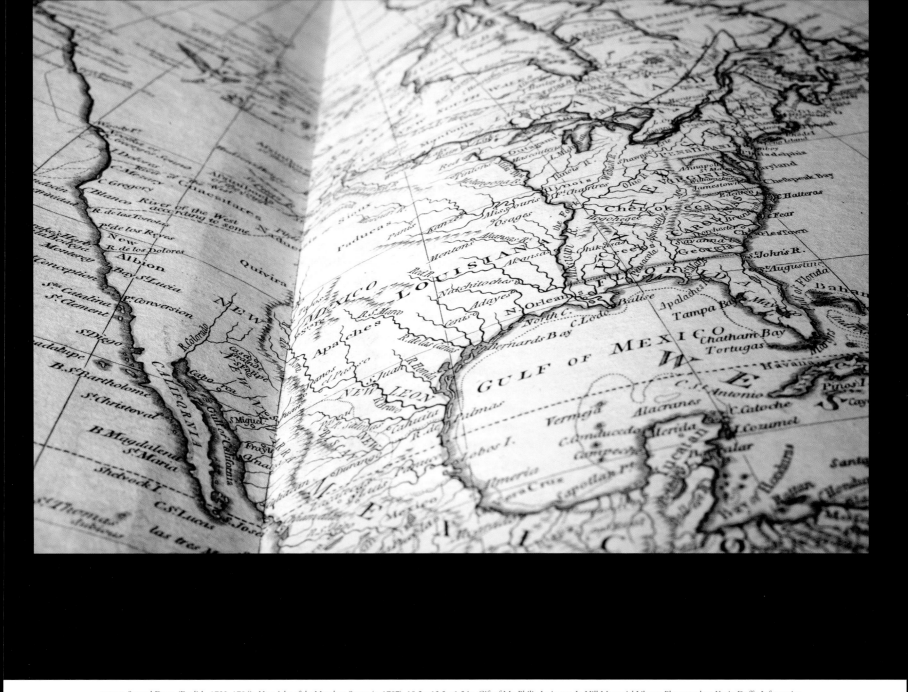

Barthélémy Lafon, *Arpenteur*
Survey of the Widow St. Maxent's Land, 1804

Barthélémy Lafon (1769–1820) executed this beautiful watercolor drawing to illustrate his 1804 survey of the Widow St. Maxent's land, located in present-day Ascension Parish. Using a form preprinted in French and English, he filled in the technical facts of the survey only in French, added the watercolor, and signed it on the second page with a flourish. Though many survey documents include pen-and-ink drawings of the plot surveyed, few include such artistic and colorful renderings. Lafon depicted not only the physical features of the land and buildings but also land use and vegetation, providing fascinating information for historians, geographers, and anthropologists.

A native of Villepinte, France, Lafon immigrated to New Orleans in about 1790. An architect, city planner, engineer, and surveyor, he was also a politician and public figure of importance, who had by 1813 amassed a fortune of more than $175,000. Surprisingly, after 1812, he was associated with the pirate Jean Lafitte, and captained his ship, the *Carmelita*, when she sailed from New Orleans to Galveston, presumably carrying supplies for Lafitte's encampment there. Having squandered his wealth, Lafon died in New Orleans of yellow fever, in 1820 at the age of fifty-one.

In 1804, Lafon was serving as a deputy surveyor appointed by Isaac Briggs, Esq., when he surveyed the land of Elizabeth La Roche de St. Maxent, the widow of Gilbert Antoine de St. Maxent. Acting at the behest of Governor Bernardo de Gálvez, Gilbert Antoine de St. Maxent had created a settlement for Isleños (immigrants from the Canary Islands) at the junction of the Amite River and Bayou Manchac. Called Galveztown, the settlement was destroyed by flooding in the early 1800s. The present-day community of Galvez, Louisiana, is located just west of the original Galveztown.

Lafon's beautiful survey represents a larger treasure held by LSU: the Louisiana and Lower Mississippi Valley Collections (LLMVC).

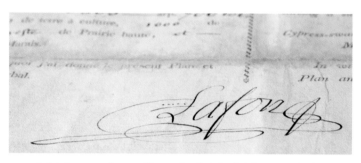

ABOVE: Lafon's signature on the survey. Photographer: Kevin Duffy, Information Technology Services. Scan courtesy of LSU Libraries.

One of the nation's premier collections of regional history materials, LLMVC includes millions of original historical documents: letters, diaries, and records of plantations, merchants, banks, and other businesses and organizations. In addition to manuscripts, LLMVC includes more than 120,000 volumes of books and periodicals, as well as maps, a comprehensive collection of Louisiana newspapers, more than 200,000 historic photographs, and 3,000 hours of oral histories, created by the T. Harry Williams Center for Oral History. The collections continue to grow as curators seek out materials that document not only the distant but also the recent past. Although most manuscript materials are gifts from donors seeking a safe home for documents they treasure, the Lafon survey was purchased with income from an endowment funded by the Friends of the LSU Libraries.

When he created the Widow St. Maxent's survey, Barthélémy Lafon was probably focused purely on the job at hand and took an artist's pleasure in making beautiful what could have been a quotidian legal document. An ambitious man, he would no doubt be pleased that we enjoy and use his work today.

—ELAINE SMYTH

References Conrad, Glenn, ed. *Dictionary of Louisiana Biography*. Lafayette, LA: Louisiana Historical Association in cooperation with the Center for Louisiana Studies of the University of Southwestern Louisiana, 1988.

Galveztown Papers. Mss. 890. Louisiana and Lower Mississippi Valley Collections, LSU Libraries, Baton Rouge, LA.

Olson, R. Dale. "French Pirates and Privateers in Texas," in *The French in Texas: History, Migration, Culture*, ed. François Lagarde. Austin: University of Texas Press, 2003. 67–68.

Daniel Clarck

E P

S. 24. E. 100 A

Bayou See

Vacherie

Chemin de Galvez a Manchac et Yberville

S. 4. E. 100 t

Veuve de S.¹ MAXENT.

5365 A 700 toi

Champs de Cotton

Antonio Veles, P. Gonsales,

Bn Gonsales,

Chemin du Baton Rouge Galvez

B Borne M
A o

Bayou d'Yberville ou Akankia,,

Echelle de Arp. ou Toises English Acr. or Fathoms.

QUARTIER. DE GALVESTON AKAKIA RIVE DROITE

The Elephant Folio

Birds of America, by John James Audubon

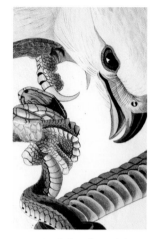

ABOVE: Detail of *Swallow-Tailed Hawk*. Photographer: Kevin Duffy, Information Technology Services.

A gifted artist and natural storyteller, John James Audubon was also by all reports a charming and vivacious man. Since his death in 1851, the influence of his masterwork, *Birds of America*, has transformed him into an iconic figure in American culture. His name is everywhere: the National Audubon Society, named in his honor and dedicated to birds and bird conservation, has more than five hundred chapters across the country. Throughout the nation, and especially in Louisiana, prints copied from the artist's magnificent double elephant folio edition of *Birds of America* are proudly displayed in homes and offices.[1]

Relatively few people, however, have had the experience of seeing the original work. Published in four volumes in London between 1827 and 1838, the first edition consists of 435 aquatint engravings, each hand colored in watercolor. LSU is fortunate to possess one complete copy of the original edition of Audubon's masterpiece, which it shares with the public twice yearly on "Audubon Days."

The work has always been a great treasure. Because it was issued by subscription over a period of eleven years, the total number of copies produced is unknown, but is estimated to be between 175 and 200. Of those, 134 are extant, 53 of them in the United States. LSU is one of twenty-six colleges and universities to possess an original edition. Purchased in 1964 with funds provided by Crown Zellerbach Foundation and housed in Hill Memorial Library, it was first owned by Hugh Percy, third Duke of Northumberland (1785–1847), who had each of the four volumes handsomely bound in leather, each bearing his bookplate.[2]

Born in 1785 on Saint-Domingue (now Haiti), Audubon was reared in France, where he first enjoyed the outdoors and drawing birds. In 1803, his father sent him to America to escape conscription in Napoleon's army. He soon wed and became a successful merchant in Henderson, Kentucky, but after the economic recession of 1819 forced him into bankruptcy, he turned his energies to creating a "complete ornithology of America."

It is not surprising that Louisianians have a special affinity for Audubon's work. He drew dozens of birds in Louisiana, including an estimated twenty-three at Oakley plantation near St. Francisville, where, in 1821, he served as a tutor for four months.

Part of the genius of Audubon's drawings is his depiction of birds at life size and in lifelike poses. He broke with the tradition of bird illustration showing stuffed specimens in profile "accurate in fine detail but unrealistic and lifeless,"[3] instead using wires to arrange his freshly killed specimens in poses he knew they assumed in life. Often his birds appear to float in space, such as the swallow-tailed hawk (modern name: swallow-tailed kite), one of his most admired drawings and one made at Oakley.

—Elaine Smyth and Gresdna A. Doty

RIGHT: John James Audubon (American, 1785–1851). *Swallow-Tailed Hawk*, from *Birds of America* (c. 1827). 38 x 26 in. E. A. McIlhenny Natural History Collection, LSU Libraries, Baton Rouge. Photographer: Kevin Duffy, Information Technology Services.

Notes 1. The double elephant folio is so called because of the size of the paper on which it was printed: approximately 38 inches by 26 inches.

2. Students of Shakespeare will recognize the names Percy and the Duke of Northumberland, figures prominent in his history plays.

3. Richard Rhodes, *John James Audubon: The Making of an American* (New York: Knopf, 2004), 11.

References Fries, Waldemar. *The Double Elephant Folio: The Story of Audubon's Birds of America*. Chicago: American Library Association, 1973.

Heitman, Danny. *A Summer of Birds: John James Audubon at Oakley House*. Baton Rouge: LSU Press, 2008.

Rhodes, Richard. *John James Audubon: The Making of an American*. New York: Knopf, 2004.

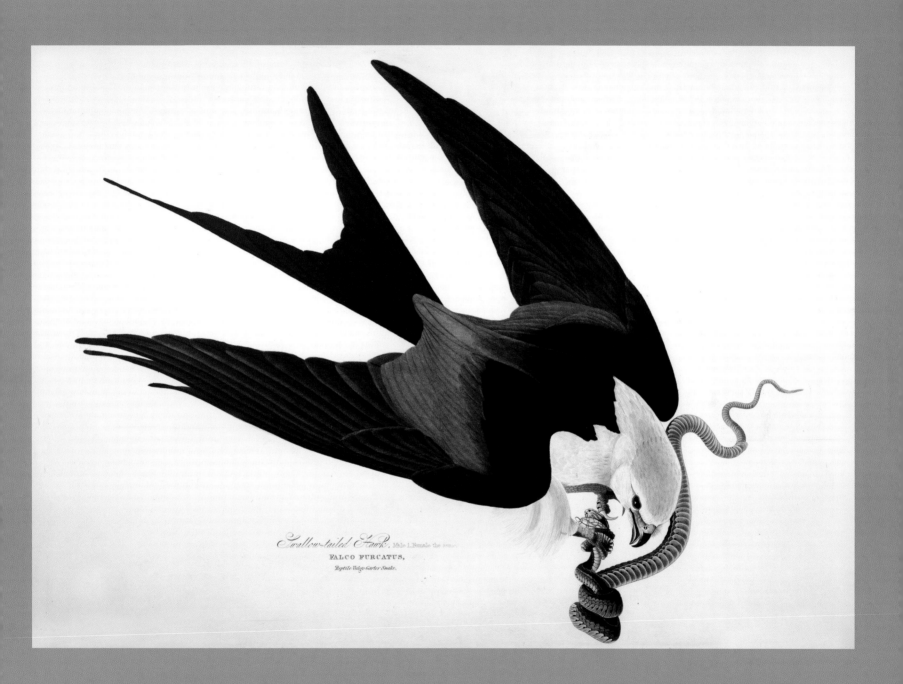

Swallow-tailed Hawk. Male 1. Female the same.

FALCO FURCATUS,

Reptile Vulgo Garter Snake.

La Petite Édition
Sketches by John James Audubon

When John James Audubon (1785–1851) returned to the United States following the successful publication of his double elephant folio *Birds of America*, he began work on publishing a smaller and less expensive version, which he hoped would provide the elusive financial support for his family that the large edition of *Birds*, despite critical acclaim, had failed to generate. The *Petite Édition*, as he dubbed it, was to be a book of lithographs produced in the size known as "royal octavo," measuring about 11 inches high by 7 inches wide, whereas the original edition of engravings had measured 38 inches by 26 inches. Sold by subscription, it cost one hundred dollars in contrast to the folio engraved edition, which had cost one thousand dollars.

Various artists made hundreds of drawings to create the five hundred plates of the *Petite Édition*. Today, a collection of thirty-two drawings, as well as some proofs of lithographs, forms part of the E. A. McIlhenny Natural History Collection at Hill Memorial Library, LSU. Among them is a drawing of the western meadowlark, one of the new birds that Audubon had observed on his travels in the western United States during the 1830s and added to the *Petite Édition*. Shown here is Audubon's own beautiful and delicate original pencil drawing, along with an uncolored proof of the lithograph also found in the archive, and the finished, colored lithograph as it was published in the first octavo edition.

Other artists also produced drawings for the reduced version of *Birds*, often working with the aid of a *camera lucida*. This mechanical device uses a prism to project a reduced (or enlarged) version of an image to be copied by an artist, who can trace the outlines of the original. Various people worked on the project, but Audubon himself lent a hand and made original drawings of added birds, whose portraits had not appeared in the first edition of *Birds*.

The provenance of the McIlhenny Collection's archive of drawings can be traced back to the noted book collector H. Bradley Martin, who purchased it sometime during the twentieth century. Heir to a steel fortune (he was the grandson of Henry Phipps, a partner of Andrew Carnegie), Martin was a fanatic collector, especially of ornithological books. After his death in 1988, his collection was sold at auction by Sotheby's in 1989. Amidst 10,000 rare and notable volumes, including Audubon's autograph journals from 1826, this small archive of materials attracted little attention. W. Thomas Taylor, bookseller and publisher in Austin, Texas, purchased it with the idea of using the drawings and proofs to create deluxe copies of a book he planned to publish on the *Petite Édition* written by art historian Ron Tyler. However, when Tyler studied the drawings, he realized that, in fact, thirteen could be attributed to Audubon himself. Based on Tyler's assessment, Taylor decided it would be preferable to keep the materials together rather than dispersing them. Given Audubon's connection with Louisiana (he lived and worked here during a crucial period of work on the *Birds of America*) and the E. A. McIlhenny Natural History Collection's focus on ornithology, LSU seemed a natural home for the collection. With the help of the Friends of the LSU Libraries, the Libraries purchased the materials for the McIlhenny Collection, where they now reside.

—ELAINE SMYTH

RIGHT: John James Audubon (American, 1785–1851). At upper left is the original drawing of the western meadowlark (c. 1840), pencil on paper. At upper right is the proof of the lithograph before it was colored; in the foreground is the final, colored lithograph as it appeared in the first edition of the octavo *Birds of America*. John James Audubon Collection, E. A. McIlhenny Natural History Collection, LSU Libraries, Baton Rouge. Photographer: Kevin Duffy, Information Technology Services.

References Reif, Rita. "Library of 10,000 Rarities to be Sold at Sotheby's." *New York Times*, December 21, 1988. Sec. C, p. 34, col. 1.

Taylor, W. Thomas, personal communication, Spring 1992.

Tyler, Ron. *Audubon's Great National Work: The Royal Octavo Edition of "Birds of America."* Austin: University of Texas Press, 1993.

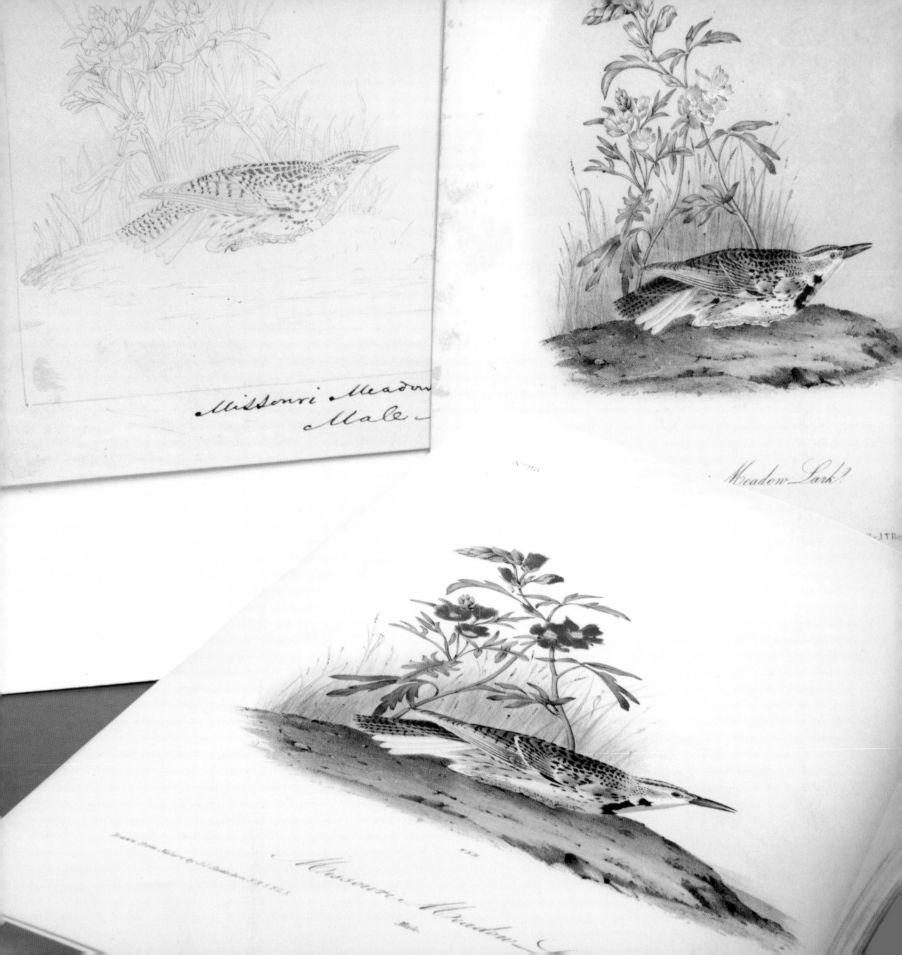

Missouri Meadow
Male

Meadow Lark?

J.T.Bo...

Missouri Meadow...
Male

Her Hands Tell a Story

Portrait of an African American Woman

She stands looking at the camera, tall and stiff as the fence post she rests her hand upon. Her expression tells us little in its neutrality. Her hands and clothing tell us more about her life than anything else in the image. Questions immediately come to mind when viewing this rare studio portrait of a poor African American woman created around 1875: Who is this woman? How did she come to stand for a photographic portrait in this artificial country setting? How did she pay for her portrait? Did someone·else pay for it and why? Fortunately, this image, and thousands more, exist as part of a larger whole, a whole that provides context and, through that context, answers to some of the questions.

We will probably never know the name of this woman, as the nineteenth-century studio business records, if any, did not survive the rigors of time. We do know, roughly, when the image was created (c. 1875) through contextual clues in the picture itself and through comparing it to other, dated images in the same collection created in the same studio setting. We know which studio created the image (Norman Studio, Natchez, Mississippi), though we do not know which operator in the studio actually shot this image. We have no way of knowing the how and why of this portrait except through inference. Nonetheless, the image itself is powerful, the subject riveting.

This photograph is part of one collection among the many in the LSU Libraries' Special Collections. Dr. Thomas Gandy (1921–2004), an LSU alumnus, Natchez family physician, and avid supporter of historical preservation efforts, discovered the remains of the Norman Studio in 1961, nearly ten years after it had closed. The negatives, relatively few prints, and some twentieth-century studio records had been stored, semiprotected, outside the home of the studio owner's widow. Working out of their home in Natchez, for nearly thirty years Dr. Gandy and his wife, Joan Gandy, worked to preserve, protect, and disseminate as many of the images as they possibly could. Their efforts resulted in a number of publications and a traveling show of prints exhibited in the United States and London. The Gandys donated the first portion of the collection to the LSU Libraries in the late 1980s, and within one year of Dr. Gandy's death, his heirs sold the remaining portion to the Libraries in 2003.

The Gandys helped preserve one of the best collections of southern studio photography in the United States. The Gurney brothers established the studio in Natchez in the 1840s. Sadly, none of their earliest work survives. The earliest images we have are a relatively small number of glass negatives from the late 1850s through the early 1870s, when the one surviving Gurney brother sold his failing studio to Henry Norman, a camera operator who worked for him beginning in 1870. Norman prospered in business, eventually passing the studio to one of his sons, Earl. After his father's death, Earl ran the studio until his own death in 1951.

As a result, we have a nearly one-hundred-year photographic record of the people, places, and life of Natchez, Mississippi, from the time before the Civil War, when it served as home to more millionaires per capita than New York City, through the war and Reconstruction, and into the twentieth century. We may look upon scenes, events, and faces long past, and in doing so learn more about our past than would have been thought possible.

—MARK E. MARTIN

RIGHT: Portrait of African American Woman (c. 1875). Photograph by the Norman Studio, Natchez, MS. Lemuel Parker Conner and Family Papers, Mss. 1403, Louisiana and Lower Mississippi Valley Collections, LSU Libraries, Baton Rouge. Photographer: Kevin Duffy, Information Technology Services.

References Accession file, Thomas H. and Joan Gandy Photographic Collection. Mss. 3778. Louisiana and Lower Mississippi Valley Collections, LSU Libraries, Baton Rouge.

Photograph of unidentified African American woman (c. 1875). Lemuel Parker Connerand Family Papers, Mss. 1403. Louisiana and Lower Mississippi Valley Collections, LSU Libraries, Baton Rouge.

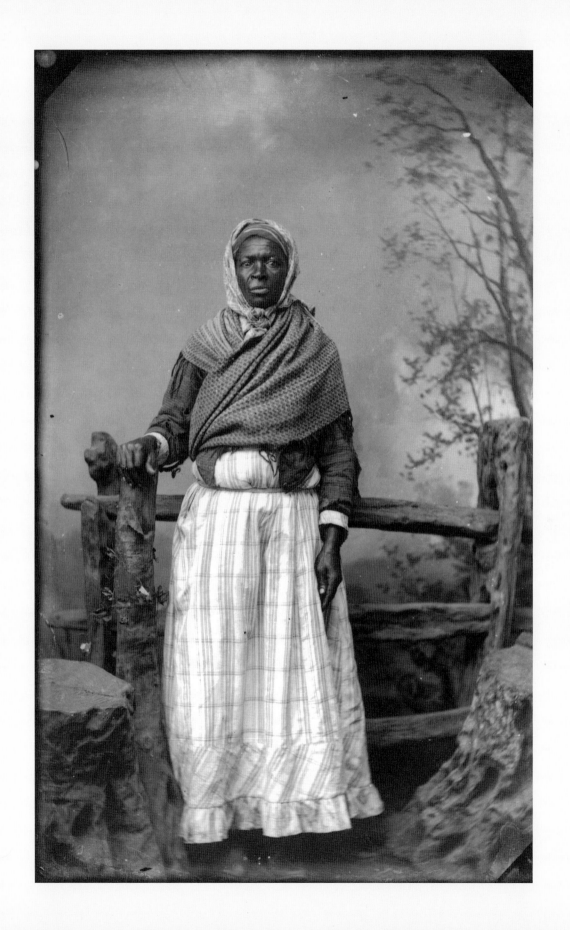

"Impossible for a Rich Man"
Huey Long's Bible

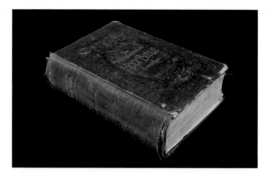

Huey Long's Bible, heavily annotated in Long's own hand, is a fascinating document concerning the powerful Louisiana governor assassinated in 1935. Long's Share Our Wealth plan sought to redistribute wealth for all Americans, taking from the rich and giving to the poor. Long (1893–1935) has never lacked for critics, who condemned his dictatorial abuse of power; supporters believed he would provide economic relief for every poor person in America. Huey Long's Bible cannot answer questions about whether redistribution of wealth was feasible in depression America, nor can it tell us if Long was deeply religious. But the Bible is heavily marked, including the title page and the front and rear endpapers, so that we can see that indeed Long read the Bible. His frequent references to specific biblical chapters and verses were made with surprising care, a care that carried over to national radio broadcasts. Long often introduced particular passages, quoting accurately the chapter and verse, almost always to demonstrate that the Bible condemned those with great wealth, or—in his interpretation—that the Bible supported redistribution of wealth.[1]

Long's son Russell, longtime U.S. senator, recalled his father's biblical references and their impact on his listeners. He recounted the story that in New Orleans, "whenever Huey was on the air, this guy would always insist on writing down immediately the chapter and verse cited by Huey in his sometimes lengthy radio programs."[2] Huey's Bible is part of the Devol Papers at the Hill Memorial Library. H. Don Devol (1906–1994) had been Long's Washington office manager. A 1982 oral history interview with Devol is found in the T. Harry Williams Oral History Collection.[3] Devol provided an important source for Long's biblical knowledge: Sixteen typewritten pages (showing extensive use) of biblical excerpts relating to redistribution of wealth and condemnations of the wealthy, assembled by Ben Loyd, a former Baptist minister whom Huey put on his payroll. Printed transcripts of Long's national NBC radio addresses are found in the Devol Papers as well, such as "Our Plundering Government," broadcast all over America on February 10, 1935: "Now that is the Bible. Maybe you don't think so. Wait a minute, I will give you a little more. St. Matthew, chapter 19, verse 24: 'it is easier for a camel to go through the eye of a needle, than for a rich man to enter into the Kingdom of God.' . . . it is practically impossible for a rich man to enter heaven."

Huey Long was reared a Baptist but did not attend church as an adult. His profanity and occasional drunken behavior did not fit with the image of a pious person. Nevertheless, whether to look for biblical parallels or simply to appear devout to his listeners, Long spent more time reading the Bible than many people much more faithful in church attendance. Long's heavily marked Bible is a perhaps surprising but fascinating treasure in the Devol Papers at LSU.

—David Culbert

Notes 1. The Year of Jubilee, which did not call for redistribution of wealth but did enjoin priests to deal generously with the poor, is discussed in Bruce M. Metzger and Michael D. Coogan, eds., *The Oxford Companion to the Bible* (New York: Oxford University Press, 1993); see entries for "Book of Leviticus," 435–37; and "Slavery," 700–701.

2. "I recall a gentleman who enjoyed sitting around a little café named 'Ye Olde College Inn' on Carrollton St., in New Orleans." The individual is not identified by name. Letter from Russell Long to Rob Johnson, November 4, 1993, reproduced as an appendix to Johnson's honors' thesis, "Huey Long and Religion" (Louisiana State University, 1993).

3. I recorded the oral history interview with Devol in Washington, D.C., shortly before Devol's death. He asked me to take the Long Bible back to Louisiana to place in the LSU Archives. Devol said the Long family thought he had stolen Long's "Deduct Box," which allegedly contained very considerable sums, based on monthly deductions from every state employee's salary.

References Letter from Russell Long to Rob Johnson, November 4, 1993. Reproduced as an appendix to Johnson's honors' thesis, "Huey Long and Religion" (Louisiana State University, 1993).

Metzger, Bruce M., and Michael D. Coogan, eds. *The Oxford Companion to the Bible*. New York: Oxford University Press, 1993.

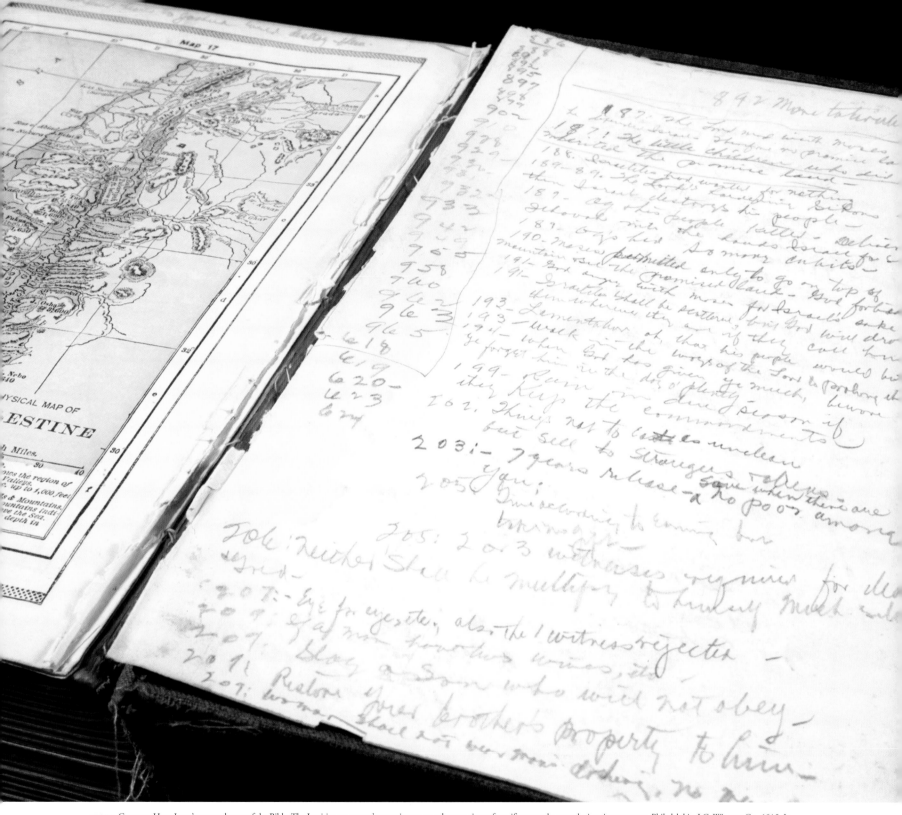

And American Letters Changed Forever

The Southern Review

ABOVE: Robert Penn Warren and Cleanth Brooks at the Faculty Club, LSU, in 1985. Photographer: Jim Zietz, Office of Communications and University Relations.

I n July 1935, LSU Press published the first issue of *The Southern Review*, and American letters were changed forever. The importance of *The Southern Review* was noted almost immediately. In 1936, in Morton Zabel's review of the journal which appeared in *Poetry* magazine, he deemed *The Southern Review* to have a competence "almost unrivaled at this moment in American Letters." A few years later, John Crowe Ransom observed that "*The Southern Review*'s five-year achievement is close to the best thing in the history of American Letters," and Charles Beard wrote, "The Review does honor to American intelligence."

Perhaps the most fascinating aspect of this first issue is its table of contents, which reads as a veritable who's who of important American writers. The list includes such illustrious authors and scholars as Ford Madox Ford, Katherine Anne Porter, John Peale Bishop, Wallace Stevens, Randall Jarrell, and Aldous Huxley, to name just a few. At the time of its inception, the four editors of *The Southern Review* were not particularly well known in either literary or academic circles, but as testament to their vision and ability to identify works of highest quality, the authors they selected are still anthologized and appreciated today.

This quarterly publication, conceived as a journal that would feature the best contemporary literature and critical thought of the day, is believed to have been the brainchild of LSU president James Monroe Smith. He approached Robert Penn Warren[1] (1905–1989) and Albert Erskine (1912–1993), who later became an influential top executive at Random House. In consultation with then–English Department faculty member Cleanth Brooks (1906–1994), they drew up a plan for and

LEFT: The first issue of *The Southern Review* (c. 1935). Photographer: Kevin Duffy, Information Technology Services.

also gave name to *The Southern Review*, which was quickly approved by President Smith.

The first issue of the journal was in an eight-by-ten-inch format and ran 208 pages. It sold for seventy-five cents a copy or for three dollars for a year's subscription. The paper, now yellowed, is of high quality, and the cover is thin cardstock. The operating budget for the journal's first year was ten thousand dollars. The masthead of this first issue lists Charles W. Pipkin (an LSU dean) as editor, Cleanth Brooks and Robert Penn Warren as managing editors, and Albert Erskine as business manager.

The first series of *The Southern Review* was discontinued in 1942. As Warren and Brooks note in their introduction to *An Anthology of Stories from "The Southern Review,"* published by LSU Press in 1953, "The War has begun, and the gravity of the crisis made some members of the administration of the university feel that there was no place for such a publication—that the funds and energies should be committed elsewhere." After a twenty-three-year hiatus, *The Southern Review* resumed publication in 1965 under the editorship of Lewis P. Simpson and Donald Stanford, and to this day strives to publish the best of emerging and established literary artists.

—JEANNE M. LEIBY

Note 1. Warren was later named U.S. poet laureate (1944–1945) and became a three-time Pulitzer Prize winner (1947 for *All the King's Men*, 1958 for *Promises*, and 1979 for *Now and Then*).

References Brooks, Cleanth, and Robert Penn Warren, eds. *An Anthology of Stories from "The Southern Review."* Baton Rouge: LSU Press, 1953.

Montesi, Albert J. "Huey Long and the 'Southern Review.'" *Journal of Modern Literature* 3, no. 1 (1973): 63–74.

A Half Million Words

An Approach to Literature and the LSU Press

In a February 1935 letter from LSU, where he had recently joined the English department faculty, the budding literary genius Robert Penn Warren—poet, novelist, scholar, and teacher—reported that his writing had been going exceptionally well and the past few months had been remarkably productive. He then added, almost as an aside, that he had been occupied of late in "making up a syllabus and analytical anthology of a modest order to be mimeographed for use in the sophomore poetry term here. For the most part the thing is a chore, but it offers moments of interest."

The "thing," of course, was the germ of what became *An Approach to Literature*, which Warren (1905–1989) wrote with his English department colleagues Cleanth Brooks (1906–1994) and John Purser (dates unknown) and which was published the following year by the newly established Louisiana State University Press. The mimeographed handout had grown into an oversized, double-columned volume of nearly six hundred pages and more than a half million words. Ordinarily such texts proceeded chronologically by genre, but Warren, Brooks, and Purser's new approach provided a lengthy general introduction; substantive introductions to all forms of writing, from the traditional poetry and fiction to the far less studied essay, biography, history, and drama; and numerous analyses of representative literary examples. The selections, too, departed from the norm in that they were chosen from many languages and literatures and ordered to demonstrate the editors' critical approach rather than chronology. Thus stories by Andrew Lytle and Ring Lardner preceded those by Bunin and Chekov, and a biographical essay on John C. Calhoun by Christopher Hollis followed pieces by Lytton Strachey and Plutarch. *The Scarlet Letter* appeared in its entirety to exemplify the novel form.

An Approach to Literature, published by the Press for a list price of three dollars (though used copies could be found for two dollars), proved to offer more than "moments of interest." Three years after its appearance, it was licensed to the commercial textbook publisher F. S. Crofts and remained in print, through multiple editions (and multiple publishers), for more than half a century.

In a radio talk entitled "The University Press and the Advancement of Learning," given in April 1937, Marcus M. Wilkerson, founding director of LSU Press, emphasized that the Press was not operated for profit, but rather had been established "to publish manuscripts that could not be profitably handled by commercial publishers." Surely *An Approach to Literature* epitomized that definition. A massive volume, extremely expensive to produce, initially intended for use at a single institution, it was hardly an inviting prospect for any profit-driven business in the midst of the Great Depression. But it is indeed a treasure that classically represents both the importance and the quality of university-press publishing.

The mission of LSU Press remains the same today, seventy-five years after its founding: to publish books of importance that cannot find their way in the commercial marketplace. Through the years, its books have earned many prestigious honors, including a total of four Pulitzer Prizes, the National Book Award, the National Book Critics Circle Award, the Booker Prize, the American Book Award, the *Los Angeles Times* Book Prize, the Bancroft Prize, the Lincoln Prize, the Lamont Poetry Selection of the Academy of American Poets, and numerous others.

—L. E. PHILLABAUM

RIGHT: Cleanth Brooks, John Purser, and Robert Penn Warren. *An Approach to Literature: A Collection of Prose and Verse, with Analyses and Discussions*. Baton Rouge: LSU Press, 1936. Photographer: Kevin Duffy, Information Technology Services.

An
Approach
To Literature

...ection of Prose and Verse with Analyses and Discussions

By

Cleanth Brooks, Jr. John Thibaut Purser

Robert Penn Warren

Department of English, Louisiana State University

BATON ROUGE

1936

"Dear Old LSU"

Official Fight Song Musical Score by Castro Carazo

Like Knights of old, Let's fight to hold
The glory of the Purple Gold.
Let's carry through, Let's die or do
To win the game for dear old LSU.
Keep trying for that high score;
Come on and fight,
We want some more, some more.
Come on you Tigers, Fight! Fight! Fight!
for dear old L-S-U.

I magine Tiger Stadium filled to capacity with more than 92,000 passionate LSU fans anticipating a "fight to the finish" game with SEC rival the University of Alabama. The LSU band members glide onto the field from the south end zone to perform the traditional pregame show. Stopping near the center of the field, the Tiger Band electrifies the crowd with its "Pregame Salute," turning to face all four corners of the stadium. The pace then quickens, and the band marches downfield to the L-S-U formation with its traditional "peak step." The Tiger Band then flips to the east side of the stadium while playing "Fight for LSU." In 1937 LSU band director and composer Castro Carazo (1895–1981) signed this copy of his recently released LSU fight song for LSU president James Monroe Smith (1888–1949). Considered one of the nation's top twenty-five college fight songs, more than seventy years later "Fight for LSU" remains the official LSU fight song and is the predominant song played when the football team enters and exits the field on game day.

Carazo's story is inextricably linked to Governor Huey P. Long, who took a personal interest in making LSU one of the country's great universities. One of Long's first moves to increase the stature and visibility of LSU was to bring Carazo to Baton Rouge in 1934 as the new LSU band-master. Born in Costa Rica, Carazo was a well-known orchestra leader who performed at the Roosevelt Hotel in New Orleans. He attained nationwide recognition through his regular weekly broadcast from the NBC network affiliate WSMB, whose studios topped the old Maison Blanche building. Forming a strong friendship, Long, a self-styled songwriter, and Carazo co-wrote several songs, including "Touchdown for LSU," "Every Man a King," and "Darling of LSU."[1]

ABOVE: Castro Carazo, LSU band director and composer. Photographer unknown, Office of Communications and University Relations.

Organized by two students in 1893 as a small military marching unit, LSU's band first appeared at a football halftime appearance in 1924.[2] Prior to Castro's arrival, it had grown to about 100 members. By the time Carazo left in 1940, it had grown to more than 250 musicians and drum majorettes, earning the nickname "The Show Band of the South."[3] Today the band has more than 300 members.

As a testimony to Long's legacy and Carazo's influence, the John Philip Sousa Foundation awarded the LSU Tiger Marching Band the 2002 Sudler Trophy, the highest honor given to a college marching band. Additional awards through the years include the 1970 All American College TV Band award, sponsored by the Chevrolet division of General Motors; and the 2008 Battle of the Bands contest, sponsored by ESPN, Paramount Pictures, and Lucasfilm. In 2009, the LSU Tiger Marching Band was inducted into the Louisiana Music Hall of Fame.

—FRANK B. WICKES AND LINDA R. MOORHOUSE

Notes 1. The U.S. National Guard adopted Carazo's "National Guard March" as its official march.

2. The two students were Wylie M. Barrow and Ruffin G. Pleasant, according to Frank Wickes, "The Marching Tigers: A Brief Look at Over 100 Years of the LSU Tiger Band, 'The Golden Band from Tigerland.'" LSU School of Music Web site.

3. Special sections of the 1936 and 1937 *Gumbo* highlight the growth of the band under Carazo. In 1936, there were 120 band men and 40 drum and bugle corps, and Carazo created a concert band, which joined forces with the already existing units, increasing the marching band's size to 205 pieces.

Reference Studwell, William E., and Bruce R. Schueneman. *College Fight Songs II: A Supplementary Anthology.* Binghamton, NY: Haworth Press, 2001.

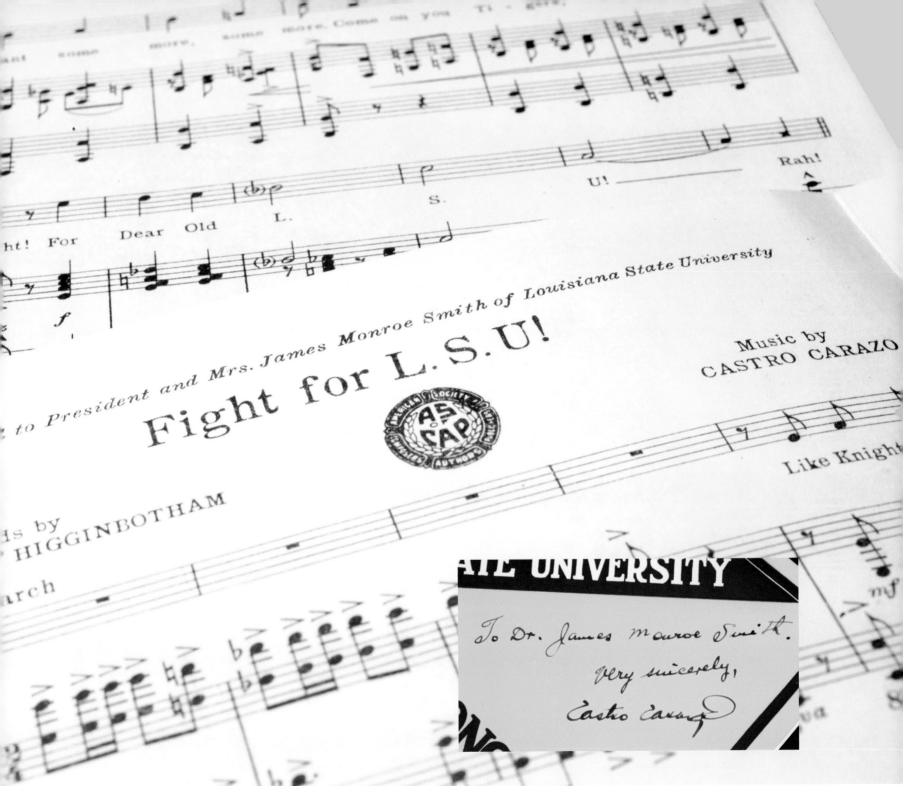

ABOVE: Castro Carazo (Costa Rican, 1895–1981). "Fight for LSU" score, 1937. Lyrics by W. G. "Hickey" Higgenbotham. New York: T. W. Allen, c. 1937. Louisiana and Lower Mississippi Valley Collections, LSU Libraries, Baton Rouge. Photographer: Kevin Duffy, Information Technology Services. **INSET:** Castro Carazo's signed dedication of the LSU fight song for LSU president James Monroe Smith. Louisiana and Lower Mississippi Valley Collections, LSU Libraries, Baton Rouge. Photographer: Kevin Duffy, Information Technology Services.

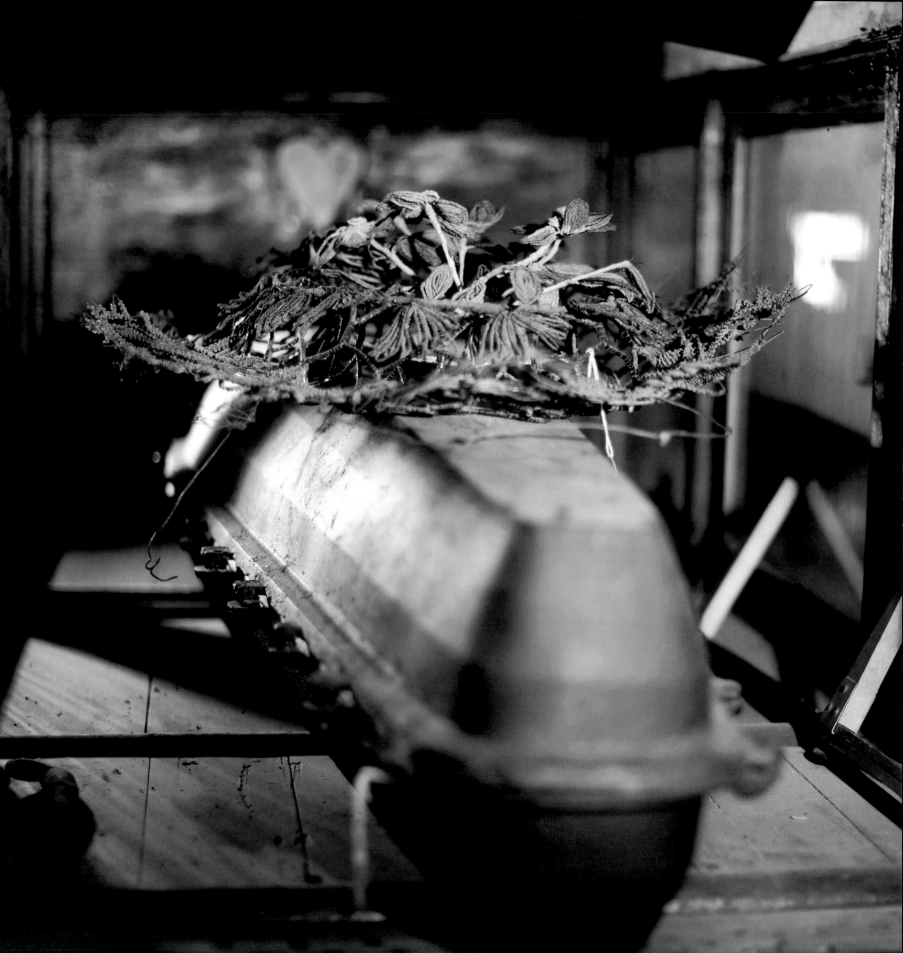

VIII

CULTURAL ARTIFACTS

Hand-Spun Quilt from Acadiana
and Other Clues to the Past

Il n'y a pas fin de cotonnade
Acadian Quilt

Like pieces of a puzzle, the *cotonnade* fabrics in this patchwork quilt provide information that help complete the picture of early Acadian life in Louisiana. *Cotonnade* is the Acadian term used for homespun-cotton, clothing-weight fabrics. It is noted for its durability, as indicated by the Cajun expression *Il n'y a pas fin de cotonnade*, or "There is no end to *cotonnade*." The quilt is comprised of otherwise unobtainable examples of hand-woven Acadian fabrics, especially those originally used in garment construction. Analysis of this and the relatively few other existing early Acadian quilts from Louisiana has enabled LSU researchers to identify many different hand-woven fabrics that were produced for use as family clothing and lightweight bedding. In contrast, thick homespun blankets are the most widely known type of Acadian hand weaving in Louisiana because their production continued into the twentieth century, whereas the weaving of fabric for clothing and sheets generally did not.

Early Acadian settlers, who came to Louisiana in the late eighteenth century, developed a distinctive lifestyle in South Louisiana that perpetuated aspects of their ancestors' culture. For example, they adapted the tools, techniques, and weaving patterns they had used for wool and linen in France and Canada to the locally available brown and white cottons found in the American South.

Typical Acadian *cotonnade* fabrics are plain-weave and are made almost exclusively from white, natural brown, and indigo-dyed cotton yarns that were woven into an astonishing variety of fabrics. The yarns in this quilt are natural white and indigo-dyed cotton with one fabric that also includes the color red, which is very unusual in Acadian textiles. The twenty-one fabrics found in this quilt could have been woven on as few as seven loom warps, with as many as five different fabrics being woven on a single threading. Variety was thus achieved with minimal effort, providing different wardrobes for family members. Both household textiles and garment fabrics could be woven on the

LEFT: The quilt features 21 different hand-woven fabrics in a total of 80 patches; this detail shows 8 different fabrics, including a repair patch. Photographer: Jason R. Peak, Information Technology Services.

same warp. The textiles in this quilt were most likely produced by a single weaver within an Acadian family.

This quilt measures approximately eighty-three by sixty-eight inches. Based on soiling, wear, and repairs, we can surmise the quilt has been well used. It is comprised of eighty pieces of fabric on the front and eight pieces on the back. All sewing on the quilt was done by hand. The largest patches are full fabric widths that make up most of the quilt backing. The patches that make up the front vary greatly in size, and sometimes patches of the same fabric are sewn together. Because of the use of a limited color range, there is often not a great deal of contrast between the fabric patches. Quilting is done in parallel rows of stitches and most of the rows lie perpendicular to the long side of the quilt, but in sections at the top and bottom they are parallel to the long side.

Acadian quilts differ from many other American quilts in that they incorporate fabric pieces in a wide variety of sizes sewn together in no apparent overall pattern. This technique provides for the most economical use of fabric scraps and a minimum amount of time required for piecing the quilt. The quilts are thick and heavy, weighing approximately twelve pounds each, and were used as warm bed coverings. Such quilts were sometimes part of *l'amour de maman*, the trousseau of household textiles an Acadian mother provided for her children.

—JENNA TEDRICK KUTTRUFF

References Burnham, Harold B., and Dorothy K. Burnham. *Keep Me Warm One Night: Early Handweaving in Eastern Canada.* Toronto: University of Toronto Press, 1972.

Glasgow, Vaughn. *L'Amour de Maman: La Tradition Acadienne du Tissage dans Louisiane.* La Rochelle, France: Musee du Nouveau Monde, 1983.

Kuttruff, Jenna Tedrick. "Pieces of a Puzzle: Acadian *Cotonnade* Quilts." *Louisiana Agriculture* 41, no. 2 (1998): 12–13.

———. "Three Louisiana Acadian *Cotonnade* Quilts: Adding Pieces to a Puzzle." *Uncoverings* 20 (1999): 63–86.

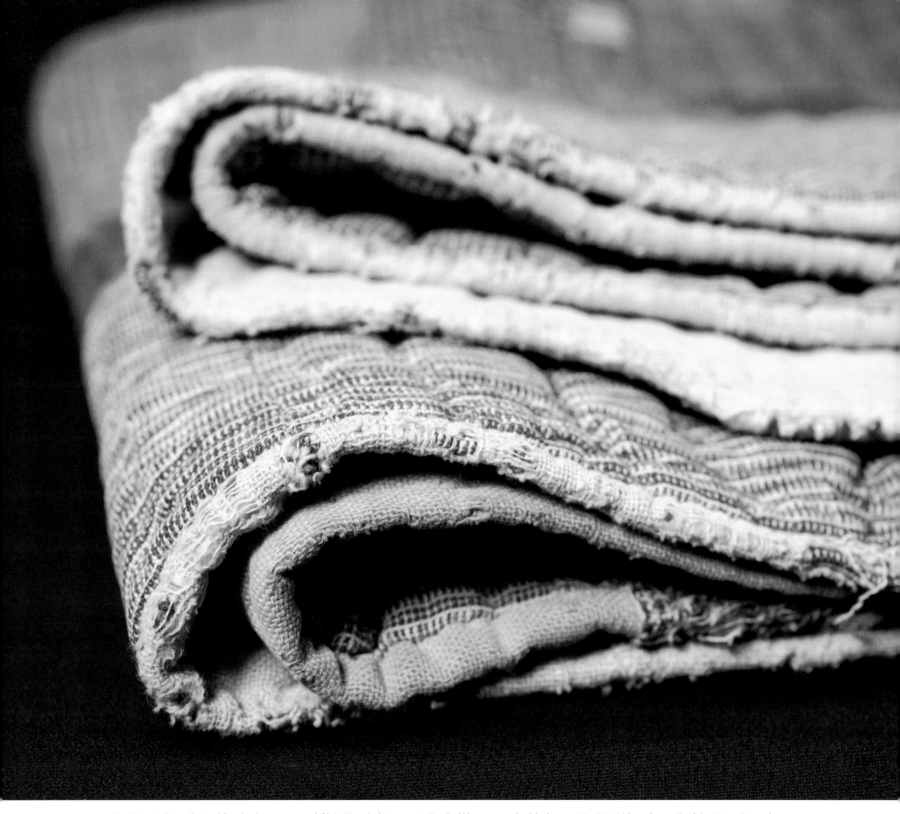

A Thousand-Year-Old Tradition

Chitimacha Baskets

ABOVE: Detail of Chitimacha basket. Photographer: Kevin Duffy, Information Technology Services.

Chitimacha baskets are widely regarded as among the finest basketry produced by Native Americans. The LSU Museum of Natural Science owns over one hundred examples, some single woven and others double woven. Experts consider the double-woven basketry "the most complex plaited basketry on the North American continent."

The Chitimacha are one of a very few southeastern Indian tribes that still produce double-woven baskets like the one pictured here. These are essentially two baskets in one; the fit of the two is exact, and they are joined at the top into a single weave. The exterior basket can have a completely different design from the interior. Woven of split cane, some baskets are able to hold water because the weave is so tight.

Dumbcane (*Arundinaria gigantica*) is the material of choice for both single- and double-weave baskets. Descriptions from the early twentieth century indicate that women cut the cane (the only part of this process that required a tool) and, while it was still green, quartered the cane by twisting it and slapping it sharply against the thigh. The outer, shiny, "cortical" layer of the cane was then peeled away in thin strips by holding the cane in the teeth. Though the cane must be broken and prepared while green, the weaving was done after the cane was aged and dyed.

Like the cane, the plants used in dyeing are found in Louisiana swamps. Some of the dyeing process is kept secret by the Chitimacha, but parts of the process are known. Three colors are used: red, yellow, and black. The black dye is the hardest to set; cane strips are boiled along with black walnut (*Juglans nigra* L.) leaves and nuts. Reds and yellows are both produced from dock (*Rumex crispus*). For these colors, the strips are dyed only after being exposed to dew for a period of six to eight days. Yellow is produced by boiling with the root; for red, the strips are soaked in lime and then boiled with the root.

The complex designs that emerge from the precision weaving of dyed and naturally colored cane were probably once widespread, and widely recognized, throughout the southeastern United States. Names of these designs include Bear's Ears (or Earrings), Little Fish or Little Trout, Worm Tracks, Alligator Entrails, Black Bird's Eyes, Cow's Eyes, Muscadine Rind, Rattlesnake, Broken Plaits, Plaits Beginning to Start, Turtle's Necktie or Turtle's Necklace, Mouse Tracks, and Rabbit's Teeth. These names are still in use in the original Chitimacha language, even if the weaver no longer speaks Chitimacha, and current terms are exactly the same as those collected at the turn of the century. These terms—and the designs they represent—appear to have deep antiquity, well over one thousand years. In an unusual instance of archaeological preservation, matting was uncovered at the Mounds Plantation site in Caddo Parish, from a context dated to AD 1050. Some of this matting retained designs clearly in the same tradition as what the Chitimacha make today, even to the presence of Black Bird's Eyes.

By the late nineteenth century, traditional basket making was almost lost. Several Chitimacha women, including Clara Dardin, wife of Chief Alexandre Dardin, preserved the skill on the Chitimacha tribal reservation in Charenton, Louisiana. In the early 1900s, a number of south Louisiana white women such as Sara Bradford of Avery Island also encouraged the craft. Thanks to these women, the basket making craft persists, and is undergoing a revival.

—REBECCA SAUNDERS

References Gregory, Hiram F., and Clarence H. Webb. "Chitimacha Basketry." *Louisiana Archaeology* 2 (1975): 23–38.

Swanton, John R. *Indian Tribes of the Lower Mississippi Valley and the Adjacent Coast of the Gulf of Mexico.* New York: Dover, 1911.

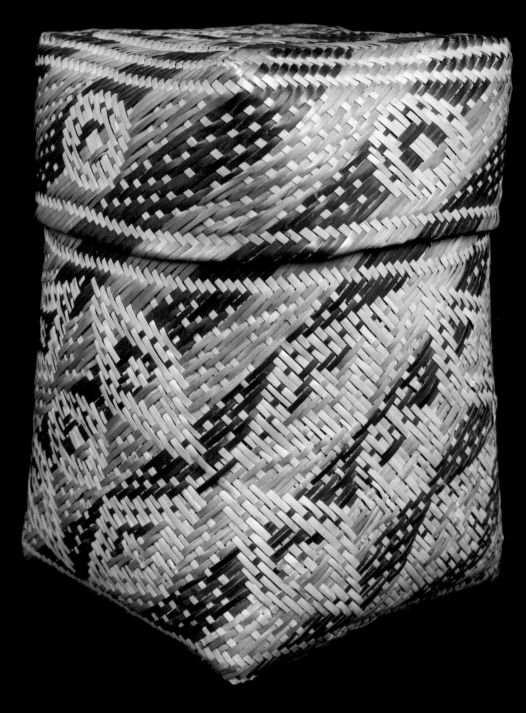

ABOVE: A double-woven Chitimacha basket. Designs are: (*basket body*) Little Trout (diamonds) and Cow's Eyes (circles); (*lid*) Cow's Eyes. LSU Museum of Natural Science. Photographer: Kevin Duffy, Information Technology Services.

"A Good Hat Makes Me Radiant"

Cashinahua Headdresses

ABOVE: Detail of Cashinahua headdresses. Photographer: Kevin Duffy, Information Technology Services.

Deep in the tropical rainforest along the border of Brazil and Peru live the Cashinahua, a farming, hunting, and gathering people who have maintained, through isolation, much of their traditional culture. Like many Amazonian peoples, the Cashinahua place great value on craftsmanship and beauty, characteristics exemplified by their outstanding feathered headdresses. These range in size and complexity from small (ten to twelve inches in diameter) "circlets," some of which fold for storage, to massive arrangements of tiered feathers similar in size to the war bonnets of Plains Indians. The LSU Museum of Natural Science has a collection of over thirty Cashinahua headdresses of several different types.

In the mythology of some Amazonian tribes, the ability to make headdresses is what sets mankind apart from animals. Though women weave the cotton fabric that sometimes covers the vine circlet of headdresses, feathered headdress construction and use are the proper domain of males. Indeed, chiefs set the standards of excellence and are expected to be good headdress makers themselves. The finished products of both chiefs and commoners are subject to considerable commentary from villagers. Working with Cashinahua informants, Phyllis Rabinou (at the time, anthropology collections manager for the Chicago Field Museum) determined that, for the Cashinahua, "all beautiful things must be asymmetrical." With the exception of the *chidin maiti*, sparseness of feathers, simplicity, and elegance of design are also important factors. Villager hats that are too elaborate, or that contain too many harpy eagle feathers, are considered "overdone."

The Cashinahua subdivide feathered headdresses into several categories based on the type of feather used: wing feather, body feather, or red macaw tail. Each category can be subdivided further. For instance, wing feather circlets, *pei maiti*, can be either rigid, so that the feathers

stick straight up, or flexible, so that the feathers fall forward into a soft brim. To create the *pei maiti*, long, stiff wing feathers are tied between two strips of vine (or a vine split in two), and the circlet is formed by overlapping the ends of the vine and tying them together with waxed (beeswax) cotton string.

In the museum collection, feathers used in the fourteen *pei maiti* include those of the snowy egret, capped heron, roseate spoonbill, oropendola, a variety of brilliant macaws, and a recent import, the muscovy duck. While most *pei maiti* use white wing feathers for the principal tier, the example shown on the left is made of yellow oropendola feathers interspersed with scarlet and blue-and-yellow macaw feathers. The lower, black tier is composed of the body feathers of the razor-billed curassow; the tier underneath that, of scarlet macaw feathers. The upright feathers—somewhat showy for a standard *pei maiti*—are scarlet macaw with cut razor-billed curassow feathers attached with beeswax.

The Museum of Natural Science also has examples of *dani maiti*, which are similar to *pei maiti* except that the principal band is made of body feathers rather than wing feathers. Trumpeter swan and harpy eagle are used in the most outstanding examples. One *dani maiti* is made with porcupine quills (considered "body feathers" by the Cashinahua), and the collection also includes several *jina maiti*, which have giant anteater tails attached.

The most ostentatious Cashinahua headdress is part of the *chidin* ceremonial outfit; the *chidin maiti* is created and worn only by the chief. The museum owns one of these, featured on the right in this picture. It is a riotous amalgamation of scarlet macaw, red-and-green macaw, and blue-and-yellow macaw tail feathers, and lower tiers of body feathers of harpy eagle, macaws, violaceous jay, and king vulture, and additional stalks of oropendola, razor-billed curassow, macaws, and snowy egret (or possibly the domesticated muscovy duck) feathers.

In addition to categorization by feather type, headdresses are divided into "real" and "unreal" headdresses. The former are *dau*, "medicine," while the latter are considered cloth or clothing. "Real" headdresses are worn in ceremonies but can also be used in daily life. For example, a

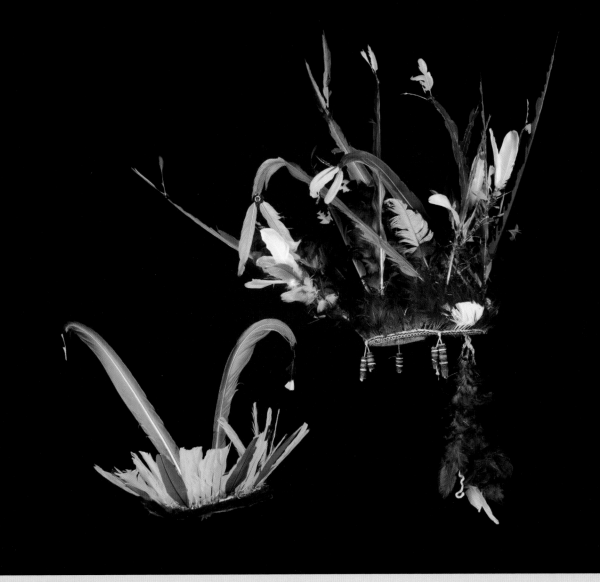

ABOVE: Cashinahua feathered headdresses. *Pei maiti* (*left*) and the chief's *chidin maiti* (*right*), worn only on ceremonial occasions. From the Amazonian forest along the border of Brazil and Peru. Gift of Dr. John O'Neill (1942–). LSU Museum of Natural Science. Photographer: Kevin Duffy, Information Technology Services.

man wishing to impress a potential lover may paint his body and wear objects, including a headdress, which can be classified as *dau*. His object is "secular," that is, the seduction of the female, but he is "involving" the assistance of supernatural forces at the same time. *Dau* has supernatural qualities in that it gives the wearer *dua*, radiance or beauty.

Regardless of the occasion, all men agree that *iti pepa ea duawai*— "a good hat makes me radiant."

—REBECCA SAUNDERS

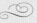

References Kensinger, Kenneth M. "Studying the Cashinahua." In *The Cashinahua of Eastern Peru*, ed. Jane Powell Dwyer.
 Boston: Haffenreffer Museum of Anthropology, 1975.
 Rabineau, Phyllis. "Artists and Leaders: The Social Context of Creativity in a Tropical Forest Culture."
 In *The Cashinahua of Eastern Peru*, ed. Jane Powell Dwyer. Boston: Haffenreffer Museum of
 Anthropology, 1975.

La Connection Française
White Cotton Day Dress

One garment in the LSU Textile & Costume Museum's Thomas Butler Collection provides evidence that two hundred years ago fashion in Paris and London influenced Louisianians. This garment is an entirely hand-sewn white cotton woman's day dress, dating most likely to the 1810s. The dress is significant not only because of its early Louisiana provenance, but also because it can be dated to a very specific time period owing to a unique design feature: a garment trim composed of three-dimensional puffs of fabric that appear to burst through slashes in the base fabric, a detail reminiscent of sixteenth- and seventeenth-century menswear that resurfaced in Western fashion following the end of the French Empire period (1804–1814). Even though the dress is of a plain muslin fabric and the amount of trim is minimal when compared to ornate examples in period fashion plates and other surviving garments, it illustrates that Americans living in outlying areas of this country recreated European fashions, regardless of fabric and construction limitations.

The Butler Collection at LSU consists of more than women's wear; it also includes a Confederate uniform jacket and other items ranging in date between 1800 and the 1890s. Supporting the collection are the Butler family papers in the LSU Libraries, Louisiana and Lower Mississippi Valley Collections, whose contents include official documents, bills, and personal correspondence. These not only trace the family's social and business activities but also document Louisiana life during the period. Thomas Butler's letters, written in the 1820s while serving in the U.S. Congress in Washington and sent home to his Cottage plantation, are richly descriptive. During financially difficult times, he sought the best price for his cotton crop and also made arrangements to meet with his wife's seamstress. Included are notes about dueling, the always-present fear of yellow fever, an eyewitness description of the Battle of New Orleans, and the original document signed by Louisiana's first governor, W. C. C. Claiborne, awarding Thomas Butler a judgeship in West Feliciana Parish. A number of letters and documents also report Civil War experiences.

The museum's collection of Butler garments combined with selected Butler family papers provide a rich resource of information about nineteenth-century life in Louisiana.

—Pamela P. Vinci

References Louisiana and Lower Mississippi Valley Collections, LSU Libraries, Louisiana State University, Baton Rouge.
 Butler Family Papers. Mss. 1026.
 Margaret Butler Papers. Mss. 1068.
 Thomas Butler and Family Papers. Mss. 2850.
 Benjamin Farrar Papers. Mss. 1364.

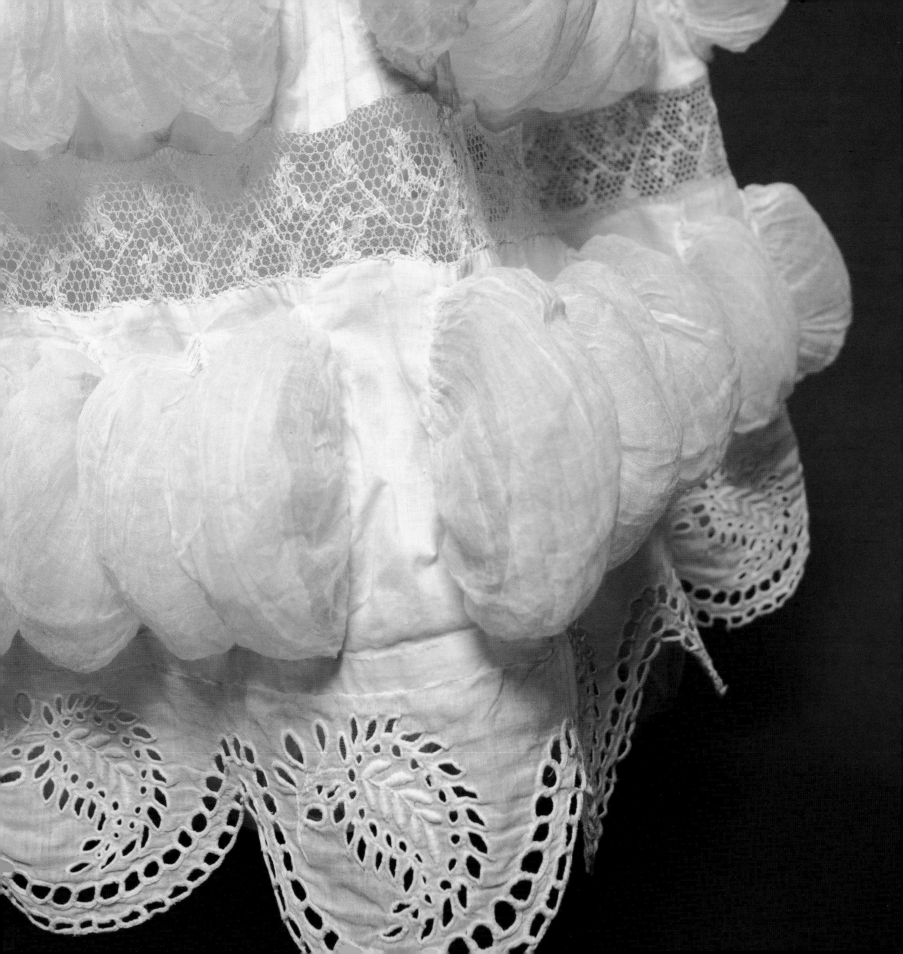

"Wears Well—& Not Easily Soiled"
LSU Cadet Corps Colors

May the grey uniform of the R.O.T.C. forever be a part of the "Old War Skule." May it always develop the kind of men it has developed; confident, self-reliant and trustworthy. Let the halo of Romance clothe their martial steps in Beauty. Long may our Cadet Corps live!

—LSU *Gumbo* (1929)

Artifacts such as the LSU cadet corps uniforms in the LSU Textile & Costume Museum, carefully preserved by their original owners long after their student years and then generously donated, serve as visual documents of pivotal changes in the university's rich and unique history. The oldest uniform in the museum, dated 1903, is made of blue-gray melton wool. The jacket has a high-standing military collar, and the trousers are straight. In contrast, other early twentieth-century jackets in the museum are paired with cavalry riding breeches and leggings. A 1968 uniform, the most recent in the collection, conforms to U.S. military specifications of the time and represents the last year of compulsory military training at LSU.

Opening in 1860 as the Louisiana State Seminary of Learning and Military Academy, the institution that became LSU offered sixty-six male students who enrolled for its first session a literary, scientific, and military curriculum. In 1859, President Francis H. Smith of the Virginia Military Institute had advised the head of the Louisiana State Seminary's board of trustees, G. Mason Graham, "I think you will find the Grey coatee the best dress. It is suitable for young men—wears well—& not easily soiled."[1] During the first session, cadets wore navy blue uniforms; however, the institution soon adopted the recommended blue-gray fabric.

In 1906, thirty-one women entered LSU, changing the all-male focus of the institution forever. Nevertheless, the university continued to require military training for male students well into the middle of the twentieth century because of the university's participation in the 1916 National Defense Act's Reserve Officers Training Corps. As a result, LSU was among the top four U.S. institutions of higher learning whose graduates became officers during World War II, including fifteen who attained the rank of general.[2] By 1969, with student dissent against U.S. involvement in Vietnam and a national movement away from mandatory military training, enrollment in LSU's cadet corps became voluntary. By 1976, the university had opened its officer training program to female students.

Although most of the museum's cadet corps uniforms are blue-gray, there are exceptions. A World War II–era jacket is constructed in U.S. Army dark green wool and is embellished with brass buttons embossed with the American bald eagle instead of the Louisiana pelican used on other LSU jackets. The 1968 uniform is composed of only a shirt and trousers in a summer-weight khaki fabric. Still other uniforms are white gabardine and skirted, once worn proudly by coeds who supported the Corps as its "sponsors" before women were allowed to participate in military training. Gray, green, khaki, white—all are reminders of the many changes, beyond uniform color, that the Ole War Skule has experienced in its 150 years.

—Pamela P. Vinci

RIGHT: LSU cadet jacket (c. 1903), commercially produced by unknown maker. Gray wool, green braid trim. LSU Rural Life Museum Collection, LSU Textile & Costume Museum. 1991.012.0006. Photographer: Jason R. Peak, Information Technology Services.

Notes 1. Francis H. Smith to G. Mason Graham, September 30, 1859, Walter L. Fleming Collection, Mss. 890, 893, Louisiana and Lower Mississippi Valley Collections, LSU Libraries, Baton Rouge. In a succeeding letter dated October 27, 1859, Smith informed Graham that "all the necessary articles for cadets" were provided by a quartermaster at a profit of 20 percent. The cadet coat sold for $14.00, winter pants for $8.00, and summer pants for $3.50.
 2. The other three institutions were the U.S. Military Academy at West Point, Texas A&M University, and Virginia Military Institute.

References Barbre, Charles S. *LSU: A Legacy of Leaders*. Baton Rouge: Bayou Sports Promotions, 2006.
 Garner, Maj. Walter L. "From Gettysburg to the Ia Drang Valley." *LSU Alumni News* (May 1966): 5–20.
 Ruffin, Thomas F. *Under Stately Oaks: A Pictorial History of LSU*. Rev. ed. Baton Rouge: LSU Press, 2006.

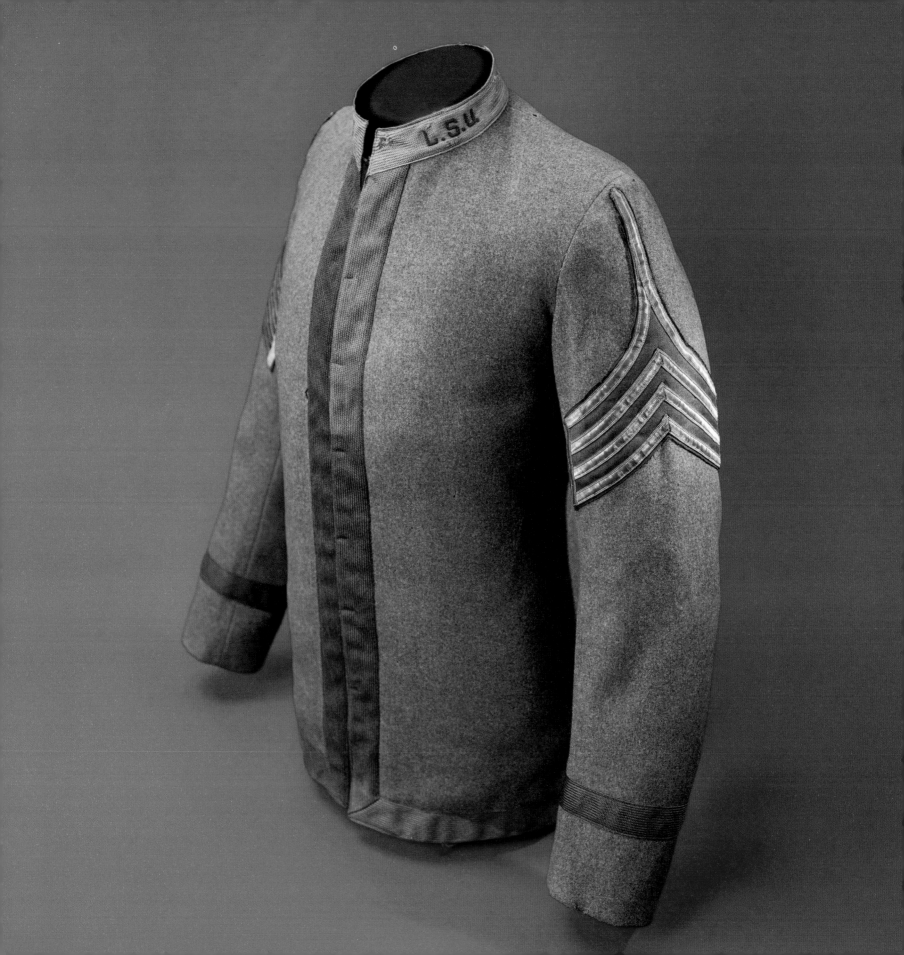

A Half Ton of Print History
Washington Hand Press

Persons entering the Journalism Building between 1968 and 2002 may recall passing the vintage printing press that sat just inside the main entrance. The press often was overlooked, but for those who cared about American printing history, the press represented an important artifact linking the School of Journalism (now the Manship School of Mass Communication) with its publishing roots.

Known as a Washington Hand Press, the nearly half-ton, all-iron printing press is a close relative of the eighteenth-century press used by Benjamin Franklin in his Philadelphia print shop. The "Washington" part of the name was intended merely to honor America's first president. "Hand Press" refers to the method of hands-on, "movable type" printing.

The Washington Hand Press is a particular style of press whose mechanical features earned its inventor Samuel Rust an 1821 patent. Highly regarded both for its reliability and portability, the Washington Hand Press was characterized by one historian as being "a plain press, sturdily built for producing the finest of impressions."[1]

The hand-press printing procedure, regardless of press style, is quite simple. The printer (or "type-setter") places individual metal (usually lead) slugs of type, each containing a raised letter, number, or punctuation mark, line by line in a tray. Each line of type is set in reverse order of how the printed copy is to appear. The printer applies ink to the raised portion of type, carefully positions a sheet of paper over the inked type, and then rolls type tray and paper beneath a heavy metal block called a platen. The printer lowers the platen so that its weight presses the paper firmly over the inked type. Once the platen is raised and the paper removed, the printer has produced a page of printed copy.

The early history of LSU's Washington Hand Press is somewhat obscure. A distinctive head plate identifies its builder as the Cincinnati Type Foundry, one of several such companies that built a version of the Washington Hand Press. The press carries no markings to indicate its age, but former Journalism School director Frank Price estimated it was built in the late 1830s.

The recent history of the Washington Hand Press is more certain. Jules Ashlock, then editor and publisher of the *Ville Platte Gazette*, purchased the press in 1962 from an Ohio printer who actually used it occasionally for certain print jobs. Ashlock and his wife donated the press to the Journalism School in 1968. The press was delivered to the school in March of that year, where it was positioned in its place of honor near the Journalism Building entrance.

The press was moved to Hatcher Hall for storage when major renovation of the Journalism Building began in 2002. And in 2009, the Manship School donated the press to the LSU Rural Life Museum. Current plans are to totally restore the Washington Hand Press to working order so that museum visitors can see firsthand this important piece of printing history.

—Ronald Garay

RIGHT: The Washington Hand Press (c. 1830s). Built by the Cincinnati Type Foundry. LSU Rural Life Museum. Photographer: Eddy Perez, Office of Communications and University Relations.

Note 1. Herschel C. Logan, *The American Hand Press: Its Origin, Development and Use* (Whittier, CA: Curt Zoller Press, 1980), 17–21.
References Ashlock, Jules. "Letter to F. J. Price." Manship School of Mass Communication Archives. February 21, 1968.
 Keller, Krystyna. "George Washington Press Given to Journalism School." *Daily Reveille* (LSU), March 13, 1968.
 Moran, James. *Printing Presses*. London: Faber and Faber, 1973.

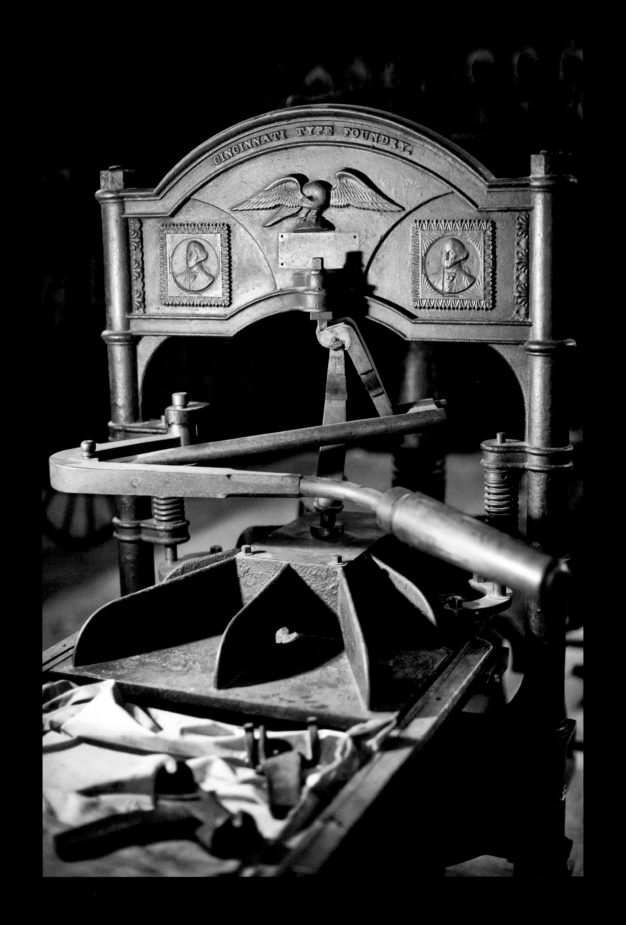

American Time
Nineteenth- and Twentieth-Century Pocket Watches

What is the time? American, decidedly. Ten years ago it was Swiss,* or English, or French. Now, ask your nearest live, progressive, patriotic neighbor. The watch he pulls out in reply is labeled, not "Geneva," not "Liverpool," nor "Versailles," but "Waltham, Massachusetts."

"Making Watches in America,"
New York Times, June 26, 1867

Three late nineteenth- and early twentieth-century pocket watches in the LSU Textile & Costume Museum document the glorious years in American watch production. One watch is encased in multicolored gold with repoussé raised engraving; another features an elaborately painted enameled dial, set with delicate filigreed hands; and a third is enclosed in a polished 14 karat yellow-gold case with a movement enhanced by seventeen jewels. All of these timepieces are classified as hunting case watches, whose decorative, but also protective, covers open to reveal their faces. All are examples regarded by American consumers of the period as the most desirable to purchase. All have movements manufactured by three U.S. companies: Waltham Watch Company, Elgin Watch Company, and Hampden Watch Company.

Prior to the 1850s, few American manufacturers made reliable watches in quantity, and European handmade watches dominated the U.S. market. However, by the turn of the twentieth century, American ingenuity had turned the tables. Popular retailers Montgomery Ward & Company and Sears, Roebuck offered customers a limited number of European watches and a wide range of American-made watches, almost exclusively from three companies: Waltham, Elgin, and Hampden.

The company that became the Waltham Watch Company was the first to mass produce affordable watches with interchangeable parts, in 1857. The company won a gold medal at the 1876 Philadelphia Centennial Exposition for its watches' precision. In its one hundred years of existence, the Waltham factory produced forty million jeweled watches.

Even Abraham Lincoln carried an 1863 Waltham pocket watch. Closing its U.S. doors in 1957, Waltham shifted production to Switzerland and The Waltham International SA.

With Waltham ties, Elgin followed in 1864, becoming the largest U.S. company in terms of production, responsible for half of the total number of pocket watches manufactured in the United States. At its one hundredth anniversary in 1964, Elgin stopped watch production and sold the rights to its name.

Hampden Watch Company was in business by 1877 in neighboring Springfield, Massachusetts, and by 1890 was manufacturing six hundred watches per day. By 1930, Hampden had also closed, shipping all of its machinery to the Russian government. Wristwatches replaced pocket watches, and production shifted abroad. Today few watches are made in this country. According to the Henry Ford Museum in its documenting of America's history of innovation, watch manufacturing has come full circle.

The Waltham, Elgin, and Hampden watches are part of a thirty-eight-piece watch collection donated by an avid and knowledgeable Louisiana collector, Marion Edwards, brother of Louisiana's former governor Edwin W. Edwards. Each of the pocket watches is unique, as the customer was often given the opportunity to pair a movement preference to a choice of exterior case. Of the twenty American and European companies represented in the collection, three American manufacturers dominate, just as was the case in the U.S. marketplace during the most prolific years of American watch production.

—Pamela P. Vinci

References *Montgomery Ward & Company Catalogue and Buyers' Guide No. 57, Spring and Summer 1895*. New York: Dover, 1969.
The 1902 Edition of the Sears Roebuck Catalogue. New York: Bounty Books, 1986.
Schugart, C., T. Engle, and R. E. Gilbert. *Complete Price Guide to Watches*. Miami Beach, FL: Tinderbox Press, 2005.
Shenton, Alan. *Pocket Watches: 19th & 20th Century*. Woodbridge, Suffolk: Antique Collectors' Club Ltd., 1995.

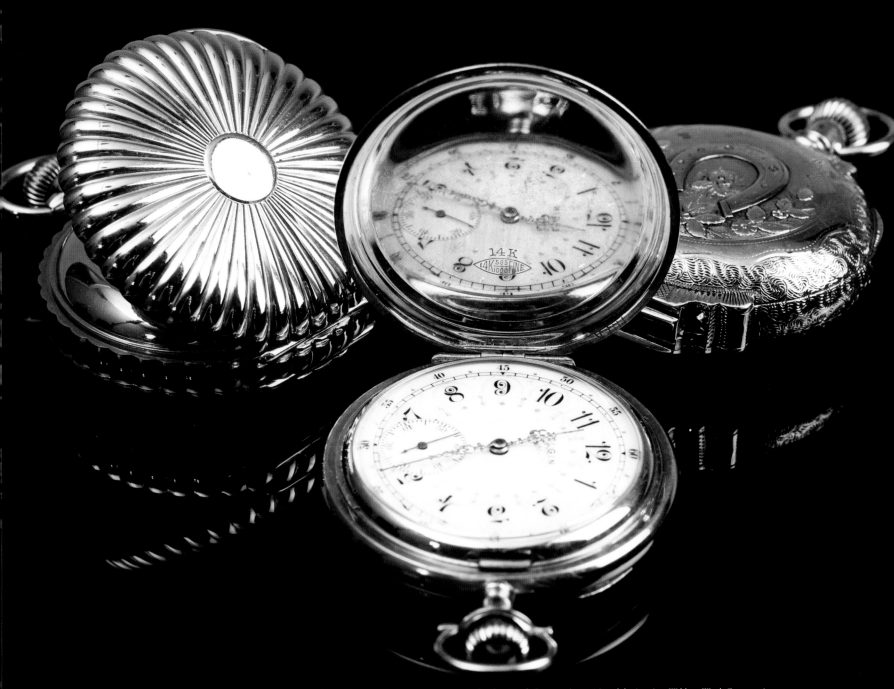

ABOVE: Men's hunting case pocket watches, produced by (*left to right*) the Hampden Watch Company (c. 1916), the Elgin Watch Company (c. 1870s), and the American Waltham Watch Company (c. 1880s). The Hampden and Elgin watches are 14 karat yellow gold, and the Waltham watch is 14 karat multicolored gold. Marion D. Edwards Collection, LSU Textile & Costume Museum. Photographer: Jason R. Peak, Information Technology Services.

Immortelles and Other Found Objects
Louisiana's Material Culture

Louisiana's residents in the nineteenth century called them *immortelles*, French for "immortal." Prepared with human hair, the intricate, handmade flower crowns were a personal farewell gift to the deceased. Placed over coffins and graves, the *immortelles* were meant to be perpetual memorials to the people they honored. The tops of the coffins they decorated featured a small glass screen so that people could see the late person's face.

Once a symbol of loss and sorrow, the nineteenth-century *immortelles* and coffins at the LSU Rural Life Museum provide a window into Louisiana's cultural history and recall the specter of yellow fever that plagued New Orleans in the 1850s. Assembled from Louisiana farms, plantations, and rural households, they are part of the museum's substantial collection of material culture. The objects offer museum visitors and LSU scholars a rare opportunity to interpret the lives of rural Louisianians between the 1750s and the 1940s.

Ranging from jewelry to gasoline-powered washing machines, approximately 30,000 objects tell the everyday life stories of the rural South. Almost all material objects at the museum have a clear provenance. The coffins, for example, are accompanied by forensic reports revealing the names of the people once buried in them and the reasons for their deaths. Most items at the Rural Life Museum were made in Louisiana, though some were manufactured elsewhere and purchased for use here.

The impressive collection of material objects is the legacy of Steele Burden (1900–1995), the donor of the property on which the Rural Life Museum stands. In 1969, the garden designer and connoisseur decided to acquire a slave cabin at a time when most people destroyed such edifices to erase this embarrassing piece of history from Louisiana's memory. This one symbolic gesture soon became a massive collecting effort, giving birth to the Rural Life Museum, home of the most extensive collection of material culture from eighteenth- and nineteenth-century rural Louisiana.

ABOVE: A closer view of an *immortelle* at the Rural Life Museum. Photographer: Eddy Perez, Information Technology Services.

Today, thousands of everyday objects people once used evoke the state's history. The walking beam steam engine, one of five American-built beam steam engines existing today and the only one operated on a regular basis, stands as an example of the industrial technology that rocked U.S. society after the Civil War. Plantation bronze bells, dating from the 1830s to the 1870s, are reminders of the sounds masters and slaves heard at the start, middle, and end of each workday, and imposing hurricane lanterns recall the antebellum devices people used when the unwelcome winds of the Gulf of Mexico shattered the peace of their daily lives. Like the *immortelles* that decorated nineteenth-century graves in Louisiana, these material objects commemorate the people who used them one hundred to two hundred years ago.

—DAVID FLOYD AND YASMINE DABBOUS

For More Information Saxon, Lyle, and E. H. Suydam. *Fabulous New Orleans*. Gretna, LA: Pelican Publishing Co., 1988.
Spitzer, Nicholas, ed. *Louisiana Folklife: A Guide to the State*. Baton Rouge: Louisiana Division of the Arts, 1999.
Video interview with Steele Burden, 1994. LSU Rural Life Museum, Baton Rouge.

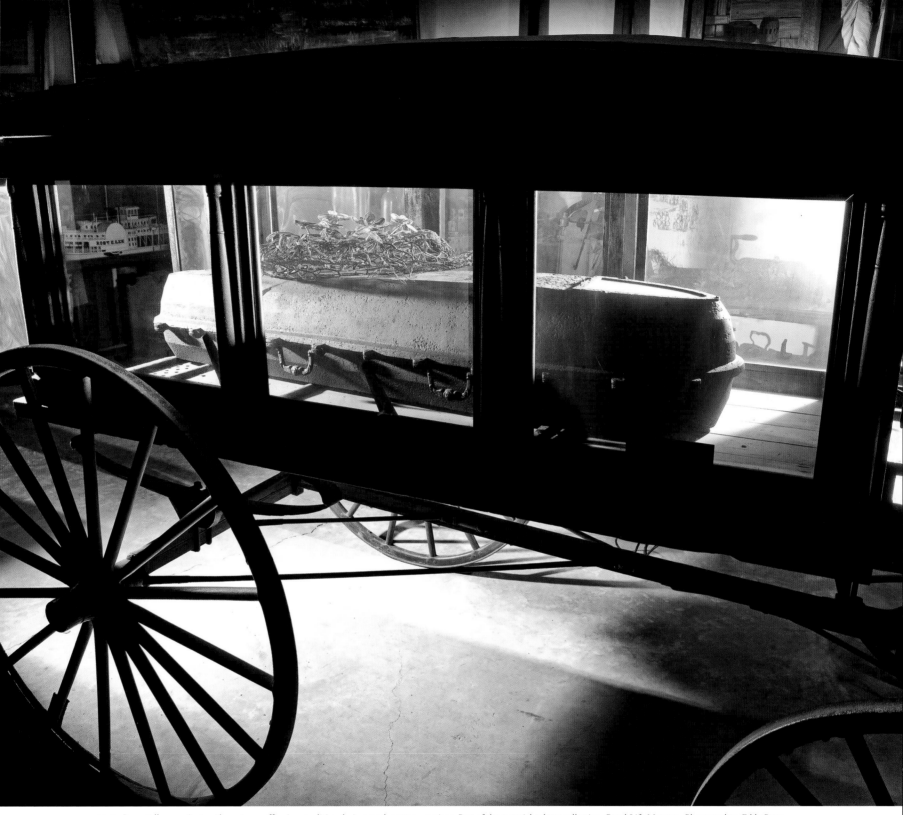

ABOVE: *Immortelle* on a nineteenth-century coffin, in a traditional nineteenth-century carriage. Part of the material culture collection, Rural Life Museum. Photographer: Eddy Perez, Information Technology Services.

179

A Stand for Justice
The Paul M. Hebert Judicial Robe

Although a standard judicial robe in cut, the dark green hue alerts one that this is no ordinary robe destined for a civilian court. Former dean of the LSU School of Law, Paul M. Hebert wore this robe when he served as one of four judges in the case of *The United States of America vs. Carl Krauch et al.*, also known as the I. G. Farben Trial, held before U.S. military courts in Nuremberg between August 27, 1947, and July 30, 1948.

This robe tangibly links Auschwitz and Baton Rouge in a rather remarkable way, resting on the fame of Judge Hebert's dissent to the verdict handed down by the tribunal in the trial. That verdict held I. G. Farben responsible only for its intended use of slave labor at Auschwitz, based on evidence that the company had built a factory next to the concentration camp. Judge Hebert's dissenting statement eloquently conveyed his concern about misuse of the defense of necessity:

> In my view all of the members of the Farben Vorstand should be held guilty under Count Three of the indictment not only for the participation by Farben in the crime of enslavement at Auschwitz, but also for Farben's widespread participation and willing cooperation with the slave labor system in other Farben plants where the utilization of forced labor in violation of the well-settled principles of international law recognized in Control Council Law No. 10 has been so conclusively shown. I disagree with the conclusion that the defense of necessity is applicable to the facts proved in this case.[1]

These tribunals were follow-ups to the International Military Tribunal that prosecuted the leaders of the Nazi party after the end of World War II. The tribunal that Judge Hebert participated in sought to prosecute the directors of the German chemical firm I. G. Farben on five counts relating to the planning and waging of a war of aggression, and the misuse of prisoners-of-war and other individuals as slave labor. It was on this latter charge that Hebert dissented from the judgments of the tribunal. He protested that all members of the board were guilty of making use of slave labor, not just those individuals who were directly responsible for the management of the facility at Auschwitz.

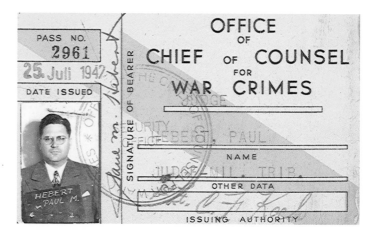

ABOVE: Hebert's identity card for the Nuremberg Tribunal. Photographer: Kevin Duffy, Information Technology Services.

Paul M. Hebert, longtime dean of the LSU School of Law, served in that capacity for most of the time between 1937 and his death in 1977. He also served as acting president of LSU between 1939 and 1941 after the resignation of James M. Smith following the "Louisiana Scandals." Before being named dean of the Law School, Hebert had served as dean of administration for LSU and president of the class of 1929.

Hebert's papers, including the complete transcripts of the Nuremberg Tribunal, are a central part of the Law Center's archival collection. The robe he wore during the tribunal, made in Albany, New York, by Cotrell and Leonard, constitutes a key part of the collection. The robe is currently not on public display but is held as part of a permanent exhibit on Paul M. Hebert to be assembled by the Law Center.

—JAMES WADE

Note 1. Military Tribunal No. VI, Case No. 6: *The United States of America against Carl Krauch et al., Dissenting Opinion by Judge Paul M. Hebert on Count Three of the Indictment*, p. 3. LSU Digital Library, Hebert Nuremberg Files.

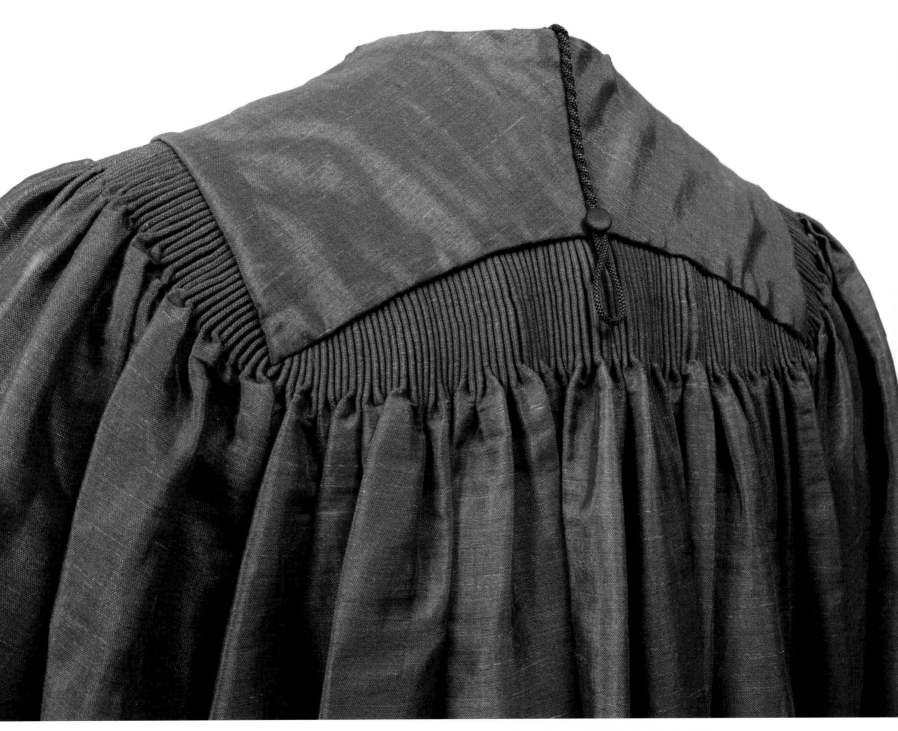

ABOVE: Detail of judicial robe worn by Paul M. Hebert at the Nuremberg Tribunal. Located at the School of Law's library. Photographer: Kevin Duffy, Information Technology Services.

"Talking Through My Hats"

Hat by Lilly Daché

Can a woman's hat illustrate cultural influences? Are there design similarities between the inflated brim of this hat by Lilly Daché from the 1960s and the silhouette of Australia's Sydney Opera House, whose construction began in 1964? Or, similarities between the same hat and New York's Kennedy Airport TWA terminal, completed in 1962 and seemingly poised as a bird to take flight? The visual impact of Daché's hat, with its undulating black-fabric brim banding, creates an impression for the viewer of swelling and contracting, like 1960s Op Art. There is no evidence that these similarities were intentional, but the possibility exists that the designer Lilly Daché was "talking through a hat" using the same creative influences that frequently permeate the designs of consumer products during any particular era.

Many period women's hats bearing the Lilly Daché label are now in the LSU Textile & Costume Museum, along with one of the two books she wrote, *Talking Through My Hats*. Daché (1907–1989), a leading milliner in the United States from the mid 1930s until she closed her business in 1969, was like many in the fashion industry today. She extended her design expertise and preferences beyond women's hats to gloves, hosiery, lingerie, loungewear, jewelry, and dresses during her lengthy influence on American apparel choices. And, like many designers, Daché was influenced by the world around her, as evidenced in 1940 when she created an all-black collection to commemorate the fall of Paris to German occupation prior to World War II.

Like architects, product developers, and interior designers, apparel designers share culturally common experiences and develop culturally common preferences, which they express in their design choices. Each communicates in his or her creative work popular product shapes and colors as each searches for design inspiration.

—Pamela P. Vinci

RIGHT: Woman's hat. Lilly Daché (New York, c. 1960s). Natural straw crown, black faille fabric brim band. 13 in. diameter, 6.25 in. height. Gift of Mary Doug Stephens. LSU Textile & Costume Museum, 1997.001.0852. Photographer: Jason R. Peak, Information Technology Services.

References Daché, Lilly. *Talking Through My Hats*. New York: Coward-McCann, 1946.

Martin, Richard. *The St. James Fashion Encyclopedia: A Survey of Style from 1945 to Present*. Detroit: Visible Ink, 1997.

Milbank, C. R. *New York Fashion: The Evolution of American Style*. New York: Harry N. Abrams, 1989.

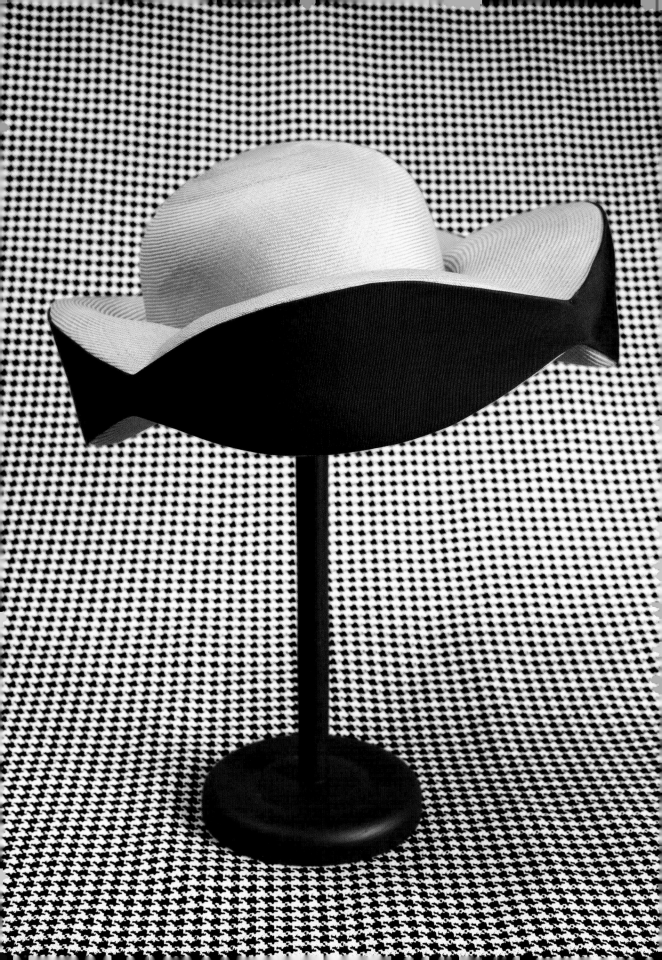

"I Liked Your Libretto"
The LSU Opera *Willie Stark*

I'm not an operatic expert by any means, he said, but even for a musical barbarian like me, I do know who you are. . . . By the way, I liked your libretto.

—Robert Penn Warren's comment, as remembered by Carlisle Floyd

LSU Opera's staging of *Willie Stark* combined all of the right elements for a memorable production, captured on DVD and videocast on Louisiana Public Broadcasting (LPB): An opera by award-winning composer Carlisle Floyd based on Robert Penn Warren's Pulitzer Prize–winning novel *All the King's Men* and the faculty and students from one of the oldest university opera programs in the nation.[1]

Warren (1905–1989) is the only person to have won Pulitzer Prizes for fiction and poetry.[2] He wrote his novel, a fictionalized account of politics as practiced in Louisiana, when he was an English professor at LSU during the administration of Governor Huey Pierce Long (1893–1935). Carlisle Floyd's adaptation for American opera focuses on the central character, Willie Stark, as he confronts an irrevocable change in his life: his impending impeachment.

Composer-librettist Carlisle Floyd (1926–), recognized for his creation of such operas as *Susannah, Of Mice and Men*, and *Cold Sassy Tree*, became one of the first recipients of the National Endowment for the Arts Opera Honors Award, the highest award given in American opera. The text from the Opera Honors Award in part reads, "One of the most admired opera composers and librettists of the last half century, Carlisle Floyd speaks in a uniquely American voice, capturing both the cadences and the mores of our society."[3] *Willie Stark*, written with the approval of Warren and applauded at its 1981 Houston Grand Opera premiere, had, in recent years, virtually disappeared from the contemporary operatic landscape. LSU Opera's production in the LSU Union Theater in the spring of 2007 was the first performance of the work in more than twenty-five years.

LSU Opera artistic director Dugg McDonough, in collaboration with LSU's faculty, staff, students, and a team of regional professional designers, conceived and directed the performances. John Keene, assistant professor and music director of LSU Opera, served as conductor. The cast featured Dennis Jesse, baritone and LSU assistant professor of voice, in the title role.[4] He was joined by an all-student cast and chorus ranging from doctoral students to undergraduates. Filming took place live during both LSU Opera performances on March 23 and 25, 2007, along with an additional shooting day on March 26 that captured close-up images of both the cast and orchestra. One of the special features of the LSU DVD is the engaging interview with the composer, recorded during one of his visits to Baton Rouge as observer and adviser to the *Willie Stark* cast and production team.[5]

The release of LSU Opera's commercial DVD recording of *Willie Stark* marked a significant milestone in the history of LSU Opera, and the recording became the first commercial DVD of any of Carlisle Floyd's operas.

—Dugg McDonough

Notes 1. LSU began its opera program in 1930. Some of its famous faculty include H. W. Stopher, Sr., Ralph Erolle, Pasquale Amato, Louis Hasslemans, Peter Paul Fuchs, and Robert Grayson. LSU graduates who have enjoyed national and international careers are Frances Greer, Marguerite Piazza, James King, Jasmine Egan, James Stuart, Michael Devlin, Leo Goeke, Paul Groves, Jeffrey Wells, Donnie Ray Albert, James Johnson, Kenneth Shaw, Chad Shelton, Scott Hendricks, Matt Morgan, Jane Redding, Chauncey Packer, Jeremy Little, Lisette Oropesa, and Daniela Mack.

2. The Pulitzer Prizes were awarded for his novel *All the King's Men* in 1947 and for *Promises: Poems, 1954–1956*, and for *Now and Then*, 1979. *All the King's Men* was made into a film and won the Academy Award for Best Picture in 1949.

3. www.nea.gov/honors/opera/floyd.html (accessed July 30, 2008). Floyd was a 2001 inductee of the American Academy of Arts and Letters and has received numerous honors, including a Guggenheim Fellowship, the National Opera Institute's Award for Service to American Opera, and the National Medal of Arts.

4. Dennis Jesse has appeared in operas and operettas on concert stages all over the United States.

5. Newport Classic, Ltd., a professional recording company, produced the DVD. Lawrence Kraman was video director; Robert Grayson, Kirkpatrick Professor of Voice in the LSU School of Music, served as executive producer; and Dawn Huertas Arevalo served as production and stage manager.

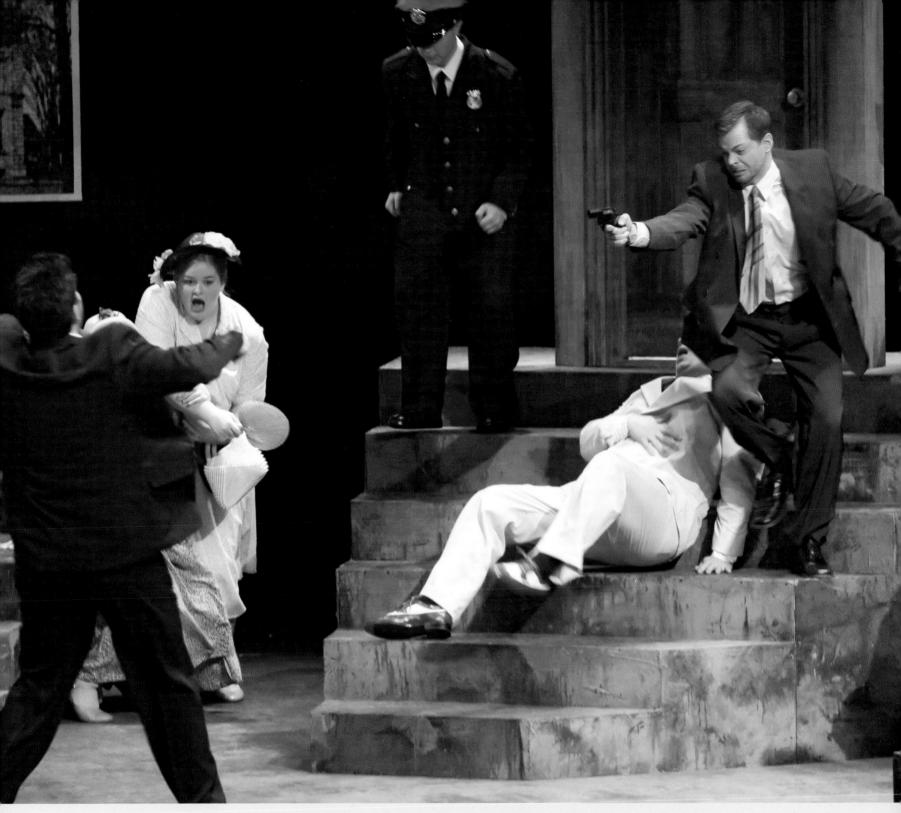

ABOVE: A scene from *Willie Stark* (March 23 and 25, 2007). Based on Robert Penn Warren's Pulitzer Prize–winning novel *All the King's Men*. Carlisle Floyd, composer; Dugg McDonough, stage director; John Keene, conductor; LSU Opera, performers. Photographer: Jason R. Peak, Information Technology Services.

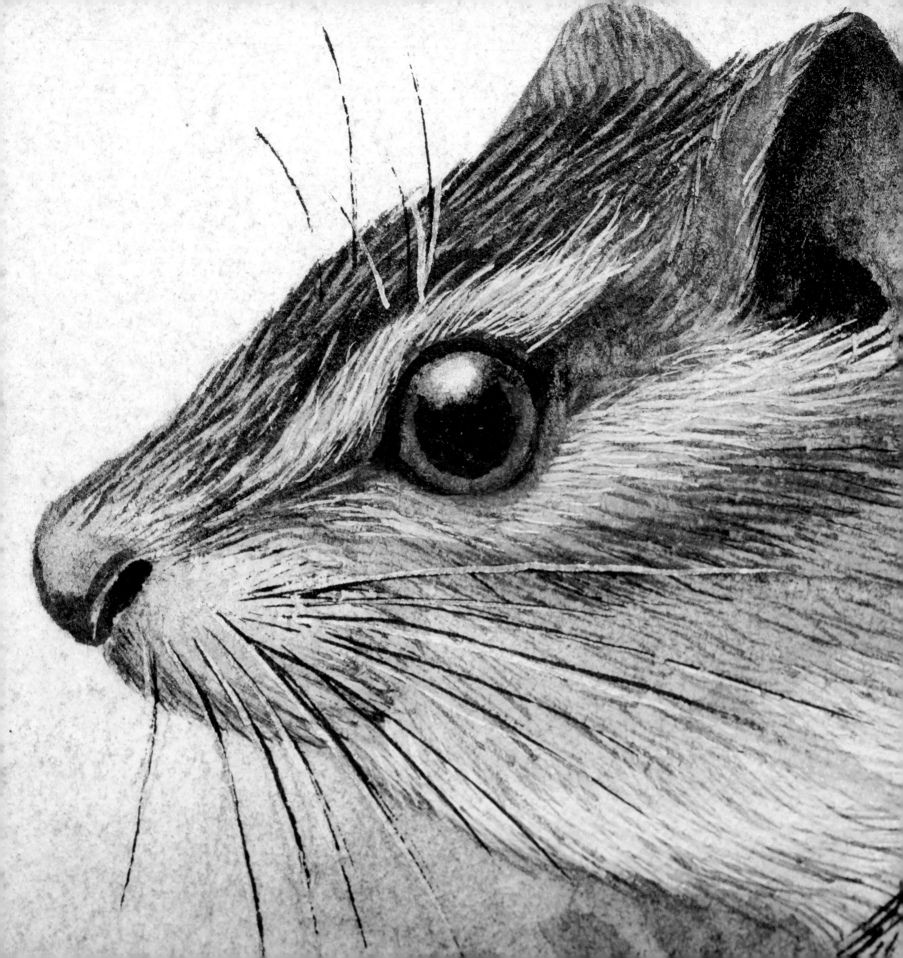

IX

RESEARCH
COLLECTIONS

Birding, Excavating, and Other
Faculty Endeavors

We Collect Birds
The LSU Bird Collection

ABOVE: The scarlet-banded barbet, discovered in 1996 in Peru. Part of the bird collection at the LSU Museum of Natural Science. Photographer: Eddy Perez, Office of Communications and University Relations.

The scarlet-banded barbet specimens astonish even the non-ornithologist visiting the LSU Museum of Natural Science collection. Discovered during a research expedition to a remote, previously unexplored range of mountains in Peru in 1996, the bird was recognized at first sight as a new species to science. What impresses the visitor is not just the striking mix of bright colors, nor the fact that these specimens are unique in the United States, but the contrast between these exceptional species and other barbets. How could such a strikingly different bird have been overlooked for so long?

The LSU Museum of Natural Science (LSUMNS) in Foster Hall houses one of the most prestigious research collections of bird specimens in the world. Established in 1936 by Boyd professor George H. Lowery, Jr. (1913–1978), this collection has now surpassed in sheer numbers all but a dozen museum collections, including the official national collection of any country except the United States, Britain, and Russia. Among university-based collections, LSU trails only three: Harvard University, the University of California at Berkeley, and the University of Michigan.

But the sheer numbers (now over 175,000 specimens) do not adequately reflect the research value of the collection. Most specimens at LSU contain, on average, two to ten times as many data fields on their labels as do the traditional museum specimens. Roughly one-third of all LSUMNS specimens also have a DNA sample or a stomach-contents sample stored separately. These samples open the door for new dimensions of specimen-based research, namely the genetics of birds and the analyses of bird diets. In both cases, the LSUMNS was the first museum in the world to include such additions. It was also the first museum in the world to establish an official research curatorial position solely for its genetic samples (curator of genetic resources).

The LSUMNS collections from Peru and Bolivia, two of the planet's richest countries in terms of bird diversity, are the largest in the world. The collections also rank among the top five of birds from Borneo, the West Indies, Mexico, Belize, Guatemala, Honduras, Costa Rica, Argentina, and Kuwait. Fieldwork in Louisiana has also produced one of the largest bird collections from any state in the country. The collection of anatomical specimens, consisting of whole birds preserved in fluid for dissection or skeletons (both essential for understanding bird morphology and anatomy), is the third largest in the world in terms of number of species: 3,200, roughly one-third of all the world's bird species.

The LSU bird collection has grown largely as a consequence of the field research conducted by its staff and students. Lowery and his students studied birds and collected specimens throughout much of Mexico and Central America. One of his students, John O'Neill, launched the LSUMNS field research program in Peru and elsewhere in South America. Professors J. V. Remsen and Robb Brumfield and their students have continued this program. Professor Frederick Sheldon and his students have further expanded LSUMNS research to Africa and Southeast Asia.

The vast majority of the LSUMNS collection consists of research specimens, such as our series of scarlet-banded barbets, not suited for display in the LSUMNS's relatively modest public exhibits. Their primary value is to researchers, not only from LSU but also from around the world.[1] LSUMNS staff and students have published many hundreds of technical articles in scientific journals as well as a number of books and monographs based on their research of the LSUMNS bird collection.

—J. V. REMSEN, JR., ROBB T. BRUMFIELD, & FREDERICK H. SHELDON

Note 1. An exceptionally busy loan program even allows researchers from outside LSU to study specimens or corresponding DNA samples.

References Mearns, B., and R. Mearns. *The Bird Collectors*. San Diego, CA: Academic Press, 1998.

O'Neill, J. P., D. F. Lane, A. W. Kratter, A. P. Capparella, and C. Fox Joo. "A Striking New Species of Barbet (Capitoninae: *Capito*) from the Eastern Andes of Peru." *Auk 117* (2000): 569–77.

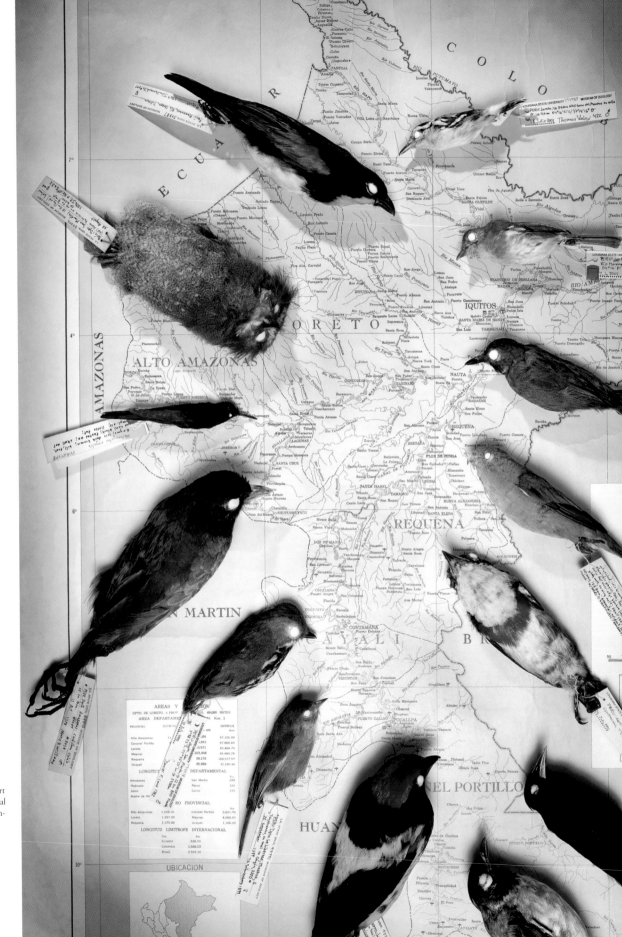

RIGHT: A collection of birds discovered in Peru, part of the bird collection at the LSU Museum of Natural Science. Photographer: Eddy Perez, Office of Communications and University Relations.

A Sixty-Foot Red River Whale
The LSU *Basilosaurus*

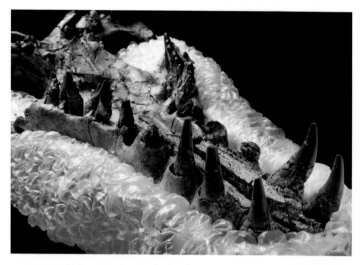

ABOVE: View of palate and teeth of fossilized *Basilosaurus* skull. Photographer: Kevin Duffy, Information Technology Services.

Basilosaurus and other primitive whales are found around the world in deposits from an ancient ocean that lay south of North America, covering much of present-day Louisiana, and south of Eurasia. One of the best specimens of this animal known to science, the remains of the front third of the skeleton of this extinct whale, was excavated by an LSU research team in the bank of the Red River near Montgomery, Louisiana, in 1980.[1]

The four-foot-long skull indicates that this whale may have been more than sixty feet long. Although it was probably a fish eater, its teeth are less well adapted to this diet than the teeth of modern dolphins and whales, which are simple spikes, without the complex small cusps seen on *Basilosaurus* back teeth. Modern toothed whales use echolocation, producing sounds and interpreting the echo to determine the locations of objects. A detailed study by LSU graduate Winston Lancaster, including work on the well-preserved inner ear bones, indicates that the LSU *Basilosaurus* did not use echolocation.

Research has revealed an exciting sequence of events that explain how a large whale was found in central Louisiana. North and South America were once joined together. At first, in the middle of the Mesozoic Era, or time of the dinosaurs, the new ocean between North and South America was small, and it easily dried up.[2] Layers of salt remained when sea water evaporated. Millions of years later, this salt would flow and billow up into younger rocks to form Louisiana's salt domes. The sea grew, and rivers carried sediments derived from the northern continent to its southern edge to begin to build the thick wedge of sediments that now underlies our state. As the sea retreated, marshes developed in the area that would form northwest Louisiana, and seas still covered the area that would become Montgomery, Louisiana.

Work on the Red River waterway required a revetment to cover the Montgomery Landing fossil site, formerly one of the best fossil sites in Louisiana. Study of the site before it was covered led to recovery of the *Basilosaurus* specimen. The Montgomery Landing fossil site included many marine vertebrates and invertebrates, and research resulted in a reconstruction of the ecology of ancient life in the shallow sea off the coast of Louisiana.

—JUDITH A. SCHIEBOUT

Notes 1. The research project was headed by Drs. Judith Schiebout and Willem Van Den Bold and supported by the Corps of Engineers, New Orleans District.

2. The Mesozoic Era was 248 to 65 million years ago.

Reference Schiebout, J. A., and W. van den Bold, eds. *Montgomery Landing Site, Marine Eocene (Jackson) of Central Louisiana: Proceedings of Symposium,*
1986 Gulf Coast Association of Geological Societies Annual Meeting.

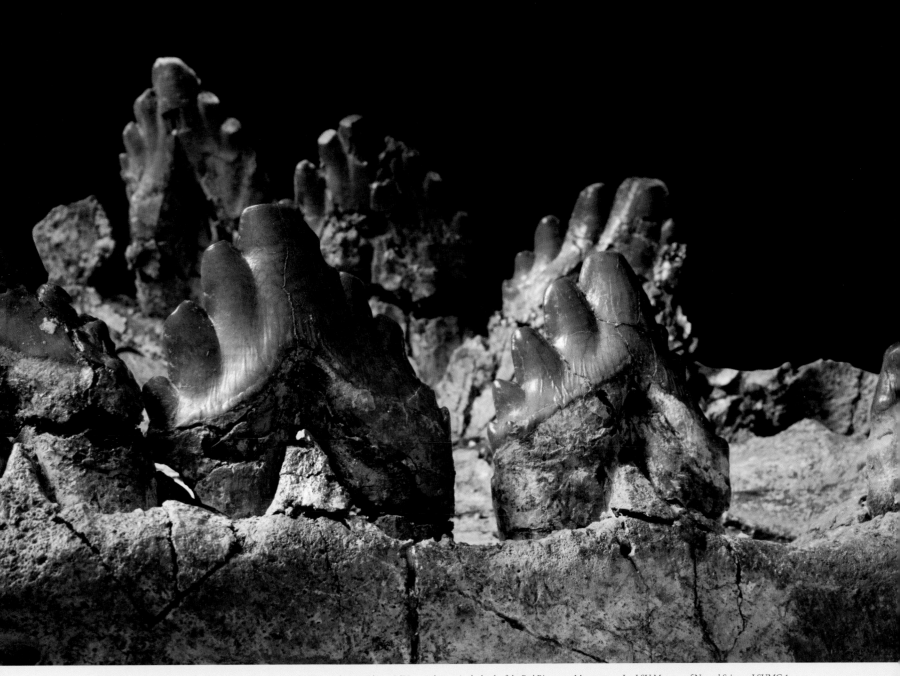

ABOVE: Close-up side view of fossilized *Basilosaurus* back teeth. Excavated in 1980 by an LSU research team in the bank of the Red River near Montgomery, La. LSU Museum of Natural Science, LSUMG 1. Photographer: Kevin Duffy, Information Technology Services.

Waiting in Ambush
Sabretooth Cat

ABOVE: A closer view of the fossilized tooth. Photographer: Kevin Duffy, Information Technology Services.

S abretooth cats, sometimes called sabretooth tigers, are among the most striking of Ice Age fossil mammals. The Museum of Natural Science fossil specimen is from a creek north of Baton Rouge and is the best fossil evidence for these cats' presence in Louisiana. The fossils found in creeks eroding Ice Age deposits, such as this sabretooth specimen, are usually considered to be eight to ten thousand years old. The specimen is a meat-slicing back tooth, similar in location in the animal's jaw to a human molar. Note the sharp, V-shaped valleys in the tooth, which is called a carnasial. These catch and hold flesh as the upper and lower teeth shear past each other, cutting meat neatly, as opposed to human molars, which have low bumps suitable for crushing a wide variety of foods, but poor as meat slicers.

Occurring in several lineages of catlike animals over the millennia, these long canine teeth of sabretooths invite speculation as to how the animals used them. Clearly not useful for attacks, in which they might hit a prey's bone and be broken, they would inflict terrible wounds in soft tissue of the throat or belly of big animals. Stocky in build and unable to run as well as cheetahs, sabretooth cats probably waited in ambush or stalked prey before striking. Possible sabretooth prey found in Ice Age deposits include mastodons, deer, bison, and extinct types of horses.

This cat may have hunted alone or as part of a group. We can surmise that stripes and/or spots would have been good camouflage in wooded country. By the time these cats lived in Louisiana, glaciers had advanced into the North American midcontinent, making Louisiana much cooler than it is today; plants such as spruce trees currently seen farther north extended into the area. Many large mammals, including the sabretooths, became extinct at the end of the Ice Age. Scientists debate whether climate change or human hunting was at fault; both probably played a role.

Found in 2001 by W. H. "Bill" Lee, accompanied by Dr. Ray Wilhite, a graduate of the LSU vertebrate paleontology program, this fossil is an important scientific treasure. Although fossils are not rare in Louisiana Ice Age deposits, carnivore fossils are less common than herbivores', carnivorous mammals being higher on the food chain.

—JUDITH A. SCHIEBOUT

RIGHT: Lateral view of fossilized meat-slicing tooth of the sabretooth cat. Discovered by Bill Lee and excavated in 2001 by an LSU research team from a creek north of Baton Rouge. LSU Museum of Natural Science, LSU MG V-17115. Photographer: Kevin Duffy, Information Technology Services.

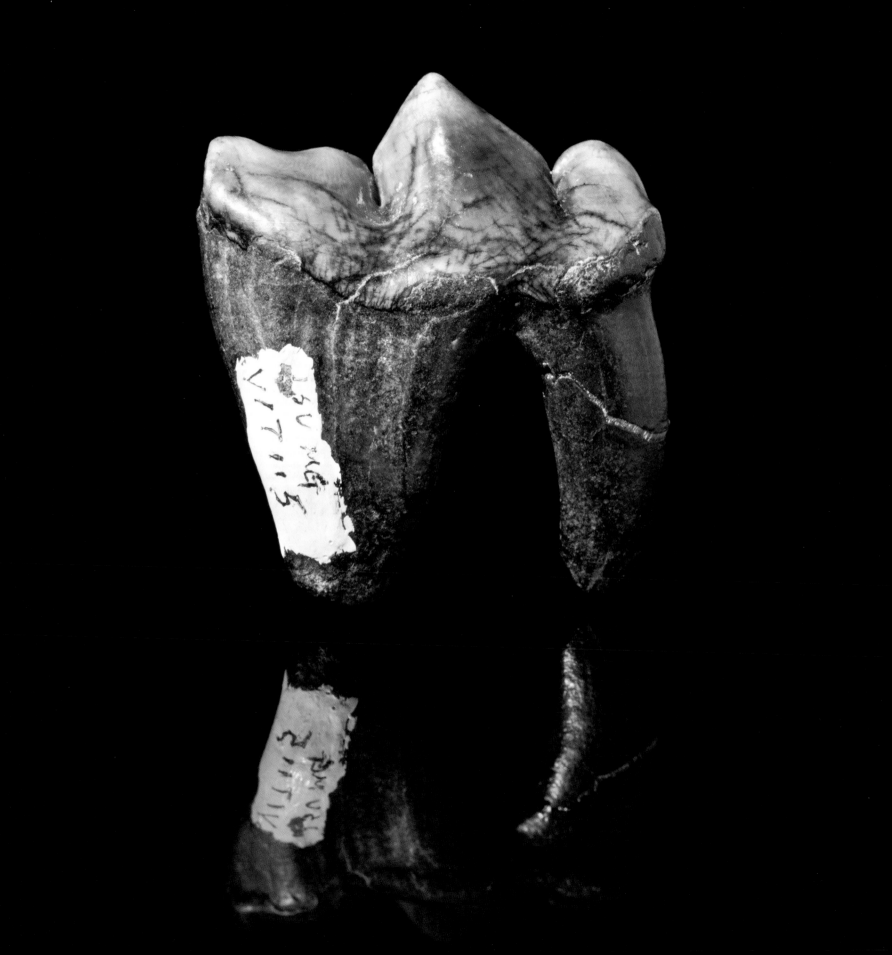

An Exciting Fossil Find

A New Louisiana Mastodon

Mastodons are elephant relatives whose name means "breast tooth," referring to the large, rounded bumps on their teeth which were good for crushing twigs and leaves. Ice Age mastodon fossils are relatively common throughout Louisiana, but in the summer of 2005, Kerry Dicharry, an amateur naturalist, discovered a much older mastodon with tusks seven feet long at a site in the Tunica Hills area, north of Baton Rouge. Estimated to be five million years old, this specimen also includes the palate and upper teeth. The true significance of this recently acquired treasure will only be known after the completion of studies currently underway.

The deposit that yielded the fossils occurred where a river entered the sea. Large animals that probably did not usually live in coastal marshes or the shallow sea, such as the mastodon, washed into the area. Dead animals float, and bones can fall from a floating carcass far from an animal's normal environment. Other animals identified from the same site include a large, short-legged rhinoceros, a dwarf rhinoceros, three types of extinct horses, and a pronghorn.

The procedure for recovering the mastodon and the large rhinoceros's pelvis has been used with large vertebrate fossils for more than two hundred years. The fossil's top surface was cleaned and hardening chemicals were then applied. A narrow trench was cut around the fossil. Layers of gauze soaked in wet plaster were added to the top and sides to form a sturdy cast, which was then flipped, and the process repeated. Strong saplings were cut and taped along the casts containing the tusks, to prevent twisting. Workers, seven or eight per tusk, estimated the weight as about six hundred pounds pounds each.

Once such fossils reach the vertebrate paleontology lab at LSU, the conservation work begins. Tusks grow in cone-shaped layers, which can crumble if they dry rapidly. A wooden frame was built above the work tables and covered with thick plastic so that humidity could be monitored. LSU vertebrate paleontologist Dr. Suyin Ting traveled to the Florida Museum of Natural History to learn their procedures with wet tusks. Dr. Ting, Kathleen MacDonald, and graduate student Michael Williams performed painstaking cleaning.

The mastodon and associated fossils are relatively recent finds and will undergo many types of study in the future. Even in preliminary study, the specimens have necessitated revision of ideas about the age of the beds in which they occur, and they represent a look at land life for the central Gulf Coast during a period of time for which almost no information was available. Isotopes will help determine what the animals ate and the temperatures in which they lived. Study of pollen from the sediments can tell about plants in the vicinity. Paleomagnetic study, which relies on patterns of change in orientation of the earth's magnetic field, will refine the age. Comparison with specimens in other collections may make it possible to determine the animal's sex. Male elephants usually have more curved tusks, for pushing in contests with other males, whereas females have straighter tusks like these, to discourage threats to their young.

—JUDITH A. SCHIEBOUT

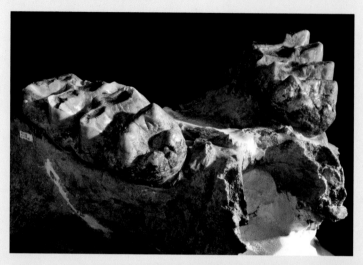

ABOVE: View of two teeth from back of mastodon palate. Photographer: Kevin Duffy, Information Technology Services.

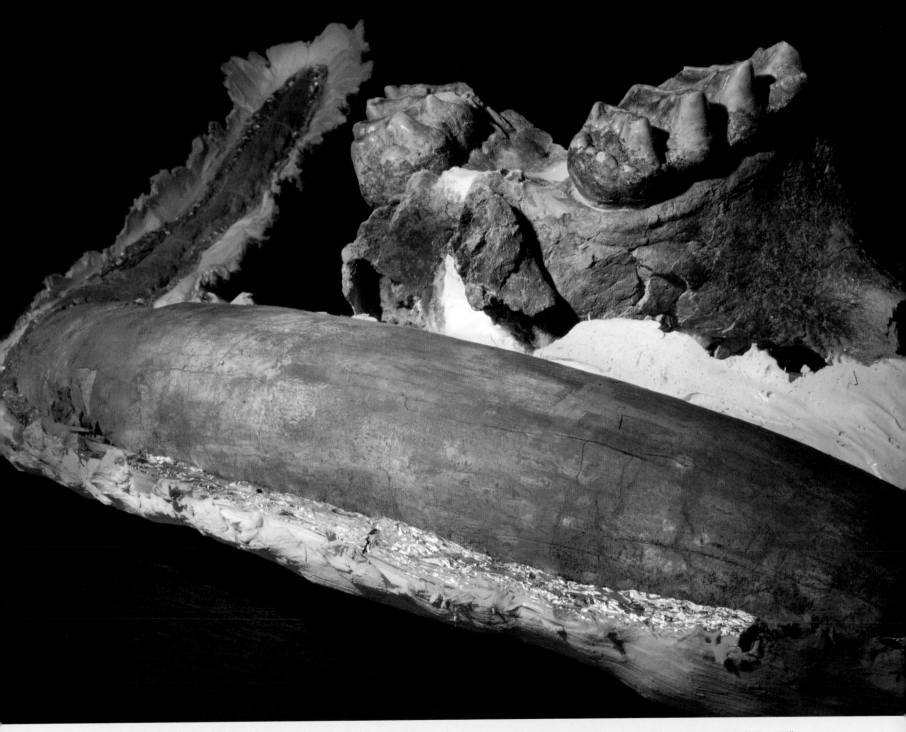

Moments in Time

The Robert C. West Photograph Collection

The view of the Incan storehouse remains might be mistaken for an ordinary tourist photograph at first glance. Little does one suspect that such an image deliberately and meticulously documents details of the geography of west-central Peru, in a collection now invaluable to scholarly "repeat photography" research.[1]

Preserved at the Cartographic Information Center of the Geography and Anthropology Department in the Howe-Russell Complex, the Robert C. West Photograph Collection illustrates past cultures, historical landscapes, and the general geography of numerous Latin American and Caribbean regions. Approximately 5,800 black-and-white photographs, featuring meticulous geographic notes on the back, provide an essential record to study change.

When LSU Boyd professor Robert C. West (1913–2001) retired in 1980, he left behind a legacy of prestigious awards, a prolific record of publications, a live oak memorial, an LSU Foundation account to support student field research, and four distinguished professorships in the department. A less well known but equally precious treasure West passed on to generations of LSU geography students is a large collection of photographs documenting his research over forty years.

Described by one colleague as a "model geographer,"[2] West compiled twenty databases, annotating and cataloging every photo. The photographs document natural landscapes and how cultures alter them, settlement patterns and individual features such as house types, variations in economic activities and their impacts on the land, and cultural differences. William Davidson, former chair of the LSU Department of Geography and Anthropology and West's close colleague, described West as "the foremost geographer and author on Mexico and Central America."[3]

The collection is invaluable in providing a visual record of landscape activity in much of Latin America during the second half of the twentieth century. Such a record is essential to the study of environmental and cultural evolution. In 2003, a doctoral student at the University

ABOVE: Boyd professor Robert C. West (American, 1913–2001), cultural geographer. Photographer: Jim Zietz, Office of Communications and University Relations.

of Texas selected two hundred photos West shot in Central America, took modern photos of the same locations from the same angles, and concluded that the area's deforestation was not as substantial as it was thought to have been.

The collection includes scenes and objects in Mexico, El Salvador, Panama, Costa Rica, Belize, Guatemala, Honduras, Ecuador, Peru, Bolivia, Cuba, Puerto Rico, the Lesser Antilles, Colombia, Uruguay, Argentina, Brazil, and Spain. As an indication of its importance, interest is mounting in placing the entire collection online, making the photos easily available to professional photographers and cultural geographers.

West received his doctorate at the University of California–Berkeley in 1946 under the guidance of Carl O. Sauer, arguably the most famous American geographer. West worked for the Smithsonian Institute for two years before joining the Department of Geography and Anthropology at LSU in 1948. He studied Latin America, in particular Mexico and Central America, with emphasis on historical and cultural perspectives. In 1970, he was named the twentieth Boyd professor of LSU.

—CHELSEA L. CORE

Notes 1. In "repeat photography," geographers take pictures of the same area or object during different time intervals to document change.

2. Miles Richardson, personal communication, June 23, 2008.

3. William Davidson, personal communication, July 30, 2008.

Reference "Beta Version of Robert C. West Photo Archive Online." *LASG and CLAG Newsletter* 109 (2007): 6.

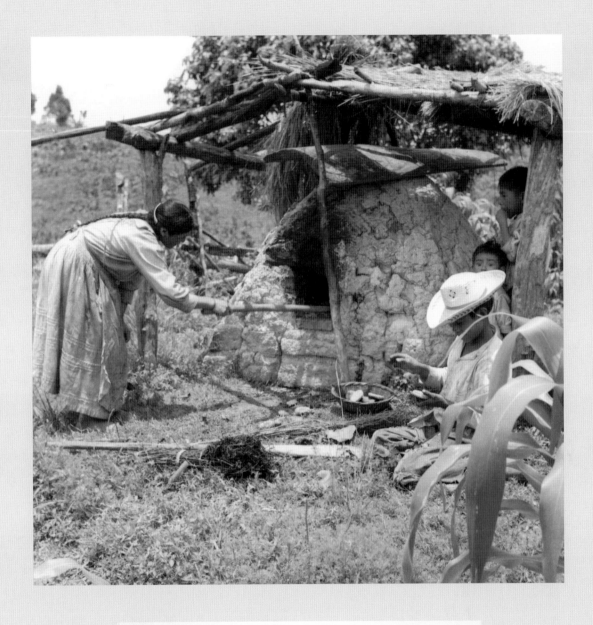

```
HONDURAS   (H1  17-8)
Baking topostes, small unlevened biscuits of
wheat flour, in outdoor oven, hamlet of
Azacualpita, in high montaña country, NW of
La Esperanza, Intibucá dept. Aug. 1957.
```

Preserved Glory

The LSU Herbarium

ABOVE: Annotation describing a dwarf palmetto. LSU Herbarium. Photographer: Jason R. Peak, Information Technology Services.

The beautiful silky-camellia, or *Stewartia malacodendron*, is a flower like no other. Relatively rare in Louisiana and in the southeastern United States, where its elegant flowers adorn the woodlands in April and May, these large native shrubs magically change color from a greenish white to bright yellow when dried. Like the enchanting silky-camellia, every specimen at the LSU Herbarium has a story.

Founded in 1869, the LSU Herbarium is one of the oldest in the Gulf South. It includes over 200,000 specimens, with more than 40,000 lichens (the largest lichen collection in the Gulf region) and approximately 25,000 fungi. It features prime accommodations and sophisticated equipment, but it is really the collection of plant specimens that makes the herbarium a significant treasure. Samples collected from around the world represent an important addition to our knowledge of plant species. Some specimens are old and say something of plant life one hundred or more years ago; others document the occurrence of rare species.

The LSU Herbarium is an essential resource for research, teaching, and public service, including the study of the wildflowers of Louisiana, the ecology of Louisiana marshes and other habitats, the medicinal plants of the Gulf South, the environmental impact assessment in Louisiana, the conservation of native plants, and Margaret Stones's Flora of Louisiana project.[1] It bears witness to the energy and foresight of those who have provided, collected, and studied the specimens for the last 140 years.

Credited as the herbarium founder, botanist and professor Americus Featherman (1822–1891) first collected flowering plants and ferns. From 1869 through 1871, he conducted botanical surveys in various regions of Louisiana and published his results as annual reports in Louisiana's official legislative documents or as separate volumes. Information about Featherman is scanty; that he was well trained in botany is evident from his published record and his carefully prepared plant specimens that form the basis of the herbarium's permanent collection. His prior employment was patent examiner for the Confederacy's department of justice during the Civil War.

Although he valued the need for scientific documentation of natural plant resources, Featherman gave equal importance to the social aspects of the process. "Botany, as a branch of the natural sciences, produces a more salutary influence to elevate and refine society, and raise the moral standard of civilization, than all the other sciences combined," he wrote.[2] Other LSU professors and botanists continued Featherman's legacy. Boyd Professor Emerita Shirley C. Tucker established and developed the excellent lichen collection, while the late professor Bernard Lowy (1916–1992) founded the fungal herbarium. Clair Alan Brown (1902–1982), director of the LSU Herbarium between 1927 and 1969, greatly influenced its development and published numerous works based on its collections.

The LSU Herbarium staff today is digitizing information from the collection. Many specimen images and label data are available on the World Wide Web. Financial support for this ongoing project was received from the National Science Foundation, the USDA Natural Resources Conservation Service, and the Louisiana Board of Regents.

—LOWELL URBATSCH

RIGHT: The silky-camellia, or *Stewartia malacodendron.* Specimen from the LSU Herbarium. Photographer: Jason R. Peak, Information Technology Services.

Notes 1. LSU chancellor Paul W. Murrill commissioned internationally renowned botanical artist Margaret Stones of Kew, England, in 1976 to produce two hundred watercolor drawings of the flora of Louisiana commemorating the bicentennial of the United States. Many Louisiana citizens and businesses supported this work, carried out in conjunction with LSU Herbarium personnel under supervision of its director, Lowell Urbatsch.

2. Americus Featherman, "Report of the Botanical Survey of Southern and Central Louisiana," *Annual Report of the Board of Supervisors of the Louisiana State Seminary of Learning* (1871).

Pliny the Elder and William D. Blake
The LSU Mineral Collection

I t may exist in awe-inspiring forms and reflect rainbows of light. Artists carve it into sculptures while industrialists use it to produce gypsum boards, create mold-resistant products and ceiling panels, and manufacture various styles of plaster. As fragile as it is beautiful, the versatile mineral gypsum is formed from the evaporation of salty water.

Gypsum is part of the William D. Blake collection of minerals at LSU. One of the largest in the southeastern United States, the collection consists of more than 350 specimens acquired from around the world. Their spectacular shapes and colors offer unprecedented teaching and learning opportunities for LSU students, faculty, and community members who live in a state where few rocks bearing minerals are exposed at the earth's surface.

The Blake collection features more than 5 percent of the known 4,200 minerals—dazzling one-inch to two-foot examples of nature's works of art. Some of the specimens are a single chemical element, such as gold or copper; others, tourmaline, for example, are a complex chemical mixture of ten or more elements that unite to produce exceptional mineral crystals. Size, shape, and color come together in a form that underscores their inherent beauty and variability. There are more than sixty specimens of the mineral calcite, all different in form. Masters of disguise, minerals can mimic a Van Gogh painting, a Monet landscape, or cerulean waters.

Former LSU alumnus William D. Blake (1932–) donated the mineral collection to the Department of Geology and Geophysics in the late 1980s. As a geology major, he discovered the beauty of crystal specimens during a mineralogy course at LSU and was inspired to begin collecting. Blake received his first specimens from friends, ordered them through the mail, or purchased them at regional mineral shows. He traveled to the world's largest showcase of minerals, the Tucson (AZ) Gem and Mineral Show, which has been held yearly since 1954, to purchase some of his finest specimens. A fascination with the elegance and wonder of minerals is not new. Roman naturalist and philosopher Pliny the Elder was the first to write about the brilliance of opal in his treatise *Historia Naturalis*.

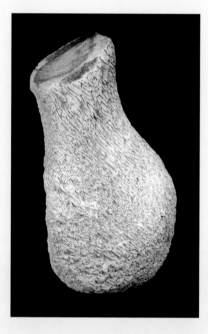

LEFT: Petrified palm wood, preserved by the mineral chalcedony. 15 x 11 x 5 in. Part of the Blake minerals collection at the Department of Geology and Geophysics, Howe-Russell Geoscience Complex, Baton Rouge. Photographer: Kevin Duffy, Information Technology Services.

Among the highlights of the Blake collection, with specific reference to Louisiana, are two specimens of petrified palm wood. One piece is comprised of a small tuberous portion of the original trunk and root system. Trace elements contained in the mineral chalcedony impart it with a variety of hues ranging from beige to red to brown.[1] Preserved forms of the wood's rodlike segments contribute to its rough but intriguing appearance. The fossil's genealogy remains obscure, but scientists speculate that it might be a distant ancestor of modern palm trees.

Petrified palm wood occurs only where environmental conditions are conducive to tropical environments, where trees are quickly buried and protected from decay, and where groundwater is rich in silica and permeates the plant's woody parts. These palm wood specimens represent a once vast tropical forest that covered much of the Gulf Coast thirty million years ago. A series of events kept them frozen in time. Slowly the mineral chalcedony (SiO_2) replaced the organic remains, changing the palm wood into an inorganic fossil. These treasures of the past were then uncovered at the earth's surface.

ABOVE: Close-up view of the crystals in a 5.5 inch span of a gypsum sample measuring 19 x 12 x 8 inches. Part of the Blake minerals collection at the Department of Geology and Geophysics, Howe-Russell Geoscience Complex, Baton Rouge. Photographer: Kevin Duffy, Information Technology Services.

Because of the occurrence of petrified palm wood in Louisiana and Texas, both states have declared them treasures. The Louisiana Legislature declared the genus of palm wood, *Palmoxylon*, the state fossil in Act No. 362, Senate Bill No. 155, of the 1976 session. Earlier, in 1969, the state of Texas declared petrified palm wood to be the official state stone.

The Blake collection, part of the Museum of Natural Science as are other mineralogy and petrology collections, is partially on display in the Howe-Russell Geoscience Building.

—BARBARA L. DUTROW

Note 1. Resistant to chemical and mechanical weathering and impervious to erosion, chalcedony is a whitish, opaque variety of quartz with crystals too small to be seen even with a microscope.

References Heinrich, Paul. "Petrified Palm Wood: The Louisiana State Fossil." Paul V. Heinrich Home and Louisiana Fossil page.

Klein, Cornelis, and Barbara L. Dutrow. *Manual of Mineral Science*. New York: J. Wiley and Sons, 2008.

Nirenberg, Morton. "The Opal: Lessing's Ring Re-Examined." *MLN* 85 (October 1970): 686–96.

"Texas: Petrified Palm Wood." State fossils Web page.

A Brush with Reality
Watercolors by Douglas Pratt

The inquisitiveness of squirrels, the nervousness of rabbits, the hunger of shrews, the cleverness of foxes and raccoons, and the playfulness of otters: In capturing the characteristics of each species in his paintings, Douglas Pratt demonstrates his mastery as a natural historian and artist. In a few background brushstrokes, he conveys the habits and habitats of the animals: the scrubby home of the armadillo, clinging tails of flying squirrels and the opossum, moths as food for bats, leaves for hiding voles, and grain as food for mice. But perhaps the most remarkable feature of these paintings is, quite simply, the quality of the fur. Ornithologists, like Douglas Pratt, deal in feathers, but his rendition of fur is exquisite in both color and texture. The plate that epitomizes all these artistic and natural history strengths is that of the squirrels, with its beautiful colors, textures, and expressions.

Born in 1944, Pratt spent his childhood in North Carolina and began drawing and painting at an early age. The Boy Scouts nurtured his love of natural history (he earned the rank of Eagle Scout), and this foundation was solidified in the years he spent as an undergraduate biology major at Davidson College and the summers he spent as a naturalist in the Great Smoky Mountains National Park. His career as an illustrator bloomed when he arrived at LSU in 1970 to begin graduate studies in ornithology under the renowned Boyd professor of zoology and LSU Museum of Natural Science founder Dr. George H. Lowery, Jr. (1913–1978). Pratt stayed at LSU as a student, research associate, and wildlife illustrator for the next thirty years. He is currently research curator of birds at the North Carolina State Museum of Natural Sciences in Raleigh.

To earn money as a graduate student, Pratt undertook the illustration of Professor Lowery's book *The Mammals of Louisiana and Its Adjacent Waters* (1974). This handbook was the result of almost four decades of research by Lowery and contains 70 species accounts and 247 illustrations, including 14 color plates by Pratt. Housed in the LSU Museum of Natural Science, the original paintings for these color plates are either watercolor or gouache, with a little acrylic used in backgrounds.

Pratt's artwork for this book also informed the science it contains, as a direct result of the intensely focused observation of specimens that is the foundation of accurate wildlife illustration. For example, while preparing drawings of the seminole bat and the red bat, Pratt noticed a difference in the skulls that established the two as morphologically distinct species. The taxonomy of these bats had previously been controversial, with some mammalogists considering the two bats to be simply different color phases of the same species. Pratt's observation of the skull difference settled the question, and Lowery's book is the first place this difference is illustrated.

Given free rein by the publisher in composition of the plates, Pratt attempted to tell a Louisiana story while rendering scientific detail. The drooling Virginia opossum chosen for the cover of the book served as visual humor, while illustrating that opossums do drool heavily when threatened or stressed. Another example of Pratt's subtle Louisiana-themed humor appears in the painting of a house mouse, shown upon a pantry shelf containing a bag of spilled rice and a bottle of hot pepper sauce. Pratt's favorite paintings in the book are his mouse pictures and those of the smaller mammals.

Pratt's work has been featured in *Encyclopaedia Britannica, Audubon, National Geographic, Birding*, and numerous other periodicals and books. His dissertation (1979) on Hawaiian birds led to a series of significant works on birds of the Pacific.[1]

—VANESSA HUNT AND FREDERICK H. SHELDON

Note 1. These works include *A Field Guide to the Birds of Hawaii and the Tropical Pacific* (1987), *Enjoying Birds in Hawaii* (1993), *Hawaii's Beautiful Birds* (1996), *A Pocket Guide to Hawaii's Birds* (1996), illustrations in Ernst Mayr and Jared Diamond's *The Birds of Northern Melanesia: Speciation, Ecology, and Biogeography* (2001), and most recently, his definitive monograph of the Drepanidinae, *The Hawaiian Honeycreepers* (2005). Pratt frequently gives talks on his life as a bird artist in which he recalls his artistic debt to his experience illustrating *The Mammals of Louisiana*.

Reference Douglas Pratt, personal communication, November 2002 and July 2008.

RIGHT: Douglas Pratt (American, b. 1944). Color plate illustration of squirrels. LSU Museum of Natural Science. Photographer: Eddy Perez, Office of Communications and University Relations.
BELOW: A closer view of a squirrel as illustrated by Douglas Pratt. Photographer: Eddy Perez, Office of Communications and University Relations.

Beauty from the Deep
The Henry V. Howe Type Collection of Microfossils

When fossils are mentioned, many people think of dinosaur bones. Much more common, however, are microfossils, the remains of microscopic organisms that can be found in many rocks even older than 500 million years. These tiny objects are beautiful and diverse, and many of them, including groups named Foraminifera and Ostracoda, are frequently used by geologists to tell ages of rocks and features of ancient environments. The Henry V. Howe Type Collection of Microfossils, consisting of numerous specimens of both fossil and modern foraminifers and ostracodes, is one of the best university repositories of microfossils anywhere in the world, and serves as an important resource for researchers in the United States and abroad.

The collection began in 1922 with the appointment of Henry V. Howe (1896–1973) as chair of LSU's Department of Geology and Mineralogy. Howe was charged with providing professional training to the generation entering the growing petroleum industry. His pioneering research on Gulf Coast biostratigraphy and petroleum geology brought him many distinctions, including LSU's Boyd professorship and the Sidney Powers Medal, the highest award given by the American Association of Petroleum Geologists. Before he retired, Howe donated to LSU his magnificent collection of Foraminifera and Ostracoda. On May 25, 1964, the LSU Board of Supervisors officially accepted the Henry V. Howe Type Collection of Microfossils, expressing "its appreciation to Professor Howe for his generosity in making the University the repository for so famous a collection." The original collection, housed in the Department of Geology and Geophysics and curated by the Museum of Natural Science, has been carefully preserved and substantially expanded by LSU faculty, research staff, and graduate students who have worked on fossil and modern foraminifers and ostracodes.

Foraminifers are primarily marine, single-celled organisms related to amoebas. They construct a shell with organic material, cemented particles, or secreted calcium carbonate. Ostracodes are aquatic crustaceans with a calcified carapace of two valves that enclose the body. They are related to crabs and shrimp, but their shells superficially resemble those of bivalve mollusks. Because of their durable shells, foraminifers and ostracodes have left a superb fossil record. There are also thousands of living species.

The "types" in the Type Collection are reference specimens used in the identification of species. Most notable are the "primary types," including (a) holotypes, single specimens that were chosen to represent the species when they were named, and (b) paratypes, representative specimens other than holotypes, also chosen by the original authors. In all, the collection contains about 2,800 primary-type specimen slides of foraminifers and ostracodes (stored in fire-resistant safes), over 9,500 figured or identified specimen lots, and nearly 5,000 assemblage slides. Much of the material is from areas in and around the Gulf of Mexico and the Caribbean. The specimens (mostly sand-grain size) are mounted on cardboard slides with a water-soluble glue. They can be examined under a light microscope, but a scanning electron microscope is sometimes used for greater detail. Over the years, numerous visitors have traveled to LSU to see specimens or have borrowed from the collection in order to solve problems of identification with their own material.

—Barun K. Sen Gupta and Lorene E. Smith

RIGHT: Specimens from the Henry V. Howe Type Collection of Microfossils, LSU Museum of Natural Science. Nos. 1, 2, and 4, foraminifers, colorized scanning electron micrographs; 3, examples of specimen slides; 5, an ostracode, digital photomicrograph. Photographer: Lorene Smith, LSU Museum of Natural Science.

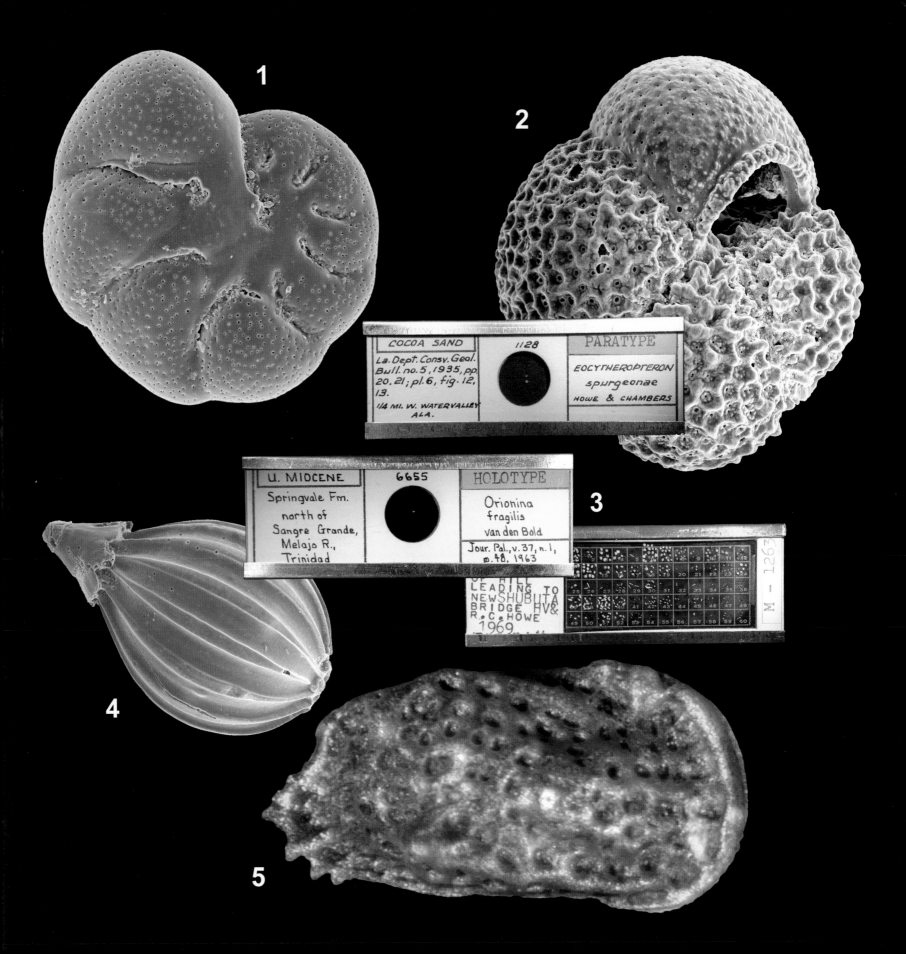

1

2

COCOA SAND

La. Dept. Consv. Geol.
Bull. no. 5, 1935, pp.
20, 21; pl. 6, fig. 12,
13.

1/4 MI. W. WATERVALLEY
ALA.

1128

PARATYPE

EOCYTHEROPTERON
spurgeonae
HOWE & CHAMBERS

U. MIOCENE

Springvale Fm.
north of
Sangre Grande,
Melajo R.,
Trinidad

6655

HOLOTYPE

Orionina
fragilis
van den Bold

Jour. Pal., v. 37, n. 1,
p. 48, 1963.

3

OF HILL
LEADING TO
NEW SHUBUTA
BRIDGE HV &
R. C. HOWE
1969

M - 1263

4

5

Contributors

Laurie Anderson, the H. V. Howe Distinguished Associate Professor and Harrison Family Field Camp Associate Professor in the Department of Geology & Geophysics, is an invertebrate paleontologist whose research explores the evolutionary history of Mollusca, particularly Bivalvia. She also teaches the freshman field camp, history of the biosphere, and paleobiology at LSU.

Meredith Blackwell, Boyd Professor in the Department of Biological Sciences, has published more than one hundred refereed papers, edited two books, and collaborated with Charles Mims on the fourth edition of *Introductory Mycology*. In addition, she has been interviewed about fungi by *Quirks & Quarks*, *Morning Edition*, *Discovery* magazine, the *New York Times*, *Science*, and the *Dallas Morning News*. In 2003 she was named Distinguished Mycologist, the highest research and service award of the Mycological Society of America.

Robb T. Brumfield is Associate Professor of Biological Sciences and Curator of Genetic Resources for the LSU Museum of Natural Science. He oversees the museum's collection of cryopreserved tissues and DNA. The collection, comprising approximately 70,000 specimens, is the oldest and largest genetic resources collection in the world, in addition to containing over 45,000 bird tissues. Most recently, Brumfield has been investigating the evolution of army-ant-following and other foraging specializations in tropical birds.

Victoria Cooke is Assistant Director for Curatorial Affairs at the LSU Museum of Art. She has worked at the Delaware Art Museum, the Hermann-Grima and Gallier Historic Houses in New Orleans, and the New Orleans Museum of Art. While the curator of European painting at NOMA, she worked on numerous exhibitions, including *Jefferson's America and Napoleon's France: An Exhibition for the Louisiana Purchase Bicentennial* and *Femme Femme Femme: Paintings of Women in French Society from Daumier to Picasso from the Museums of France*.

Chelsea L. Core, a graduate student in the LSU Department of Geography and Anthropology, is an Environmental Specialist at the Lake Pontchartrain Basin Foundation. Her professional and academic interests are in geographic information systems (GIS), physical geography, and environmental studies.

Van L. Cox, FASLA, is Assistant Director and Professor in the Robert Reich School of Landscape Architecture. He has taught design, graphics, and professional practice courses in the school since 1977. He is also the Louisiana landscape architects' representative on the Horticulture Commission (licensure agency). In addition to teaching, Professor Cox practices as a licensed landscape architect, and was a member of the design firm for the Main Academic Quadrangle renovations from 1975 to1982.

David Culbert is John L. Loos Professor of History at LSU. He was the Director of Historical Research and Associate Producer for Ken Burns's "Huey Long" (1985), available on DVD.

Yasmine Dabbous is a Ph.D. candidate in the Manship School of Mass Communication. She specializes in press criticism as well as media in the Middle East. Professionally, Dabbous has worked for several years in journalism and public relations.

J. Michael Desmond, AIA, is an Associate Professor in the LSU School of Architecture. Dr. Desmond teaches architectural history and urban design. His interests and expertise are in the study of architectural forms in context and the ways in which they both manifest and enable the associative lives of peoples.

Gresdna A. Doty, Alumni Professor of Theatre Emerita, is the author of *The Career of Anne Brunton Merry in the American Theatre* and coeditor of *Inside the Royal Court Theatre, 1956–1981: Artists Talk*. She has served as the Director of Theatre and on the founding board of directors of Swine Palace Productions, and was the first chair of the LSU Department of Theatre.

Kevin Duffy has been an LSU photographer for fifteen years. He works as digital imaging coordinator for Information Technology Services and also works on many projects in the local community. His personal photography can be seen in area restaurants, businesses, galleries, museum catalogs, and residences.

Barbara L. Dutrow is the A. G. Gueymard Professor of Geology at LSU. Her research interests involve computational modeling of mineral nucleation and growth combined with field studies of metamorphic rocks to understand the development of mountain belts around the world. She is a coauthor of the 23rd edition

of the *Manual of Mineral Science*—the longest-running title of John Wiley and Sons.

TIA EMBAUGH, CFRE, is Director of External Relations for the LSU Honors College. She oversees all communications and fundraising initiatives of the college, including a campaign to raise funds to restore the French House to its original grandeur and make it a state-of-the-art learning facility for honors students.

DAVID FLOYD has been Director of the Rural Life Museum since 1994. He has over thirty years of experience as a museum director, curator, and restoration consultant. He was voted Preservationist of the Year by the Foundation for Historic Louisiana (1994) and was awarded the Museum's Preservation Award (1996) and the Museum Director Lifetime Achievement Award (2003) by the Louisiana Preservation Alliance.

RONALD GARAY is the F. Walker Lockett, Jr., Distinguished Professor in the Manship School of Mass Communication. He served as the school's associate director and associate dean for thirteen years before returning to full-time teaching in 2005. Garay is the author of four books and has a varied range of research interests that include biography, media history, Texas history, industrial history, and church history.

KIMBERLY HOUSER, LSU Professional-in-Residence, Harp, has performed at the World Harp Congress, the American Harp Society Convention, and the Soka City International Festival in Japan. She has toured Mexico, Japan, Prague, and Puerto Rico and has performed in venues such as Casals Hall, Tokyo, and Nordstrom Recital Hall at Benaroya Hall, Seattle.

ELEANOR BARNETT HOWES is a linguist who taught in the Department of English at LSU for more than twenty years. She also served as the editor of *A&S@LSU* and as coordinator of public relations for the College of Arts and Sciences. She has been fascinated by the murals in Allen Hall since she was introduced to them as a child, and she was privileged to be part of the group who encouraged their restoration in 2001.

VANESSA HUNT is Assistant Professor of Science Education at Central Washington University. Her research focuses on the development of expertise in field biology, and a particular interest is the life stories of contemporary wildlife artists. She is working on a book describing the experiences and philosophies of leading bird artists in the United States, Europe, and Australia.

ERIKA KATAYAMA has worked in museums for over ten years, including the Freer Gallery of Art and the Arthur M. Sackler Museum at the Smithsonian Institution, the Museum of Art & History at the McPherson Center in Santa Cruz, California, the Louisiana State Museum, and the LSU Museum of Art.

KRISTIN MALIA KROLAK is Gallery Coordinator in Foster Hall and in the Alfred C. Glassell Exhibition Gallery in the Shaw Center for the Arts, where she curates art exhibitions for the School of Art. She has earned degrees in philosophy, ceramics, and art history.

JENNA TEDRICK KUTTRUFF is the Doris Lasseigne Carville and Jules A. Carville Jr. Professor in the School of Human Ecology, where she served as the first curator of the Textile & Costume Museum. Her research areas include the cultural and historical significance of textiles and apparel. One of her research interests is the documentation of hand-woven Louisiana Acadian textiles and the tools used in the home production of those textiles.

JEANNE M. LEIBY is Editor and Director of *The Southern Review*. Her collection of short stories, *Downriver*, won the Doris Bakwin Award from Carolina Wren Press.

LAURA F. LINDSAY, Professor Emerita of Mass Communication, served LSU in a number of administrative positions, including Dean of the Junior Division and Vice Provost and Interim Vice Chancellor for Academic Affairs. As Assistant to the Chancellor and Executive Director of the LSU Museum of Art, she represented the university during the construction phase of the Shaw Center for the Arts and the move of the LSU Museum of Art from the campus to its downtown location.

THOMAS A. LIVESAY has been Executive Director of the LSU Museum of Art since January 2007. Previously he served as Director of the Whatcom Museum of History and Art in Washington, Director of the Museum of New Mexico in Santa Fe, Assistant Director of the Dallas Museum of Art, and Director of the Amarillo Art Center in Amarillo, Texas.

MICHAEL LONG is pursuing graduate studies in prehistoric art and archaeology with an emphasis on paleolithic "rock art" and pre-Columbian art and architecture. As a student at LSU, he was the Lead Curator for the Union Art Gallery.

MARK E. MARTIN has been a working archivist for nearly twenty years. He currently serves as Photographic Collections Processing Archivist in Special Collections, Hill Memorial Library, LSU.

Marchita B. Mauck, Professor of Art History in the School of Art, has degrees in both medieval studies and liturgical studies and theology. Her interests also include contemporary art and architecture. She is nationally and internationally recognized as a liturgical design consultant, earning design awards for her renovation and new church projects. She has served as visiting professor at the Chicago Theological Union, the University of Notre Dame, and Yale University.

Natalie Mault is Assistant Curator at the LSU Museum of Art. Since joining the museum in 2006, she has been sole curator for numerous exhibitions including *New Orleans Union Passenger Terminal: The Sketches of Conrad Albrizio, The Daugherty Collection,* and *Reunion: James Burke, Edward Pramuk, and Robert Warrens.* She has also served as in-house curator for several exhibitions, including *Rodin: A Magnificent Obsession.*

Melanie Monce McCandless is the coordinator for the Cain Department of Chemical Engineering at LSU. She serves as the writer and designer for the department's annual alumni newsletter and is responsible for content on the department's Web site.

Dugg McDonough is the Mary Barrett Fruehan Associate Professor of Opera in the School of Music and Artistic Director of LSU Opera. As a professional stage director, he has created productions for companies in the United States and abroad, ranging from the New York City Opera to the Taipei International Arts Festival in Taiwan. As a specialist in working with young performers, McDonough is Co-Director of the James M. Collier Apprentice Artist Program of the Des Moines Metro Opera.

Linda R. Moorhouse serves as Associate Director of Bands in the School of Music. She is past president of both the National Band Association and Women Band Directors International, and has been recognized by the John Philip Sousa Foundation with the Sudler Order of Merit.

Chris Nelson is a Ph.D. candidate in theatre studies in the Department of Theatre. His primary interests are Tudor and Stuart theatre, as well as performance and directing.

Jason R. Peak, coordinator for Information Technology Services, graduated from LSU in 2005 with a degree in English literature. Since then, he has worked as photographer for the LSU community, performing studio and event photographic services.

Eddy Perez, coordinator of photography for the Office of Communications and University Relations, first discovered his passion for photography as a student in the LSU fine arts program, from which he received his bachelor's in fine arts in 2006. He likes portraying the world around him as beautiful memories through photography.

L. E. Phillabaum (1936–2009) was Director Emeritus of Louisiana State University Press. During his tenure, LSU Press books and authors received numerous prizes and awards, including three Pulitzer Prizes, the National Book Award, the National Book Critics Circle Award, the Los Angeles Times First Fiction Award, and the Ruth Lilly Poetry Prize. He twice served on the board of directors of the Association of American University Presses and was the association's president in 1983–84. He retired in 2003.

J. V. Remsen, Jr., is Professor of Biological Sciences and Curator of Birds for the LSU Museum of Natural Science.

Rebecca Saunders is Associate Professor in the LSU Department of Geography and Anthropology and Curator of Anthropology at the LSU Museum of Natural Science. She studies prehistoric and contact-period societies of the southeastern United States. She has also participated in forensic excavations of mass graves in Guatemala and in the former Yugoslavia.

Judith A. Schiebout is Associate Curator of the LSU Museum of Natural Science, Adjunct Associate Professor of Geology and Geophysics, and Associate Professor in Women's & Gender Studies. Her research interest is vertebrate paleontology. She received the 2001 Association for Women Geoscientists Foundation Outstanding Educator Award, and was a participant in the 2008 Earth Science Literacy Initiative.

Barun K. Sen Gupta is H. V. Howe Distinguished Professor Emeritus in the Department of Geology and Geophysics. His present research emphasis is on the ecology, diversity, and biogeography of living and fossil Foraminifera.

Frederick H. Sheldon is Director of the LSU Museum of Natural Science and the George H. Lowery, Jr., Professor of Natural Science. He is also an ornithologist.

Lorene E. Smith is the Collections Manager of fossil protists and invertebrates at the LSU Museum of Natural Science. Her professional interests include microscopy and Gulf of Mexico biodiversity.

Elaine Smyth is Head of Special Collections for the LSU Libraries. She has served as curator of the E. A. McIlhenny Natural History Collection and the Rare Books Collection since 1990, and as curator of published materials for the Louisiana and Lower Mississippi Valley Collections since 2000. Her professional interests include history of the book and printing, as well as book design and typography.

Karen M. Soniat is Director of Communications and External Relations at the Paul M. Hebert Law Center. She joined the Law Center in 2004 and is responsible for the communications, alumni relations, and advancement programs. Prior to coming to LSU, she was Executive Assistant to the President of Southeastern Louisiana State University and Education Senior Consultant in the Louisiana Department of Education.

Darius A. Spieth is an Associate Professor in the School of Art and a specialist in early modern European art history. He is author of *Napoleon's Sorcerers: The Sophisians*, which analyzes Egyptian themes in nineteenth-century Freemasonic art. His current research focuses on a book project dealing with art, auctions, and public spectacle in nineteenth-century Paris.

Judith R. Stahl is Gallery Director for the Union Art Gallery. Her responsibilities include curating annual rotating exhibits for the gallery and the development and acquisitions of Louisiana art for the Union's permanent art collection.

Mary Ann Sternberg is a part-time associate at the LSU School of Mass Communication and a longtime freelance writer and nonfiction author. Her books include *Winding through Time: The Forgotten History and Present-Day Peril of Bayou Manchac* (2007), *Along the River Road: Past and Present on Louisiana's Historic Byway* (rev. ed., 2001), and *The Pelican Guide to Louisiana* (2nd ed., 1993).

Emily Turner currently attends New York University, where she is majoring in history, with minors in French and psychology.

Suzanne Turner is Professor Emerita of Landscape Architecture. She is a landscape preservationist and historian, and coauthor of *Gardens of Louisiana: Places of Work and Wonder* (1997) with photographer A. J. Meek. Turner has been involved in the preservation of many southern landscapes, including those at Shadows-on-the-Teche, New Iberia, Louisiana; Drayton Hall, Charleston, South Carolina; Magnolia and Oakland plantations in Natchitoches, Louisiana; the Hermann-Grima House in the New Orleans French Quarter; and The Oaks and Tougaloo College near Jackson, Mississippi. Her firm was responsible for the landscape sections of the *Louisiana Speaks Pattern Book*, which was awarded a 2007 Charter Award by the Congress for New Urbanism.

Lowell Urbatsch is Professor of Biological Sciences and Director of the Herbarium at LSU. He specializes in the identification and classification of vascular plants of the lower Mississippi Valley and in certain genera worldwide belonging to the sunflower family, Asteraceae.

Pamela P. Vinci is Curator of the LSU Textile & Costume Museum and a faculty member in the School of Human Ecology. Her research interests focus on historic dress as well as Louisiana-related topics such as Acadian-produced textiles and the early twentieth-century production and marketing of hand-sewn infants' and children's garments in the state.

James Wade is the former Rare Books Librarian and Archivist for the Paul M. Hebert Law Center Library. He was responsible for the preservation of the Law Center's history archives. He is now pursuing a degree in historical preservation at Tulane University.

Sophie Warny is Curator of Education at the LSU Museum of Natural Science and an Assistant Professor in the Department of Geology and Geophysics. She is a paleontologist who studies microscopic fossils of pollen and algae to reconstruct paleoclimates. In addition to her research programs, she focuses on sharing ongoing research with the public and schools via outreach programs.

Frank B. Wickes is the Julian and Sidney Carruth Alumni Professor of Music. Since 1980 he has served as Director of LSU Bands. He is an elected member of the National Band Association Academy of Wind and Percussion Arts, and was recently elected to the National Band Association Hall of Fame of Distinguished Band Conductors.

Jim Zietz is University Photographer and Assistant Director for Public Affairs, Office of Communications and University Relations. He began his photographic career at age fourteen, and enrolled as a student at LSU in January 1975. Away from LSU, he works on his personal photography, which he exhibits in galleries and group shows around the region.